FREDERICK HART
CHANGING TIDES

Beauty is truth, truth beauty — that is all
Ye know on earth, and all ye need to know.

—John Keats
(1795–1821)

The antidote to the meaningless, the ugliness, and the nihilism that characterize so much of today's art is not necessarily a Soviet-style dogma of art, or a rigid academy attempting to relive the past. The antidote to meaninglessness is meaning and value. The antidote to ugliness is beauty, and the antidote to nihilism is spiritual renewal. Meaning and values, beauty and spiritual renewal are complex challenges subject to many interpretations. But the commitment to them is a very simple, albeit radical, change of direction — which in its search for interpretation will inevitably yield abundant fruit.

There are, in fact, many who in different quarters and disciplines have long been moving in this direction, and they are the changing flow in the coming cultural tides.

—Frederick Hart
(1943–1999)

FREDERICK HART

CHANGING TIDES

Foreword by Frederick Turner

Essay by Michael Novak

Hudson Hills Press

NEW YORK AND MANCHESTER

Published in the United States by Hudson Hills Press LLC, 74-2 Union Street,
Manchester, Vermont 05254.
Distributed in the United States, its territories and possessions, and
Canada by National Book Network, Inc. Distributed in the United Kingdom,
Eire, and Europe by Windsor Books International.

Co-Directors: Randall Perkins and Leslie van Breen
Founding Publisher: Paul Anbinder

Editor: Mary Yakush
Designer: Dean Bornstein
Proofreader: Richard G. Gallin
Indexer: Karla Knight
Color separations by Pre Tech Color, Wilder, Vermont
Printed and bound by Snoeck-Ducaju & Zoon, Gent, Belgium

ISBN 1-55595-233-X

Library of Congress Cataloguing-in-Publication Data

Turner, Frederick, 1943–
 Frederick Hart : changing tides / Frederick Turner, Michael Novak.
 p. cm.
 Includes bibliographical reference and index.
 ISBN 1-55595-233-X (alk. paper)
 1. Hart, Frederick, 1943—Criticism and interpretation. I. Hart,
Frederick, 1943– II. Novak, Michael. III. Title.
 NB237.H29T87 2005
 730'.92–DC22
 2004026625

Frontispiece: The young Frederick Hart, c. 1974

CONTENTS

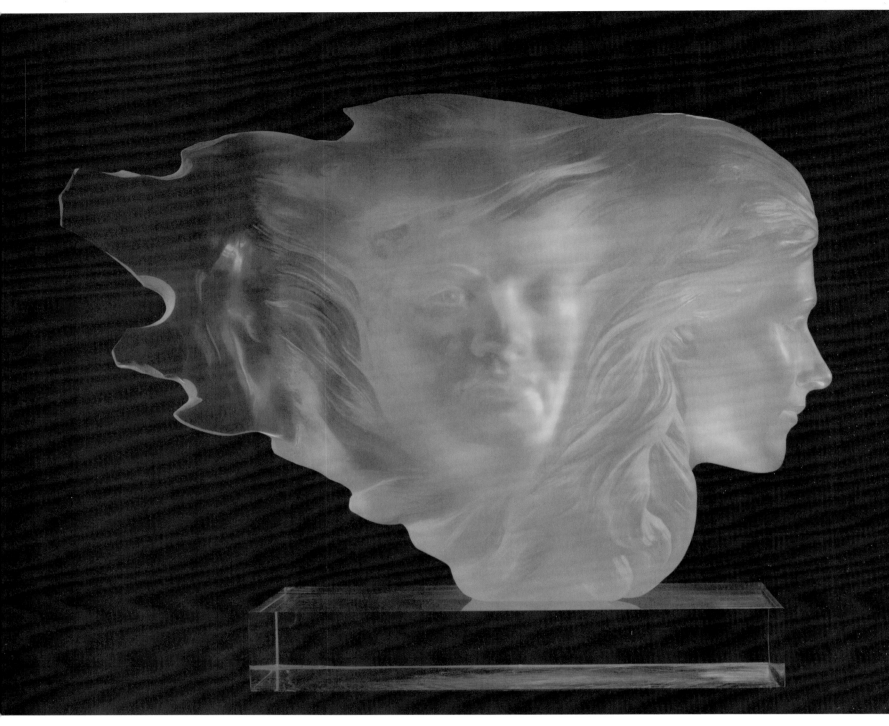

Herself, clear acrylic resin, 1984

PREFACE

Robert Chase

Frederick Hart confounded and intrigued those who knew him in much the same way as a military general who writes poetry might, or a professional athlete who cultivates roses, or an actor who races cars. His life was richly textured, layered with colorful characters, episodes, and causes, and these formed a bold pattern. An intimate essay in this book, contributed by his wife, Lindy Lain Hart, seeks to explain some of the apparent contradictions that made him the person he was. As a spirited youth who, on his own, had already veered from the path taken by most of his art school peers, Hart nevertheless harnessed enough discipline to earn an apprenticeship with the master stone carvers at Washington National Cathedral. His work there eventually led to his receiving what Tom Wolfe called "the most monumental commission for religious sculpture in the United States in the twentieth century," for the sculptures that now adorn the west facade of the Cathedral.

Published here for the first time is a selection of the artist's writings, including a remarkable letter (page 22) that he wrote just prior to receiving the Cathedral commission. The letter reveals a young man with a keen sense of artistic integrity, who had grappled with and mastered the works of philosophy that gave him a firm grounding for his personal aesthetic. Also included for the first time are documents from the Cathedral's archives that trace the development of the building committee's unusual choice of the Creation theme for the west facade, and the structuring of the competition for the commission. The subsequent collaboration included Hart, the Cathedral building committee and benefactors, and essential craftsmen such as the clay enlarger, the plaster casters, the stone mill personnel, the stone carvers, and the laborers. Collaboration on such a scale might seem to run counter to an artist's individuality and need to maintain the integrity of his

vision; but Hart met this challenge, focusing on the project as a whole, with a measure of practicality and an open sense of humor.

The Cathedral Sculptures were a formative experience for Frederick Hart and led, with the turn of a page more than a quarter century ago, to our partnership. Leafing through the pages of an art journal, I was struck by a lavish photographic spread of a work in clay called *Ex Nihilo* by an artist unknown to me. Deeply moved by the passion and life force of the work, I was determined to shake the hand that shaped that sculpture. The next day a search for Frederick Hart's telephone number led to my first conversation with him. He graciously invited me to his studio, and though a photograph had been inspiration enough to bring me to Washington, nothing prepared me for the intensity of the art I encountered there. It was a moment I shall never forget.

We began talking, and after several hours the conversation turned to Hart's hopes and dreams for his career. When asked if he intended to work exclusively on monuments, or whether he also envisioned creating smaller-scale works, his answer was to lead me to a table in the corner. He explained that he had been "tinkering" for years with a translucent material that allowed light to penetrate the surface of a sculpture and become a component of the work itself. Hart was intrigued and captivated by the capricious nature of this medium, which allowed him to use the reflection, refraction, and absorption of light to create a mysterious, eloquent message with spiritual, emotional, and sensual impact. Most earlier sculptors had worked in opaque mediums such as stone and bronze.

He proceeded to show me a block of clear acrylic resin that contained an embedded sculpture of a translucent embryo-like form. As he carried the piece to the window, light seemed to emanate from within it

as if the birth of life was being expressed with pure light. This idea eventually resulted in cast acrylic resin works such as *Herself* (page viii), first conceived in clay in 1971 and realized in cast acrylic resin in 1984. Born of Hart's impulse to "sculpt with light," the works in resin represent a major innovation in technique and materials, one that thrusts the interplay of abstract form and figural representation into a new dimension.

This first fortuitous meeting eventually led to collaboration between Frederick Hart the artist and myself as publisher. It lasted for the remainder of his life, and included the entire spectrum of his work in bronze, marble, cast marble, and clear acrylic resin.

Hart believed that the cultural tides were changing, and that the twenty-first century would bring a renaissance and an age of enlightenment. He determined to create sculptures that physically and spiritually reflected this and spoke to the transforming power of beauty. It is no surprise that at a time when the art world had largely spurned the human figure, Hart chose to champion it. His genius glowed with a deep conviction in the freedom of choice and was the source of his sense of destiny and his self-confidence. It was also the wellspring of the set of contradictory impulses that propelled him through a rich and extraordinary life, about which Lindy and I have often reminisced. Hart's years at the Cathedral deepened his dedication to the pursuit of truth, beauty, and goodness in art — a pursuit Hart thought was unattainable without an aesthetic anchored by the human figure. This thinking pushed him further out of the mainstream of contemporary art, yet he remained convinced the twenty-first century would see changes.

Hart had a poised, somewhat shy, but unassuming manner. Yet he also had a fixation on Daniel H. Burnham's admonition, "Make no little plans, they have no power to stir men's blood. . . ." He built a lavish home for his family in the Virginia hunt country, complete with a grand ballroom and ornate plasterwork he designed in collaboration with his long-time friend David Hytla. Some might interpret this gesture as self-aggrandizing, but Frederick Hart built Chesley because he, as a sculptor, was inspired to create beauty by being surrounded by beauty — the beauty of the Virginia countryside and the beauty of the home into which he had poured his talent and his love of architecture. The grounds provided a perfect setting for his large bronzes, and he delighted in opening his home to friends and to the neighboring community. Over the years, the Harts hosted many charity benefits at Chesley.

It was impossible to escape Rick's generosity of spirit. In the early 1980s Rick, my son Bobby, and I indulged in a day of fishing on Chesapeake Bay, where we caught an astonishing fifty-four bluefish. We cleaned them, put them on ice, and then visited the Cathedral, still in our fishing clothes. There we climbed the scaffolding to view the progress of *Ex Nihilo*. Then Rick drove us around Washington, delivering the day's catch to friends and fellow workers from the Cathedral. Finally we went to his home near Dupont Circle, where we enjoyed a great dinner prepared by Lindy. Always I shall remember that wonderful day and Rick's capacity to enjoy and embrace life.

I always looked forward to visiting the Cathedral with Rick while the Creation Sculptures were in progress. Each time I marveled to see the sculptures majestically coming to life in the stone. One memorable visit began at the Cosmos Club where Rick was a proud member. After lunch, Rick challenged me to a game of pool. It was a short game because, as the saying goes, "he cleaned my clock," which fortunately allowed us time to stop at the Cathedral on the way to the airport.

Twilight surrounded us as we climbed the scaffolding to view what had been recently accomplished. Returning to the car some minutes later, we reached to open the car doors, hesitated, and obeyed simultaneous impulses to turn for one more glimpse. Over our shoulders through the now dark sky loomed the form of the great Cathedral. At that precise moment, from behind the trees, a brilliant full moon emerged. Poised in the sky and encircled by clouds, the moon appeared to prompt heaven itself to echo the forms of the *Creation of Night* tympanum, which was then taking shape in stone. Neither of us spoke. In this spellbinding moment between friends, I wondered if life were imitating art, or art were imitating life.

Hart's diverse interests, multiple talents, and manifold turns of mind must have kept an internal balancing

wheel in constant motion. He sharpened his intellect and imagination with the ongoing study of philosophy, history, and aesthetics, as well as stimulating discussions at an informal gathering of neighborhood gentlemen, where he was especially impressed by the local postman's breadth and depth of knowledge. Rick was a model train enthusiast, found relaxation in fishing and hunting (but not too vigorously), and was conversant in the mechanics of ponds and the raising of swans. He enjoyed taking his two young sons camping, and any deficiency in outdoorsmanship found in this city-bred father was more than overcome by his enthusiasm. Regularly opening his studio for student tours and church and community groups, he valued knowing people from all walks of life and could easily converse about farm machinery or why sheep manure was the best fertilizer for geraniums.

He relished the colorful traditions of fox hunting, which he enthusiastically discussed with Prince Charles at the installation of *Daughters of Odessa* at Highgrove, the Prince's country estate. Rick was honored to meet Pope John Paul II in his private quarters in the Vatican where Hart presented the pontiff with a special cast of *The Cross of the Millennium*. He was just as honored to donate another cast in the edition to Saint Peter's Mission, his family's church in Washington, Virginia.

Not one to shrink from controversy or to accept compromises, Frederick Hart rallied to David and Goliath causes. His courage and success in taking on a major film studio to protect the integrity of his masterwork *Ex Nihilo* was an inspiration to all artists, and provided the impetus for ongoing discussions by journalists and in law schools throughout the United States concerning the ethics and legality of the unauthorized appropriation of sacred art for profane purposes. Locally, he marched with his neighbors against another media giant's intention to build a Civil War theme park in the heart of Virginia's cherished historical battlefields.

Entirely in character was Hart's choice to take a stand for morality, integrity, and honesty. He was as passionate in following a course that would place him in opposition to the prevailing currents of art criticism. To have worked with a man of such principle and purpose, who became my close friend and who created works of inestimable importance and value, was a great honor and privilege. Now, some years after his death, it seems urgent to offer historians and collectors of Frederick Hart's work a more intimate view of his life, work, and philosophy than has yet been made public.

Frederick Hart's memory will be well served if this book helps guide readers to a more complete understanding of him as an individual who never abandoned his convictions about art and beauty, and whose life was ever expanding in the directions he chose to take. His rich, tumultuous life resulted not only in several of the most important monumental public artworks of the twentieth century, but in other artists' renewed interest, which is fast becoming a movement, in creating sculpture of the human figure.

ACKNOWLEDGMENTS

Many have contributed their time and expertise to this book, and we are grateful for their efforts to sustain both the memory and the legacy of the artist. Sincerest thanks are owed to our authors: Robert Chase for his thoughtful preface that provides a first hand account of a twenty-five-year friendship and collaboration; Lindy Lain Hart for an essay that brims with empathy and a soul mate's insight; Michael Novak and Frederick Turner for especially lucid analyses of the ideas that define and distinguish Frederick Hart's sculpture; and Davis Buckley, James F. Cooper, the late Reverend Dr. Stephen Happel, Martha Lufkin, Edward C. Smith, the late Senator Strom Thurmond, and Tom Wolfe. None has worked harder or more sincerely on behalf of Frederick Hart's legacy than Madeline Kisting who conceived and guided the book, and Lori Schwartz who capably managed its production. We thank Erik Vochinsky for his research on Frederick Hart's work at Washington National Cathedral and for his contributions to this book. We are indebted to our editor, Mary Yakush, who greatly influenced the content as well as the style of this book. Dean Bornstein's elegant design and typography significantly enhanced the publication.

We also thank the administration at Washington National Cathedral: the Right Reverend John Bryson Chane, Bishop of Washington and Interim Dean; the Very Reverend Nathan D. Baxter, Dean (retired June 30, 2003); and the Cathedral Chapter. We wish to also thank the staff who graciously opened the Cathedral archives and answered queries, especially the Honorary Canon Richard G. Hewlett, historiographer.

Many others have lent their support, including Darrell Acree, Becky Ault, James Baker, Anna Belkin, Brian Bettencourt, Carol Breckenridge, Susan Chaires, Moya Chase, Robert Chase, Jr., Ovidiu Colea, Mike Cunningham, Stefania de Kenessey, Elliot Gantz, Jeffery L. Hall, Alexander T. Hart, Frederick Lain Hart, Fred Hetzel, Vanessa Hoheb, Frederick Holmes, David Hytla, the Reverend Monsignor W. Ronald Jameson, Jane Junhaus, Dana Kozer, James Mann, the Reverend James P. Meyers, James Moss, Michael Pagliuco, Terry and Charles Pelter, Dick Polich, Duke Short, Sheryl Rudat, Sandra Sanderson, Betsy Schabilion, Diane Schroeder, Andrew Walworth, Ben Wattenberg, and Lisa Wolfe.

We would like to remember those no longer with us who significantly influenced and guided Frederick Hart, especially Canon Clerk of the Works Richard T. Feller, and Master Stone Carvers Roger Morigi and Vincent Palumbo from Washington National Cathedral, the Reverend Dr. Stephen Happel, and J. Carter Brown whose path intersected with Frederick Hart's at a crucial time for the arts in Washington.

NOTES TO THE READER

1. All Frederick Hart works editioned from October 1, 1994 through December 31, 2004 are illustrated in this book. Some works prior to October 1, 1994 are also illustrated. For all work editioned prior to October 1, 1994, refer to the book *Frederick Hart, Sculptor*.

2. Frederick Hart conceived the works published here between 1970 and 1999. For monuments and statues the date given is the dedication date and for all other works it is the copyright date.

3. Fig. 100, c. 1992, ink drawing, spiral-bound cardboard-covered notebook of the artist.

4. Dimensions for the sculptures refer to height. The height includes the base for any work issued in an edition greater than twenty-five. The heights of the clear acrylic resins are approximate, as each is slightly different owing to the expansion and contraction inherent in the casting process, as well as the hand-finishing of each. Within an edition the patina, polishing, base, position, and mounting may vary.

5. A catalogue raisonné of the works of Frederick Hart is in preparation. Edition specifications for all works will be contained therein.

CONTRIBUTORS

DAVIS BUCKLEY founded the Washington, D.C. architectural firm bearing his name in 1979. Among many awards he received a Presidential Federal Design Achievement Award for Excellence in Design from the National Endowment for the Arts and was twice awarded the Henry Herring Memorial Medal by the National Sculpture Society. His work has been the focus of two exhibitions at the National Building Museum in Washington, D.C.

ROBERT CHASE is a Founding Partner of Sculpture Group Limited and Chesley; a seventeenth to twentieth-century fine print and sculpture dealer and collector; a lecturer; and a sustaining fellow and governing member of the Art Institute of Chicago. Chase was Hart's publisher and principal collaborator from the late 1970s.

JAMES F. COOPER is Founding Director of the Newington-Cropsey Cultural Studies Center in Hastings-on-Hudson, New York. He has written extensively on art and cultural issues and is editor of *American Arts Quarterly*. His most recent book, *Knights of the Brush*, was published in 2001.

STEPHEN HAPPEL (the late Reverend Doctor) was Dean of the School of Theology and Religious Studies of The Catholic University of America, Washington, D.C. Happel was an expert in systematic theology, foundational and fundamental theology, and religion.

LINDY LAIN HART was Frederick Hart's wife and model. They met in 1977 when he asked her to model for the *Ex Nihilo* tympanum and they were married in 1978. They have two sons, Lain and Alexander.

MARTHA LUFKIN, a lawyer and journalist, is legal correspondent for the *Art Newspaper*, and has written on copyright, the free-speech rights of artists, and Nazi-looted art.

MICHAEL NOVAK, an educator and author, is the George Frederick Jewett Chair in Religion and Public Policy at the American Enterprise Institute in Washington, D. C. He has taught at Harvard, Stanford, Syracuse, and Notre Dame and is the author of more than twenty-five books on the philosophy and theology of culture. His writings have been published in every major Western language. Among numerous other awards, he received the Templeton Prize for Progress in Religion at Westminster Abbey where he delivered the Templeton Address; the Masaryk Medal, presented by Václav Havel of the Czech Republic; and the Cézanne Medal from the City of Provence.

EDWARD C. SMITH is Director of American Studies and Special Assistant to the Dean of the College of Arts and Sciences at American University, Washington, D.C., and a lecturer for the Smithsonian Institution.

FREDERICK TURNER is Founders Professor of Arts and Humanities at the University of Texas, Dallas, and former editor of the *Kenyon Review*, is the author of *Beauty: The Value of Values*, and *April Wind*, a collection of poetry; and has contributed to numerous books on the arts, including *Frederick Hart, Sculptor*.

ERIK VOCHINSKY represents Washington National Cathedral in its work with Chesley on the Cathedral Collection of Frederick Hart's sculptures, and directs publication projects for the Cathedral.

TOM WOLFE is the best-selling author of more than twenty-five books of fiction and non-fiction, including *The Painted Word*, *Bonfire of the Vanities*, *A Man in Full*, *The Right Stuff*, *Hooking Up*, and most recently, *I Am Charlotte Simmons*.

MARY YAKUSH is Senior Editor at the National Gallery of Art, Washington, D.C., and a freelance editor and writer.

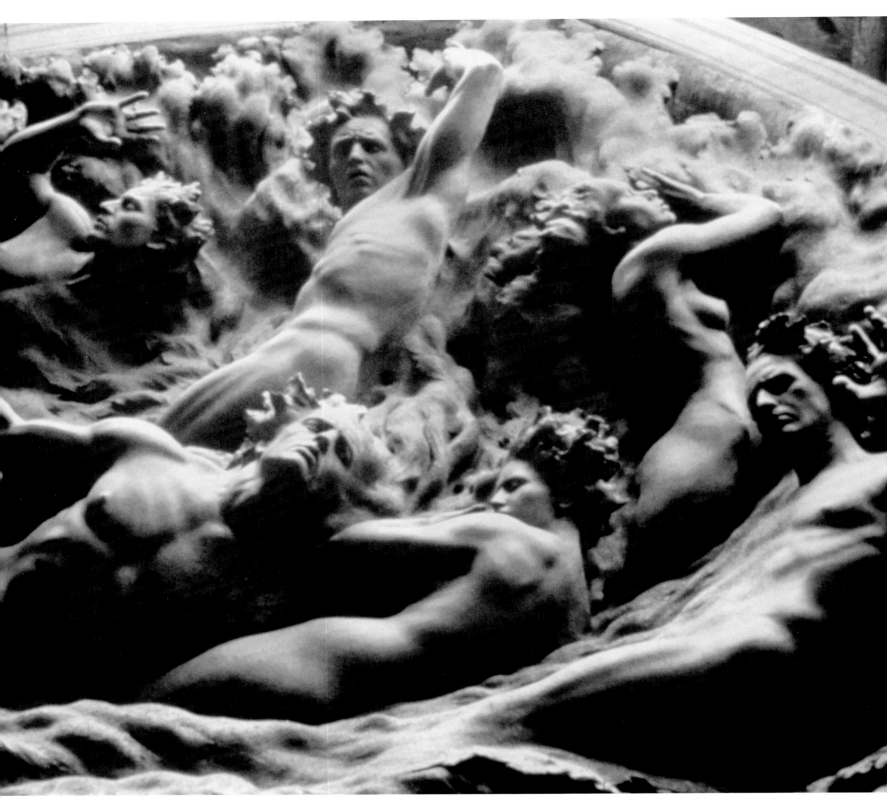

Detail, *Ex Nihilo*, Washington National Cathedral, clay

FOREWORD

Frederick Turner

I first came to know Rick through his Creation Sculptures on the facade of Washington National Cathedral. They were curiously attractive to me — they were unlike any contemporary religious art I had seen, and they somehow chimed with my own sense of the great mystery of the creation of the world. I thought of Saint Francis's love of nature, his habit of calling the sun and moon his brother and sister. I also felt the boldness of the unknown artist in having so frankly incorporated the theory of evolution into America's greatest religious building. (Later I found that Rick had been captured, as had I, by the genius of Pierre Teilhard de Chardin, the Catholic theologian and paleontologist who saw evolution not as a disproof of God's creative power, but as an astonishing revelation of its inner meaning.)

Years afterward I met Rick through a different medium: James Cooper, a passionate devotee of Rick's work, had arranged a telephone conversation between the two of us. He published it in *American Arts Quarterly*, of which he was editor. He said that it helped to determine the editorial direction of the magazine in the years to come. I was delighted to have met the artist whose work I had admired but whose name I did not know. It was an unusual stroke, to bring a poet and a sculptor together in a time when the arts were scarcely speaking to each other at all. But Cooper rightly guessed that our shared passion for beauty, for nature, for craftsmanship, for real ideas in art, and for the moral and spiritual role of art in society would give us enough to talk about; and indeed it did.

Rick and I became close friends, though living at opposite ends of the country made it difficult to meet. I came to know Rick's other works: *Three Soldiers* at the Vietnam Veterans Memorial, so gallantly and so wearily confronting Maya Lin's black wall of national despair; the many portraits of his wife Lindy; the beautiful and mysterious *The Source*, with its flow of fresh water over crystal; the grand — Beethovenian! — portraits of public figures; the warning *The Angel*; *The Cross of the Millennium*; *Daughters of Odessa*, with their tragic appeal to the conscience of the world; and so many other works that have helped shape my own visual imagination in the following years. His beautiful house on the Blue Ridge became a meeting place for poets, composers, writers, architects, editors, philosophers, and even the occasional anthropologist; there a new movement in the arts of America began, to which can now be traced the recoveries of meter and rhyme in poetry, visionary realism in the visual arts, melody in music, and humane proportion in architecture and city planning.

Hart's peculiar attitude to evolution, which I am only now coming to understand, is that in choosing the evolutionary process as his system for creating the universe, God was choosing the freest of all possible methods — to set the universe up in its first incandescent moment of the Big Bang, so that everything would be in a state of free play — everything could choose for itself what it was going to be next, limited only by the constraints it had already created for itself, and by the fact that everything else was also similarly exercising its own freedom to become what it wished.

This apparent chaos of choices actually resulted in a highly ordered universe — so ordered, in fact, that Enlightenment philosophers made the mistake of believing it was simply a huge piece of deterministic clockwork. But we now know that the spontaneous interaction of many agents — whether water molecules in a mountain torrent or proteins in a living body — can self-organize into highly elaborate structures that are orderly not just because of external constraints or single-outcome causes, but because of their own autonomous capacity for self-maintenance. Consider Hart's

Ex Nihilo, for instance, his magnificent depiction of the creation of the universe: the forms of the figures emerge out of the free play of a turbulent whirlpool, but the figures are free in a new way. Their freedom consists not in absence of rule but in ruling themselves, as does a democratic nation. They keep, so to speak, the promises they have made and can therefore be trusted to be predictable within certain self-chosen limits. Like a work of art, each of whose parts defines the context of each of the others and shows us how to understand them, a living organism generates its own canons of judgment. The Latin word for beauty is *forma*, from which comes our word *form*—implying pattern, self-imposed shape, chosen limits. It is this sense of beauty that lies at the core of Hart's work.

In this sense the universe is free, not deterministic; and Rick drew the conclusion, as I do, that the Creator of such a universe must value freedom more highly than any other characteristic of his creations, even to the extent of permitting them to defy his own will. The freedom we value in humans is a freedom that knows itself, and in knowing itself chooses its own nature and its own kind of consistency. To choose against that consistency is to choose unbeing over being. In Christian theology that choice is called the Fall; Rick Hart knew this too and showed us its tragic side by implication in *Three Soldiers, The Cross of the Millennium*, and *Daughters of Odessa*.

But as with Hart's paradoxical union of the birth, death, and resurrection of Christ in his translucent cross, there may be an even greater beauty in the process of experiencing the destruction and sacrificial redemption of *forma* than there is in the untested primal order. If the revolutionary side of modernism was a choice against consistency, a choice against nature, a choice of nonbeing over being, then we have, as Rick felt, the enormous privilege and burden as artists of following the way of the cross and bringing new *forma* out of the chaos. *Daughters* refers mutely to the terrible results of the twentieth-century secular totalitarian choice to defy the will of God, but it also implies, through its loving reconstruction of the youth and beauty of the girls, the possibility of a recovery of humane civilization. The whirlwind of *Ex Nihilo* is also the whirlwind of the book of Job, out of which God

speaks when he reveals to his suffering, questioning servant the dreadful engines of creation that underlie our precious and fragile sense of justice.

This intuition of the importance of freedom is both an artistic one, confirmed by having to struggle with stone's insistence on its own stoneness and bronze with its bronzeness, and a political one, learned from Rick's own participation in the early civil rights movement. Rick's politics were not partisan, but they were always for freedom, and his artistic stance was for freedom and the responsibility to one's own self-chosen promises and constraints that freedom implies. *Forma*, beauty, then, is the glory that self-ordering freedom carries with it, the resemblance to God of whatever possesses it. Evolution was, for Rick, the way God arranged for his creations to be self-creations, as God himself is. Out of this perspective comes an understanding of aesthetics at odds with much contemporary theory, an understanding that informs the "changing tide" in culture this book celebrates. Let me try to summarize briefly its characteristics, as we hammered these out in those long talks in the Virginia hills. These are in many ways ancient and classical—but in just the same ways, in close agreement with the cutting edge of contemporary science.

What we came to see was that the experience of beauty is a recognition of the deepest tendency or theme of the universe as a whole. This may seem a very strange thing to say; but there is a gathering movement across many of the sciences indicating that the universe does have a deep theme or tendency, a leitmotif that we can begin very tentatively to describe, if not fully understand. Beauty in this view is the highest integrative level of understanding and the most comprehensive capacity for effective action. It enables us to go with, rather than against, the deepest tendency or theme of the universe, to be able to model what will happen and adapt to or change it.

Humans, we agreed, are part of nature: we have a nature ourselves, one that art can nurture. Nature is beautiful and meaningful in itself; we humans evolved to love and enjoy and make beauty because to do so helps us flourish and prosper, and because the universe itself was set up from its beginnings to select for beauty and for beauty experiencers and beauty makers. The

phenomenon of evolution implies that there is such a thing as real progress; but it also implies that any significant work in the present must include and be the culmination of the past. Beauty is a fundamental reality; it is what the richness and depth and productiveness of Being itself looks like. But beauty exists only in the accepted presence of shame and tragedy. Beauty, though it may be surprising, must also be familiar; it connects past and future, the known and the unknown. The ideal of beauty, but not the form, is culturally universal and goes beyond the subjective self, personal taste, and inner desire; it is a true description of the real world, the guide of politics, the core of morality and speculative understanding. It is not the handmaiden of politics.

Beauty is the defining property of Being, but only if Being is conceived of as complicated, interfered-with, reflexive, and epistemological; that is, matter is at least potentially aware of and sensitive to its environment. We can learn about beauty by looking at the universe itself, as the great Renaissance masters such as Leonardo da Vinci knew, and as the great Greek sculptors, like Praxiteles, knew before them. Like the evolving universe, beauty combines unity with multiplicity. Our best knowledge about the beginning of the universe is that everything in the universe was contracted into a single hot dense atom; artistic beauty should likewise derive from a single principle but diversify itself into great richness of form. To experience beauty is to experience what is generative and creative: the universe generates a new moment every moment, and each moment has genuine novelties. Its tendency or theme is that it should not just stop. Beauty discovers complexity within simplicity: the universe is very complicated, yet very simple physical laws, like the laws of thermodynamics, generated it. As it has cooled, it produced all the laws of chemistry, all the new species of animals and plants, and finally ourselves and our history.

With all its freedom, beauty is the keeping of its own promises—the carrying out into the future of the act proposed by its beginning. It is thus repetitive or iterative—it repeats its own theme. Thus another feature of beauty is rhythmicity: the universe can be described as a gigantic, self-nested scale of vibrations, from the highest-frequency particles, which oscillate with an energy of ten million trillion giga-electron volts, to the slowest conceivable frequency (or deepest of all notes), which vibrates over a period sufficient for a wave to cross the entire universe and return. Out of these vibrations, often in the most delicate and elaborate mixtures or harmonies of tone, everything is made.

The many and one, the complex and the simple, the unique and the repeated, are joined together by hierarchical organization: big pieces of the universe contain smaller pieces, and smaller pieces contain smaller pieces still, and so on. Relatively big pieces, such as planets and stars, control to some extent—through their collective gravitational and electromagnetic fields—the behavior of the smaller pieces of which they are composed, while the smaller pieces together determine what the larger pieces are to begin with. We see the same hierarchical organization, much more marvelously complex and precise, in the relationship of the smallest parts of the human body to the highest levels of its organization, from elementary particles through atoms, molecules, cells, organelles, and organs, to the neural synthesis that delegates its control down the chain. Consider also the elegant hierarchy of support, control, cooperation, and dependency that one finds in the parts and whole of a Bach canon.

Beauty involves the property that we have recently learned to call "self-similarity," now being investigated by chaos theorists and fractal mathematicians: the smaller parts of a beautiful thing tend to resemble in shape and structure the larger parts of which they are components, and those larger parts in turn resemble the still larger systems that contain them. The universe itself is a "scaling" phenomenon of this kind. Like Dante's *Divine Comedy*, in which the three-line stanza of its microcosm is echoed in the Trinitarian theology of its middle-level organization and in the tripartite structure of the whole poem, so the universe tends to echo its themes at different scales. If one looks at the branches of a tree—Yeats's chestnut tree, perhaps, that "great-rooted blossomer"—one can see how the length of a twig stands in the same relation to the length of the small branches as the small branches stand to the large branches, and the large branches to the trunk. One can find this pattern in all kinds of

phenomena—electrical discharges, frost flowers, the annual patterns of rise and decline in competing animal populations, stock market fluctuations, weather formations and clouds, the bronchi of the lungs, corals, turbulent waters, and so on. And this harmonious relation of small to large is *beautiful*.

Beauty only rises to its next higher level through a radical challenge to all these principles; a challenge to them, not the destruction of them. Beauty is symmetry, but also symmetry breaking, when the symmetry breaking is incorporated into a new symmetry. Beauty is hierarchy breaking, but only when the new hierarchy that results is richer and more inclusive and more flexible than the old. Beauty is always fresh precisely because it is generative, it gives birth to branched and bifurcated futures and open possibilities. Beauty thus implies a tragic undertone whose triumphant answer is always a mystery. And the tragic can only exist in a world in which joy and triumph are also possible.

In person, Rick lived up to the ideals of his art. There was a beauty in his personal relationships that expressed itself in two chief ways: his delightful sense of humor, and the delightful surprises that he was always concocting for his friends. You never knew what was going to happen when you visited Rick; you only knew that you would not be harmed and that you would carry away memories of something you had never experienced before. He was a free man, and he helped make others free—from clogging routines and dead opinions and sullen moods.

And here I would like to leave a brief personal memoir so that those who did not know him personally might have some sense of him as a human being. I remember those long afternoons of discussions, looking out from the colonnade of Chesley, his beautiful house in the Virginia hills, with an exquisite frozen bouquet of fruits and flowers composed by Lindy in a glass vase, and Bellinis to drink; and as dusk fell over the lake and ducks circled and splashed down, the move into the study with its books and mementos and cigars. I recall the walks in his woods and meadows, which he was gradually landscaping so as to bring out their finest points—planting trees that only his sons would see in their full glory, clearing wind-damaged forest, opening up streams, visiting the horses. He had

a ferocious yellow bulldozer, with his characteristic quiet humor, named "Camille" after the take-no-prisoners cultural critic Camille Paglia, whom Rick rather admired. I remember not getting the message that a meeting had been canceled because of bad weather, and driving through strange magical bowed forests covered with the jeweling of an ice-storm, and the warm welcome at his house, the kitchen with its open fire and Rick's German shepherd Einstein lying before it with his paws crossed. I remember waking next morning to the sounds of a bagpiper in full kilt and tartan cape, striding to and fro along the colonnade, playing the great haunting Celtic tunes for my benefit—Rick knew of my Scottish ancestry, and it was one of the little surprises he liked to arrange for his friends.

When I visited Rick's gravesite—appropriately on his own land, and in view of the great wavy line of the Blue Ridge—something strange happened: we were standing there in silence, and suddenly we noticed that the whole forest around us was full of deer. Until we noticed them they had remained, undisturbed by our presence. The moment one of us noticed them—deer camouflage is very effective—they fled at once. But I took it not so much as a supernatural sign but as a sort of interpretive message: for the old English word for such deer, as I as a literature professor and pedant am supposed to know, is *hart*. The harts were still here.

I remember his deep, simple, and modest love of his wife, the beautiful Lindy, the core of his life, and his pride and delight in his sons. For all the depth and sophistication of his artistic mind, there was a remarkable simplicity and innocence about the man, an enthusiasm and quiet sense of humor that not everybody would catch; he affected, I think, the outward guise of being rather ordinary and even stuffy, when what was going on in his head was magic and speculation. Many contemporary artists I know seem to be making a desperate unconscious effort to look like Jackson Pollock, or possibly Jean-Michel Basquiat, and so distinguish themselves from the common herd (philosophers do the same, though they usually try to look like Ludwig Wittgenstein). Rick didn't look like an artist at all; depending on where he was, he looked like a down-at-heels Russian count of the nineteenth century, a French banker, a Virginia farmer, or one of the

raffish explorers or engineers who still hang around the Cosmos Club. Rick was always trying to get me to join the Cosmos Club, but I am not as clubbable as he was; however, I was his guest there often and got into trouble for not wearing a tie at breakfast.

Rick's influence will be an important part of the revival of beauty and spirituality in all the arts that I believe is now well on the way; as my friend and former student, the poet Wade Newman, put it so eloquently in a letter to the *New York Times*:

The Sept. 11 attacks have rendered postmodern, narcissistic art irrelevant. John Rockwell's article "Peering Into the Abyss of the Future" [Sept. 23] posed the question, "What is the role of the arts in the present crisis?" In other words, what kind of art will provide us with solace, memorialize our heroes and translate humanity's hopes and fears into lasting works of beauty?

Not paintings from the private universes of their individual creators that fail to communicate universal meanings. Not scrap-metal sculptures welded into abstract heaps that resemble poor imitations of our recent ruins. Not atonal music compositions, not confessionalist free-verse poetry and not plotless fiction.

We are suddenly faced with life-and-death issues, next to which the personal rantings of so many artists from the last few decades appear self-centered, vapid and inconsequential. What we need are American artists who can deepen our sense of our own humanity, who through a balance of form and content can create something as enduring as our will to survive.

Rick was never shrill or angry in his opinions, as I am afraid I sometimes am. He has taught me some lessons in calm and patience, and I wish he were still around to teach me more. But he had a deep conviction that American art was not living up to its enormous potential, that American cities, given our great wealth and our access to all the grand traditions of civilization, are so often ugly and unimaginative, compared with those of Europe. His vision of what our civilization could be will prevail, I believe; but it is up to us who survive him to make it come to be.

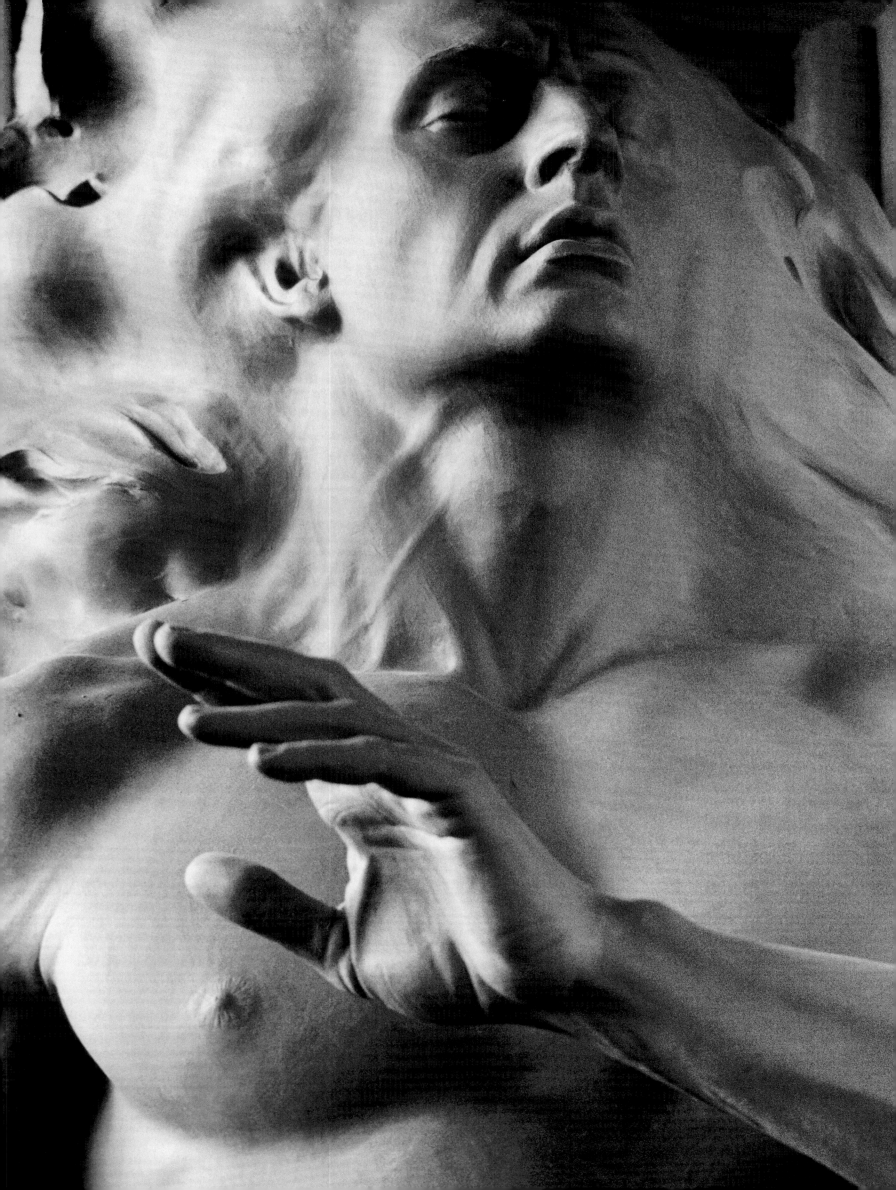

BEAUTY IS TRUTH: THE CHANGING OF THE TIDES

Michael Novak

A major exhibition of Frederick Hart's sculptures—some fifty works—was presented at Belmont University in Nashville, Tennessee, in March 2004. It was a bold show. It was a knock-me-down show.

That brave exhibition may go down in history as a landmark of a major movement in American art. It may mark a changing of the tides. It certainly pushed open, if only by a crack, the huge rusty gates that hold the waters back from the sheltered bay of modern art. Already one can hear the swirling, pent-up waters gurgling inward. The work of Frederick Hart is changing the world of art.

For the exhibition in Nashville, I had been invited to offer a few remarks on the inspiration and significance of Frederick Hart's work. My aim was to enter as best I could into Mr. Hart's own way of seeing, and to sketch out his philosophy from the clues he left us.

The Creator and the Artist

No sculptor since Auguste Rodin has been so embraced by the public. Hart's sculptures have been among the most successfully editioned in the past century. Twice Frederick Hart had the opportunity to produce works for Pope John Paul II. In 1979 he was commissioned to create the processional *Cross* for the historic visit to Washington; in 1997, in a private audience, he presented to the pope that magnificent celebration of light, the acrylic *The Cross of the Millennium* (figs. 1, 2).

In 1997, the Holy Father had rare high praise for Hart's work—as one artist to another—and so I think it is not too fanciful to believe that when John Paul II released his quite beautiful "Letter to Artists" for Easter 1999, his mind still retained images of Frederick Hart's sculptures. The pope's words, to which we will come in just a moment, begin with the very images

Hart chose for his first monument commissioned by Washington National Cathedral, the *Ex Nihilo*, an interpretation of the Creation, described in the opening chapter of Genesis.

Most of you will recall that before John Paul II set his mind on becoming a priest, he was an actor, and that in Nazi-occupied Krakow he and his friends kept open a clandestine theater. The Nazis aimed to enslave the Poles and to annihilate Polish culture. Karol Wojtyla's theater group was determined—at the risk of imprisonment, banishment to work camps, or a death sentence—to keep the great works of Polish theater alive, and to that end they secretly met in living rooms and other hidden places to put on their performances. By art, cultures live.

If you keep in your mind images of Hart's work, and if you recall what you know of Hart's life, and what he and his admirers have written of his own convictions about art, you may agree that the pope succinctly put into words the core of Hart's life and work, voiced some of Hart's own deepest convictions, and almost tangibly described Hart's very work. Here are the pope's words:

None can sense more deeply than you artists, ingenious creators of beauty that you are, something of the pathos with which God at the dawn of creation looked upon the work of his hands. A glimmer of that feeling has shone so often in your eyes when — like the artists of every age — captivated by the hidden power of sounds and words, colors and shapes, you have admired the work of your inspiration, sensing in it some echo of the mystery of creation with which God, the sole Creator of all things, has wished in some way to associate you.

That is why it seems to me that there are no better words than the text of Genesis with which to begin my letter to you, to whom I feel closely linked by

Detail, *Adam*, clay

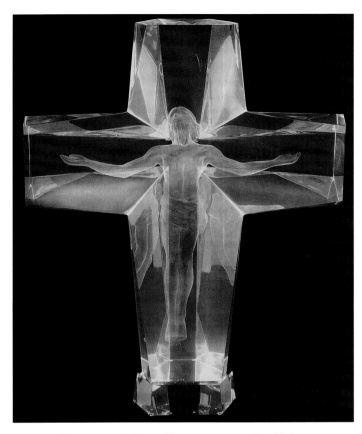

FIG. 1: *The Cross of the Millennium*, (one-third life-size), clear acrylic resin, 1992

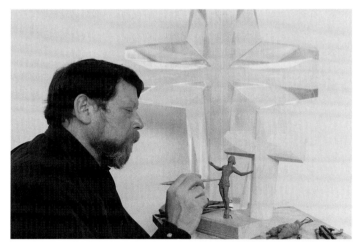

FIG. 2: Hart sculpts the clay maquette for *The Cross of the Millennium*

experiences reaching far back in time and which have indelibly marked my life.

Let me read what the pope says about the dialogue between the Church and artists that has been going on from the beginning. (Every time a church has been built in the last 1700 years, many new jobs have opened up for architects, sculptors, carvers, painters, mosaic-makers; so it was also for Frederick Hart.)

This dialogue is not dictated merely by historical accident or practical need, but is rooted in the very essence of both religious experience and artistic creativity. . . . the human craftsman mirrors the image of God as Creator. This relationship is particularly clear in the Polish language because of the lexical link between the words stwórca *(creator) and* twórca *(craftsman).*

Doesn't that almost perfectly express what Frederick Hart believed, and what he was trying to do? I ask those of you who have been associated with his work for more than twenty-five years, did he not believe precisely this?

Frederick Hart loved to speak of "the forgotten trinity"—beauty, truth, goodness. And it is as if the pope had read what Hart had written:

The theme of beauty is decisive for a discourse on art. It was already present when I stressed God's delighted gaze upon creation. In perceiving that all he had created was good, God saw that it was beautiful as well. The link between good and beautiful stirs fruitful reflection. In a certain sense, beauty is the visible form of the good, just as the good is the metaphysical condition of beauty. This was well understood by the Greeks who, by fusing the two concepts, coined a term which embraces both: kalokagathía, *or beauty-goodness.*

Philosophical Convictions

Several important philosophical convictions lie behind Hart's work. One of the arguments at the heart of the work of Albert Camus, Nobel Prize laureate and French existentialist, will help us. As Berlin collapsed in flames under Soviet onslaught in 1945, all of Western tradition seemed to lie in ruins. Camus wrote in *The Rebel*: "We are now at the extremities. At the end of this tunnel of darkness, however, there is inevitably a light, which we already divine and for which we have only to fight to ensure its coming. All of us, among the ruins, are preparing a renaissance beyond the limits of nihilism." And again, in another book, "Even within nihilism, it is possible to find the means to proceed beyond nihilism."

We have to begin in the Absurd. In the chaos. In the night. Is that not precisely where the young Frederick Hart began, raw and unfinished—having failed the

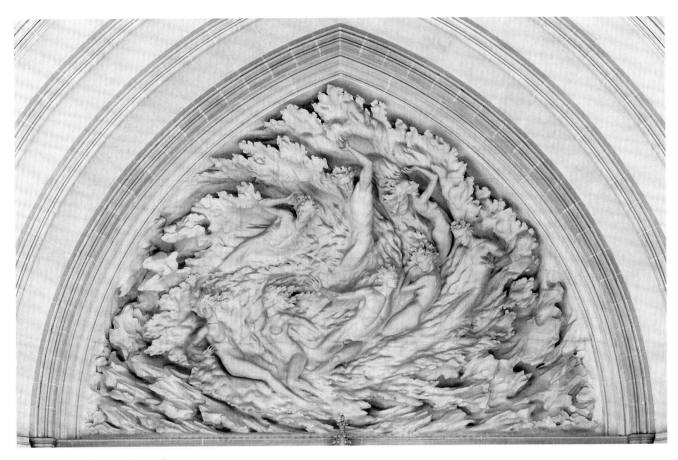

FIG. 3: *Ex Nihilo*, Indiana limestone, 1982

ninth grade, and then having been thrown out of school when he tried again; then, having stunningly scored thirty-four out of a possible thirty-five points on the aptitude test for the University of South Carolina and having been admitted as a freshman, being obliged to leave again after one year because of his participation in a civil rights demonstration on behalf of racial equality, the lone white to do so. His mother—a glowing woman who had bravely ventured from South Carolina to join the world of New York theater—returned home to the South, then died when Rick was only four years old. Her first child, Frederick William, died in his infancy. More than two decades later, Frederick Hart's younger sister, Chesley, died from a dread disease. He had grown up surrounded by death, haunted by death, despite a happy and sheltered childhood with his extended family. In his early twenties, trying to find his location, he experienced a certain emptiness and loneliness. When he fled the university, he drifted north to Washington, D.C.

When the young artist was improbably taken on as an apprentice by the stone carvers working on Washington National Cathedral, he fortunately came under the care of a wise Italian master, Roger [Ruggiero] Morigi, who saw his special gift and assigned him small, then slightly larger, creative tasks. Think how crucial an event that was. Frederick Hart had known from the first time he had taken clay in hand that he would be a sculptor. But when he first appeared at the Cathedral, no one immediately recognized this. After a short time Roger Morigi saw his talent—and so did the canon of the Cathedral, Richard Feller. And they encouraged this raw young man to enter the international competition for the largest sculpture commission of the last part of the twentieth century, the west portals of Washington National Cathedral, the last in the great line of Gothic cathedrals reaching back 800 years. This opportunity, as it were, came from nowhere, out of nothingness. Is it any wonder that *Ex Nihilo* (fig. 3) appealed deeply to Frederick Hart as his signature theme?

To understand better the way Hart approached the theme of *Ex Nihilo*, we need to follow the thread of some of the philosophical concepts that were churning in the young man's mind. We need to reflect on *existence*

(or *being*); *presence*; *truth, beauty*, and *goodness*; and *creative evolution*. I will be drawing on a tradition of thinking on these questions that is very old, perennial, and beautifully stated for our own age by Flannery O'Connor in *The Habit of Being*, Jacques Maritain in *Creative Intuition in Art and Poetry*, James Joyce, Gabriel Marcel, and Pierre Teilhard de Chardin.

(1) *Existence.* The critics who write of Frederick Hart speak of his commitment to "substance, beauty, truth." But here I think the telling word is *existence*. Think of its Latin root: *ex* (out from) + *sistere* (to stand) — to "stand out from the nothingness, to come into being." To stand at least momentarily out of the abyss, suspended, as it were, between two darknesses. The taste of existence is so sweet, all the more so because so brief. The human being can be poignantly aware of the passage of time. One can feel the sun on one's cheek as one stands in the glittering waters off the beach of Oran, to pick up a metaphor again from Albert Camus, aware that the sun is moving across its zenith and the day will soon fade.

Hart was almost painfully aware of the passingness of things. How suddenly they are, and then are not, like the blossoms of spring. So the artist's work is to catch them in flight. And to catch that moment with the breath of life and the tension of motion still alive in it. To freeze it there, so as to remind all of us of its momentary glory, beauty, truth.

In my office I have a photo of my little granddaughter Emily in a blue dress. She holds up three fingers toward the camera, but her head actually turns away, toward one of those circular loops through which children blow bubbles, and her own breath has just filled a sparkling bubble in the instant before it closed and took flight, while it is still being infused by her breath. It is such a powerful image of life. The Hebrew word *spirit* in fact comes from the word for *breath*, as our own word *spirit* does. That picture of Emily is, precisely, of Emily *spirited*, creating the life of a bubble. The life span of the bubble is short — even shorter than Emily's or ours.

Emily's bubble, as it were, came out of the nothingness, *ex nihilo*. Of course there were special materials there — the loop, the viscous bubble mix — whereas in the creation of the world there was nothing at all. But the analogy works, as far as it goes. Frederick Hart wanted to celebrate the coming-into-being of things, and their fragility and dependence, but also their real truth and beauty and stubborn "beingness" so long as they were in existence. As if he thought we must give gratitude for such things. We must at least see them, and recognize them, and allow them to raise our spirits and lift up our hearts. *Sursum corda*, as the prayer says: *Lift up your hearts. Notice. Look.* Whatever the confusion, the chaos, the seeming hopelessness, do not be afraid. In the extremities of life, be of good cheer. The renaissance cometh.

(2) *Presence.* This word, too, has a Latin root that helps us to understand. The word for that kneeler on which a solitary person, or two, may kneel before the altar, in the presence of God, is called in derivation from the Latin a *prie-dieu*, a "pray before God." *Prae + esse*, "to be before, in the presence of," is like that. To be in the presence of a person further implies a distinctive form of presence, which was also very important to Frederick Hart.

The best example I know of for making this concept clear comes from Gabriel Marcel, the French Catholic existentialist who lectured at Harvard when I was there as a graduate student. In his marvelous little book *The Mystery of Being*, Marcel tells two stories to make clear what being present to another person is.

For physical reasons Marcel could not serve at the front during World War I, and so was assigned to a missing persons bureau, where he organized each scrap of information about a missing person on index cards. Every so often a real person would come in and identify himself, seeking to connect with others. Marcel observed that no matter how thick a file of index cards he had, the real person standing before him was always incommensurable with the long list of written characteristics. A person is always more than his descriptions. A person's own liberty, and the changing conditions of life, mean that no list, however long, can ever exhaust the knowledge to be gained about a human being. A person can change his way of life, be converted, set off in a new direction, change dramatically. We are unfathomable, even to ourselves, Marcel concluded. To be in the presence of such creatures requires a certain awe and respect.

Marcel's second example is similarly homespun.

4

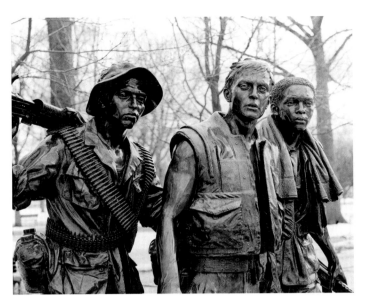

FIG. 4: Detail, *Three Soldiers*, Vietnam Veterans Memorial, Washington, D.C., bronze, 1984

Often we treat other persons around us as though they were posts, potted plants, things. We simply do not notice them. If we are conversing, we don't allow them into the circle of living presences; we ignore them as though they were dead objects. He recalls once being on a subway, not noticing a single one of the persons packed into the car with him, his head buried in his paper. Others were just things to him, until his stop came up and then, as he stepped to go out, an attractive young lady in a blue raincoat also stepped forward. Both drew back, and then simultaneously blocked each other again. This time their eyes met, they shared a smile, he ushered her through and she said "thanks" and hurried away. Some hours later, in the Fine Arts Museum, he meets the lady in blue again, and again their eyes meet, and they smile again, as if they had known one another for years. This person, among all the others on the subway, had become "present" to him, and he to her. They had met in a human way and included each other in a respectful human ritual, with a light touch of mutual humor. They had had an "encounter." They had ceased being like *I-it* and had become *I-thou*, humans who included each other in each other's recognition. They had become "present" to each other. Presence is much more than just being a post or a chair.

Are the qualities that Marcel sees in *presence* not also evident in Frederick Hart's statue at the Vietnam Veterans Memorial (fig. 4), as three young men push out from the jungle to discover, in some awe, the black marble wall with the names of 58,235 of their fallen comrades? We are arrested by the strangely clad military figures in the uniforms of the U.S. military in Vietnam. We stop to let our eyes absorb everything about them, and their relation to one another, and to their background, and to what meets their eyes. We make their inner world our inner world. At the same time, we notice how these three figures are "present" to the names of their fallen comrades on the wall, and perhaps in wonderment about whether their names, too, are to be written on that wall.

In all his work, Hart's figures are present to us, and ask us to be present to them—to sense in them with living persons they represent. They somehow break out from the world of mere objects to engage us, to collar us, and to demand our presence to them. This double meaning of "presence" is invoked by every great work of art, by everything that draws on the human within us.

I remember walking, when I was twenty-two, through the Uffizi in Florence when I came suddenly upon Sandro Botticelli's *Spring*. It bowled me over. I had to sit down. I remember sitting there, without moving, for something like twenty minutes, totally absorbed in every detail. I experienced the same blow upon seeing *Daughters of Odessa* (fig. 5) for the first time. I had to step back and simply look on with reverence and awe.

Existence and *presence* go together, one building on the other.

(3) *Being, good, truth, beauty.* Not only are existents fragile and brief—like a rose that blooms, ages, falls in a matter of days; like a scent that lies sweet on the air and then wafts away—they are also, in the Creator's eyes, *good*. "God looked at everything he had made, and he found it very good" (Gen. 1:31). A grain of sand in the palm of one's hand, a blade of grass, a leaf, a snowflake—all of these humble existents have a surprising, even stunning beauty when one makes the effort to "see" them, to allow them to come to you, allow them to exist for you. They are always there, such things, but we do not notice them. This is above all so with people, human beings, each of them so totally individual and

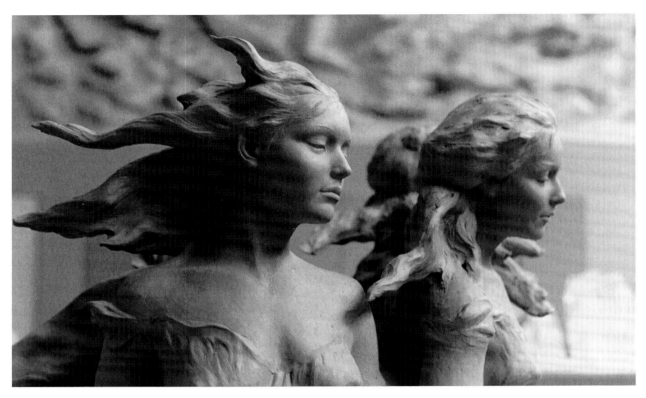

FIG. 5: Detail, *Daughters of Odessa*, clay, 1997

unique. It is important to look at them, to really see and to listen, to notice, to "be in their presence."

Frederick Hart at one point in his early adulthood became a Catholic. In the philosophical traditions that the Church has cherished for two thousand years is a stream of reflection on three aspects of reality. Indeed, these three are held to be "convertible" with *existence* (*being*). That is, wherever there is one, there you will find the other. Wherever there is being, there will you find truth, and goodness, and beauty.

One of the lines James Joyce most loved from Thomas Aquinas is this: "Beauty is the splendor of being." As when one says of a glorious day in April, "What a splendid day." John Paul II has loved another phrase in the tradition: "The splendor of truth." As we saw above, John Paul II also ties together a phrase he might just as well have taken from Frederick Hart, although it recurs often in the tradition, "beauty and goodness." *Beauty is the visible form of the good, just as the good is the metaphysical condition of beauty.*

This is the point made by the ancient saying that "*being* and *good* are convertible," that is, "wherever you have a being, an existent, you have a good." Everything that is has a goodness in it, is good. All you have to do is open yourself to it. What the artist wants to do is take you by the lapels and say, "Here, don't rush by this, take it in. Notice it. Grab onto it before it passes away." The artist is forever trying to pull out pieces, to rescue them, from the flames of time. Before they pass away.

But more than *being* and *good* are convertible. In the ancient view, which is also the view of common sense, *truth* is the splendor of being—its radiance, what flashes out to our minds from any and every existent as our minds try to observe and assess them. And, as we saw above, Thomas Aquinas also defines *beauty* as "the splendor of being." John Keats's famous ode strikes a similar vein of ore:

> Beauty is truth, truth beauty,—that is all
> Ye know on earth, and all ye need to know.

Why did the ancients think this? Beauty and truth and the good flow from the inner life of God, who infused them into everything he made. Every being has in it the truth of its own reality, which God put there with great care. This truth—this intelligibility—has a great beauty, humble though it be. It is a gift. Every existent is a gift that might not have been. Its perishable truth, and its beauty, are also gifts. That God Himself, in making them to be, saw that they were good,

is what the Bible insists. Yet ancient philosophy, too, figured out on pagan grounds that the same intelligible reality that shines out from every existing being is true and beautiful and good in its own distinctive way, which the mind ought to notice and rejoice in. One can see that ancient artists noticed and rejoiced in true and beautiful and good things, and so has the worldwide public that still stands in awe of what they recorded. There is something eternal, or timeless, about such beauty, truth, goodness—and, yes, each being. The ancients knew nothing of "creation"(many thought the cosmos eternal, and time itself a series of endless repetitions), yet they understood well that the evanescent being of things depends on an eternal power holding them in existence, and touching them with a ray of eternal beauty.

Beauty-goodness. Words true to the way Frederick Hart saw existent things: a rose, the swell of a woman's breast, the roaring waves of the abyss, the stunned gaze of a soldier, the delicate hand of an innocent girl in the springtime. *Beauty-goodness*.

In a lecture delivered at the Newington-Cropsey Foundation in 1995, Frederick Hart expressed his corresponding view: "I would like to see the public consciousness raised to understand the Good and the True inherent in the nature of Beauty. I would like to see the standard of Beauty regain its preeminent place in all aspects of public arts. . . ."

(4) *Evolutionary creation*. It is widely known that Rick was reading Teilhard de Chardin, S. J., the great French paleontologist, when he was thinking through his own design for the Washington National Cathedral portal. Teilhard de Chardin had written two books well known in America in the 1960s, which represented what he had learned from his scientific studies of the origins of species and of life itself, *The Phenomenon of Man* and *The Divine Milieu*. What fascinated this scientist was the enormous sequence of contingencies, and "switches" from one truth to another, that had to be met, all pointing in one upward direction, for human life to have emerged at all on this earth, and to have developed along the evolutionary lines that it has. The probabilities of all these contingencies being met, one after the other, and in the necessary sequence and in the right proportions, were infinitesimally tiny.

Yet at every switching point at which the emergence of the right degree of carbon, the proper disposition of a nervous system, and the development of a brain capable of self-consciousness, would have been rendered impossible, instead, evolution took the required turn. The direction was always in favor of the emergence of consciousness.

Man is the phenomenon, Chardin was to write, by which evolution was to become conscious of itself. Although one might never have predicted this from the beginning, looking back on it one can see a direction in evolution from the start—always in the direction of the emergence of consciousness. Slowly. By trial and error. At a staggering cost in abandoned lines of evolution, and the disappearance of countless numbers of species (study of which was Chardin's specialty). The human phenomenon emerged out of the "nothingness" or "chaos" with the "big bang," in a highly improbable series of evolutionary emergences, always in the direction necessary for the later emergence of consciousness.

Chardin calls the world of consciousness "the noosphere." And he formulates a law of species that goes something like this: when a new species emerges, first it multiplies to fill up its space, and then the interactions among its members begin multiplying too, until the pressure of these interactions inspires a breakthrough to a new level of being. He hypothesizes that as the human race increases and multiplies over tens of thousands of years of evolution, these conscious beings begin more frequent interactions with each other, and the temperature, so to speak, of the world of consciousness—the noosphere—becomes more intense. The world of consciousness becomes ever more important. Chardin pictures, as it were, upward-sweeping emergences out of lower, less delicate forms. Not unlike those tumultuous, upward-sweeping waves from which Hart's humans emerge.

What is most gripping in this bare outline of Chardin's vision is the sort of spiraling upwards that it describes, something like the *Everything That Rises Must Converge* of Flannery O'Connor's title, as everything conspires to bring forth conscious beings, who more and more interact, creating a new world of human interaction. You can see these spirals, I think, in the tympanum of the *Ex Nihilo*, as if one can

7

experience the tension and the struggle of the upward spiraling out of the chaos, the pain of creativity, the uncertainty, the heartbreak. It is not altogether a rosy story. It also forbids the loss of hope. It also forbids the easy sentimentality that there can be life without suffering, acute suffering.

What we see here is a new sensibility about the cosmos, as compared with the almost static worldview of the great sculptors of Greece or even of Michelangelo, Bernini, and the other masters of the Renaissance. It is the modern sensibility of turbulent evolutionary upward sweep, redolent of terror and contingency and chance. One feels in it also the impending tragedy that hangs over *Daughters of Odessa*. This new point of view, while full of hope and beauty, is not at all rosy, or cheaply optimistic. Great suffering and loss have preceded, and accompanied, the phenomenon of man.

The Three Triumphs of Frederick Hart

We come, then, to the three triumphs of Frederick Hart.

The first was the series of great public works of beauty that he bequeathed to our nation and our heritage. The west portals of Washington National Cathedral cry out to be seen among their greatest predecessors, running back some eight hundred years, at Rouen, Chartres, Nôtre Dame de Paris, Cologne, Orvieto, and all through the English countryside. Its image of the Creation follows in the lineage of Michelangelo's colorful frescoes on the Sistine Chapel ceiling.

Others of Hart's great works include my own favorite, *Daughters of Odessa*, which is dedicated to the millions of victims of the great holocausts of the twentieth century; and the Vietnam Veterans Memorial described herein. What is particularly affecting in *Daughters of Odessa* is that the artist captures these four young women in the very blossoming of their beauty, in the vitality of their youth, in the happy springtime of their lives, in a kind of dance of happiness—just before cold death is to strike them down. The pain of millions of deaths is thereby more sharply thrust into our souls.

Among the other legacies left us through his works are sixty-four luminous pieces in the art form he invented, his translucent works in cast acrylic resin, or

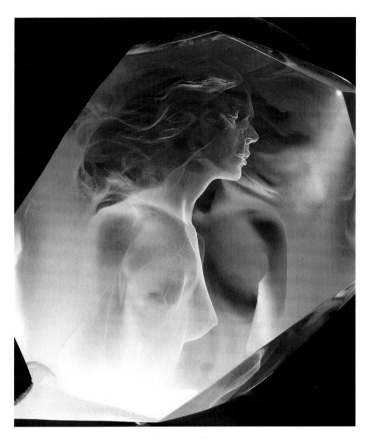

FIG. 6 : Detail, *Memoir*, clear acrylic resin, 1985

Lucite, each illuminated with the inner splendor of light (fig. 6). The marvel of these editioned works is that the artist first had to see them imaginatively from multiple angles, reflections, and light effects, *before* they were cast in their final form. How he could have accomplished that fills the viewer with wonder.

This sense of wonder is heightened by the paradox between the work's accessibility and its mysticism. The very openness of the medium—the transparency, which allows light to penetrate and seek out its inner possibilities—is what enabled Hart to achieve a greater sense of mystery. What is revealed suggests what is still to be revealed. Hart states: "I first became intrigued with clear acrylic resin when I was working on the National Cathedral. In stone, the figures are opaque and emerge from a solid mass. Here (in clear acrylic) the figures are translucent and disappear into the light creating a spiritual relationship between light and form and a sense of mystery around being and non-being." Altogether, these marvelous works are a suitable image of Hart's theories about the luminosity of *being, truth, beauty* and the *good*.

The second of Frederick Hart's triumphs was this:

He came in his youth into an art world fixated upon the extrahuman, the nonhuman, the *thing*. Sometimes canvases of abstract lines and crisscrossing colors. Sometimes splotches of paint. Sometimes cans of soup. Distorted, viscous, flowing faces. Fluorescent light tubes thrust into sand. I beams connected at illogical angles. Boulders helter-skelter in a city plaza. Randomness. Thingness. Things, things, things thrust into our faces, as if to bruise our noses. To teach us our insignificance. Our randomness.

For many decades now, the art world has turned its back to beauty, truth, goodness, and the inner splendor of the world of actual existents. An almost total shutout. Official voices tell us that to appreciate contemporary art, one must search along an extensive, winding thick wall, look for the huge iron-plated gate, and seek entry into a secret sect of "those who know."

Frederick Hart's second triumph, then, was to start opening those iron gates, to swing them back, to start them creaking slowly open, so that the public might rush in, so that a revolution in taste and expectation might sweep through all the public arts—through writing and music and poetry and architecture, through painting and sculpture, and dance and theater—so that the human being might be brought back to the center again, along with existence, and beauty, and the good. Frederick Hart lived too brief a time to complete that task. But he did begin it, along with Dana Gioia in poetry, Tom Wolfe in fiction and in journalism, Frederick Turner in philosophy and poetry, Thomas Gordon Smith or Michael Graves in architecture, and composers such as the brilliant Stefania de Kenessey. The paintings and sculptures of my wife, Karen Laub-Novak, who studied under Oskar Kokoschka, were the first to teach me how difficult it was in our day to recenter the human figure in the arts. It was a far lonelier task until Frederick Hart became the single greatest artist to push against that huge, rusty, creaking gate.

The third triumph of Frederick Hart was his own life—his triumph over his own much-beset early beginnings, over his failures in school, over the rocky life of his beginnings in the world of art, without heat, without much to eat, without any thing but the barest necessities—and one slightly frayed tuxedo. And, finally, his triumph for a time over his own ill health.

It was in this period that Frederick Hart did his much-discussed television interview with Ben Wattenberg on *Think Tank*. He continued to work until an overwhelming bout of illness hospitalized him, and death snatched him from us, when he had reached but the age of fifty-five.

Frederick Hart married a devoted soul mate, had two fine sons, built up a stunning body of work, and began to overturn the whole art world just before a new century was to begin. He courageously stepped into the vanguard of a school of vision, sensibility, and excellence. In his last days, he was able to recall the excellence of a life well lived and to conjure a death for which he was well prepared.

Do you see his monument? It is likely to come in a flood of new works by others celebrating the beauty of God's creation, the radiance of each humble being within it, the truth, the goodness in things, the freshness, the appeal to excellence within us, and our delight in our living. Frederick Hart's work and his artistic drive were gifts of grace to our time. They have lifted up our public life.

His school might be called the Everyday Transcendentalists, for they see the transcendental in the materials of daily life. They see beauty and good wherever it is, and it is everywhere, in all the concrete things around us. They teach us to glory in the nobility of the humble things of life. And, above all, in the nobility and excellence and beauty of the human beings who surround us.

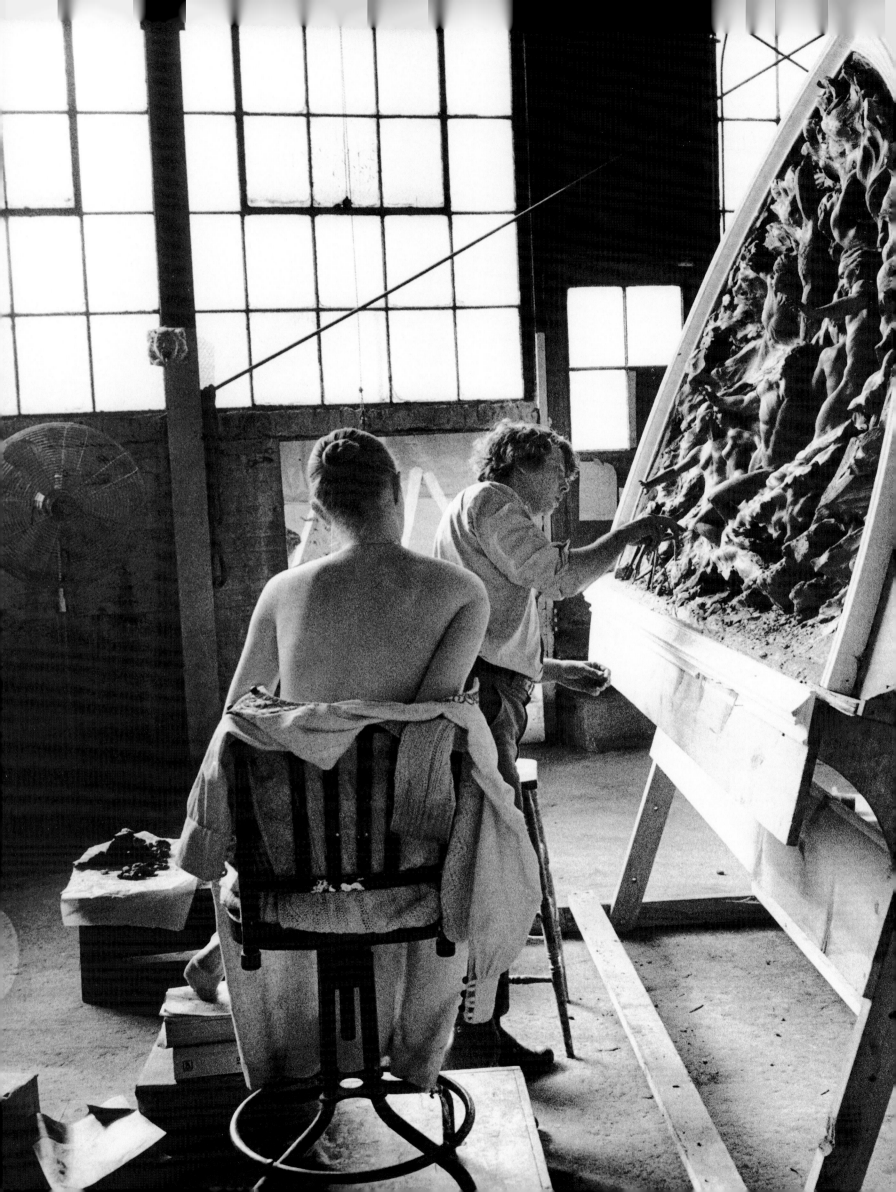

WASHINGTON NATIONAL CATHEDRAL
THE CREATION OF FREDERICK HART'S PERSONAL STYLE

Mary Yakush/Erik Vochinsky

A Church for National Purposes

The idea of a national cathedral is as old as Washington itself. In 1791, after Congress had selected the site for the capital city of the new United States, President George Washington commissioned the French-born American Major Pierre Charles L'Enfant (1754–1825) to design an overall plan for the city. Included in L'Enfant's plan was a church "intended for national purposes, such as public prayer, thanksgiving, funeral orations, etc., and assigned to the special use of no particular sect or denomination, but equally open to all."

A century later the building plans for Washington National Cathedral gained momentum, largely through the efforts of local community leaders such as Riggs Bank President Charles C. Glover. On January 6, 1893 Congress granted a charter to the Protestant Episcopal Cathedral Foundation of the District of Columbia to establish a cathedral and institutions of higher learning. Signed by President Benjamin Harrison, this charter was the birth certificate of Washington National Cathedral. The Reverend Dr. Henry Yates Satterlee, consecrated as the first Episcopal Bishop of Washington in 1896, secured land on Mount Saint Alban, the most commanding spot in the entire Washington area, as a site on which to build the national house of prayer. Another decade would pass before a crowd of ten thousand people assembled for the laying of the Cathedral's foundation stone. The Bishop of London and President Theodore Roosevelt were among the dignitaries who delivered remarks during the ceremony on September 29, 1907. The stone, from a field near Bethlehem, was inset into a larger piece of

Hart sculpts working model in clay for *Ex Nihilo*, 1975–76

American granite and inscribed: "The Word was made flesh, and dwelt among us" (John 1:14).

The grassy, tree-shaded Cathedral Close (fig. 7) became home to the longest-running construction site in the history of the nation's capital. Daily services began soon after the completion of Bethlehem Chapel in 1912. Subsequent work was subject to the ebb and flow of donations and suspended during the world wars. The central tower was completed by 1964, and in 1972 the Cathedral nave was enclosed as the north and south walls met at the west facade; the west facade and towers, however, were all still to be completed. The completed nave was dedicated in 1976 in a series of ceremonies attended by Her Majesty Queen Elizabeth II, President Gerald Ford, the Archbishop of Canterbury, Frederick Donald Coggan, and thousands of other worshipers. The completion of the west towers in September 1990 marked the end of eighty-three years of effort by generations of architects, engineers, stonemasons, stone carvers, and artists, to create a place where people of all faiths would gather to worship and pray, to mourn the passing of world leaders, and to confront pressing moral and social issues.

The Debate over the Iconography of the West Facade

Countless works of sacred art and decorative embellishment now adorn the Cathedral inside and out. Frederick Hart's remarkable Creation Sculptures were not yet in place over the three grand portals of the west facade when the nave was dedicated in 1976, however. It had been the intention of the Cathedral leadership to complete the portals, or at least the central portal (for which a donor had pledged funds), by 1976, but delays inevitably arose. This was probably

11

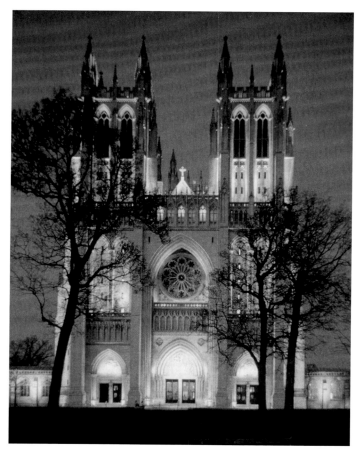

FIG. 7 : Washington National Cathedral, Washington, D. C.

owing to the rigorous process of review established by the Cathedral's founders, which required the participation of the succeeding bishops, deans, architects, and the volunteer building committee in all decisions concerning the Cathedral's iconography and the selection of artists engaged to create them.

Indeed, as late as 1970 the Cathedral's dean and building committee were engaged in debate over the iconographical program for this sacred element, which would be the largest and most prominent of all the exterior sculptures. Only in 1971 did they issue the formal "Charge to the Artist"[1] to guide the artists who would participate in a competition to create a work of sculpture that would fulfill the goal of building a cathedral embodying the highest possible artistic achievement. The eloquently worded charge ended with the audacious statement that the sculptures, when realized, would refute Lord Kenneth Clark's remark that Protestantism had never made a major contribution to art.

The debates, the competition, and the eventual selection of Frederick Hart's design, as well as the evolu-

tion of his design concept, are recorded in documents, several of which are transcribed below, in the archives of Washington National Cathedral. The first, a memorandum of November 18, 1970 from Richard T. Feller to the Cathedral's fifth dean, the Very Reverend Francis B. Sayre, Jr. (1951–1978), illustrates the deliberate nature of the procedures for commissioning works of art. Richard Feller (1919–2003) was an expert in the engineering techniques of Gothic construction and had visited and studied all of the major Gothic cathedrals of northern Europe. A layperson, he joined the Cathedral staff in 1953 and in 1957 became Clerk of the Works, directing architects, engineers, stonemasons, stone carvers, and stained-glass, wrought-iron, and other artisans. Feller's position of authority, his erudition, and years of dedication would lead to his being named a Canon of the Cathedral in 1982, a distinction normally accorded only to members of the clergy. He pushed hard for the theme of Creation, but the committee as a whole had to agree before any action could be taken.[2] His memorandum is almost a treatise in which he debates the merits of the various ideas proposed for the iconography and eliminates them one by one, hoping to persuade committee members who were undecided or who held views such as those he describes. In the end, he arrives back at the theme of the Creation. Although this theme had also been chosen for the west rose window (directly above the central tympanum) by the Cathedral's first dean, in a location as prominent as the west portals, and on such a large scale, the Creation was a radical and probably surprising idea, especially considering that the sculptures would be viewed in a Gothic framework. Canon Feller's long memorandum reflects not only his own ideas, but also his and the committee's shared sense of duty and sacred purpose.

. . . Over the summer months, this enormous iconographic problem has been with me every day. With considerable thought and widespread reading in search of inspiration, I now wish to submit a new proposal. But before offering it, a note about the past.

It is unnecessary to submit a recital of the many ideas you and I have already rejected in our numerous meetings and conversations; and yet there are certain stumbling blocks and mental images that must be

removed before others might be willing to consider this new proposal open-mindedly. They are as follows:

1. A figure of Christ in the center trumeau of a west facade is a well-established tradition among medieval cathedrals. Appealing as this may be on theological grounds, I believe Washington Cathedral has satisfied this particular bit of imagery in having Christ as the center focal piece of the south portal tympanum. In this sculpture, surrounded by His disciples, His outstretched arms offer an invitation for all to enter and worship and partake of salvation through His divine sacrifice.

2. Many cathedral west facades feature a roll call of martyrs, prophets, and church luminaries. Salisbury is a prime example. In stone and glass, and with a High Altar Reredos containing nearly one hundred figures, we have about exhausted the list of 'saints.' There appears little reason to duplicate these many figures on our west facade. . . .

3. Numerous cathedrals, and in particular those of France, incorporate statues of monarchs, kings, and rulers over their portals. The doctrine of the separation of church and state did not exist at the time of building those cathedrals. In that era of history, the ruling monarch frequently represented both church and state.

On the west facade of Washington Cathedral the architect has provided for seventy-six fully defined individual statues plus three bas-relief tympanum carvings. It could border on the ludicrous for us to include all the Presidents of the United States followed by Chief Justices and Secretaries of State.

4. At this point in national history, it would appear that our nation's major contribution to Western civilization has been our production of goods—mass-production assembly lines and labor-saving devices. This theme is spotlighted in many museums and would be redundant on this cathedral facade.

5. With our Cathedral ecclesiastical name, there is ample reason for naming the western towers as Saint Peter and Saint Paul. There is also good reason for the trumeau niche of the north tower portal to contain the figure of Peter and likewise, the figure of Paul in the south tower trumeau niche. I fully support this past position.

When becoming Clerk of the Works, I was advised that the tympana above these respective north and south portal doors would portray the great events in the lives of these two saints. Peter's calling to discipleship might be in the tympanum above his statue, and the dramatic conversion of Paul above his statue. To implement these themes would be non-controversial and might lead to very banal sculpture, becoming essentially decorative only.

6. Dean Bratenahl's early iconography, adopted by the Chapter, gave the north rose window the theme of the Last Judgment; the south rose the theme of the Church Triumphant, and the west rose the theme of Creation. In one of our several meetings you did suggest the possibility of this doctrine being depicted in the tympanum of the center portal. After discussion, we laid it aside when it did not fit the overall orderly theme we chose.

7. The doctrines of [Christ's] Passion, suffering, and death, and [of] Hell [and] the hereafter have been fully explored in the sculpture of many medieval churches. In that period of history and church doctrine, many considered the secular outside world to be the world of evil, whereas the inside of the church was the heavenly Jerusalem. In order to enter this world of light and salvation, one symbolically had to pass through the portal of Judgment. As a result of that dominating theology, the gates of Hell, eternal judgment, and related themes were repeated over and over in west portals. We live in a different age, and such a theme would have little relevance to our worshipers. . . .

8. Our memorandum and proposals of last March dealt with Freedom of Man. We considered the God-given freedom and then man's struggle within his political organizations to create laws that would guarantee his freedom. I have now come to believe this subject is so abstract, that it is sculpturally impossible to shape it into visual symbols; forms that are fresh, vital, and at the same time understandable. Furthermore, the debate over 'individual freedom' versus the total social fabric is a bit overheated today.

9. The visual and perceptual problems of the (three) bas-relief tympanum sculptures are not to be overlooked, especially in our age of abstract sculpture. The dichotomy between objective and subjective remains a

burning central issue. We know that images seen with our eyes and experienced through our senses are but a portion of an unseen reality. (The moon is no longer only a romantic light for lovers. It is this, but also a reality unknown to scientists a few years ago.) Every great artist suffers eternal tension between his inner vision and his expression or communication with the observer. In short, I would caution that old forms and old symbols do not so control and hamper our thinking as to restrict these sculptures from being creative and a reflection of the latter part of the twentieth century, even though lodged in a non-contemporary and eternal style of architecture.

10. From time to time, I have pondered the possibility of recommending to you a national competition for ideas. Several members, including you, suggested this. I am aware of the publicity value likely to be received from such a competition. Your suggestion a number of years ago, for a gargoyle competition, attracted widespread interest. I am not persuaded, however, that the iconographic problems of this west facade would prove as interesting to the average newspaper reader as did the subject of gargoyles. (Why do gargoyles intrigue people when they don't believe in evil anymore?) I submit my reasons for at this time rejecting the idea of a competition.

(a) After the first publicity release, it will be necessary to have mimeographed fact sheets available, along with diagrammatic drawings giving rather detailed information about the sculptural areas of the facade. Dimensions and other such data should be given on this sheet.

(b) Few persons entering the contest will have any concept of the limitations of the medium of stone sculpture, and hence, many of their ideas, although sincere, will be simply unworkable from a material standpoint. (Six hundred people requested information on the gargoyles. Only eighteen photographs were finally submitted.)

(c) Such a contest is also likely to elicit a wide variety of questions, all of which require individual answers. Such a contest is also bound to attract a number of kooky suggestions, which are not to be ignored with rudeness.

(d) It is conceivable that we might receive as many

as several hundred letters suggesting ideas or seeds of a thought. Some person must read all of these letters; sift, sort, judge, and consolidate them into a finalized report. Neither I, nor any person on my staff, have the time to do this.

(e) Undertaking such a contest will require a time span of possibly six to eight months. The desirability of commissioning work at the earliest possible date on the central portal trumeau and tympanum, with a gift now pledged, argues for early action, if at all possible, on this iconography of the west facade.

(f) Finally, the magnitude of this iconographic problem requires an organized, unified concept for three portals. It cannot be a reverse bingo game with each contestant calling off names and hoping he holds a winning card. Deriving publicity value from such a contest—yes. Deriving any workable iconography—very doubtful. And after all the wasted time, the "buck will come home to rest."

Now what great themes are left? Good question! I asked the same thing over and over. In our time, old theological patterns have been shaken. Furthermore, theology is the product of men's minds and indeed all such products are fallible. Church doctrine is subject to change. Today, the sacred and secular seem to be merging. (Possibly the sacred is just disappearing.) There seems little difference between the two, at least in current theological terms. Although the Church and State rightly remain separated as institutions, there is an ever-diminishing gray area between the sacred and secular worlds. This convergence may open new possibilities for us in connection with the west facade iconography. Histories of church art show how the artist tended to reflect the theological thinking of his time. (I hope our iconography will not reflect the theological confusion of our time.)

It is now my proposal that one of the greatest themes of church doctrine heretofore unexplored in any cathedral is that of the Creation. Michelangelo's Sistine Chapel ceiling is the only monumental exploration of this doctrine known to me. Of course, it was created five hundred years ago, and is in paint not sculpture. Our age is peppered with new discoveries of God's universe—both microcosm and macrocosm. Recent moonwalks may very well have been totally secular

in origin, but as Christians, we can view them as fresh discoveries of what God has created. Depiction of our universe is also most timely with all the debates over ecology, environment, and man's destruction of the delicate balance of nature created by divine will.

The biblical Creation theme is narrated in the early chapters of Genesis. We know that recitation is not a scientific description of the beginning of the world. Fortunately, our branch of the Protestant Church has never labored under the belief that the Bible story was fundamental and God's Creation stopped at the end of the sixth day. The glorious Genesis story was not written to record what was created, but to acknowledge that it was an act of God. The writers of the Book of Genesis were telling of the powers that do the forming, and only secondarily about the forms themselves. Creation is, in itself, a special concept; it is endless; it is constant; it is both seen and unseen. The creation of new human life goes on in reality as well as appearances. There is an unseeable and unknowable reality about endless creation. Let me now move from theology to perceptual imagery.

The viewer of a work of art perceives it on whatever level he is capable of receiving its multiplicity of meanings. He may receive a visual image with gladness or sorrow, as eternal or terminal, with clarity or with perplexity. It is acknowledged that great works of art are living, changing objects and constantly recreating themselves in the eyes of succeeding generations.

Imagery is projected in the form of symbols, some abstract, some geometric, some naturalistic in form. A famous name (Hitler) can become a symbol as well as a reality of flesh and bone. A statue of George Washington becomes a symbol of the founding of our country. He becomes symbolic of all the other founders of our nations. Hence, in this west facade we can use statues in human form that are symbols as well as images of a single life. Having expressed these rather lofty idealistic terms, this is not the place to expand the theme. . . . I will illustrate certain applications of the proposal.

For the center trumeau figure, I would recommend Adam, symbol of the first homo sapien. The sculpture itself might not be fully articulated in order to lend visual concept to the fact that human life is never fully formed and finished. (We grow taller with each generation.) For the tympanum above Adam, I would challenge the artist to illustrate life in both mind and body. This is biological creation. I would not limit it only to human life, but all of biological creation—animals, birds, and fish. Man's sole self-awareness of birth and death might even be symbolized here.

The nine major niches above the central portal would be filled with those who have unlocked the secrets of biological and mental conditions of man. There are three major niches on either side of the center portal doors at the same level as the trumeau. I suggest that Creation was not started without Eve, and so would propose her for the first niche to the viewer's left (Adam's right hand). The other two figures by her side would also be female progeny. To Adam's left (the viewer's right) I'd propose two great humanists in the course of history. The third niche, I'd leave forever empty, symbolizing the future and yet unfulfilled expectancy of the human species.

There are also forty-two voussoir niches in this center portal. I do not see money or circumstances permitting their carving at this time. The two large quatrefoils above the portal, for bas-relief sculpture, offer an extension of the tympanum theme.

The north portal trumeau would, as I stated earlier, contain the figure of Peter. As a fisherman, he dealt with life supported by the sea. A fish is a fish because it lives in a body of water. In this north portal tympanum I would challenge the artist to symbolize God's Creation of earth, water, flowers, mountains, streams, planets, and all the visible universe. This would illustrate the Genesis passages where God created the firmament. Even night and day are part of the visible universe.

Above the north portal, dealing with the visible universe, would be a natural place for the eight large niche figures to be selected as those in history who have unlocked the secrets of the natural universe of cosmos.

The south portal trumeau will feature Paul. This literate figure dealt with the world of ideas. The unseeable and unfathomable. As for the tympanum, here I think the sculptor would be challenged to symbolize all those invisible (to the naked eye) objects of God's

Creation, such as protons, neutrons, electricity, the forces of gravity, turbulent gasses, and recently discovered prostaglandins—these little substances only now coming to the attention of our advanced scientists. Paul dealt with a creative intelligence, a psyche of mental thought, communication, and free will.

Man (center portal) is an animal—but he has intellect and intelligence (south portal) and he lives in a universe (north portal). The twenty-five larger-than-life figures across the facade become symbolic of the vast number of minds who have opened these secrets. On the north is the macrocosm and on the south the microcosm.

Man may be the chief actor in the Genesis drama of Creation, but God was the playwright, producer, and director. In these three bas-relief tympana, the viewer must perceive that Creation is not only seen with the eye, but felt with the senses. He must perceive that there is an Infinite Majesty who created this complex universe. The viewer must perceive that Creation is still taking place. The symbolic sculptures (if there are some) will speak to the viewer on whatever level he is capable of perceiving them. I do not believe that every bit of sculpture of this west facade must be purely figurative or representational.

Innovation of the groined and ribbed vault helped raise men's perception of ultimate truth. Analogical art partakes of the mystical. Anagogical art partakes of ultimate truth. The sculpture of this west facade must be anagogical in nature and analogical in spirit. I further suggest that this west facade sculpture be addressed to the sensibility of the individual viewer as against the corporate group. The art forms and iconography of the Cathedral interior are not intended to assist in corporate worship.

In conclusion, I would not deny the artist of the west rose window the subject of Creation. Many worshipers and visitors will always enter by the transepts. They will look down the nave to the west. The Creation theme is still right for this rose. The Ten Commandments will be carved in the bosses just inside the west rose and over the west balcony. Then the worshipers will walk beneath the creedal statements of the nave clerestory bosses and between the great Old Testament figures in clerestory stained glass. The viewer approaches the sanctuary by passing under the crucifixion of the rood beam and between the parable and miracle windows in the choir chapels. He then sights the vast assembly of saints representing the apostles, prophets, and those who have met the six-fold test of God.*

Theologians have said the Creation was the first revelation of God and the second was His incarnation. Where does our Cathedral worshiper find this second revelation? In the Majestus of the Ter Sanctus Reredos. This mute image is symbolic of the words carved around the outside of the apse: "Hallelujah, The Lord God Omnipotent Reigneth Eternal."

In Lord Kenneth Clark's Civilization series, he says in effect that Protestantism has never made a major contribution to the art world. The west facade of Washington Cathedral may be our last chance—at least it is our Cathedral's last chance. It must not, and with Divine help will not, slip between our fingers. This is a golden opportunity to forge a major statement in the art of imagery and symbolism.[2]

Frederick Hart's Bid for the Commission

From 1967 to 1971 Hart worked as an office clerk on the staff of Washington National Cathedral, and also as an apprentice to Roger Morigi (1908–1995), the Cathedral's master stone carver. In time, Morigi entrusted the young apprentice with the carving of various decorative elements, then with increasingly challenging sculpting and carving projects including boss stones in the interior vaulting, niche figures, and gargoyles.

Hart's ambitions extended well beyond stone carving, though, and he must have heard the discussions going on within the institution about the iconographic program for the tympana. Aware that these tympana were strategically important locations and that the sculptures that would eventually adorn them would take on monumental significance, the young artist, still a fledgling, made the astonishing resolution to execute the sculptures himself. Hart had always had a strong sense of destiny, evident in a January 19, 1971 letter that he wrote to Canon Feller. In it he explains that while he arrived at the Cathedral seeking discipline and opportunity to hone his skills, he also wanted to gain more than a mere technical facility. He had already

decided, and apparently informed Canon Feller, that the Cathedral did not offer him opportunities for further growth, but the possibility of executing the tympanum sculptures on the theme of the Creation now offered him a reason to stay. He applauds the idea of a theme so potentially rich in possibilities and innovation, and explains his own ideas about the Creation. The many long, searching conversations that he had at this time with members of the clergy must have given him the self-assurance that emerges in his letter, and which is unusual in one so young. The letter is an astonishing statement, especially in his perceptive reading of the concept of the Creation as evolutionary:

As I told you, I was truly staggered by your concept for the West Front iconography. It was not solely excitement over the freshness of the concept itself, but also a very personal reaction in terms of questions and intuitions I have had on the meaning of art and my desire to find and create meaning as an artist.

Somehow, thoughts, direction, values, and hopes that have meandered though my mind in different paths for years seemed to converge all at once on a point and light up all the lights of my mind.

I would like to explain my reaction by, first, a bit of personal history. Then a summation of the concept of Creation as I have thus far come to understand it, and finally what I see the implications of such a concept in terms of a work of art to be.

As I think you understand, I came to the Cathedral in search of discipline, a mastery of the logic and execution of the work of sculpture; a development of facility. I have always seen the artist as both composer and performer. It long ago appeared obvious to me that I must first develop myself solely as a performer, as a technician. That, for a time, I must forget completely myself as a composer, a creator. I felt that I had to master the grammar of the language of sculpture before I attempted to construct works of true expressive value.

I knew that at some point I would begin to encounter the danger of becoming only a virtuoso. That facility as an end in itself would be a failure. If I extend my current route I can only foresee myself developing into a highly competent neo-traditionalist and at very best infuse it with a uniquely personal style.

This is why I told you I felt that it was time for me to leave in order to grow as an artist. I am coming to a point where I must find myself as a composer, a poet, and an artist. Up until your announcement of the theme of creation, I didn't feel any of the future work of the Cathedral would offer me any opportunity for growth.

The directions that I expected to take in that search are based on values, inclinations, and some hypothetical speculation.

I have asked myself what is the greatest challenge? What for? Why sculpt? My feeling is that the artist's greatest challenge is to make men see, as if for the first time. To alter and enrich man's perception and conception of the world and himself. How? By seeing its Truth as has never been seen before. This is to me the essential purpose and value of art.

Needless to say, that truth must be communicated richly, immediately, and effectively, if it is to succeed. The merit and substantial worth of a work depends both on the measure of truth conveyed and on the manner of conveyance.

My inclination has been to seek a new heroic sculpture that reflects the consciousness of the new humanism that is developing in men's minds today. Not a revival (God forbid) but a new synthesis.

Two things have stayed in my mind, clues, and the embryo of ideas that have suggested possible directions. One, an experience; the other, a hypothesis. The first was an experience I had while I was modeling Erasmus. At one point I was overcome by an uncanny sense that the work was creating itself. A very uncanny feeling that its state of becoming was infinitely unique to itself. A feeling of movement or energy beyond myself. I have always felt that there was something urgent in that feeling that relates to what I intuitively seek.

The second is hypothetical and is a thought that has intrigued me for years. In his book, The Psychology of Perception, *Rudolf Arnheim states that our visual perception of the world is based principally on our concept of what we see, not what we actually see. Our mental framework determines what and how we see. We see through the mind not the eyes.*

For example, we take a primitive person to a rectangular-shaped swimming pool and we show him

two pictures, one a realistic perspective rendering of the swimming pool and the other a flat rectangle of the same proportions and ask him which looks more like the swimming pool. He will insist absolutely that the rectangle is more real. The reason being that in primitive culture, people unaccustomed to concepts of natural representation think and see in diagrammatic relationships. This accounts for the geometric tendency in all primitive art, and in early art work of children.

A further and more exciting example by its implications is that of Giotto and the response to his work. When his contemporaries saw his work they marveled at what they thought was the ultimate in realistic representation. In their minds they could not distinguish between his work and their concept of reality. The truth is that what we perceive as visually real is based on a progressive condition of consciousness not on a fixed absolute as we presume. The inevitable question — is it not possible that what was true in Giotto's case might also be true in our own?

Our perception of the real has been determined by the invention of photography. Art assumed there was nothing more beyond this and abandoned the search for the real to put aesthetic emphasis partially or totally on abstract form. But the hypothesis suggests otherwise.

Well, such has generally been my thinking, and I think you can perhaps sense the resonance between my direction and the theme of Creation.

In order for me to more fully grasp what the artistic mission is, it became necessary for me to examine and summarize the theme (Creation), as I understand it, to see what implication we involved in artistic terms. What is to be said — how it is to be said.

Firstly, when you speak of Creation I presume you are not envisioning a simplistic, fundamentalist interpretation, but are speaking of a concept of a much greater breadth and essence. The danger of a vague and meaningless pantheism becomes apparent unless Creation has a defined and explicit meaning.

Creation, in the term that I believe you intend, means Creation as a state of becoming; an evolutionary Creation. Genesis as a configuration of a concept of life in state of constant growth.

To understand the weight of this viewpoint as opposed to the Darwinian view, one must see evolution (in terms of Bergson, Huxley, and especially Chardin) as a continuance of the whole mass of the Universe in a process of transformation toward a Divine consciousness.

The process of evolution, in its whole referred to as cosmogenesis, is the rise of consciousness from subatomic units to atoms, from atoms to inorganic matter to organic molecules, thence to the first sub-cellular living units, thence to cell, the multi-cellular individuals, to cephalized metazoa with brains, to primitive man, and finally, to civilized societies. The Universe seen as a whole born of one and the same system — a whole of non-repeating directions. In short, three stages can be defined, Geo-Genesis, Bio-Genesis, and Psycho-Genesis. We have entered into what Chardin calls the psychozoic era of the history of the Universe.

Evolution can be understood only in terms of consciousness, i.e. the 'within' of things. To take the purely scientific view is but to study the isolated fragments of the outer physical manifestation of phenomenon: the tangential energy. To understand clearly the relationship between matter and spirit, the concept of radial energy, the inner life drive, must also be considered. This inner impetus of life is its struggle for consciousness. (Consciousness in the broad sense — consciousness veiled by morphology. There is a single force or energy operating in the world; consciousness is the substance and heart of life in process.)

Evolution has a precise orientation (consciousness) and a privileged axis in man. He is the axis and leading shoot of evolution. Man is the center of the construction of the Universe. Man was born of direct lineal descent from a total effort of life.

The rise of consciousness affects not only the isolated species of man, but forevermore irrevocably altered the entire and total organism of the world. A reflection of the parts in their relation to the whole. The earth finds its soul. Man is not an isolated unit lost in cosmic solitudes, but that the Universe converges and is 'hominized' in him (hominization — progressive spiritualization). Man is evolution become conscious of itself.

Evolution is not a system, is not a hypothesis. It is a general condition to which all systems must bow.

A light illuminating all facts, a curve which all lines must follow. The following premise can be drawn to illustrate the condition as it is reflected in the life of man: increased power (invention, science, creativity, etc.) for increased action.

But above all, increased action for increased being. An important aspect of this thinking is Chardin's law of complexity and convergence. As organisms become more complex, be they biological or sociological, such as a group of diverse cultures, they expand by way of convergent integration. Along with their [increasing complexity] and convergence a tension is created by the demand for a functional consciousness. Psychic energy increases with the complexity of organized units. The man, the object of greatest complexity, achieves full consciousness by virtue of that organized complexity.

Were it not for the simple spherical reality of the earth's roundness, the multiplicity of life's drives would have expanded to infinity, without ever need of convergence. The limit of space requires that the multiplicity of form must converge and integrate toward beings of higher functional integration—right up to a state of governing consciousness.

By way of illustration, this can be seen very clearly in human or psychological evolution, convergence leads to increased complexity. Increased population and expansion of consciousness by way of improved communication has caused man to consciously seek convergent integration by way of higher organization and increased being. Mankind as a whole will accordingly achieve more intense, more complete, and more integrated mental activity, which can guide the human species up the paths of progress to higher levels. . . .

Very well, this being the summation of the concept, what then are the implications for a work of art that seeks to express it? Should it be representational? If so, what should it seek to represent? Should it be abstract? If so, what should it seek to imply? Starting from either view, I think, would be a mistake. The 'how' is innately implicit in the 'what.' From the condition of a revised view of the world from an evolutionary perspective implies a revised view of the nature of form and art. This by way of a fundamental requirement of a work of art of any substance.

A work of art, in our case, a sculpture, is a non-verbal statement of a consciousness—a world view. The work makes this statement not only in its outer manifestations (subject or idiom) but also more precisely in its concept of form. To fulfill itself completely, the work must embrace the concept it seeks to express, by embracing a concept of form in syntax of its statement.

To illustrate, think of attempting to make a Renaissance statement of a world view in the context of late Gothic form. Ludicrous, ineffective, and doomed to be a failure as a work of art. You would be dressing a thought in the garb of its predecessor.

Thus, the real challenge, and the thing that lit all the lights of my mind when I first heard you speak and was intuitively staggered by the implications, is to seek a concept of form which by its nature embraces an understanding of cosmogenesis.

It could, of course, be done by way of making a simple representational statement, much like a magazine illustration that pretty much gets the message across in simple graphic terms. It could be done, with relative ease, by any one of a number of competent sculptors. And it would be the artistic crime of the century.

What is truly required is a work that alters man's perception of the world—a new artistic synthesis—that alters by way of a non-verbal expression of an artistic cosmogenesis. Not as a revision of aspects or parts but a new awareness of a whole and a totality.

Henceforth by the simple fact that we are dealing with two different forms of communication, the language of sculpture and the language of words, the search to fulfill the criteria must, of course, be made in the language of sculpture.[3]

The First Competition

In February 1971 the Cathedral building committee formally adopted a resolution concerning the "West Facade Iconography and Sculpture." The resolution substantively affirmed the idea that the theme of the Creation should grace the west facade portals, and reiterated that with the execution of these tympana sculptures Protestantism would at last make a major contribution to art history. By this time it had also been decided that a competition should be held to identify a sculptor for the three tympanum sculptures. Because

FIG. 8: *Adam,* Indiana limestone, 1978

Canon Feller had warned that a national competition could possibly overtax Cathedral staff and resources, not more than five sculptors were to be invited to submit proposals.

The invitees were Theodore Barbarossa (1906–1992), Donald DeLue (1897–1988), William McVey (1904–1995), Walker Hancock (1901–1998), and Frederick Hart. Because of his relative inexperience Frederick Hart was an unlikely contestant, but his talent and keen interest must have convinced Canon Feller, who had earlier nurtured several other artists and craftspeople, to include him. Hancock, already at work on other important commissions for the Cathedral in-

cluding a large portrait of Abraham Lincoln in bronze for the nave, was dropped from the list of names. The other artists were asked to submit, by November 1971, a statement along with a clay model, for which each would receive a fee.

The statement Frederick Hart submitted for this first competition follows.

I have designed the tympanum and figure as a single unit of expression. The parts reverberate against each other, creating a play of forces in a state of tension, making a unified statement. I describe it as a poetic configuration of a metaphysical reality.

The viewer is also an integral part of the work, creating a phenomenon in which all the parts interact; acting as a living process parallel to the concept of Creation.

I have sought in the tympanum to imply this supreme and unique mastery and mystery of divine force in a state of out of nothingness, as simple and as austere as possible. At full size this simplicity will be practically monolithic. Most importantly, I have made it as profoundly subtle as possible. This subtlety is crucial in terms of its impact and in creating a sense of impending movement, to be suggestive rather than graphic—as of waves, of wind, of the sea, of the maelstrom—and to strike in the heart of the viewer a sense of the symphonic grandeur and the immeasurable intimacy and peace of Presence, to penetrate him with subtlety, but forcefully and unforgettably. The lingering image disturbs, intrudes, and awakens his deepest inner nature.

I have attempted to create a contemplative evocation of the great breadth of quietude and tranquility that is the inner force of all metamorphosis, an evocation to be recreated by generations to come, whose meaning is clear yet still evolving.

Adam as unfinished man I have used as a vehicle between the viewer and the tympanum [figs. 8–10]. *Man is physically finite, his psycho-spiritual nature is not. The unfinished nature of Adam is expressed by his psychological relationship to the tympanum, of his evolving consciousness and physical energy suspended in a sense of impending movement. His whole expression is that of tense power and inward concentration, as if seeking to grasp and find union*

20

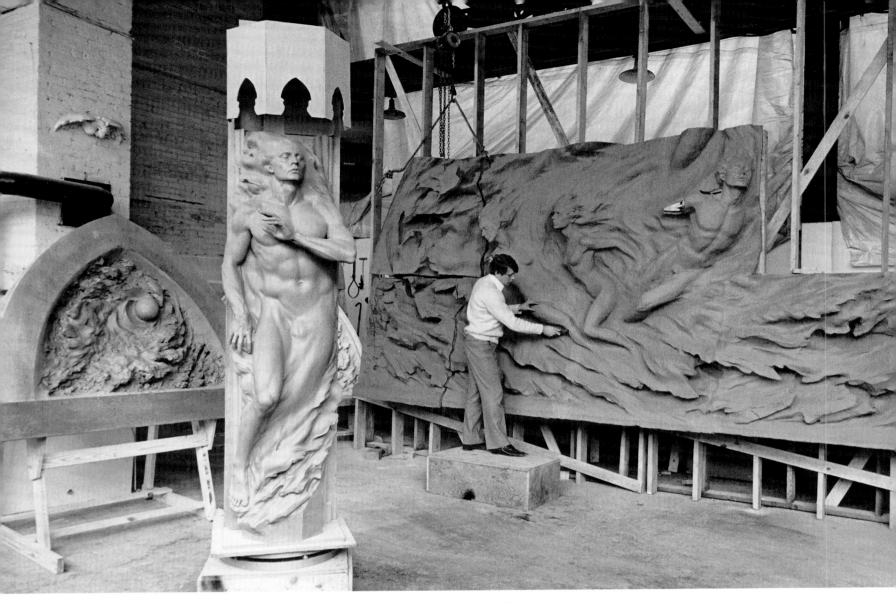

FIG. 9: Hart sculpts full-scale clay model for *Ex Nihilo* in his Georgetown studio, 1976–79.

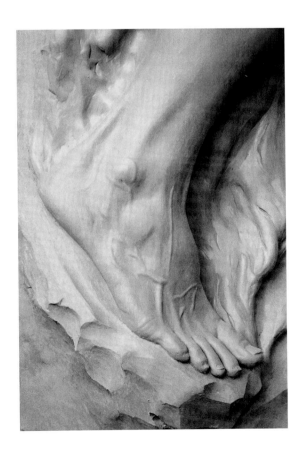

FIG. 10: Detail, *Adam,* clay

with that presence echoing through him from the tympanum.

The tympanum and Adam resonate with one another and within one another as of flesh and spirit, yet an underlying tension is felt underscoring man's free will and the burden of choice. Together they place the burden of choice on the viewer.[4]

When the Cathedral's building committee met in January 1973 to appraise the results of this first competition, the consensus was that none was likely to result in a work of sacred art of lasting importance. A photograph of Hart's early study for *Ex Nihilo* (fig. 11) suggests that despite Canon Feller's avowed willingness to consider a nonfigural design, other members of the building committee must have found Hart's idea too simple and austere, and perhaps too conceptual.

21

FIG. 11: Early study for *Ex Nihilo*, 1973

Whatever the reasons, it was markedly different from the design that now decorates the central tympanum.

The Building Committee Expands Its Search

In 1974 the Committee invited Josef Henselmann (German, 1898–?), Michael Lantz (American, 1909–1998), and Constantine Seferlis (1925), a sculptor and stone carver at the Cathedral for many years, to participate in the competition for the commission, but made no announcement after reviewing their submissions. Meanwhile Hart revised his first submission (figs. 12–14). He created new models for the central portal tympanum and trumeau and, surpassing the request of the Cathedral building committee, models for the flanking tympanum sculptures. He wrote a long letter to Canon Feller, which was read to the committee on May 14, 1974, and submitted the following statement for review with the models.

In these preliminary studies, I have designed the works of sculpture of the West Front as an integrated arrangement of parts to a whole statement. All of the parts, each tympanum and figure, are interrelated in concept, expression, style, symbol and motif. They are meant to combine to form a single orchestrated expression of the doctrine of Creation as the metamorphosis of divine spirit and energy, in its varying shades of light and darkness, of creative evolution—a poetic configuration of a metaphysical reality.

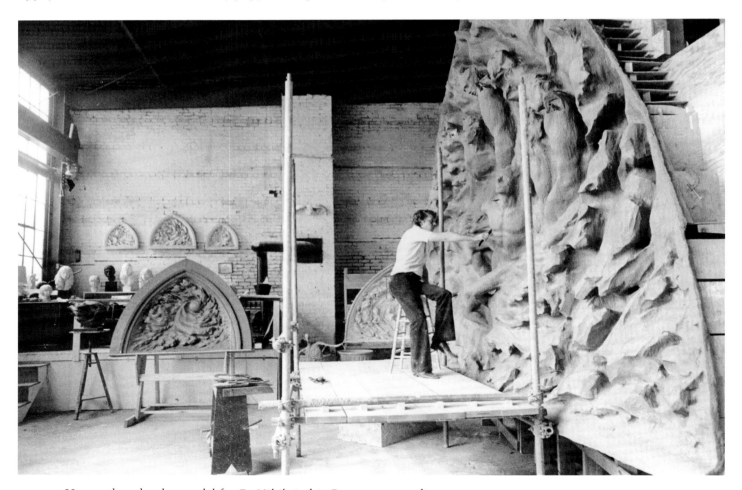

FIG. 12: Hart sculpts the clay model for *Ex Nihilo* in his Georgetown studio.

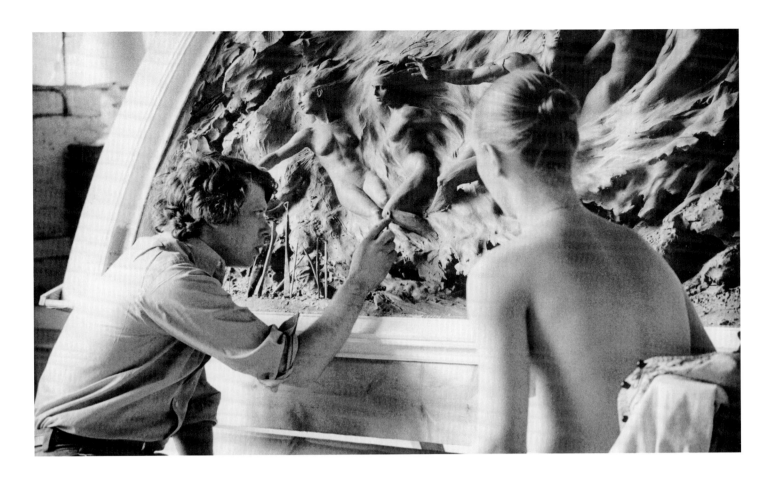

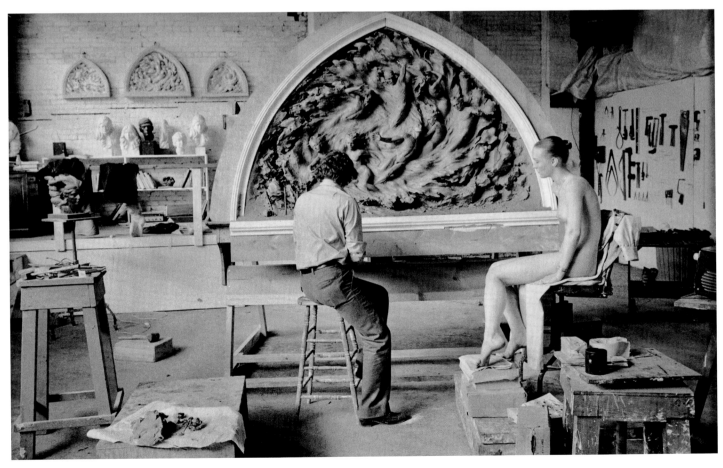

FIGS. 13, 14: Hart sculpts the Working Model for *Ex Nihilo* in clay.

23

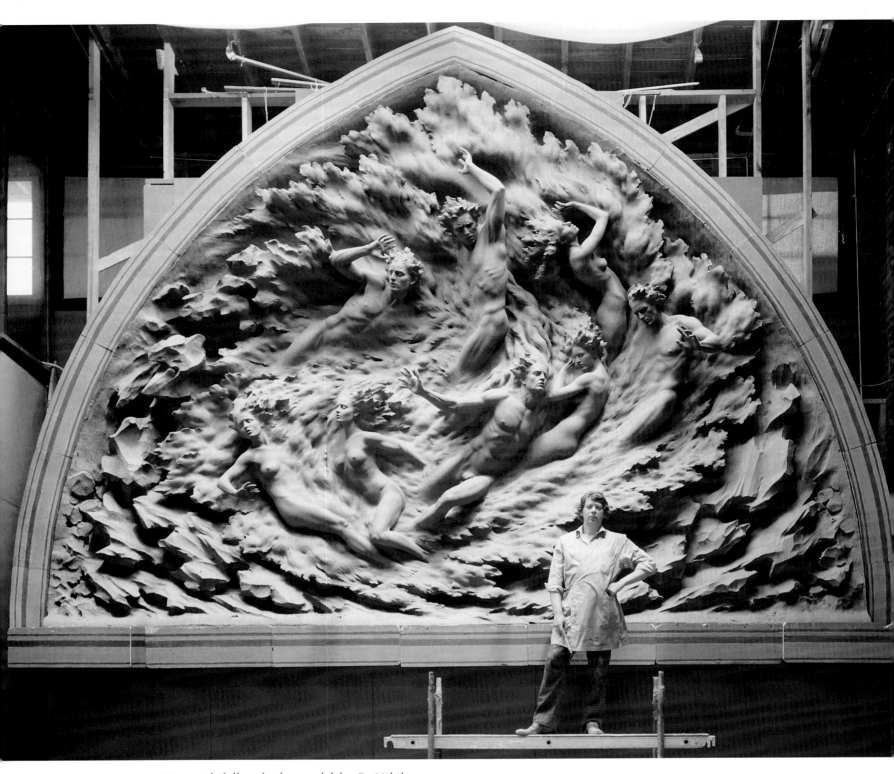

FIG. 15: Hart with full-scale clay model for *Ex Nihilo, 1979*

I have sought to imply the supreme and unique majesty and mystery of divine force in a state of becoming. In the central tympanum, Ex Nihilo [fig. 15], I use the emergence of the mass of humanity from the void to evoke the nature of the phenomenon of Creation, that is, the evolution of form and psycho-spiritual consciousness from the rampant chaos of cosmic energy. The ground is not simply a backdrop but uses an active force of equal significance to the emerging figures.

Adam I portray as man the singular individual, the finite man, fully emerged yet still in a state of becoming, still a part of the ongoing phenomenon of Creation. The motif of the flame of Creation is on his heals as he steps forward.

I have endeavored to render the figures of Peter and Paul [figs. 16–19] in the character, spirit and psychological presence that we know of them both as persons and/or symbols of differing aspects of Creation. I

24

FIG. 16: Hart's first sketch for
Saint Peter

FIG. 17: *Saint Peter*, Indiana limestone, 1984

*would portray them at the precise moment they were
each confronted with Christ! Peter as he was fish-
ing—symbolic of the material, the actual, of man's
struggle with nature. This is consistent with the theme
of the tympanum above. His pose, character, modeling
is robust, alive and physical.*

*Paul is portrayed at the moment he was struck
blind when Christ spoke to him. Blind and yet awak-
ened spiritually, reiterating the mystery of the implicit
paradox of the theme of the tympanum above; the un-
seen, the invisible acts of Creation. The general treat-
ment of the figure is consistent with Paul both in this
nature and as a symbol; subdued, spiritual, mental.*

*In my search for allegorical imagery for the north
and south tympanum to portray the themes of the ac-
tual and invisible aspects of Creation I use the image
of the* Creation of Day *and* Night. *Day and Night, not*

*as nouns, but as verbs, not as static depictions but as
events in a state of becoming. Day and Night as the
polarities of Creation.*

The Creation of Day *is an abstract design around
the sun suggestive of active power, of the sweep of
change and motion, of the actual, of the expansive and
exterior aspects of Creation.*

The Creation of Night *is designed around the moon,
planets and nebulae, suggesting the elusive, the tran-
scendent and contemplative. It denotes the intellect in
the formal relationship of spatial abstracts. It implies
the unseen, the unknown—the inward and interior,
but also the ongoing metamorphosis of Creation and
the promise of discovery and awakening.[5]*

The Minutes of the Building Committee, dated May
14, 1974, record that the Reverend Charles Perry, who
served as Provost of the Cathedral from 1978 until

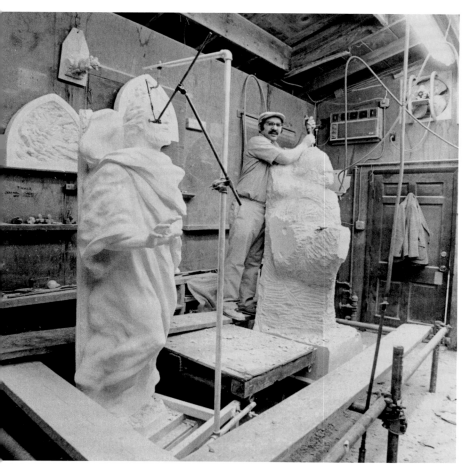

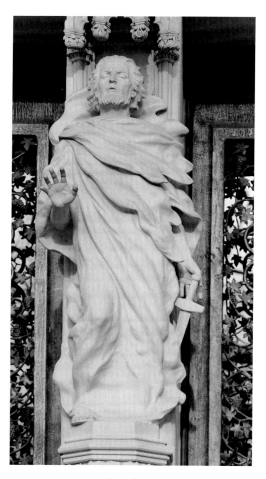

FIG. 18: Master Carver Vincent Palumbo roughs out *Saint Paul* in stone, 1982.

FIG. 19: *Saint Paul*, Indiana limestone, 1983

1990, moved that the commission be given to Hart. Hart's clay model for this second proposal for the central tympanum, as well as his accompanying statement, took a dramatically different tack from the first model, presenting Adam as an individual and giving him and eight other figures human forms that are almost fully articulated. Movement is not suggested but more clearly represented in the roiling forms of the background. Hart's model for *Ex Nihilo* had dramatically evolved from a contemplative evocation of the theme into an almost literal interpretation in which the tension of choice, a key element, was not underlying but palpable and apparent.

On May 14, 1974, after voting against further consideration of finalist Michael Lantz's models, the building committee again looked at the proposals submitted by the other two finalists, Hart and Seferlis.[6] They voted to accept Hart's second proposal for the central tympanum and the trumeau figure of Adam and reached a "general consensus that some further

study might be given by the artist to his north and south tympanum models although his concepts are totally acceptable to this committee."[7] The ambiguity of this statement suggests at least some resistance to the nonfigural form that Hart proposed for the *Creation of Day* and the *Creation of Night*. Yet in a letter of May 21, 1974, Canon Feller notified Hart that the building committee had voted unanimously to award him a commission for the central portal tympanum and the trumeau figure of Adam. Feller added his personal congratulations:

Rick, it goes without saying, but I must include. . . my own personal gratification at your winning this design [commission]. I think it has tremendous potential to be one of the great art statements of Protestantism. My very best wishes that you will succeed in this achievement.[8]

26

FIG. 20: Robert Parke poses for *Adam*, 1976.

Continuing Negotiations between the Artist and Patron

As was the experience of artists working on ecclesiastical commissions in the fourteenth, fifteenth, and indeed all centuries, Hart worked closely with his patrons—the members of the building committee. Although many of the details of this interaction have been lost, Cathedral records provide glimpses into the ongoing involvement of the committee in Hart's work on the sculptures as they evolved from maquettes to final models.

For example, on April 8, 1975, the building committee discussed concerns about the direction that Hart's trumeau figure of Adam had taken. Since the final sculpture is significantly more literal than the maquette, it is clear that there was general approval of the concept of Adam being represented as "fully emerged but still in a state of becoming." But there was uneasiness about the degree of definition in the figure and the extent to which it should be seen to have emerged from the void. Some may have seen the sculpture as indecorous, or perhaps saw in it an overemphasis on the "burden of choice" (see page 21). It had evolved into a

. . . muscular, naked male, whereas the earlier emerging nude suggested Adam in process of creation. Here the dean commented on a letter he had received about this figure, and Dr. Golding noted that in Hebrew a-dam means 'person' rather than 'a man' [fig. 20].[9]

The committee may have sought a more figural representation than the second one that Hart produced, which has not survived. The committee asked Hart to "restudy the subject with respect to the niche." The revised *Adam* [figs. 21, 22], reviewed by the committee about one month later, met with general approval but this time it was suggested "that the mass out of which Adam rises should be brought a bit higher."

The committee continued to ask for changes to the artist's conception. Two years later, on May 10, 1977,

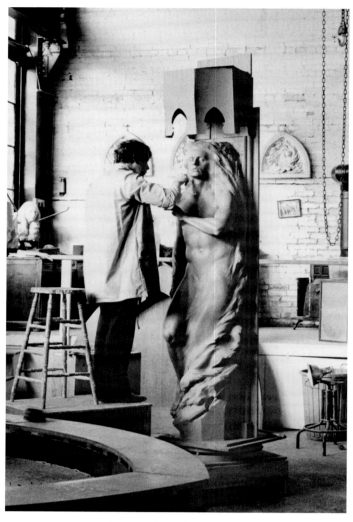

FIG. 21: Hart completes *Adam*, clay.

point the artist held firm, and the building committee eventually capitulated.

The Importance of the Cathedral Sculptures for Hart's Later Work

In early 1982 the translation into carved stone of Hart's clay models was completed (fig 23). As has been shown, the final designs, especially for the west portal tympanum, differ significantly from the artist's original, abstract clay sketches. As the Cathedral Sculptures evolved, Hart seems to have come full circle and to have become convinced, as he worked through initially subtle, evocative ideas to more direct, immediately recognizable forms, of the efficacy of the human form. The building committee's push for more literal solutions to the problem of representing the Creation might have helped the artist find his place as a champion, at the highly unlikely moment of the later twentieth century, of artistic representations of the human figure.

Hart never veered from the articulated figural course he followed over the years in which the Cathedral commission occupied him almost fully. In 1982 Hart expressed a desire to edition his studies for and fragments from The Creation Sculptures.[10] Later this would result in the Washington National Cathedral Collection (page 33). The differences between these early versions and the works carved in stone allow the viewer to see these sculptures through the eyes of the artist. In doing so, one perceives the "simple" and the "austere" tugging at his consciousness, and at the same moment, the contradictory pull of the human figure's capacity for expression. Hart's later work shows that he seldom glanced backward to the early, abstract ideas that were the departure point for the Cathedral Sculptures, but embraced the human form fully, wringing from it numerous works that succeed both as layered metaphors (for example, *Daughters of Odessa*, page 66, and *Counterpoint*, page 153) and as celebrations of sensuous, mortal beauty.

members voiced concerns about the essentially abstract nature of Hart's designs for the north and south tympana, even noting Hart's departure from the figural style of medieval cathedral sculpture. As late as March 13, 1979 Hart was still pressing for empty jamb niches and for low-relief tracery rather than voussoir sculptures, to which the committee eventually agreed. In March 1981 the tension between Hart and his collective "patron," that is, the building committee, reached a boiling point over the issue of the depiction of the full-size trumeau figure of Saint Paul. The model of the blinded saint that the committee had accepted in June 1977 showed the eyes closed, but members of the committee had recently asked Hart to depict the eyes open. The artist was unwilling to make this change, and argued that the closed eyes were fundamental to the conception of the work, since it expressed the interiority or 'unseeable' nature of consciousness. On this

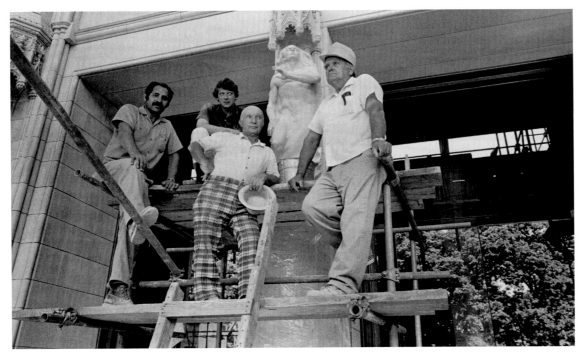

FIG. 22: Stone carvers (left to right): Vincent Palumbo, Hart, Roger Morigi, and Frank Zuchett, 1978

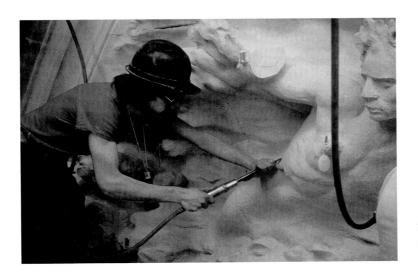

FIG. 23: Walter Arnold, stone carver, working on *Ex Nihilo*

NOTES

We are greatly indebted to Washington National Cathedral for kindly granting permission to publish material from their archives.

1. Archives, Washington National Cathedral.
2. Memorandum, Canon Richard T. Feller to the Very Reverend Francis B. Sayre, Jr.; archives, Washington National Cathedral. Aside from his apparent interest in the theme, Canon Feller was also responsible for keeping construction on schedule; his memo probably also reflects his desire that the committee reach a decision so that the work could begin.
3. Letter, Frederick Hart to Canon Richard T. Feller, dated; archives, Washington National Cathedral.
4. Letter, Frederick Hart to Canon Richard T. Feller, dated; archives, Washington National Cathedral.
5. Letter, Frederick Hart to Canon Richard T. Feller, undated; archives, Washington National Cathedral.
6. Although Seferlis's submission is a mere sketch, it appears more literal than Hart's, despite the symbolism and dreamlike naiveté.
7. Minutes of the building committee, dated; archives, Washington National Cathedral.
8. Letter, Canon Richard T. Feller to Frederick Hart, dated; archives, Washington National Cathedral.
9. Minutes of the building committee, dated, archives, Washington National Cathedral.
10. Minutes of the building committee record a discussion but not a conclusion on this; archives, Washington National Cathedral.

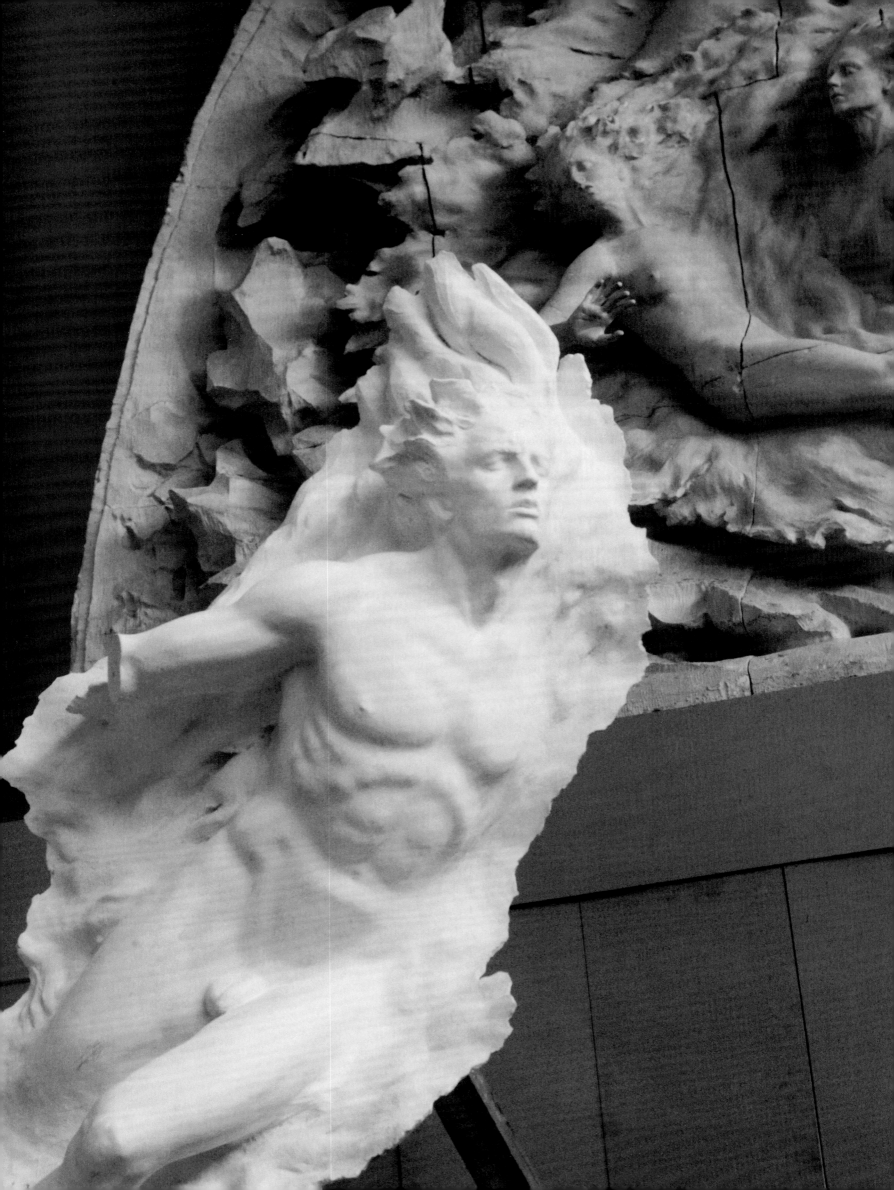

WASHINGTON NATIONAL CATHEDRAL COLLECTION

Remarks made on the occasion of the Cathedral's ninety-fourth anniversary, September 29, 2001, when the Washington National Cathedral Collection of Frederick Hart sculptures was announced.

. . . The central portal, the tympanum, Ex Nihilo, *as you see above us, and the figure of Adam beneath it were dedicated on the occasion of this Cathedral's open house in 1982.*

The sculptures are indeed the creative works of Frederick Hart, whom we lovingly refer to as Rick. They are the culmination of a relationship between Hart and the Cathedral that began in 1967 when Hart became an apprentice stone carver and sculptor here.

Rick Hart said once, 'Working at the Cathedral was the best experience of my learning life. It taught me how to work. I wanted to know and feel the discipline, the mastery of stone carving, and I learned that in the hours of working up on the scaffolding.'

—The Very Reverend Nathan D. Baxter
Dean of Washington National Cathedral

Washington National Cathedral and Chesley are pleased to announce the release of limited editions of sculptures created for the Cathedral by the late Frederick E. Hart. Among the most important works of Mr. Hart's oeuvre are the sculptures he created for Washington National Cathedral's west facade. These include the renowned Ex Nihilo *tympanum and the trumeau figures of* Saint Peter, Saint Paul, *and* Adam.

Celebrating the memory of Frederick Hart and one of America's architectural treasures, as well as the Spirit which inspired both, the editioned Cathedral works will also provide important support to the programs and ministries of Washington National Cathedral in its role as a national House of Prayer for All People.

The works include casts from Hart's maquette and working model for Ex Nihilo, *castings in bronze from the full-scale plasters of* Saint Peter, Saint Paul, *and* Adam, *as well as bronze castings of* Ex Nihilo *details from the full-scale plaster for the final stone sculptures.*

—Madeline Kisting
Managing Director, Chesley LLC

Plaster model for *Ex Nihilo, Figure No. 5,* (full-scale), in Hart's studio

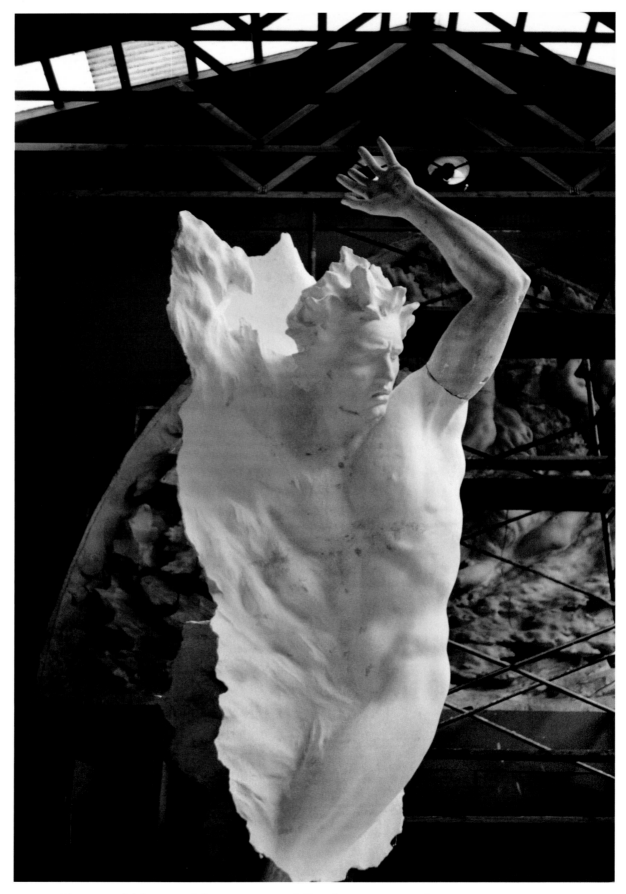

FIG. 24: Plaster model for *Ex Nihilo, Figure No. 4* (full-scale), in Hart's studio

FIG. 25: *Ex Nihilo, Figure No. 4* (full-scale), 62¼", bronze, 2002

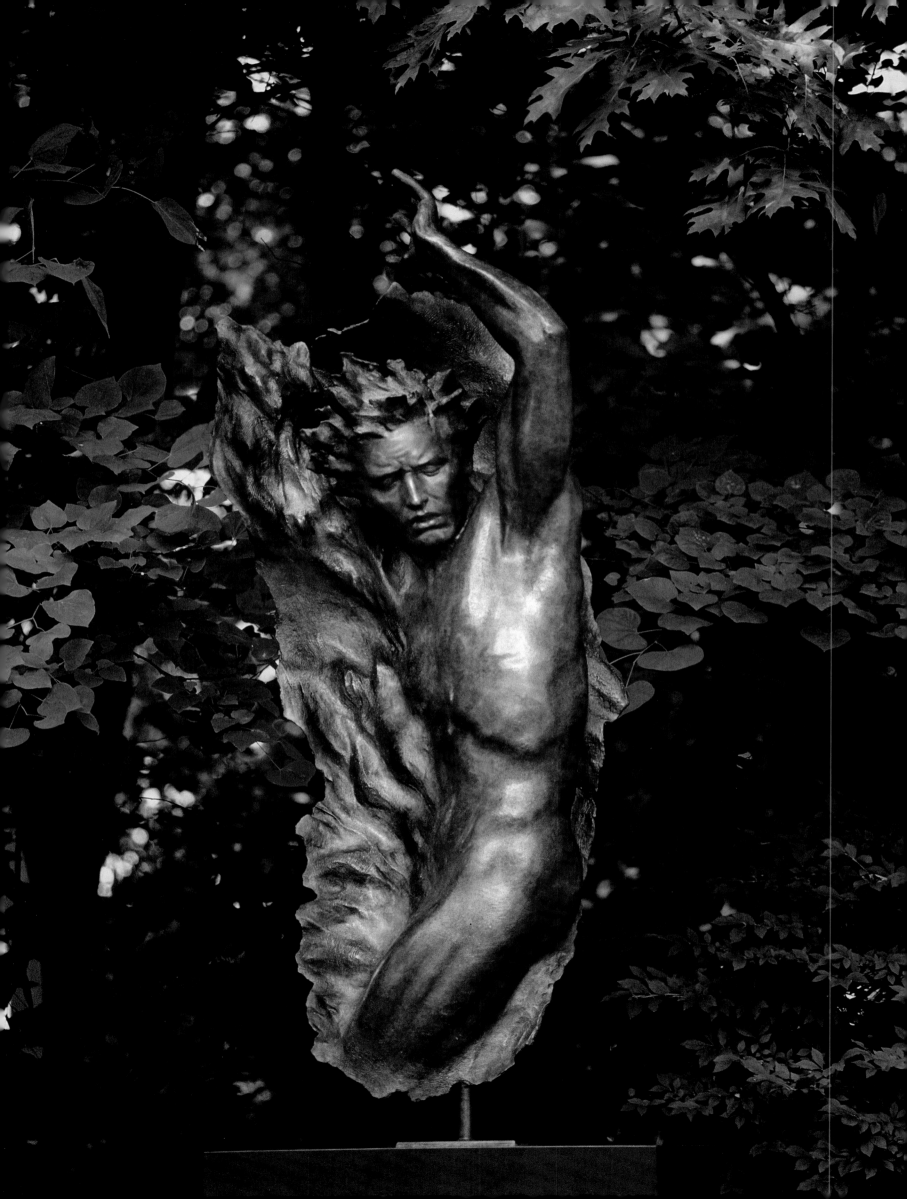

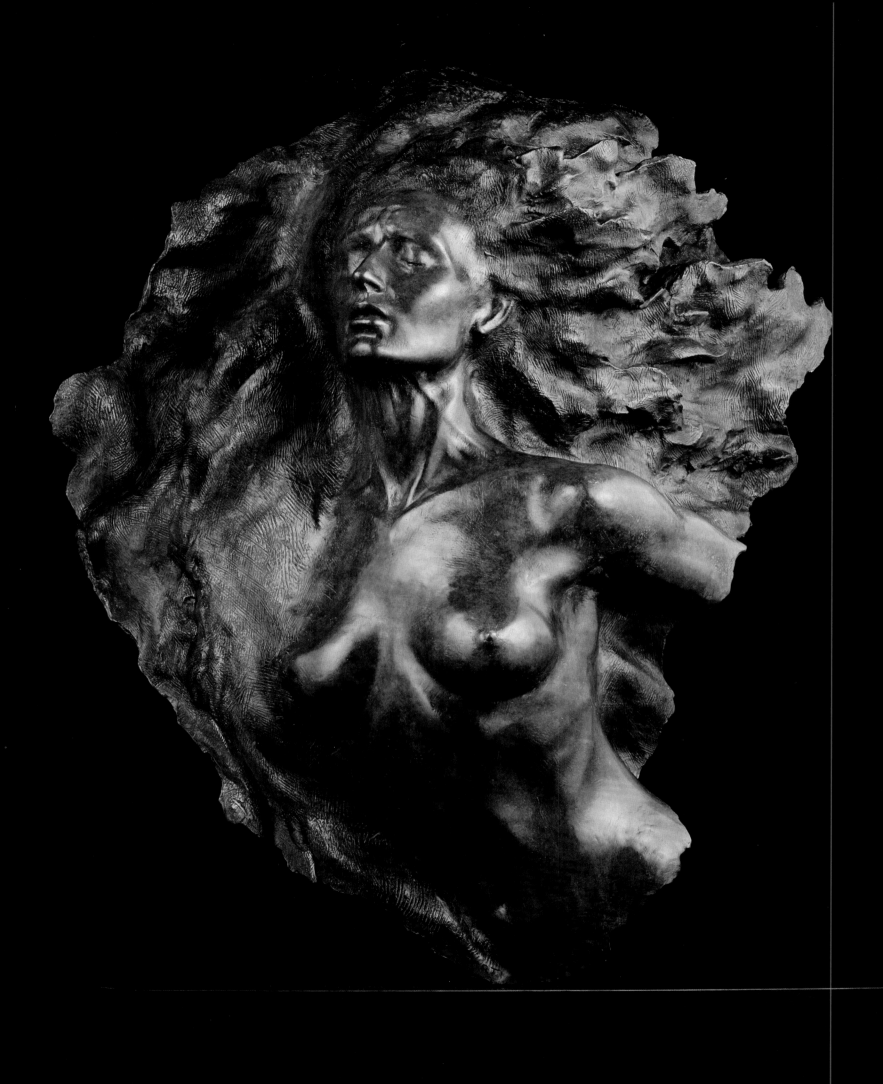

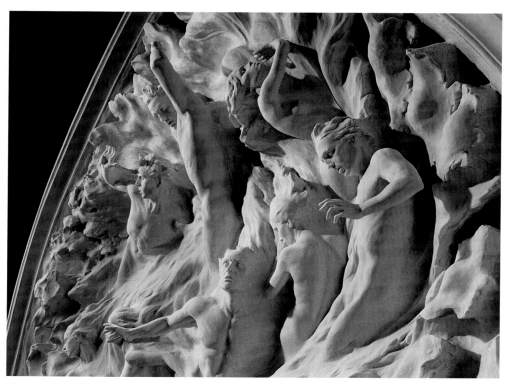

FIG. 27: Detail, *Ex Nihilo, Working Model,* cast marble

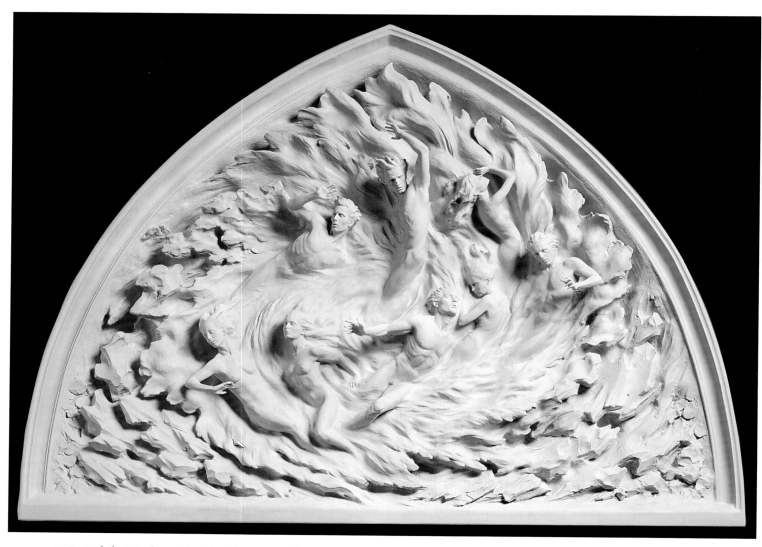

FIG. 28: *Ex Nihilo, Working Model,* 61", cast marble, 2002

FIG. 29: *Ex Nihilo, Working Model*, 60½", bronze, 2002

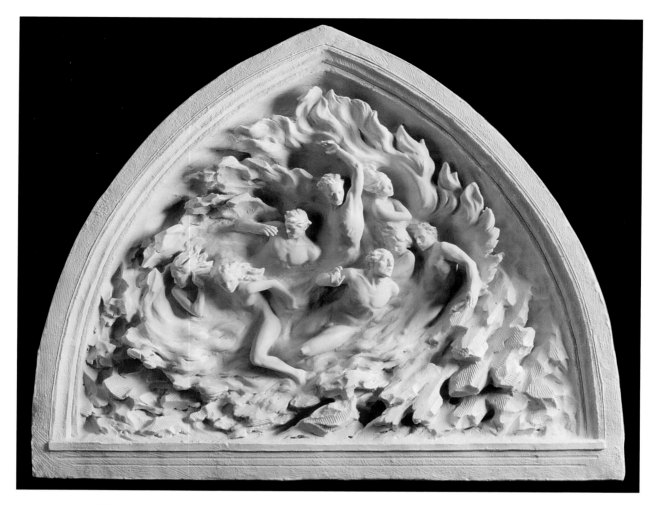

FIG. 30: *Ex Nihilo, Maquette,* 28", cast marble, 2001. This maquette won the design competition for The Creation Sculptures.

FIG. 31: The Creation Sculptures Maquette Suite, *Creation of Day,* 20¾", bronze, 2002

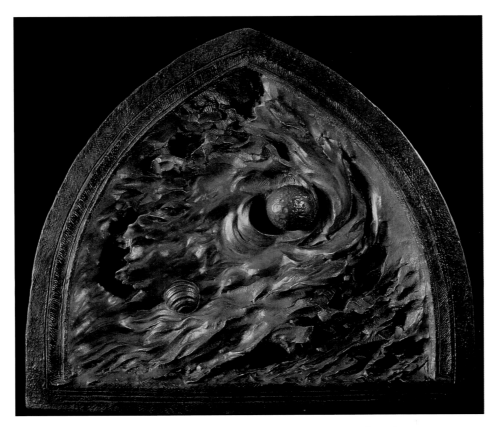

FIG. 32: The Creation Sculptures Maquette Suite, *Creation of Night*, 21",
bronze, 2002

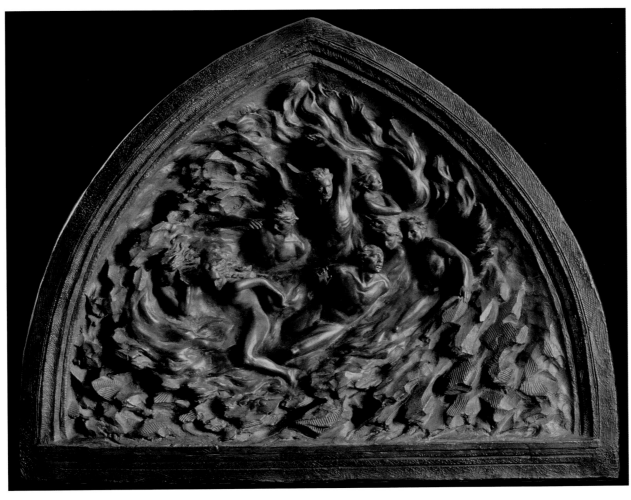

FIG. 33: The Creation Sculptures Maquette Suite, *Ex Nihilo*, 27⅛", bronze, 2002

FIG. 34: *Arm of Adam* (full-scale), 22", bronze, 2002

FIG. 35: *Adam* (full-scale), 81", bronze, 2002

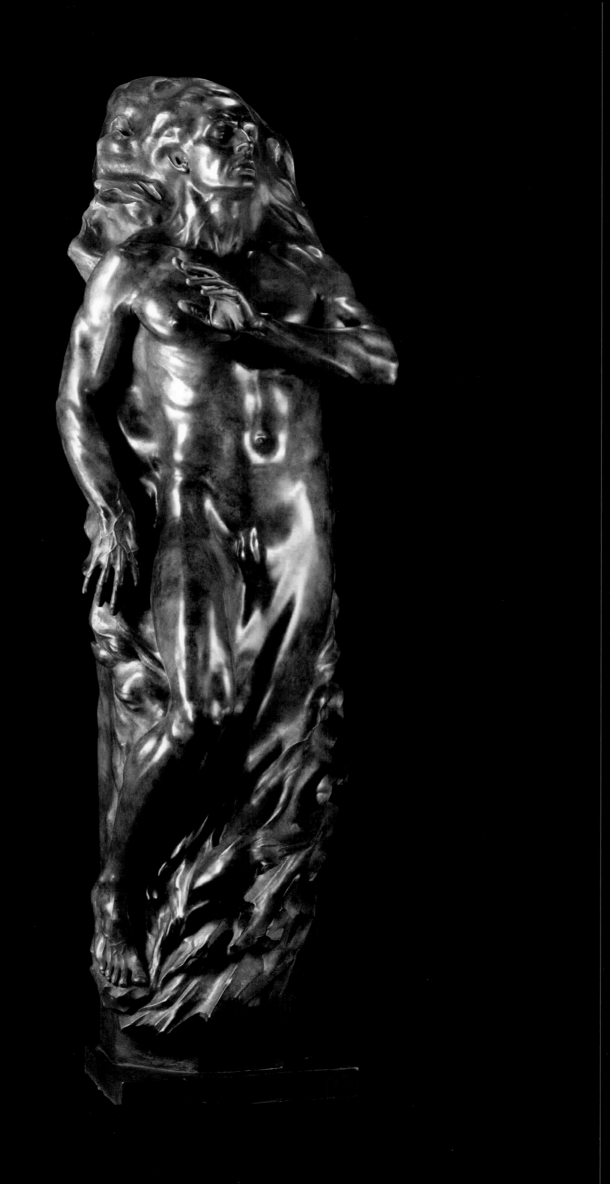

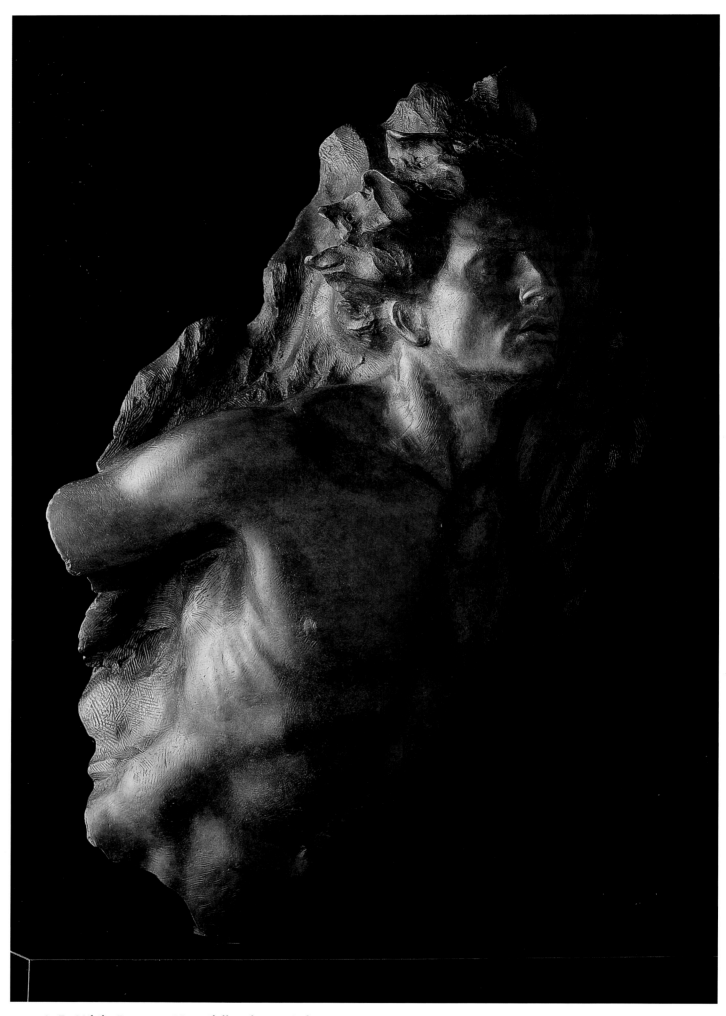

FIG. 36: *Ex Nihilo, Fragment No. 5* (full-scale), 43½", bronze, 2003

FIG. 37: *Ex Nihilo, Figure No. 6* (full-scale), 64", bronze, 2003

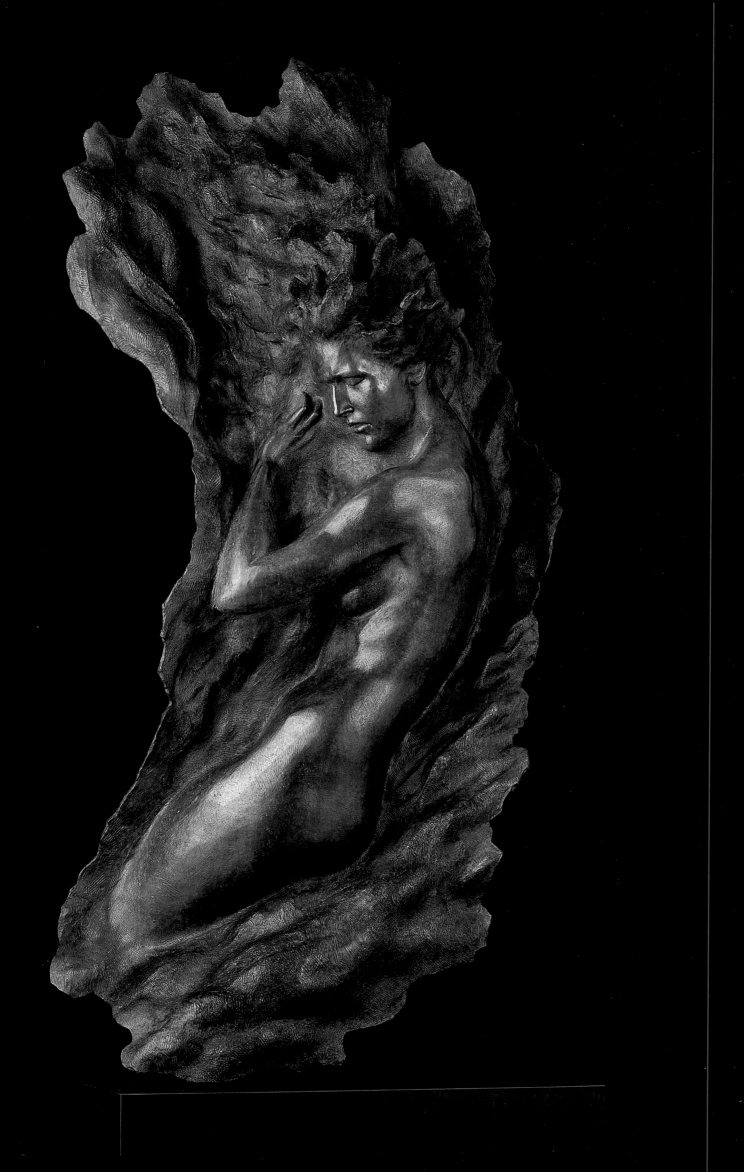

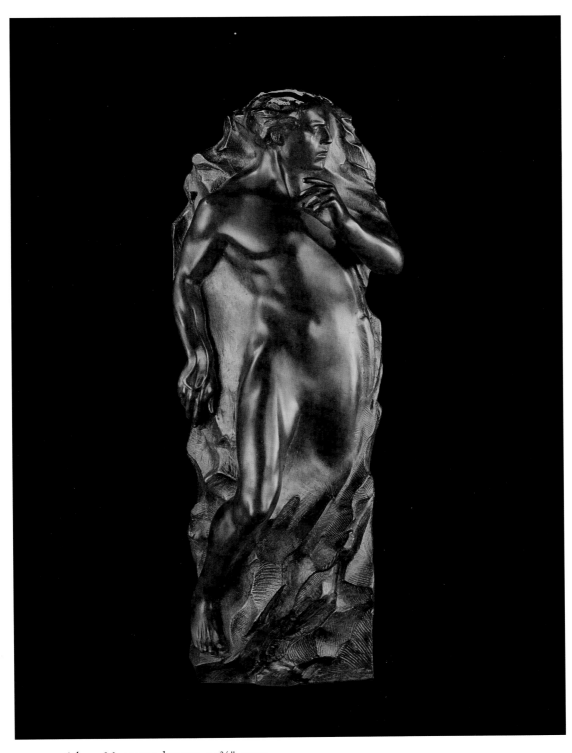

FIG. 39: *Adam, Maquette*, bronze, 21¾", 2003

FIG. 38: *Saint Peter* (full-scale), 70", bronze, 2003

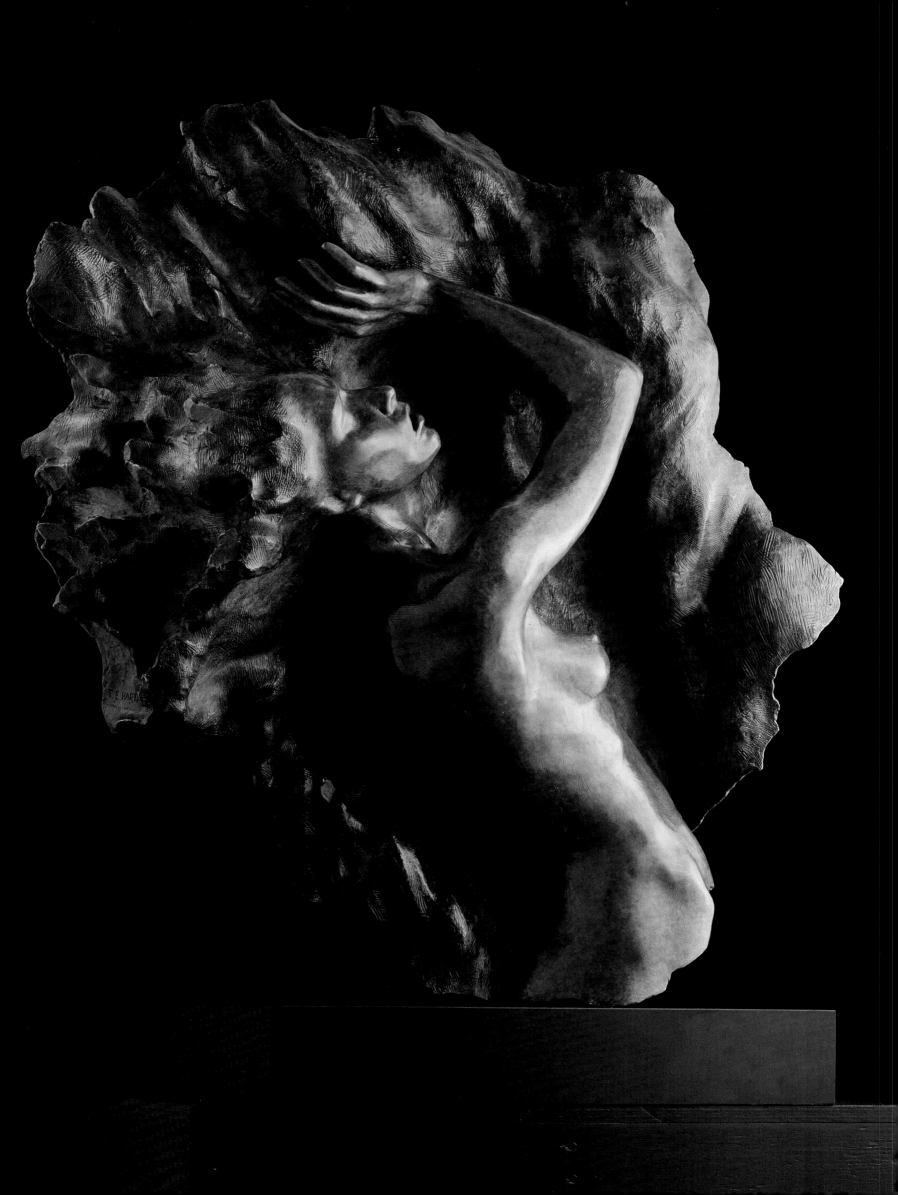

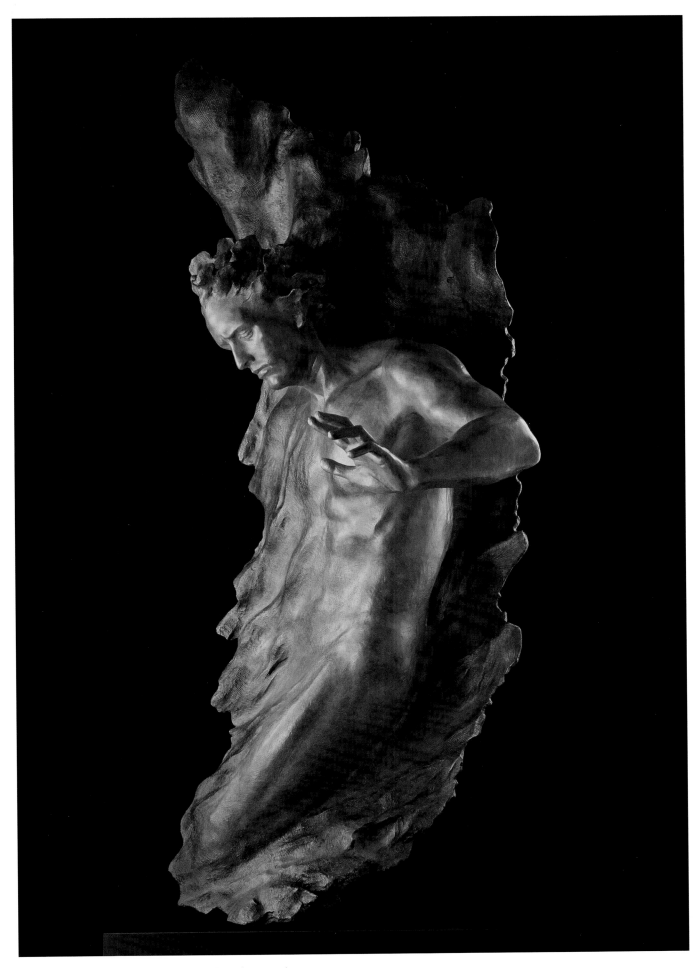

FIG. 41: *Ex Nihilo, Figure No. 8* (full-scale), 68", bronze, 2004

FIG. 40: *Ex Nihilo, Fragment No. 7* (full-scale), 45¾", bronze, 2004

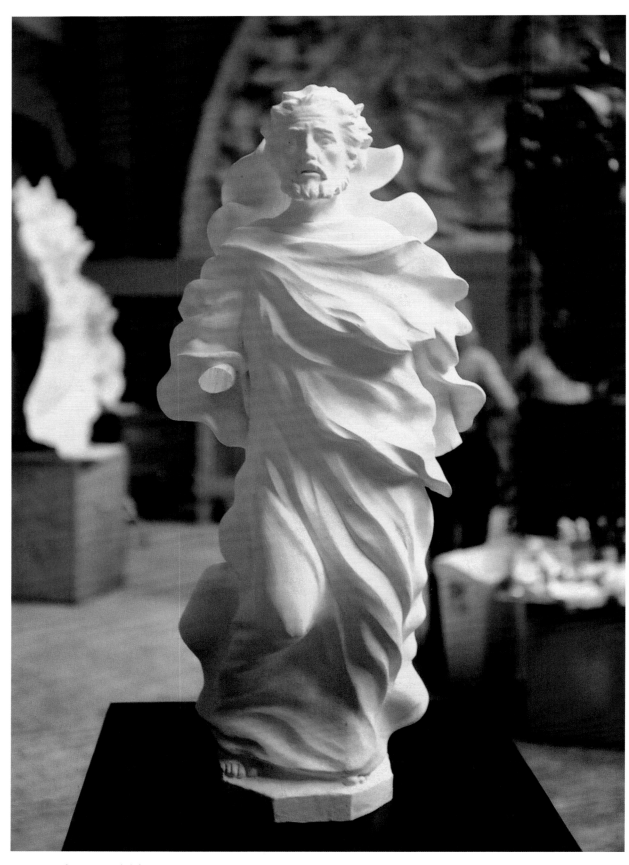

FIG. 42: Plaster model for *Saint Paul, Maquette* in artist's studio

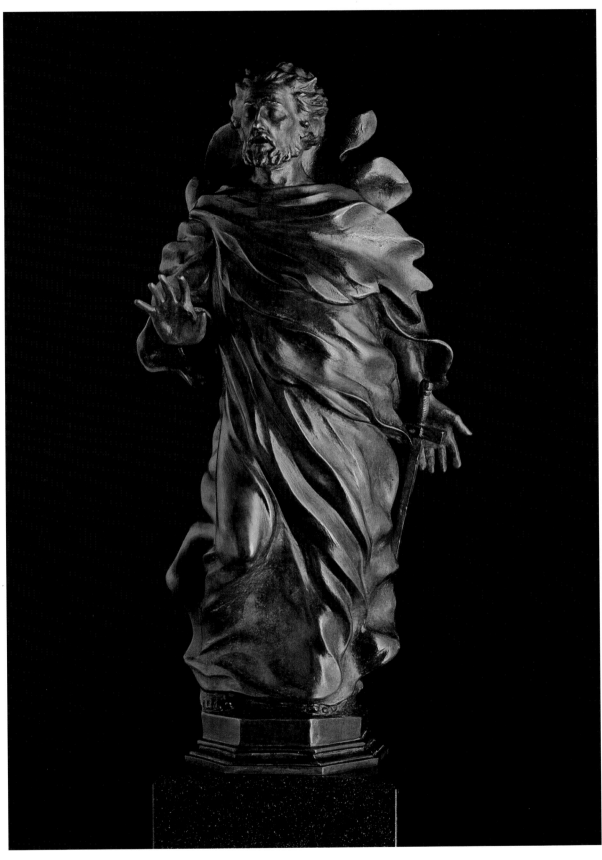

FIG. 43: *Saint Paul, Maquette*, 24¾", bronze, 2004

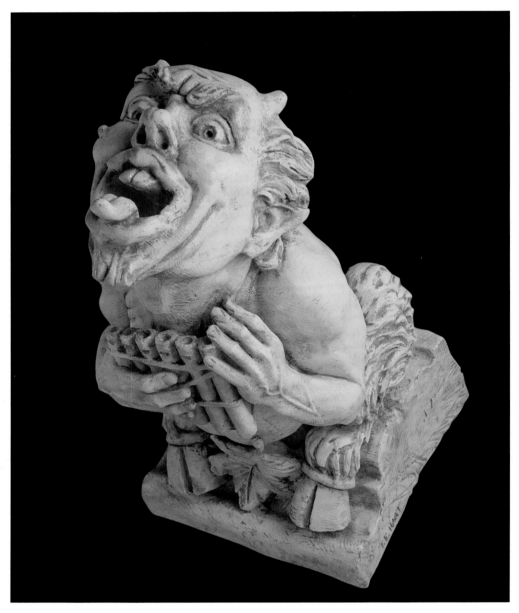

FIG. 44: *Pan Gargoyle, Maquette*, 16½", cast marble, 2004

FIG. 45: *Saint Paul* (full-scale), 69", bronze, 2004

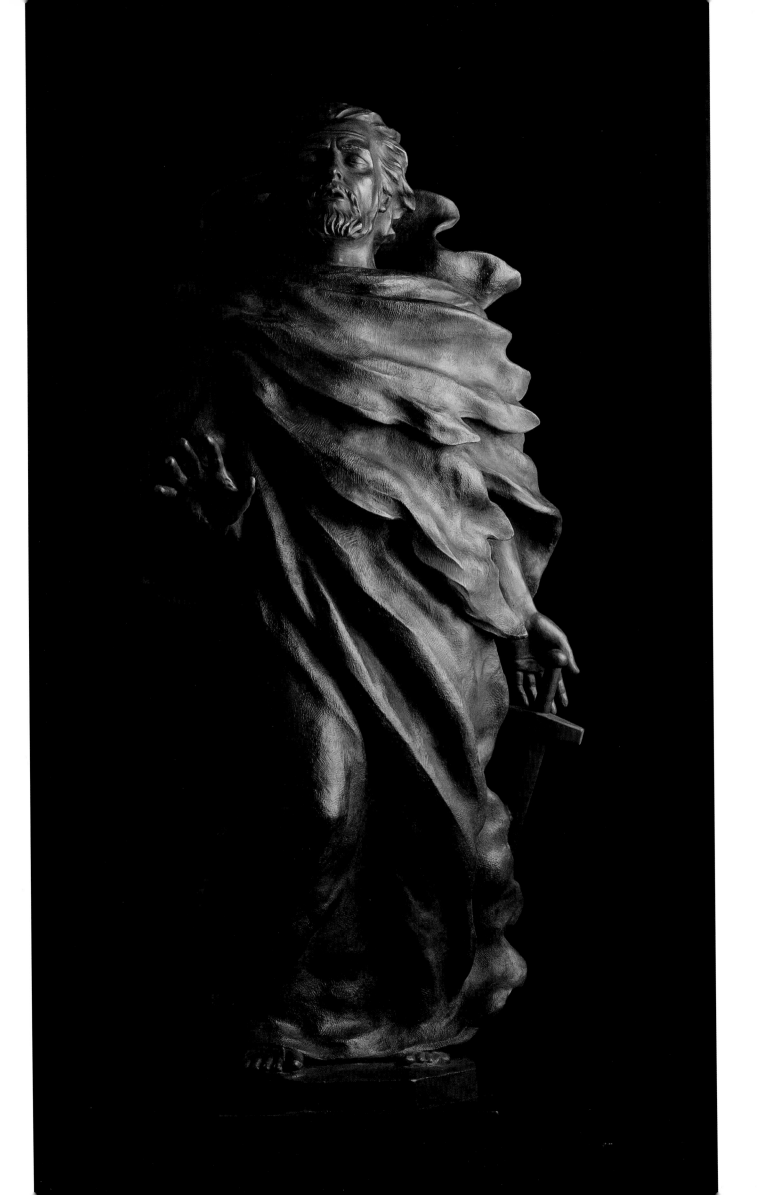

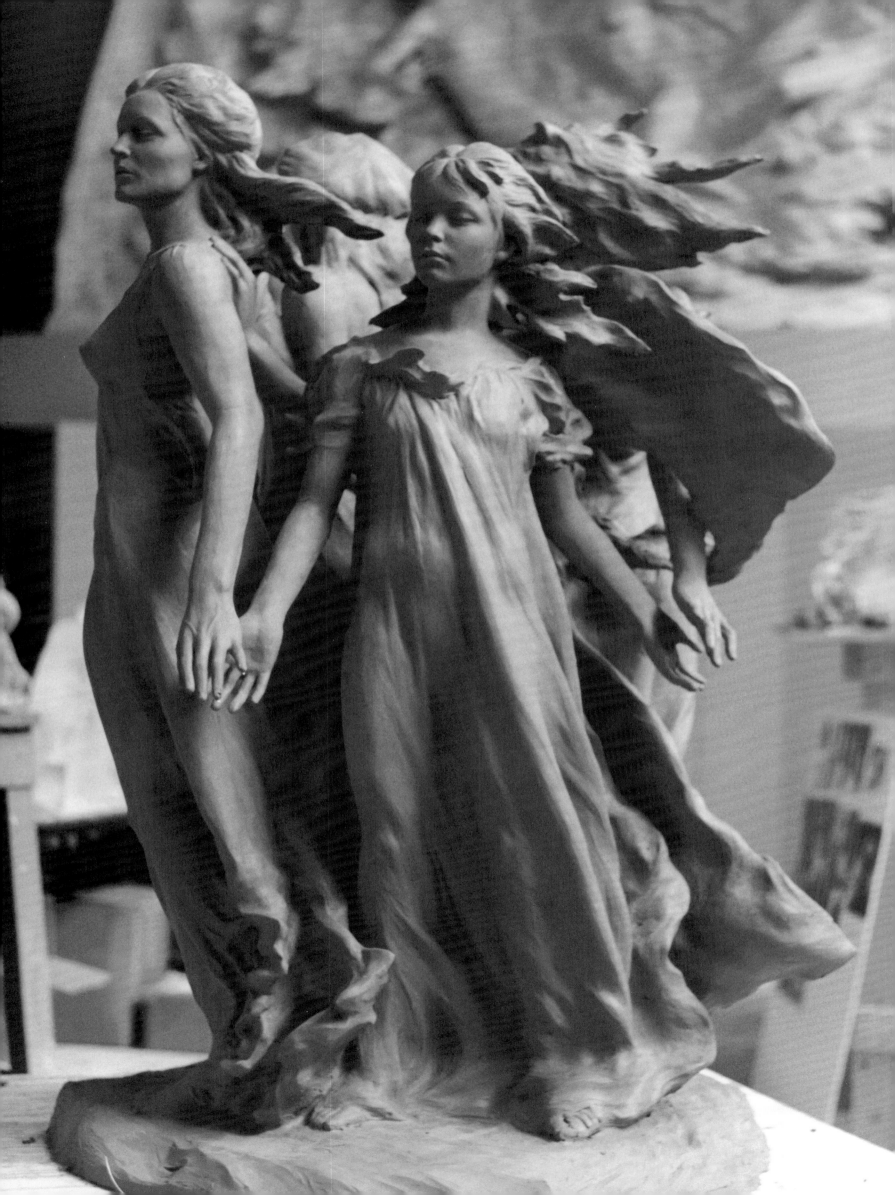

DAUGHTERS OF ODESSA

FREDERICK E. HART
CHESLEY

The "Daughters of Odessa" was inspired
by my interest in Russian history. It is based
on the story of the four Romanov daughters:
Olga, Maria, Tatiana and Anastasia, who were
assassinated in 1917.

Even though it is based on their
history, it is not meant as a portrait or a memorial
to them. Rather, it is meant as an allegorical
work, an elegy in bronze, which is dedicated to
the memory of all of the innocent victims of
the Twentieth century.

Frederick Hart

September 14 1997

Daughters of Odessa (three-quarter life-size), clay

FIG. 46: Official portrait of the young grand duchesses (left to right) Olga, Tatiana, Marie, and Anastasia, 1906

Daughters of Odessa
Martyrs of Modernism

The *Daughters of Odessa* is an allegorical sculpture in remembrance of the innocent victims of all of the brutal acts of repression of the twentieth century. It initially began because I was moved by the story of the murder of the four lovely young daughters of Nicholas II (fig. 46) by the Bolsheviks in 1918, but it evolved into a theme of greater importance: into an elegiac work which is a tribute to the delicate and sacred beauty of life; of all of God's children. It is essentially a redemptive work even though its subject is profoundly tragic. It is entitled *Daughters of Odessa* because of the enormous human suffering that has occurred in the Ukraine as a result of human folly and capricious brutality—the Jewish pogroms, suppression of the rebellion of 1905, the First World War, the Revolution and Civil War, Stalinist purges and famine, the Nazi invasion and Holocaust, Soviet tyranny, and most recently Chernobyl. The work is equally about Anne Frank, the children of Rwanda, Tiananmen Square, Hiroshima, and so forth.

Simultaneously, the theme of this work has to do with art in the twentieth century. The work is subtitled *Martyrs of Modernism*, and is a refutation of the nihilism, abstraction, and deliberate destruction of the ideals of Grace and Beauty that characterize much of the art of the twentieth century.

—*Frederick Hart*
(August 1998)

FIG. 47: Completed *Daughters of Odessa*
(three-quarter life-size), clay, 1997

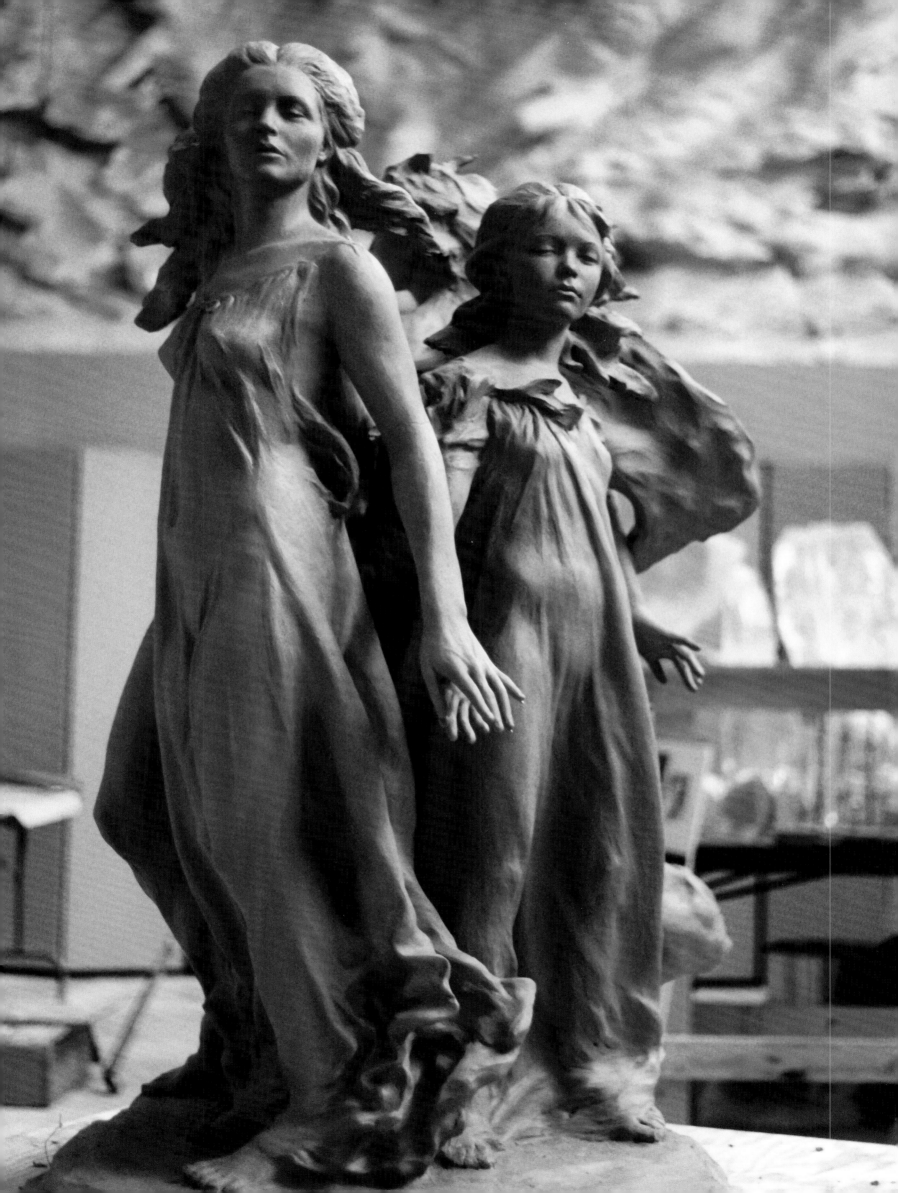

James Cooper, prologue
"Transcendence and Renewal"
2000

Frederick Hart is America's greatest figurative sculptor since Daniel Chester French. Hart not only created works of great beauty and gravitas, he was singularly responsible for restoring to American public monuments and memorials an iconology worthy of a great nation.

The thematic and formal language he employed in works such as *Ex Nihilo* and *Three Soldiers* represents the highest of standards of excellence, scholarship and craft. After a century of nihilism and violence, Frederick Hart created, during his short lifetime, a visual language that rekindles hope and nurtures our collective yearning for beauty and spirituality. Hart's oeuvre reconfirms the important historical role great artists play in renewing the core values of civilization.

"Art should embrace things of vital human concern . . . that can stand as icons for future generations," Hart wrote. *Ex Nihilo,* which graces the facade of the National Cathedral in Washington, D.C., is such an icon. This magnificent bas-relief of eight life-sized figures, emerging from a primordial cloud carved from Indiana limestone, represents a radical departure from contemporary public art. Hart's works address those transcendental themes a civilization must retain if the arts are to remain relevant and vigorous: creation, beauty, virtue, spirituality, and God. His desire to create a

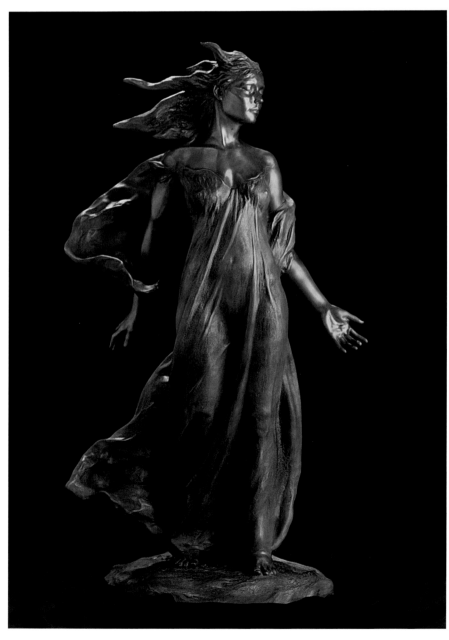

FIG. 48: *Daughter* (three-quarter life-size), 49½", bronze, 1997

living myth from stone, marble, acrylic, and bronze was both profoundly artistic and deeply personal.

Hart's *Daughters of Odessa*, perhaps his greatest bronze (fig. 61), is an exquisite archetypal image of four young women joined in a circle. Their femininity and delicacy suggest favorable comparison to Botticelli's *Primavera* and Raphael's *Three Graces*, but the most obvious comparison in terms of aesthetics and historical significance is Rodin's *Burghers of Calais*. A full century separates these two monumental works. *Burghers of Calais* was one of the seminal works that ushered in the twentieth century and modern existential culture. *Daughters of Odessa* is an auspicious work that also heralds a new century and a new criteria of spirituality, beauty, and virtue. Hart, like Rodin, had chosen the theme of martyrdom to make a point about the fragility of life and the enduring values of beauty. The faces of these tragic sisters are lifted upward, their eyes shut, their expressions taut, their bodies drawn together as if listening to the same distant music. Although they are standing quite still, there is a sense of joy, movement, and dance, created by the artist's brilliant deployment of gesture. Like Rodin's *Burghers*, these figures are so perfectly conceived they have also been cast and exhibited separately (fig. 48).

During his career Hart worked brilliantly in several different mediums, eliciting what is most pleasing in each. *The Cross of the Millennium* embraces light as a spiritual resource in its unique use of acrylic, much as medieval artists employed stained glass in Gothic cathedrals. In *Daughters*, the sculptor employed a highly refined process of patina for the bronze surface that is as delicate as a watercolor painting. His private and public work share a philosophical approach and longing for perfection. Hart's success as a sculptor was achieved at great personal cost. He had to acquire and master the lost craft of figurative sculpture. A great deal of soul searching and education were necessary to develop the spiritual iconography that shaped his vision. That Hart persevered and flourished in the face of adversity and indifference is a testament to his courage and intelligence. To put it simply, Hart is an American hero. He joins the pantheon of past artists and poets who sacrificed much so that we might see those truths that bind us together under God.

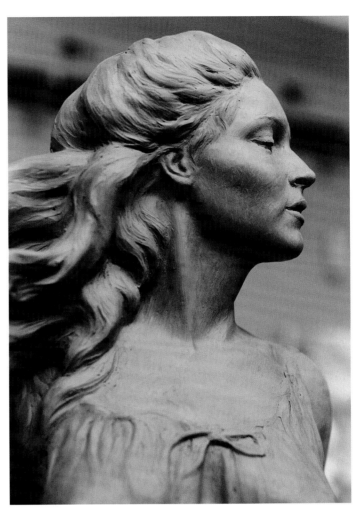

FIG. 49: Detail, completed *Daughters of Odessa* (three-quarter life-size), clay

Edward C. Smith
excerpted from "Couriers of the Spirit: Frederick Hart's Daughters of Odessa"
1998

Frederick Hart is the American Michelangelo and Rodin of our time. Hart is a master of three distinctly different mediums of sculptural expression: stone, bronze, and acrylic. His signature style is his unrelenting fidelity to realism. In *Daughters of Odessa* (figs. 49, 50), the artist has, in effect, transcended himself. Indeed I believe that his entire body of work, of more than 20 years, has been preparatory for the fulfillment of this magnificent portrait of the triumph of truth (as in the force of faith) over tragedy. . . .

Hart's extraordinary technical skill is hardly what has made him America's salient sculptor. What he is,

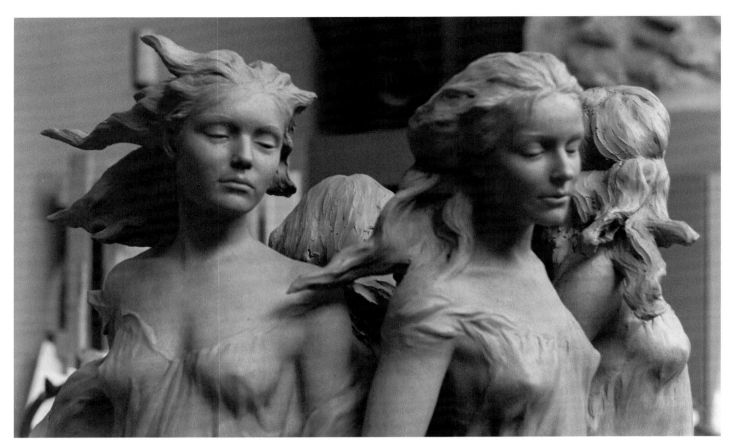

FIG. 50: Detail, completed *Daughters of Odessa* (three-quarter life-size), clay

above all else, is a master storyteller, one capable of making frozen form move the imagination to greater depths of insight and understanding of those universal visions and values that articulate the human experience.

As a work of art the *Daughters of Odessa* is rooted in the reality of the violent excesses of the twentieth century. All of the vices of past centuries remain an indelible part of the present (murder, rape, pillage, plunder and more) but no one would deny that since 1900 the world-wide volume of vice has increased dramatically. The four daughters of the last Russian Czar, Nicholas II, along with the other members of the family and its devoted coterie of servants, were killed by Bolshevik butchers in July, 1918. Ironically, the Czar, Slavic for "caesar," had abdicated his throne a few months earlier on the Ides of March, 1917, to a small group of Russian aristocrats that became a Provisional Government led by Prince Lvov and Alexander Kerensky. The communist party overthrew the Provisional Government later that year in November, then signed a separate treaty (Brest-Litovsk) with Germany, thereby remov-

ing Russia from World War I, and to make certain that the royal family would never regain power, Lenin determined (during the Russian Civil War that immediately followed the communist coup) that the last of the Romanovs must die. And so they were slaughtered, all of them including their pets, in the most humiliating manner imaginable.

The artist wants us to view his portrait of this painful parcel of our times in a much larger context. . . . Simply stated, as a romantic-idealist Hart refuses to amputate himself from our artistic ancestry which we inherited from the ancient Greeks and Romans whose aspiring ideals were rooted in the eternal elasticity of the celebration of grace, beauty, and the eminence of the spiritual over the material. This legacy is worth lasting. It therefore must be preserved, protected, and promoted. . . .

The composition of the *Daughters of Odessa* reminds the observer of the figures in Rodin's *Burghers of Calais* and one of the most impressive aspects of Frederick Hart's skill is his work with hands (fig. 51). Many sculptors find the human hand to be a difficult

challenge to master, partly because it is not merely a limb but a limb with limbs, meaning the five fingers. After all, there are only three parts of the human anatomy capable of communicating thoughts and feelings: the mouth, eyes, and hands. The hand gestures we see, for example, in the Burghers provide all the animation and articulation necessary in order for the viewer to fully understand and appreciate the valor of those noble men who were prepared to sacrifice their lives in 1347 during The Hundred Years War between England and France, to save their beloved city. As with the Daughters I am especially touched by a subtle nuance in the composition in how the artist bonds the two older women together by one gently resting her left hand on the left shoulder of her sister (fig. 52). It is a simple yet powerful symbol of reassuring solidarity shared by those innocents as they are about to meet their deaths. . . .

As the scope of his public and private work reveals, along with his choice in following in the time-honored and heroic tradition of such esteemed American predecessors as Daniel Chester French, Henry Shrady, and Augustus Saint-Gaudens, it can be said, without exaggeration, that Frederick Hart has become our nation's foremost sculptor. The new master and the moment have met and we all who enjoy the pleasure of contemplating the beautiful are the beneficiaries because of it.

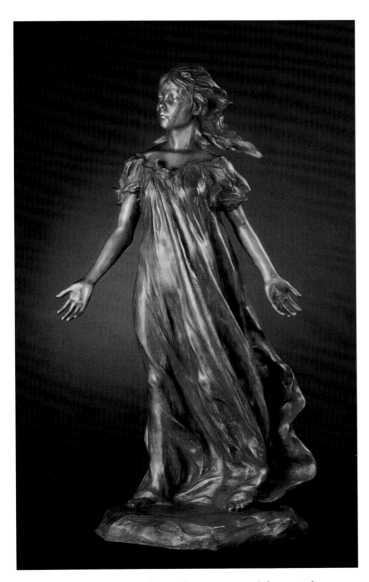

FIG. 51: *Youngest Daughter* (three-quarter life-size), bronze, 43", 1999

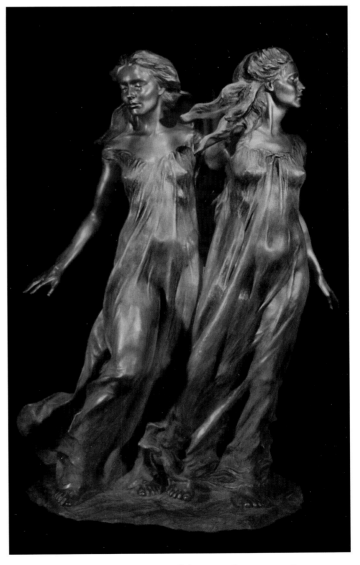

FIG. 52: *Sisters* (three-quarter life-size), bronze, 48", 1997

Making of a Master Work

The creation of *Daughters of Odessa* began with Frederick Hart exploring his composition in a small clay maquette, (fig. 53). Next, he built an armature for the actual work, and sculpted the nude figures in clay (figs. 54, 55). Then Hart applied clay to the already detailed clay sculpture, to create the illusion of flowing diaphanous drapery, (figs. 56, 57). In applying clay in this manner he borrowed from the ancient Greeks who had first explored wet drapery. . . . This technique allows the artist to suggest a point of a hip or a bended knee, contributing to a sense of movement and lightness, (figs. 58–60). A plaster mold of the clay was made and through the lost wax process, the final work was cast in bronze, and a patina was applied in a precise and painterly fashion through the use of chemicals and heat. A period of five years spanned the time from the first sculpting of the maquette to the final casting in bronze of the finished work (fig. 61).

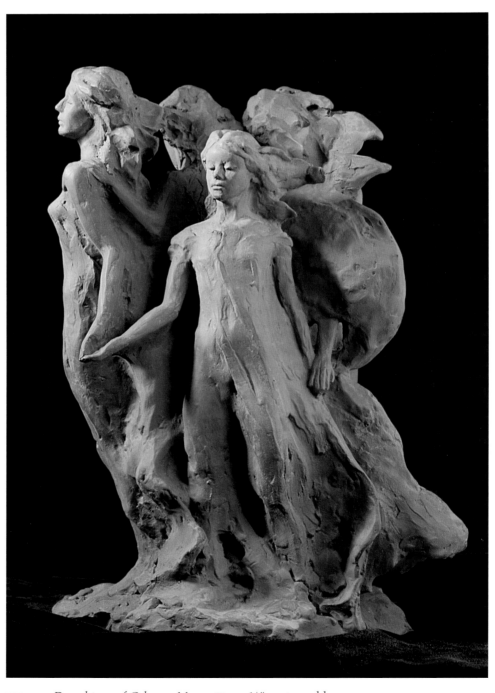

FIG. 53: *Daughters of Odessa, Maquette*, 12¼", cast marble, 1993

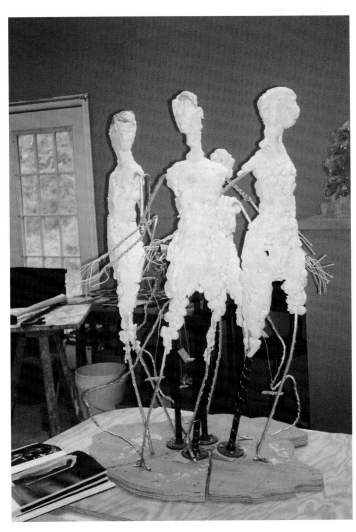

FIG. 54: Armature for *Daughters of Odessa*

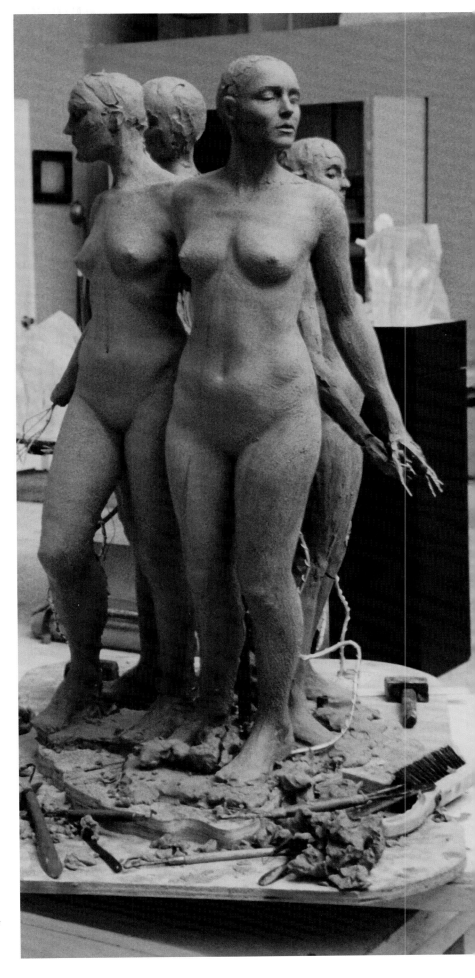

FIG. 55: *Daughters of Odessa* (three-quarter life-size), clay

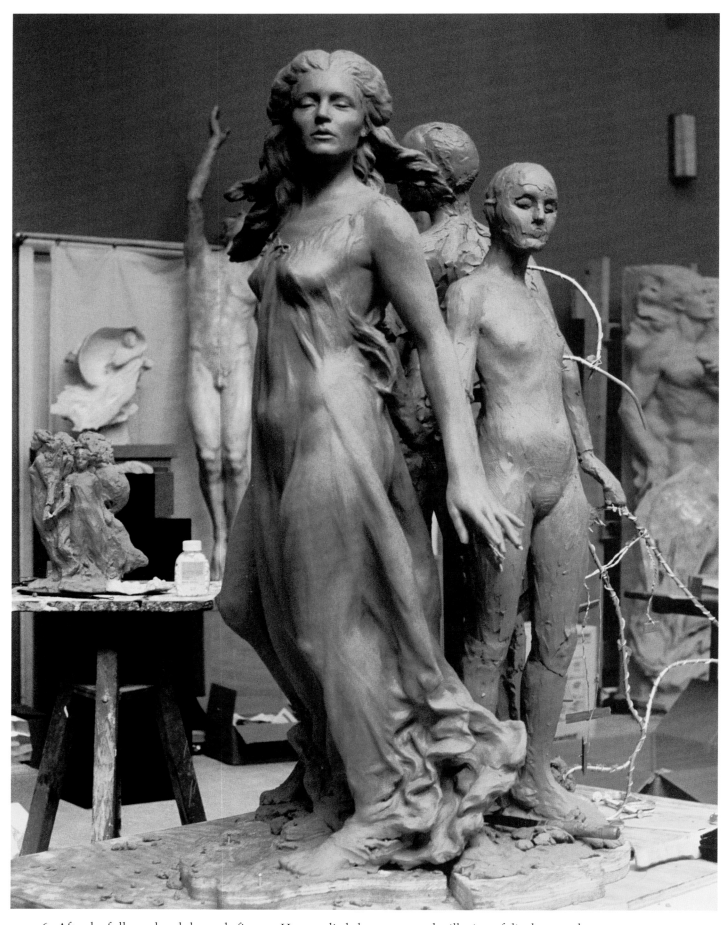

FIG. 56: After he fully sculpted the nude figures, Hart applied clay to create the illusion of diaphanous drapery.

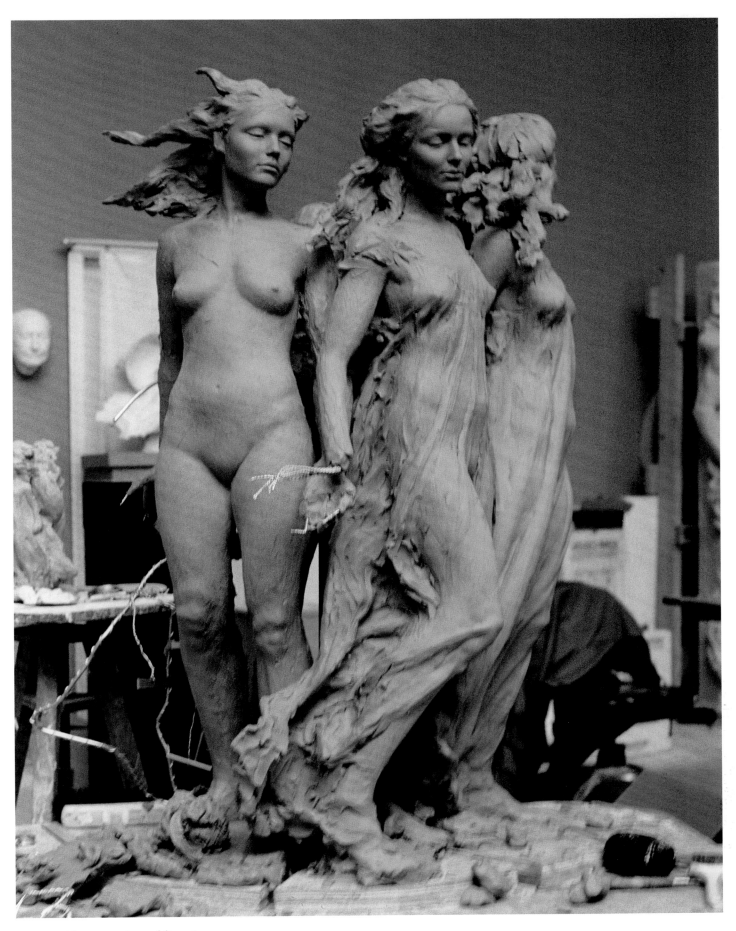

FIG. 57: Alternate view of fig. 56

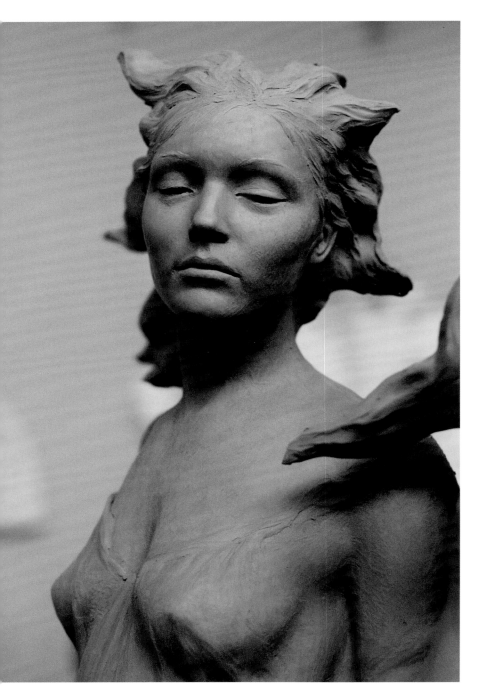

FIG. 58 and FIG. 59 (below): Details, *Daughters of Odessa* (three-quarter life-size), clay

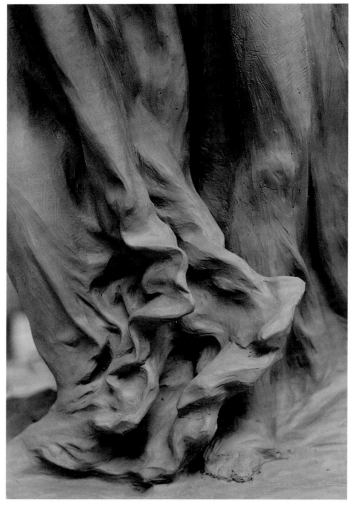

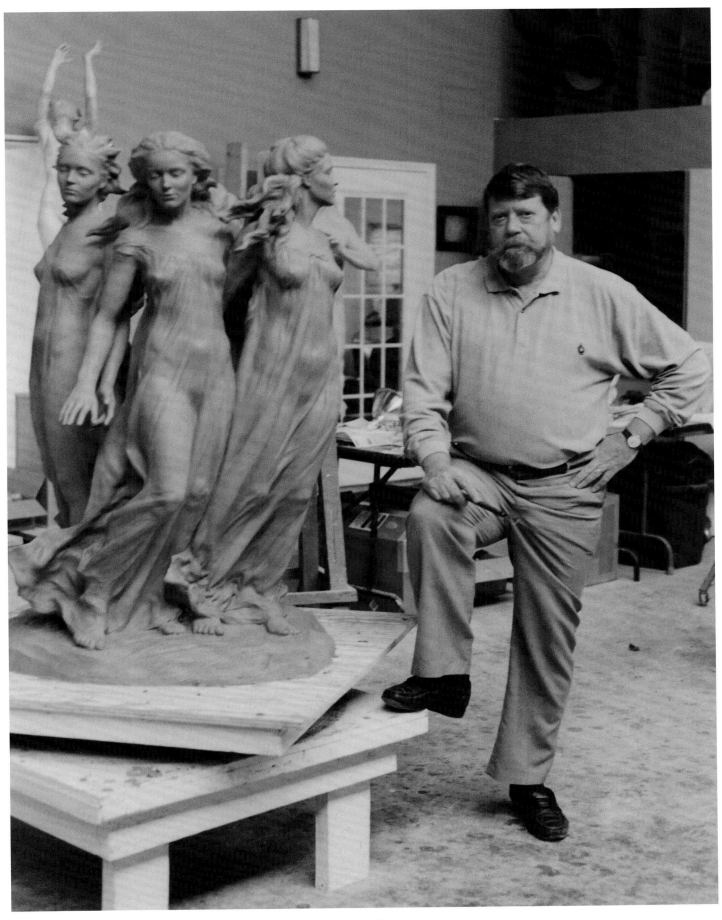

FIG. 60: Hart with *Daughters of Odessa* (three-quarter life-size), clay

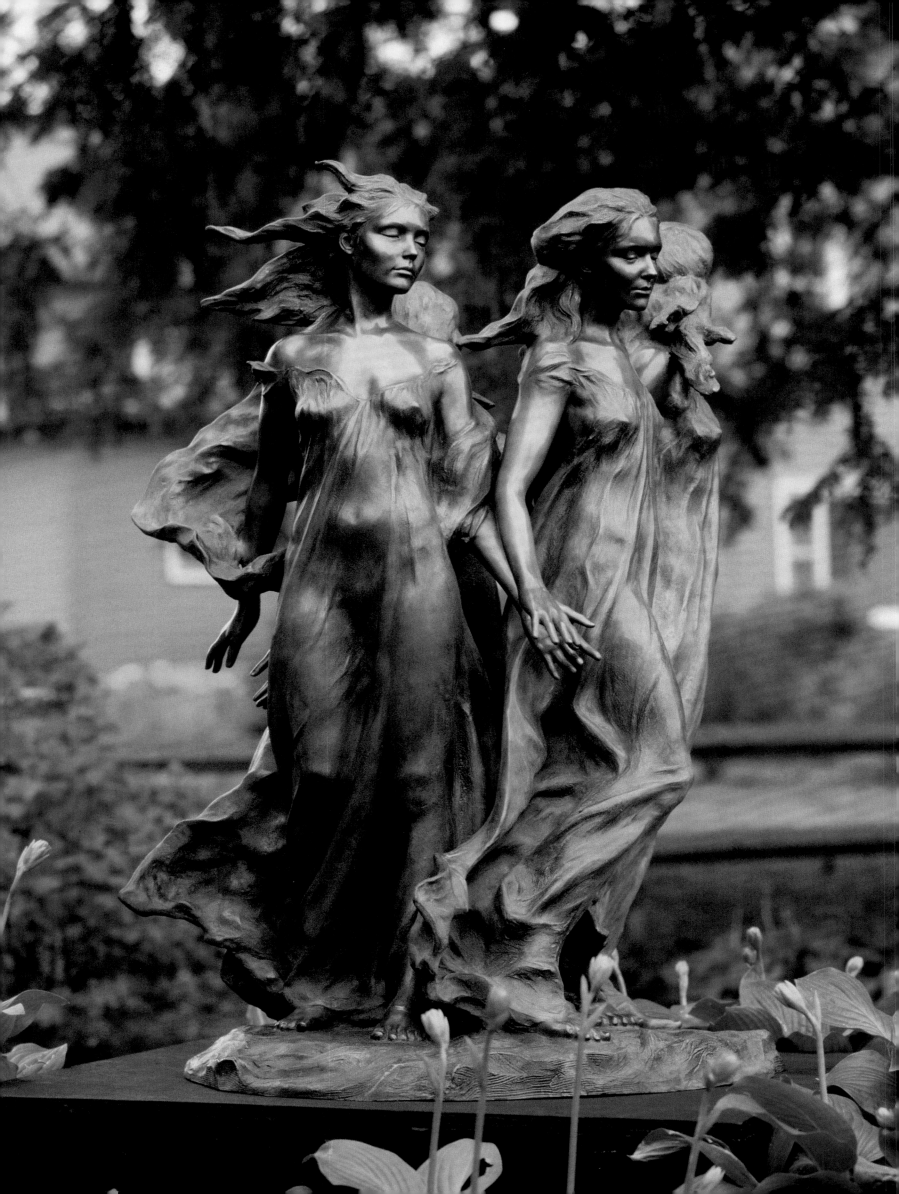

The Daughters of Odessa, An Allegorical Song Cycle

Stefania de Kenessey, *Composer*
Frederick Turner, *Poet*

This musical composition was commissioned by sculptor Frederick Hart
in honor of the Prince of Wales,
to commemorate the presentation of the bronze sculpture
Daughters of Odessa to His Royal Highness.

First Song: *Music, in memory of the Armenian dead*

Force took me from my flowering glades
And promised I should be a queen;
A century I dwelt in shades,
An iron lamp where the sun had been;

Force sought to buy me with his powers,
Gave me sharp instruments with blades
To strip the flesh and reap the flowers,
So I might aid in his crusades;

Force could not win me to his needs:
I served him, but I never ate:
But for six pomegranate seeds,
And these, he said, made me his mate–

But now I hear the poet come,
And now he's given me his lyre:
The bloodstained fields of Erzerum
Are flowering with my springtime's fire.

Second Song: *Poetry, in memory of the Chinese dead*

I drank the poisonous wine of enviousness
That those I thought my friends had given me.
Shame worked on me its bitter alchemy:
I soon forgot my music's old caress.
My lute was broken, my drum beaten in.
The dragons that I once had tamed awoke;

FIG. 61: *Daughters of Odessa* (three-quarter life-size), 47½", bronze, 1997

The city's books, the sweet songs of its folk
Roared in the furnaces of old Pekin.

But now I know my shame, it is my friend;
Envy, exhausted, drains down to its end;
The summer dawns upon the wings of shame.
Now carefully I mend my old lute's strings;
My flute shall charm the serpent from its stings;
And beauty is remembering her name.

Third Song: *Drama, in memory of the Jewish dead*

I was the one in the mask, who mimicked another.
Mirroring you, I teased you to knowing yourself.
Laughing or weeping, I told you your life as a story;
I was the clown who was killed but was always reborn.

But always I needed the sacred space of my stage:
All was a holy pretense when we cursed or we sang;
But then they stepped over the footlights, the soldiers, the armbands,
Who serve self-righteous, know neither laughter nor tears.

They took that poet who sang of the snow and the poppy;
"Der springt noch auf," they called, as, struggling to rise,
The young violinist bled from the wounds of the bullets;
And I must stand cold in the fall with no mask for my eyes.

Fourth Song: *Sculpture, in memory of the Russian dead*

If even winter has an end,
I frozen, yet may move:
The image of the princesses
May still awaken love.

I am the spirit of the stone,
Who lets proud mortals know
They are but bodies, flesh and bone,
That melt as does the snow.

But love speaks only through the bonds
Of flesh and bronze and stone;
My limits make a home and place
Where you are not alone.

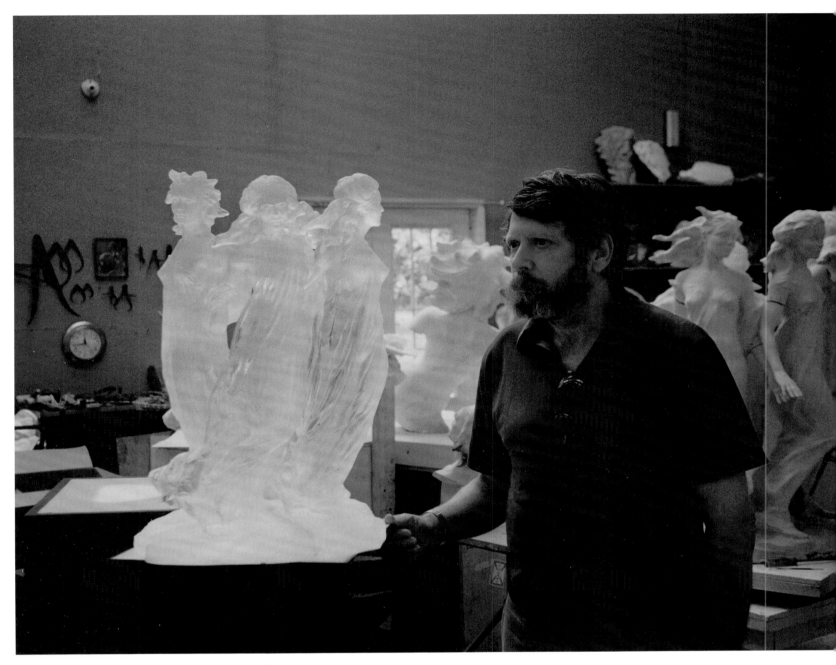

FIG. 62: Frederick Hart with *Songs of Grace,* clear acrylic resin, 1999

Pride silenced, for the sake of Man,
A hundred million men;
My warm breeze of humility
Will make them speak again.

I come to serve a gentle prince
Here in the groves of spring
And sing a song of innocence
To one who will be king.

69

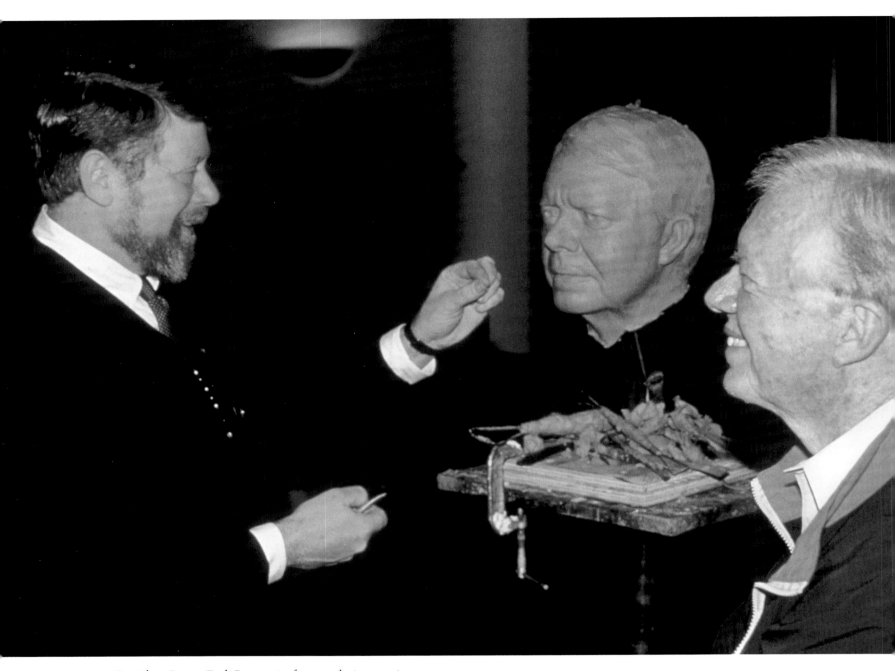

President James Earl Carter sits for a sculpting session.

OF PUBLIC INTEREST

Art, at its most eloquent and greatest, is a tremendous thrust of spirit and meaning—intentionally wrought through high craft to embody a meaning considered far more important than the meaning of art itself.

late 1980s

I want to see again the truly timeless core metaphor of all great public art restored to its preeminence: the human figure. And by use of this ageless device of art, I want to see the deep resonances of art brought back into the realm of the concern, values, and aspirations of the common man, in a language accessible to him. . . . I would like to see the public consciousness raised to understand the Good and the True inherent in the nature of Beauty. I would like to see the standard of Beauty regain its preeminent place in all aspects of public arts. . . .

March 11, 1995

. . . Public art can serve no higher purpose than to reveal and embody the nobility of the human spirit. . . .

May 31, 1999

—Frederick Hart

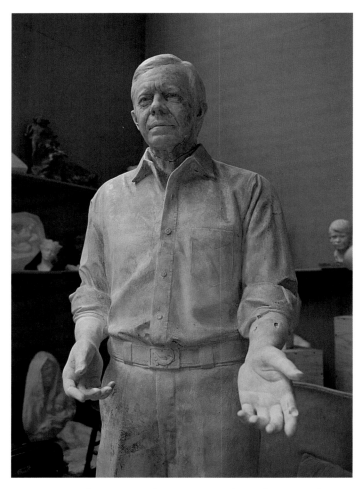

FIG. 63: Detail, *James Earl Carter Presidential Statue*, plaster, the artist's studio

James Earl (Jimmy) Carter was born October 1, 1924, in Plains, Georgia. He graduated from the United States Naval Academy and while a submariner he rose to the rank of lieutenant. He later worked in the nuclear submarine program. He resigned his naval commission in 1953 to return to Georgia, where he became a community leader. In 1962 he won election to the Georgia Senate and, in 1971, he became governor of Georgia.

In 1977 Carter became the thirty-ninth president of the United States. His diplomatic accomplishments included the Panama Canal treaties, the Camp David Accords, the peace treaty between Egypt and Israel, SALT II, and the establishment of relations with the People's Republic of China. He championed human

rights throughout the world and instituted major environmental protection legislation. He wrote sixteen books. In 1982 he joined the faculty at Emory University where he founded the Carter Center to resolve conflict, promote democracy, protect human rights, and prevent disease. His leadership and volunteer work of Habitat for Humanity are well known. In 2002 he received the Nobel Peace Prize.

In 1994 Frederick Hart's bronze monumental sculpture of Carter was unveiled, and it was placed on the grounds of the Georgia State Capitol in Atlanta.

In honor of President Carter's past work as a farmer as well as his environmental initiatives, his love of the outdoors, and his work on behalf of grassroots organizations, I have sculpted him in bronze on a low pedestal, in an informal pose, dressed in khakis with his sleeves rolled up [fig. 63]. The gestures of the figure refer to the generosity of Carter's nature, his eagerness to share a vision of justice, and his unpretentious delight in spreading a message of brotherhood.

I am greatly honored to have been selected to sculpt President Carter, a man who has served our country in so many ways. From the Camp David Accords and SALT II Treaty that were among the achievements of his presidency, to the myriad projects he has since undertaken on behalf of human and environmental needs, Carter exemplifies a rare combination of leadership and service, greatness coupled with simplicity. It is these qualities that I have sought to capture in this sculpture [fig. 64].

FIG. 64: *James Earl Carter Presidential Statue*, bronze, Jimmy Carter Tribute Gardens, on the Georgia State House grounds, 1994

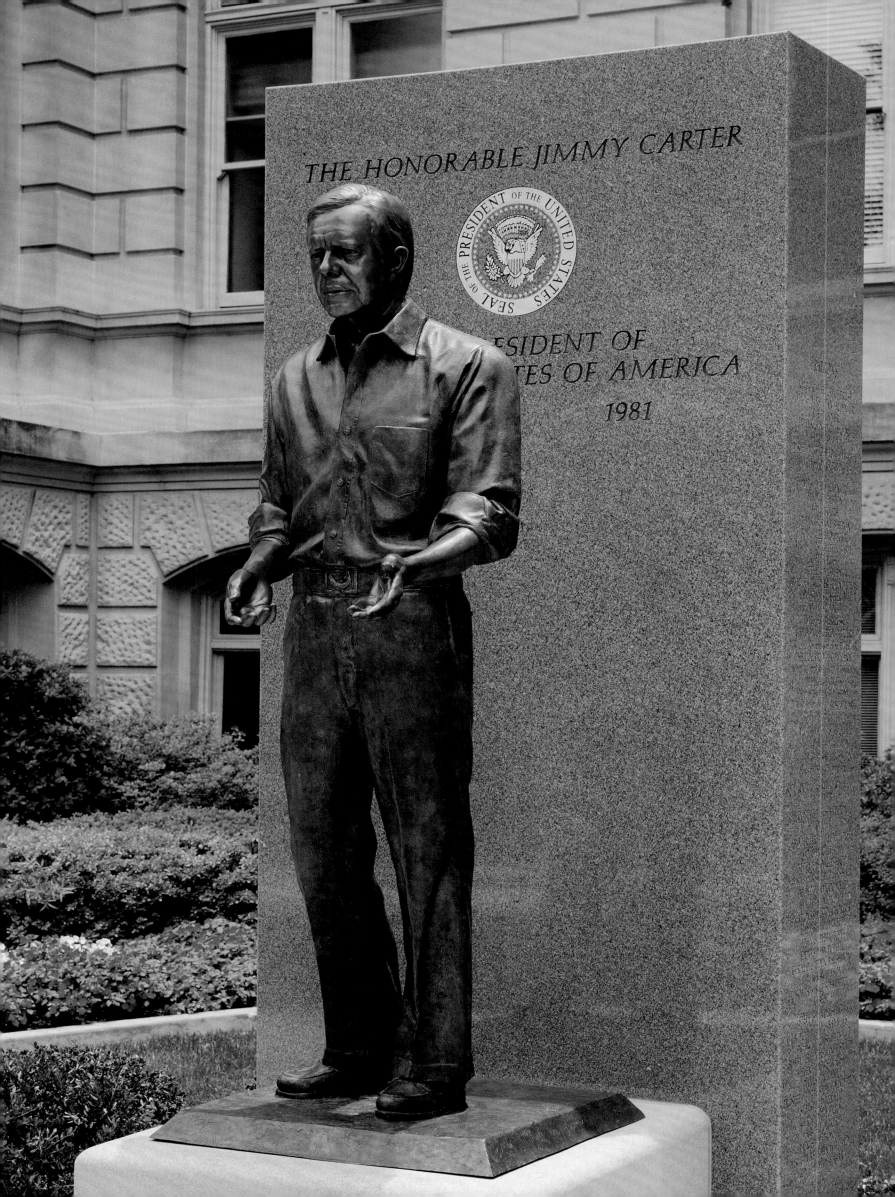

THE HONORABLE JIMMY CARTER

PRESIDENT OF
TES OF AMERICA
1981

RICHARD B RUSSELL JR
SENATOR FROM GEORGIA
1933 197

Richard Brevard Russell, Jr., one of the leading states-men and senators of the twentieth century, was born in Winder, Georgia. He entered the United States Naval Reserve and later practiced law with his father. In 1920 he was elected to the state house of representatives, and quickly rose to become its speaker. In 1930 he was elected governor of Georgia and in 1932 he became a United States Senator.

Russell presided over hearings on President Harry S. Truman's dismissal of General Douglas MacArthur during the Korean War and served on the Appropriations Committee and the Armed Services Committee, which he chaired for sixteen years. An advocate for a strong national defense, Russell also supported school lunch programs and farm assistance. He was, however, at odds with mainstream America on the issue of civil rights; Russell actively defended the Southern position on segregation and argued that states' rights should prevail in the matter of race relations.

In 1963 a reporter for *Newsweek* magazine described him as, "Modest, even shy, in manner, devastatingly skilled in debate, he has a brilliant mind, encyclopedic learning, unrivaled access to pressure points of senatorial power and a gift for using them." Over the course of his Senate career, Russell advised six presidents, especially on issues of national security. He died in 1971.

Frederick Hart's memorial statue of Senator Russell is "meant to convey both his personable and gracious courtliness as well as evoke the dignified aura of a distinguished public servant....Russell exemplified a tradition in American politics, particularly in the South, of the classical model of gentleman and public servant." Vincent Palumbo, master stone carver at Washington National Cathedral, translated Hart's model into marble. The finished statue was unveiled on January 24, 1996.

FIG. 65: *Richard B. Russell, Jr. Memorial Statue,* marble, 1996

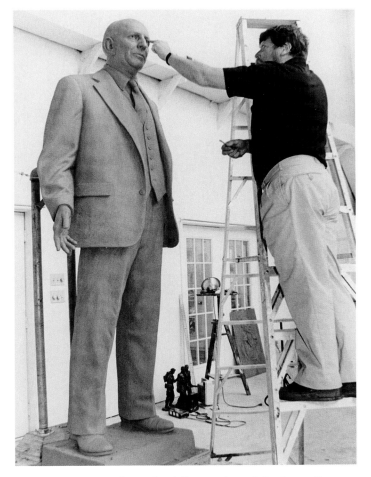

FIG. 66: Hart completes the full-size clay of the *Russell Memorial Statue,* 1995

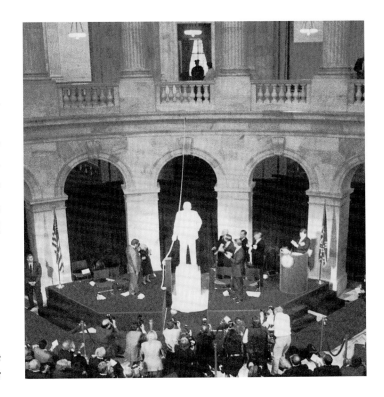

FIG. 67: Unveiling ceremony for the *Russell Memorial Statue*

An Unrealized Design for the World War II Memorial
Davis Buckley, Architect

We are an immigrant nation, composed of individuals from diverse backgrounds, all attracted by the principles upon which our country was founded: liberty, equality, freedom, and equal justice. World War II was the crucible that tested our resolve to uphold these principles. We bound together, and we fought as one nation, indivisible, but it was a close call. We entered the War long after it had ravaged Europe and Asia. President Franklin Delano Roosevelt had been torn between mounting pressure to join the war effort from Winston Churchill, and a Congress hesitant to consent.

I was honored when, in 1995, the American Battle Monuments Commission (ABMC) selected me to prepare the site selection study for the congressionally authorized World War II Memorial. As an essential part of the lexicon of the people's history of the United States, World War II deserved representation in the people's space, the National Mall. There, the Rainbow Pool stood out as the ideal site, located at the intersection of three major view corridors. It would provide a powerfully symbolic context for commemorating World War II: between symbols of the Civil War, evoked by the Lincoln and Grant Memorials, in the legacy of the principles forged by our founding fathers, symbolized by the Washington Monument on the Mall cross axis. After presentations before the United States Commission of Fine Arts, the National Capital Planning Commission, and the National Park Service, all approved of the Rainbow Pool as the most symbolically viable site.

My vision called for a representational sculpture, with strong allegorical elements, to be placed at the center of a newly reconstructed Rainbow Pool (fig. 74). My thoughts turned to the artist of the *Three Soldiers* at the Vietnam Veterans Memorial, and when I called Frederick Hart to ask him to join me in pursuit of this commission, he accepted, saying it was his "destiny" to do so. I then asked Carol R. Johnson, landscape architect, to join us. I first became acquainted with Carol's work, early in my career, working with her on

the landscape design at the American Pavilion at the 1967 World's Fair (fig. 75).

Given our qualifications, it was with great confidence that we began preparing our submission (fig. 68). After significant progress, however, the ABMC announced that the selection process would be changed and that the design for the memorial would be selected through a two-tier national competition. We decided to enter the competition.

Hart's wonderful contribution was an allegorical sculptural piece that achieved presence through its placement, within the center of the Rainbow Pool. This design approach retained monumentality while joining the seminal iconic monuments along the view corridors, visually linking in a linear composition the Lincoln and Grant memorials, the Washington Monument, and Congress. The theme of Hart's sculpture is the connection between Liberty and Sacrifice (figs. 69, 70), two allegorical figures in the pool's center. Liberty's left hand holds aloft, in the absolute center of the configuration, the sculpture's most important icon: the olive branch (fig. 71). Her right hand reaches for the instrument of war, a sword, handed to her by a hesitant Sacrifice (figs. 72, 73). The following excerpt from our design submission further describes this allegory within the context of the memorial design:

Liberty and Sacrifice symbolize moral principles for which the nation went to war, as well as the burdens of grief borne by the necessity of defending those principles. Liberty and Sacrifice guide a swirl of vigorous allegorical male figures across the seas into the storms of war. Thunder and configurations of the water-play represent the storms of war on the two circular pools, symbolic of the great oceans of the two theaters, European and Pacific. Although the overall spirit of the Monument is classical—reflecting the origins of democracy—the facial features of the allegorical fountain figures are not Greco-Roman, but are racially indeterminate, reflecting the great diversity of the American peoples.

The furious energy of the main grouping is coun-

The central feature of the Memorial is a great Fountain containing an allegorical sculptural ensemble, and the sculptures in the surrounding colonnades contain specific historical sculptural imagery. The Fountain sculpture achieves its heroic presence by having its mass form a horizontal arc across the pool, rather than creating a vertical presence obstructive to the axial vistas. The highest point of the sculpture is approximately 16 feet above the water level. The same design resolution was used in the Fountain of Apollo at Versailles, to solve a nearly identical problem.

Two female allegorical figures, Liberty and Sacrifice, dominate the Fountain group. Liberty holds aloft, in the absolute center of the site, the single most important iconographic element of the entire monument: the olive branch. With her right hand she reaches down for the instrument of war, which is handed by the reluctant figure of Sacrifice. The two figures symbolize both the moral principles for which the nation went to war, as well the burdens of grief borne by the necessity of defending those principles. Liberty and Sacrifice guide a swirl of vigorous allegorical male figures across the seas into the storms of war. The thunder and configurations of the waterplay evoke the storms of war on the two circular pools that denote the great oceans of the two theaters. Although the overall spirit of the Monument is classical – reflecting the origins of democracy – the facial features of the allegorical fountain figures are not Greco-Roman, but are racially indeterminate, reflecting the great diversity of the American peoples.

The furious energy of the main grouping is counterbalanced by the four Home Front groupings in the corners of the pool, which in somber fashion further underscore the sacrifices of the nation and the inherent tragedy of war. The subjects of the allegorical grouping are: the widow with her children, the disabled veteran, the grieving parents, and the young life unfulfilled. It is in the bases of these groupings that the laurel leaves of Victory are incorporated.

The two flanking colonnades representing the European and Pacific theaters contain visual references to the leadership, the battles, the men and women in uniform and the various units in which they served. An exhibition space, set below a shallow mound of earth at the south end of the site, is entered through a pavilion behind the south colonnade. The military leadership of both theaters is honored by bronze portrait medallions set in the frieze of the entablature. Prominent portrait treatments of MacArthur and Eisenhower face each other above the entries on either side. The names of the major battles are incised in gilded Roman lettering in the stone frieze. Polychromed heraldic relief-work of all the various military units decorate the crown molding of the entablature. The branches of the services: Army, Navy, Marines, Army Air Corps, Wacs, Waves, etc. are portrayed by caryatid like figures in high relief carved stone, incorporated into the colonnade. Thus in August fashion, the people and events of World War II are enshrined around a centerpiece that reflects the moral resolve of a unified nation.

SOUTH COLONNADE

EXHIBITION SPACE ENTRANCE

EUROPEAN THEATER

FOUNTAIN SCULPTURE

PACIFIC THEATER

EXHIBITION SPACE

★ THE WORLD WAR II MEMORIAL ★
IN THE NATION'S CAPITAL

FIG. 68: World War II Memorial competition entry

terbalanced by the four Home Front groupings in the corners of the pool, which in somber fashion further underscore the sacrifices of the nation and the inherent tragedy of war. The subjects of the allegorical grouping are: the widow with her children, the disabled veteran, the grieving parents, and the young life unfulfilled. It is in the bases of these groupings that the laurel leaves of Victory are incorporated.

The two flanking colonnades representing the European and Pacific theaters contain visual references to the leadership, the battles, the men and women in uniform and the various units in which they served. An

77

FIG. 69: *Liberty and Sacrifice*, 36½", bronze, 1997

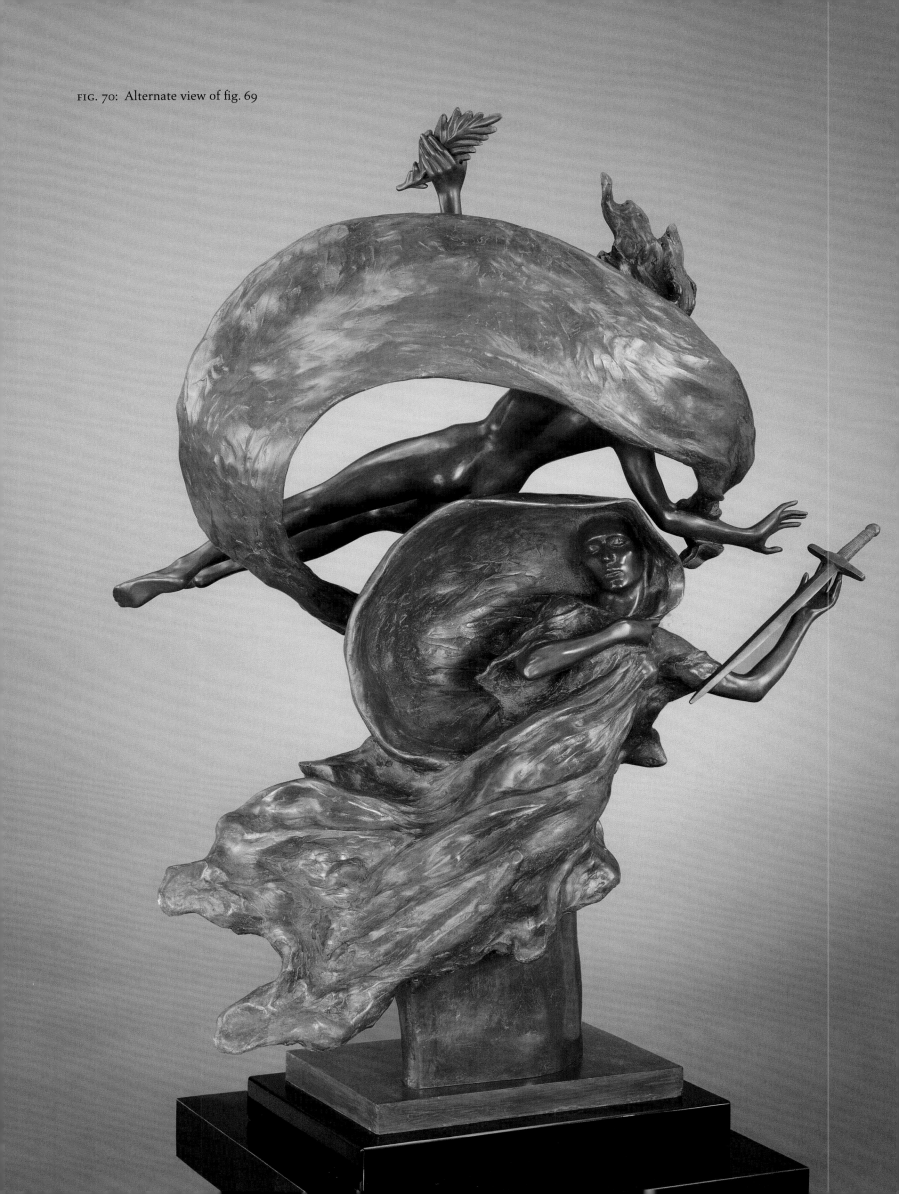

FIG. 70: Alternate view of fig. 69

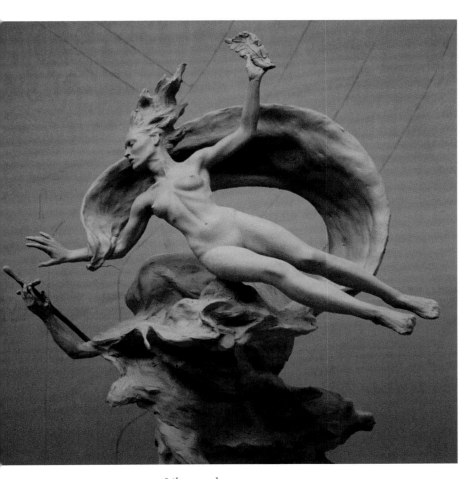

FIG. 71: *Liberty,* clay

exhibition space, set below a shallow mound of earth at the south end of the site, is entered through a pavilion behind the south colonnade. The military leadership of both theaters is honored by bronze portrait medallions set in the frieze of the entablature. Prominent portrait treatments of MacArthur and Eisenhower face each other above the entries on either side. The names of the major battles are incised in gilt Roman lettering in the stone frieze. Polychromed heraldic relief-work of all the various military units decorates the frieze of the entablature. The branches of the services: Army, Army Air Corps, Navy, Marines, Wacs, and Waves are portrayed by caryatid-like figures in high relief carved stone, incorporated into the colonnade. Thus in august fashion, the people and events of World War II are enshrined around a centerpiece that reflects the moral resolve of a unified nation.

Our design submission was not among the six finalists chosen. In fact, unsettling to me and heartbreaking to Rick, none of the finalists included any representa-

tional sculpture in their designs. We accepted the inevitable and pressed on with our lives and creative work. I had gained much, even if we had not been granted the commission: working with Carol was wonderful, and my friendship with Rick flourished. I was lucky to have the opportunity to collaborate with such a brilliant sculptor and human being. His thoughtfulness and dedication to representational sculpture will always inspire us all.

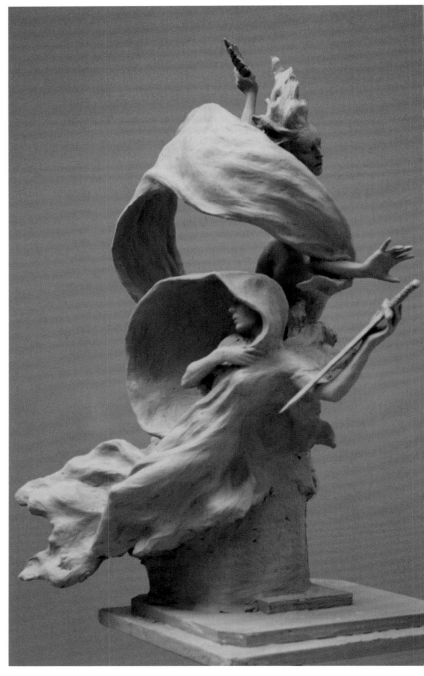

FIG. 72: *Sacrifice,* clay

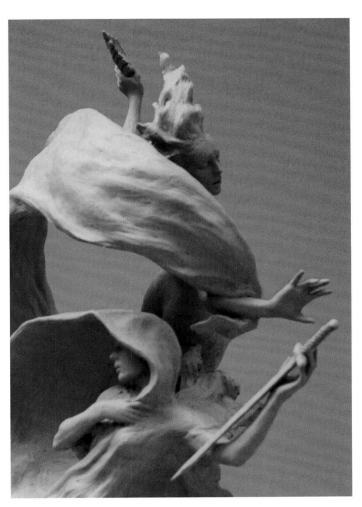

FIG. 73: Detail, *Liberty and Sacrifice*, clay

FIG. 75: Design team for entry in the World War II memorial competition (left to right): Davis Buckley, A.I.A., architect; Carol R. Johnson, F.A.S.L.A., landscape architect; and Frederick Hart, sculptor

FIG. 74: Site for World War II Memorial

Portrait of Lord Mountbatten

His Royal Highness The Prince of Wales
October 25, 1996

Sir,

I was deeply touched and honored by your kind letter in response to the book which I sent to you last year. I wanted to do something to express my gratitude, even though it did put me into something of an Aesopian lion/mouse quandary. After some time, it occurred to me that given your well known devotion to Lord Mountbatten, you might enjoy having a portrait study of him. It was a pleasure to do because unlike most great men of history, he actually looked like one of the Great Men of History. Given the character of bronze, I think it would be suitable in a study, library, or perhaps on a garden wall.

I'm certain that I am joined by all of your many American admirers in wishing you a very Happy Birthday with much happiness and success in the coming year.

Yours Respectfully
Frederick Hart

P. S. At the invitation of Dr. Richard John, I had the pleasure last summer of lecturing students from The Prince of Wales School of Architecture and the Building Arts.

FIG. 76: *Portrait of Lord Mountbatten*, clay, in Hart's studio

FIG. 77: The Harts with the Prince of Wales at Highgrove, viewing the bronze bas-relief of Lord Mountbatten, 1997

James Strom Thurmond was born in Edgefield, South Carolina, in 1902. He was a high school teacher and county superintendent of education. Admitted to the South Carolina bar in 1930, he served as city and county attorney, in the South Carolina state senate, and as a circuit judge. During World War II he volunteered for active duty and served in Europe and in the Pacific. Assigned to the 82nd Airborne Division, he participated in the Normandy invasion in 1944 and later rose to major general in the United States Army Reserves. In 1946 he was elected governor of South Carolina.

In 1948 Thurmond challenged President Harry Truman, running on the States' Rights Democratic ticket. In 1954, after losing the South Carolina Democratic Senate primary, he sought election as a write-in candidate and won, becoming the first person to be elected to a major office on a write-in basis. Because of a promise he made to voters, Thurmond resigned his Senate seat in 1956 to force another election in which he could win by traditional means. He won the election, ironically filling the vacancy caused by his own resignation. Over the next four decades, he won re-election seven times—although he switched his affiliation from the Democratic Party to the Republican Party in 1964.

Senator Thurmond chaired the Armed Services and the Judiciary Committees and served as president pro tempore of the Senate from 1981 to 1987, and again from 1995 to 2001, when he was named president pro tempore emeritus. In 1957 he set the record for delivering the longest single speech in the Senate, which lasted twenty-four hours and eighteen minutes. In 1997 he became the longest-serving senator in history.

As a point of reference for his portrait bust of Senator Thurmond, Frederick Hart used a plaster cast made from a life mask, later refining the clay model through several sittings with Thurmond. The bust was cast in bronze and unveiled on June 5, 1997.

FIG. 78: Hart with Senator Strom Thurmond, Russell Senate Office Building, 1997

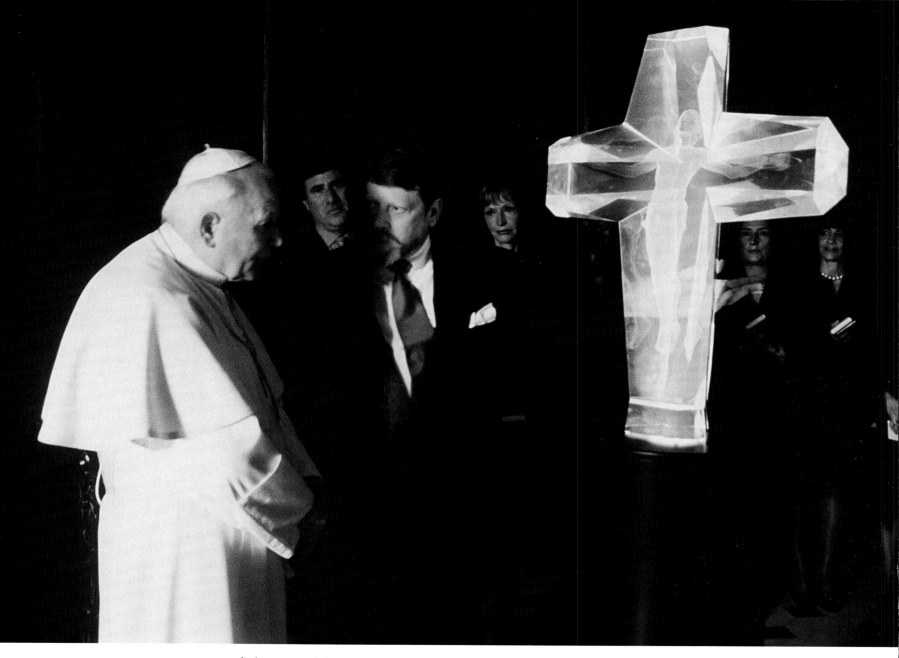

FIG. 79: Presentation of *The Cross of the Millennium* to Pope John Paul II, May 17, 1997. The Pope responded, "You have created a profound theological statement for our day."

The Cross of the Millenium

The Cross of the Millennium commemorates the approaching millennium and was created in celebration of the 2,000th anniversary of the birth of our Lord. The time-less mystery and glory of the Resurrection are vividly retold in the materials of our advanced technological age as we enter the twenty-first century.

The translucent acrylic resin material and the new technology allow for the creation of sculpture made of pure light—the very symbol of Christ. The work is designed so that the birth, evoked by the facets of the star of Bethlehem, the death, and the mystery of the Resurrection, are seen simultaneously as a single impulse of the Creator.

—*Frederick Hart*
1997

84

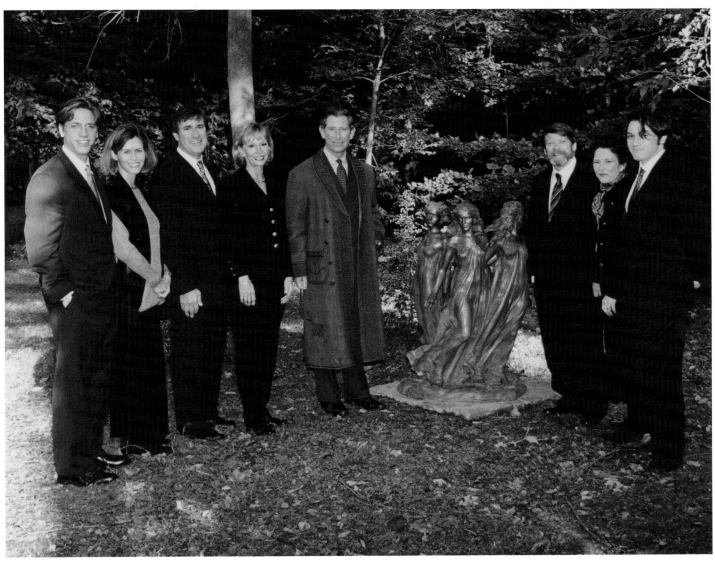

FIG. 80: The Hart and Chase families with the Prince of Wales at Highgrove, 1998

Press Release Issued July 20, 1998
American Artists and Architects to Honor His Royal Highness the Prince of Wales

A group of American artists and architects will honor His Royal Highness the Prince of Wales for his leadership in art and architecture by giving a sculpture, which will be given in his honor to the Prince of Wales' Institute. The bronze sculpture entitled *The Daughters of Odessa* was created by sculptor Frederick Hart and will be donated by Hart and his dealer Robert Chase on behalf of the group of artists and architects. The sculpture will be permanently installed in the garden at Highgrove, the Prince of Wales' home.

The architects and artists are honoring the Prince of Wales for his championing of the traditional artistic values of beauty and order as well as his efforts to preserve and promote the traditional building crafts and decorative arts and his advocacy of humanistic values in art, architecture, and planning.

International Edition
The Art Newspaper
April, 1998

"Moral rights; a US case history"
Rampant Immorality
Sculptor sues Warner Bros successfully over misuse of
religious work in "Devil's Advocate" movie

By Martha Lufkin

BOSTON. In October 1997, Warner Brothers released "The Devil's Advocate" in the US, a movie portraying lawyers as so low that the managing partner of a New York law film turns out to be the devil himself.

But lawyers got back at Warner Brothers, who found themselves sitting in a very hot spot indeed. A prominent prop in the movie is a bas relief of swirling nudes which hangs on Satan's penthouse wall. Among movie goers who noticed that the bas relief looks a lot like the tympanum by Frederick E. Hart at the Washington National Cathedral was J. Carter Brown, former director of the National Gallery of Art in Washington. He later became an expert witness for the Cathedral and Mr. Hart in their lawsuit brought against Warner Brothers in December 1997 seeking injunctions against display of the film and claiming copyright infringement and distortion of the Hart sculpture.

In a settlement announced February 13, after the judge said the court would halt video releases if an agreement was not reached, Warner Brothers disassociated Mr. Hart and the cathedral from the movie and announced it would change portions of the film "to eliminate any perceived confusion" in future distributions.

The Cathedral commissioned the sculpture in 1974 and it was completed in 1982. The Cathedral and Mr. Hart argued in federal court that the movie violated US copyright law by copying, distributing, publicly displaying and preparing derivative works based on the sculpture, to which they jointly own the copyright.

Under the Visual Artists Rights Act, which protects the "moral" rights of the artists to the integrity of their artwork, the plaintiffs further claimed that the film was an intentional distortion of the sculpture which was prejudicial to Mr. Hart's honour and reputation.

"Ex Nihilo, creation of mankind out of nothing," is Mr. Hart's bas relief over the main entrance to the neo-Gothic Washington National Cathedral, a major US architectural landmark. Mr. Hart, also known for his bronzes at the Vietnam Veterans Memorial, is a religious man, who recently presented Pope John Paul II with a sculpture, *The Cross of the Millennium*. *Ex Nihilo* is meant to extol God's creation of mankind out of nothing.

The plaintiffs argued in their court papers that Warner Brothers twisted the sculpture's religious import into an embodiment of things demonic in a climactic movie scene where the sculpted figures on the wall appear to come alive and "begin engaging in sexual acts" while the devil encourages his offspring to "engage in incestuous sexual acts."

The offending bas relief was the most prominent image used to promote the movie, the plaintiffs said, appearing on posters, in newspaper ads and as downloadable material on the movie web site. They said that damaging viewer confusion had arisen as to their affiliation with, or endorsement of, the film, and that the film's commercial use of a "substantially similar" bas relief would likely cause confusion as to the origin and sponsorship of both bas reliefs, in violation of the US Lanham Act. They further argued that the sculpture, Mr. Hart's defining work which he has used in promotional materials, amounted to his "trademark," which the movie makers had infringed and diluted.

Mr. Brown, in his court declaration, said that he had reviewed materials supplied by Warner Brothers containing preparatory sketches and many photographs

of artworks including *Ex Nihilo*. Warner Brothers supplied the packet to show the photographic resources it had given to its artist for the bas relief. The *Ex Nihilo* illustration, Brown said, came "by far the closest in spirit and style" to the movie sculpture. "I was also struck that one of the studies for the film envisioned the relief in a space defined by an almost identical Gothic pointed arch to the Hart tympanum," he said in his statement.

The use of figures so similar to Mr. Hart's to represent "the lascivious, the prurient and the damned" in the movie could only denigrate the experience of Mr. Hart's bas relief "for anyone from here on who goes to the Cathedral and has seen the movie," Mr. Brown said.

Money damages were not mentioned in the statement about the settlement, but the plaintiffs sued for damages and it is hard to imagine a settlement without them.

Mr. Hart suffered a stroke in February. He is reportedly pleased with the settlement.

Congressional Record

PROCEEDINGS AND DEBATES OF THE 106ᵀᴴ CONGRESS, FIRST SESSION

Vol. 145 WASHINGTON, MONDAY, OCTOBER 25, 1999 No. 146

Senate

The Late Frederick "Rick" Hart

MR. THURMOND. Mr. President, one of the most unpleasant tasks we carry-out is to come to the Senate floor in order to mark the passage of friends who have died. Today, it is my sad duty to share my memories of a man who was not only a valued friend, but one of the nation's treasures, Mr. Frederick, "Rick" Hart, who passed away unexpectedly in August.

All recognize that Washington is the capital of the United States, and almost all also recognize it as a beautiful city, with impressive, inspiring and humbling architecture and monuments. People from all over the world travel to the District of Columbia to see and visit places such as the Capitol, the White House, the Vietnam Veterans Memorial, and the National Cathedral. Through their explorations of Washington, millions of people have been exposed to, and moved by, the artwork of Rick Hart.

Rick Hart was one of the world's most talented and appreciated sculptors who created many impressive pieces during his career, but it is two pieces in particular with which visitors to Washington are most familiar. Though they may have never known that these two pieces were created by Rick Hart, countless individuals have been taken by The Creation Sculptures at the National Cathedral and the *Three Soldiers* at the Vietnam Veterans Memorial.

It is appropriate that one of Rick's most famous sculptures is to be found at the National Cathedral, for it was there that he began his career as an apprentice stone carver, working on the gargoyles that adorn the gothic structure. From the beginning of his involvement in art, it was obvious that Rick was a man of tremendous talent and creativity. This was proven unquestionably when at age thirty-one his design for a sculpture to adorn the west facade of the Cathedral was picked after an international call for submissions.

One decade after his design for the National Cathedral was accepted, his emotion evoking sculpture *Three Soldiers* was dedicated in November of 1984 as a supplement to the Vietnam War [sic] Memorial. It certainly must have been a challenge for this artist to go from creating a work that helped to express the glory of creation and God with a work that stands as a reminder to those who served and died in Vietnam. Not surprisingly, Rick rose to the challenge and sculpted what has become one of the most recognized and respected military sculptures in the world, and one that helps to pay appropriate homage to all those who participated in that conflict.

All that Rick accomplished in his life is that much more impressive given his humble and hard beginnings. Born in Atlanta, Georgia, Rick lost his mother at an early age and was reared in rural South Carolina for much of his young life, until he and his father moved to Washington. Rick was a bright man with both his hands and his mind, and his exceedingly high Scholastic Aptitude Test scores allowed his entrance in college at the young age of sixteen. Just as many who have been born and raised in the South have done, Rick chose to return "home" and he enrolled in the University of South Carolina as a philosophy student. Rick's higher education also included studies at the Corcoran and American University, where ironically, he was scheduled to give the commencement address at next year's graduation and to be awarded an honorary degree.

My chief of staff, R. J. "Duke" Short, his wife Dee, and our good friend Harry Sacks have been friends of

Rick for many years, and it was they who introduced me to Rick back in 1995. Rick generously and graciously volunteered to create a bust of me which has been donated to the United States Senate and is on display not far from this Chamber, in Senate-238, also known as "The Strom Thurmond Room." In order to sculpt my bust, Rick and I spent a considerable amount of time together. Rick was a warm, outgoing, and humble man and it was obvious that creating works of art was a passion for him.

Though still very young, only in his fifties, Rick suffered a serious health setback last year when he was felled with a stroke. Strong and vital, Rick was making an impressive recovery when he was admitted to Johns Hopkins Hospital in August to be treated for pneumonia. Tragically, Doctors discovered that his body had been overtaken by cancer and he had quite literally only days to live. His death was sudden, unexpected, and tragic, and has left us all pondering how someone so vital could be taken at such a young age. His passing saddens all who knew him and his death leaves a tremendous void in the American art community. My condolences and sympathies are with his wife Lindy and sons Alexander and Lain. While their husband and father may no longer be here, Frederick "Rick" Hart has achieved a kind of immortality through his great works of art.

—*Strom Thurmond*

FIG. 81: Senator Strom Thurmond presents Lindy Hart the Gold Line Congressional Tribute, which he entered into *The Congressional Record*, 1999.

FIG. 82: *James Danford Quayle Vice Presidential Bust,* commissioned by the Senate Committee on Rules and Administration, 1998

James Danforth Quayle was born in Indianapolis in 1947. He served in the Indiana National Guard from 1969 to 1975, established a law practice in his home state, and worked as associate publisher for the *Huntington Herald-Press*. In 1977 he was elected to the United States House of Representatives and, in 1981, to the United States Senate. Senator Quayle sponsored the Quayle-Kennedy bill, which created the Job Training Partnership Act of 1982.

In 1989 Quayle became vice president under George H. W. Bush. After the Bush-Quayle ticket's unsuccess-ful 1992 re-election bid, Quayle returned to Indiana. In 1994 he briefly sought his party's presidential nomination. He remembers his Senate years with fondness, noting the importance of preserving the Senate as "the heart and the balance of a democratic republic."

Frederick Hart died in 1999, before he could complete the clay model of the Quayle bust for the Senate's Vice Presidential Bust Collection. Hart's assistant, Jeffery Hall, completed it and prepared the plaster cast. Daniel Sinclair translated the bust into marble.

FIG. 83: Presentation of Quayle bust, Rotunda, United States Senate, 2003 (left to right): Senator Trent Lott, Marilyn Quayle, Lindy Hart, Jeffery Hall, Daniel Sinclair, and former Vice President Dan Quayle

The highest award given to artists and arts patrons by the United States Government, the National Medal of Arts is awarded by the President of the United Sates to individuals or groups who, in his judgment, ". . . are deserving of special recognition by reason of their outstanding contributions to the excellence, growth, support and availability of the arts in the United States."

FIG. 84: National Medal of Arts

FIG. 86: President George W. Bush and Laura Bush present the 2004 National Medal of Arts to Lindy Hart, who accepts the award on behalf of her late husband Frederick Hart, during a ceremony in the Oval Office, November 17, 2004. (Left to right): Xander Hart, Moya Chase, President Bush, Lindy Hart, Laura Bush, Lain Hart, and Bob Chase

The President of the United States of America

Awards this

National Medal of Arts

to

Frederick Hart

For his important body of work – including the Washington
National Cathedral's *Creation Sculptures* and the Vietnam
Veterans Memorial's *Three Soldiers* – which heralded a new age
for contemporary public art.

November 17, 2004

FIG. 85: National Medal of Arts Proclamation November 17, 2004

93

PLATES

PLATE 1: *Mother and Child*, 25", clear acrylic resin, 1997

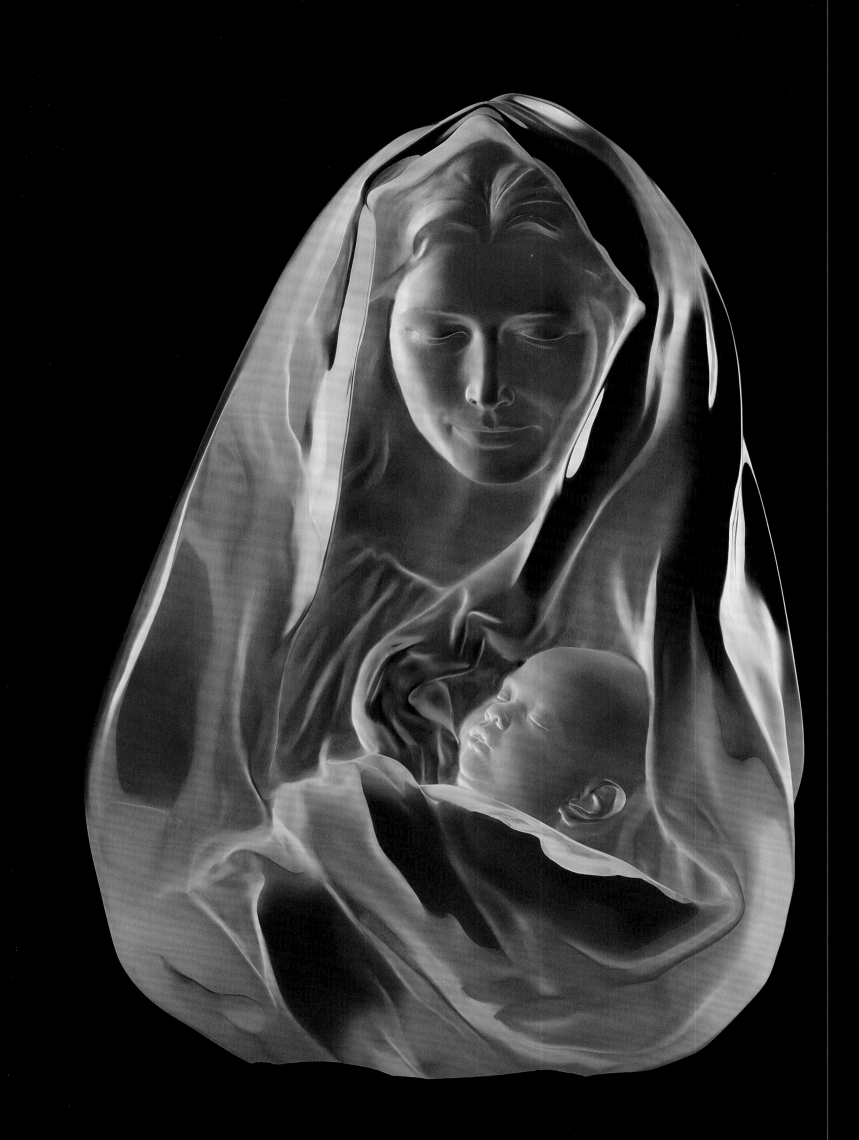

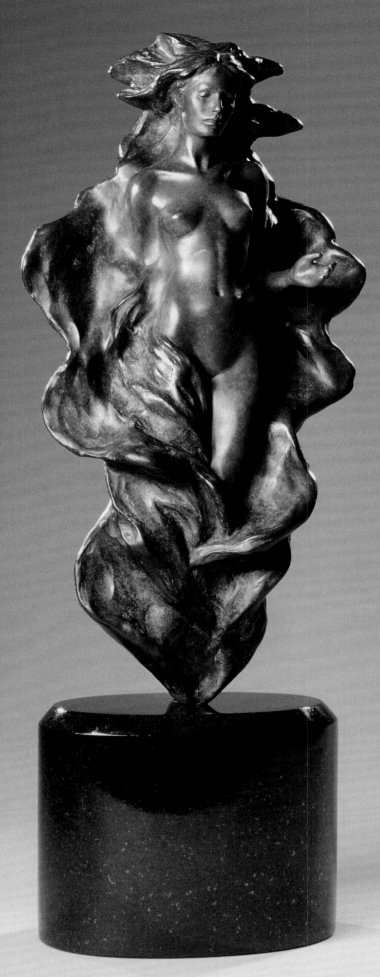

PLATE 2: *Woman with Outstretched Arm*, 20", bronze, 2002

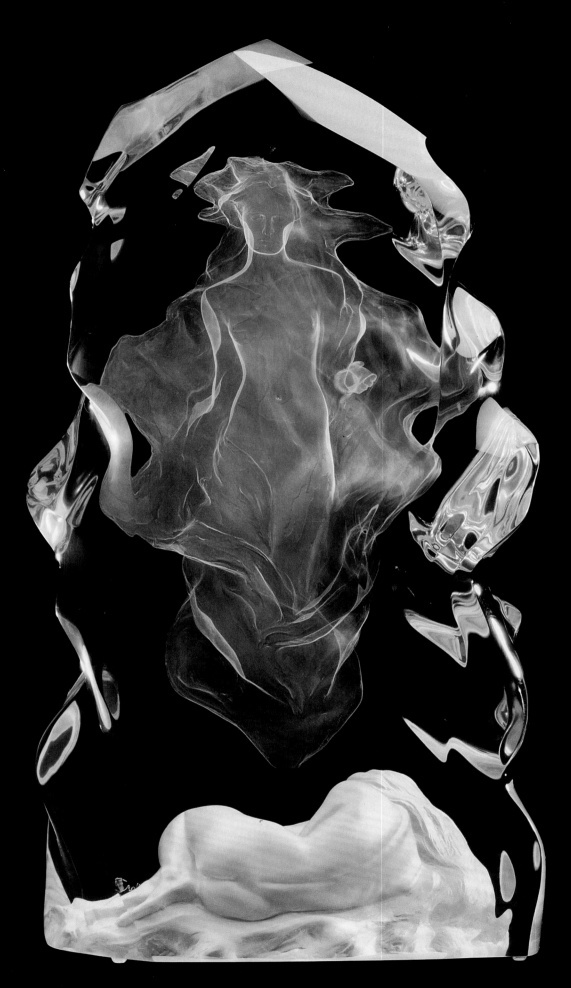

PLATE 3: *Echo of Silence*, 22", clear acrylic resin, 1992

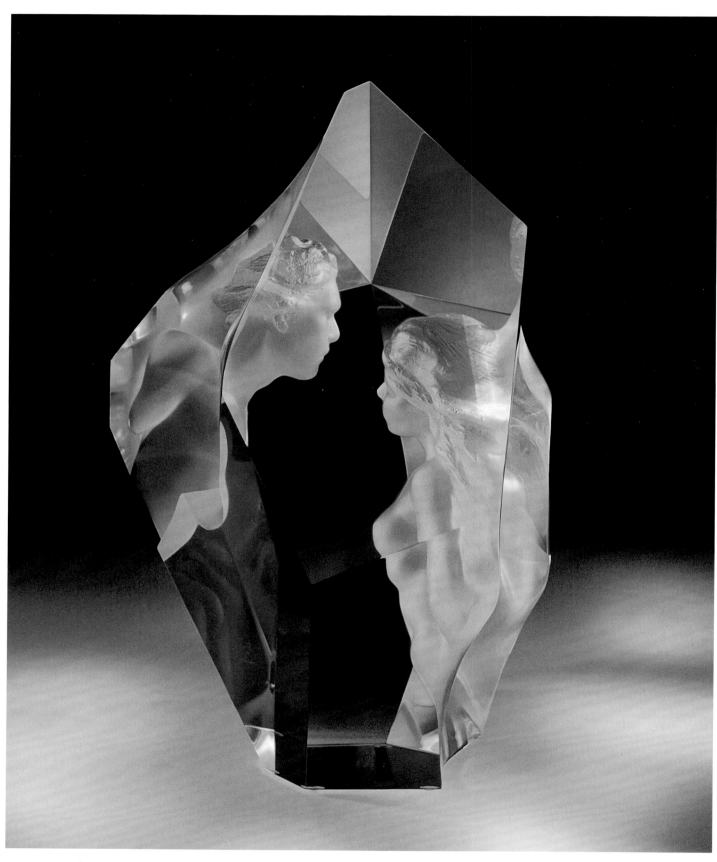

PLATE 4: *Prologue,* 10½", clear acrylic resin, 2000

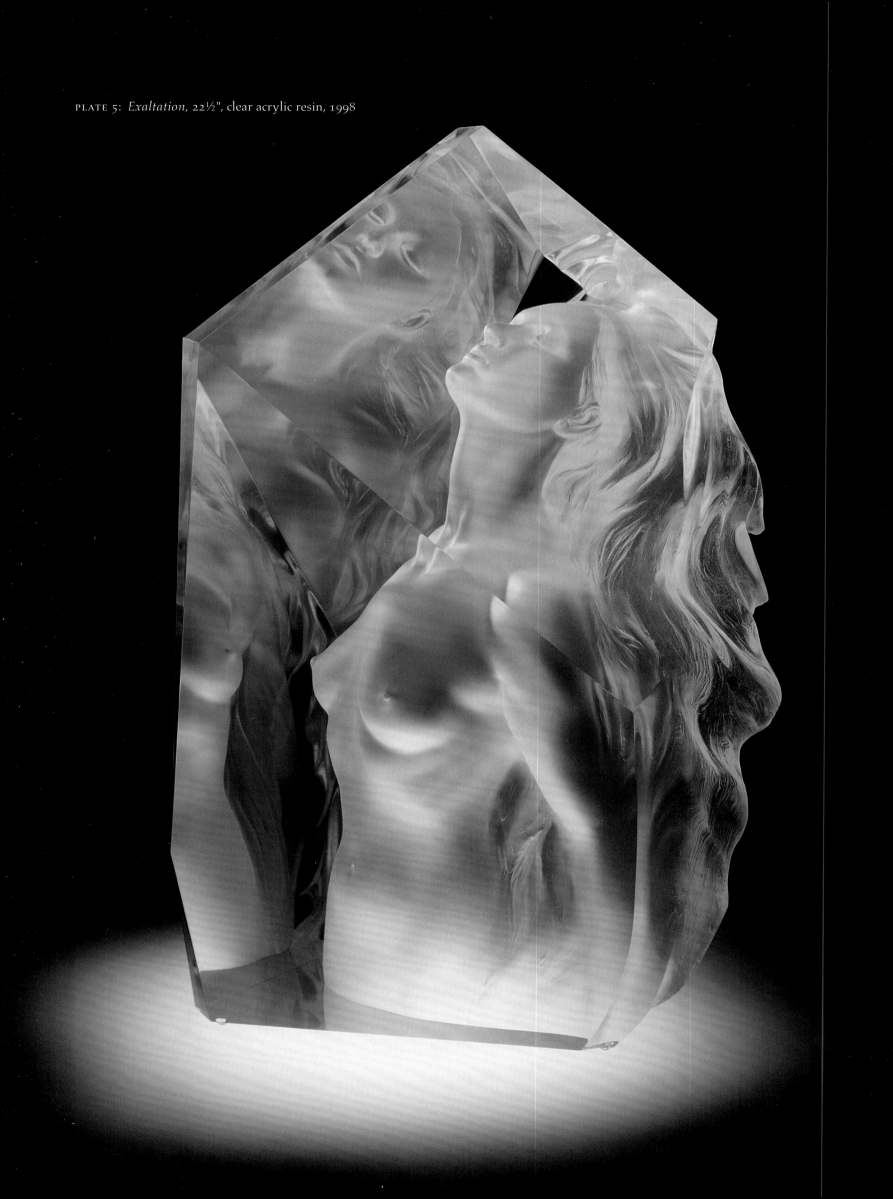

PLATE 5: *Exaltation*, 22½", clear acrylic resin, 1998

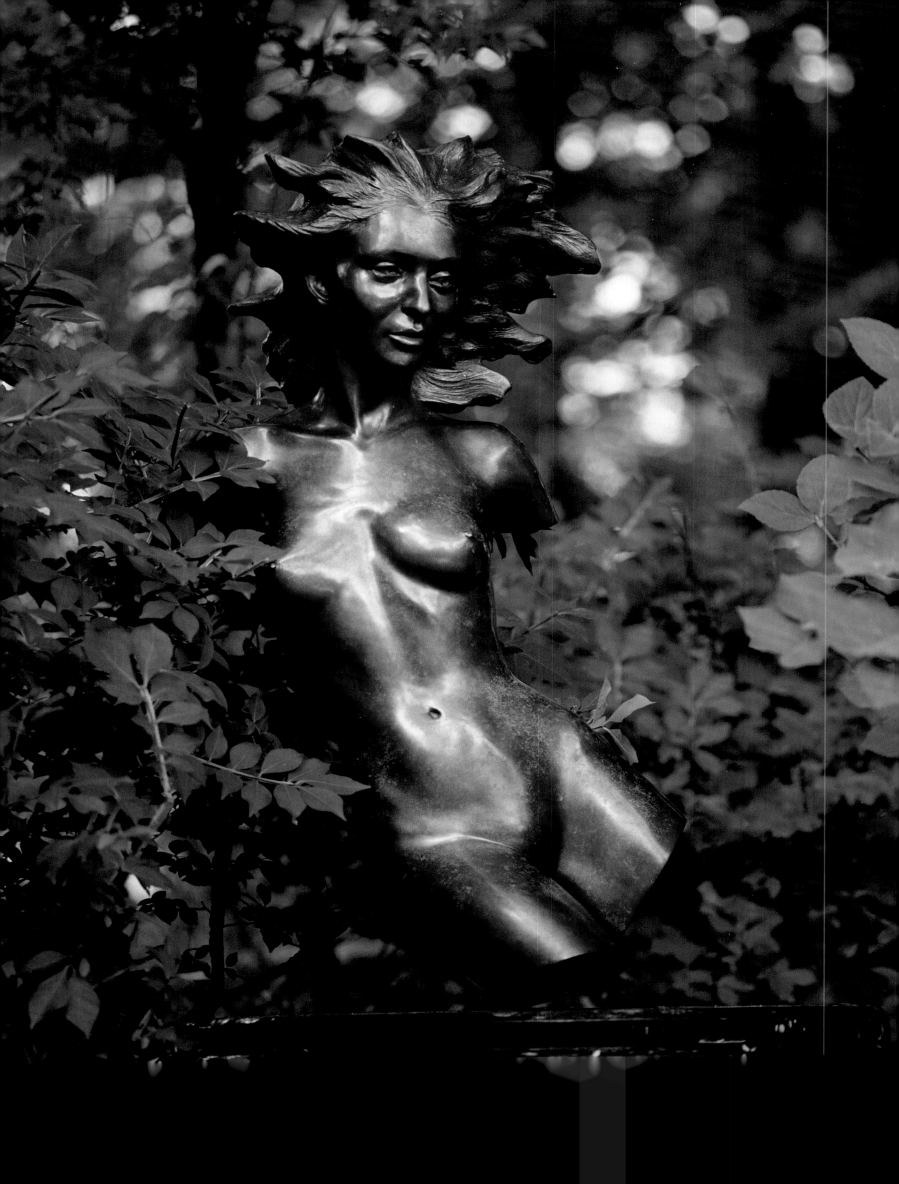

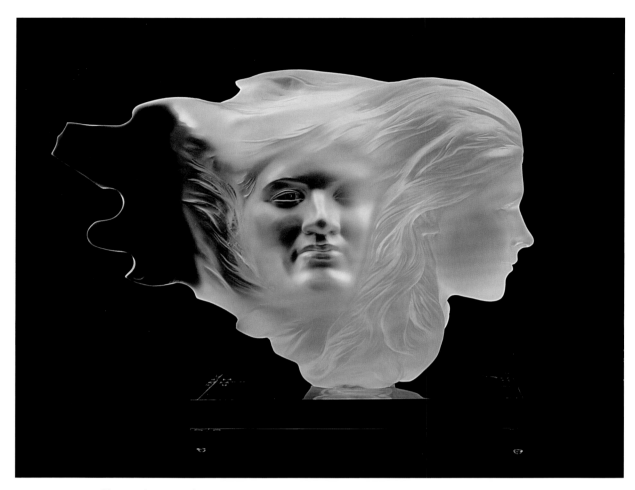

PLATE 7: *Herself,* 14", clear acrylic resin, 1984

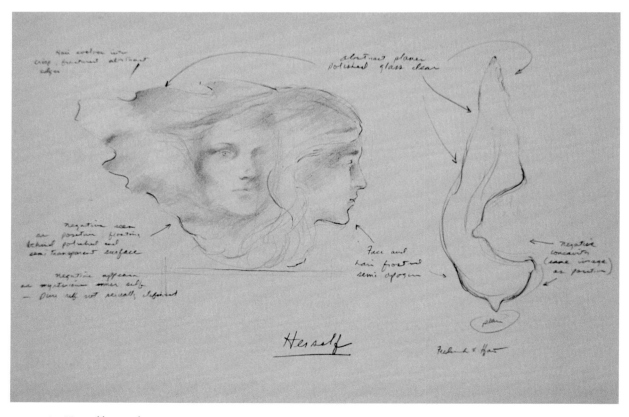

PLATE 8: *Herself,* pencil on paper

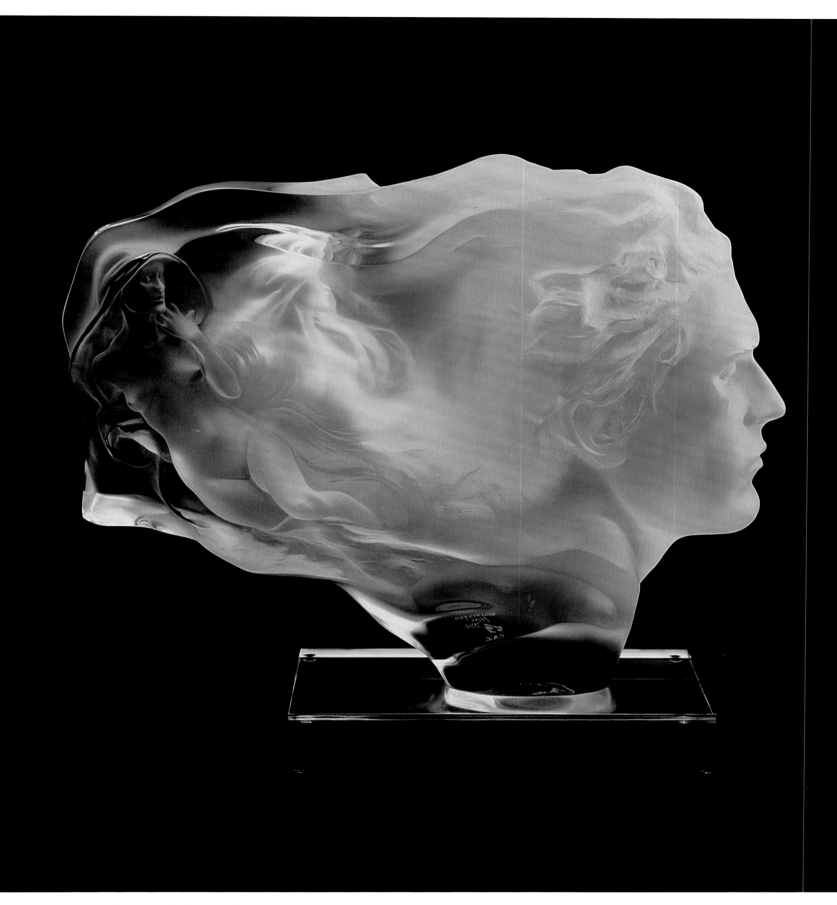

PLATE 9: *Reverie*, 14", clear acrylic resin, 1995

PLATE 10: *Torso (female)*, 41", bronze, 1991

PLATE 11: *Torso (male)*, 39", bronze, 1994

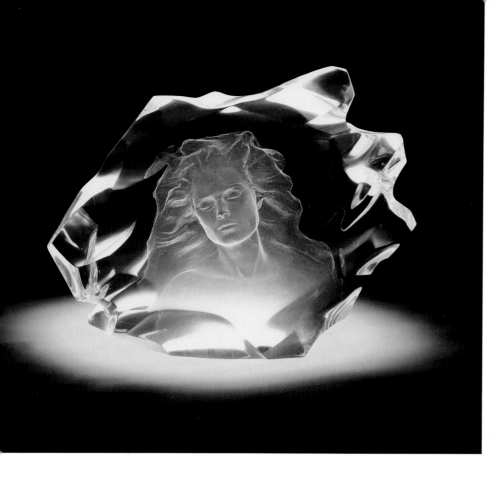

PLATE 12: *Illuminata I, 12½",*
clear acrylic resin, 1997

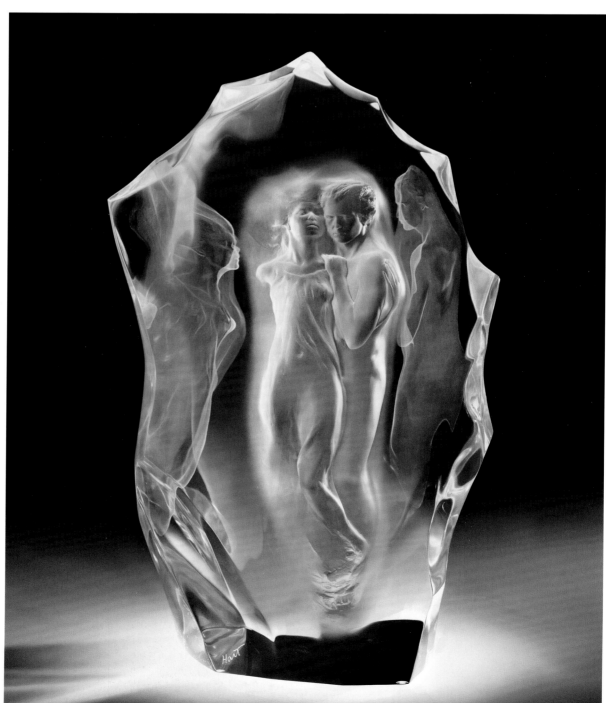

PLATE 13: *Illuminata III, 16½",*
clear acrylic resin, 1999

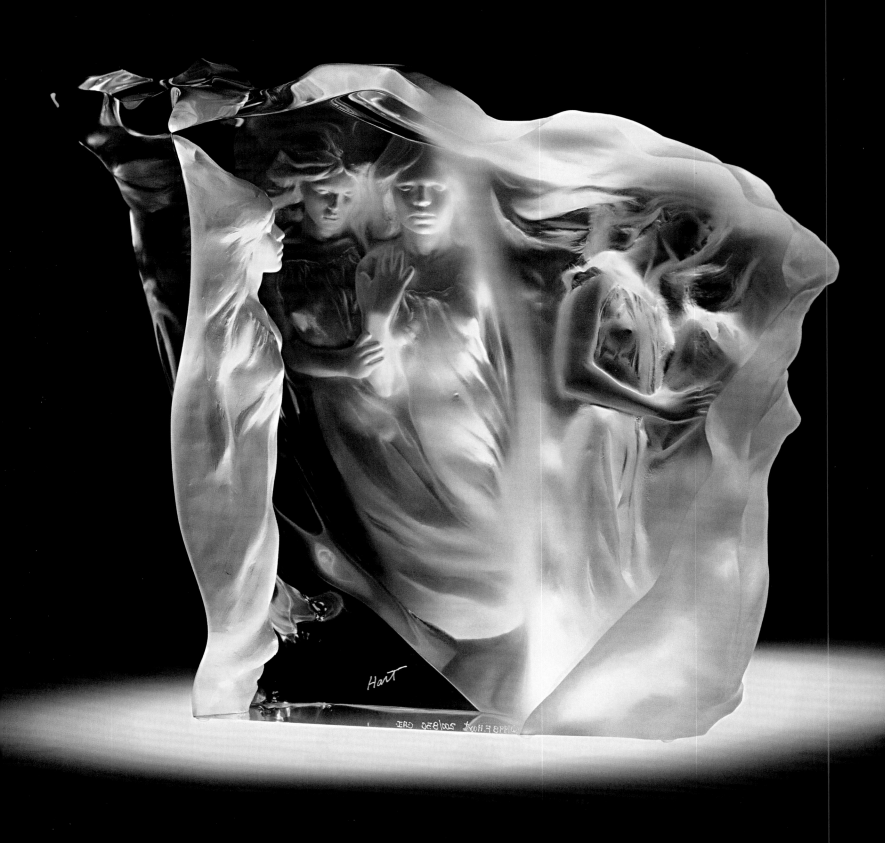

PLATE 14: *Illuminata II* (back), 13", clear acrylic resin, 1998

PLATE 15: *Duet: A Spiritual Song of Love* (one-half life-size),
26", clear acrylic resin, 1996

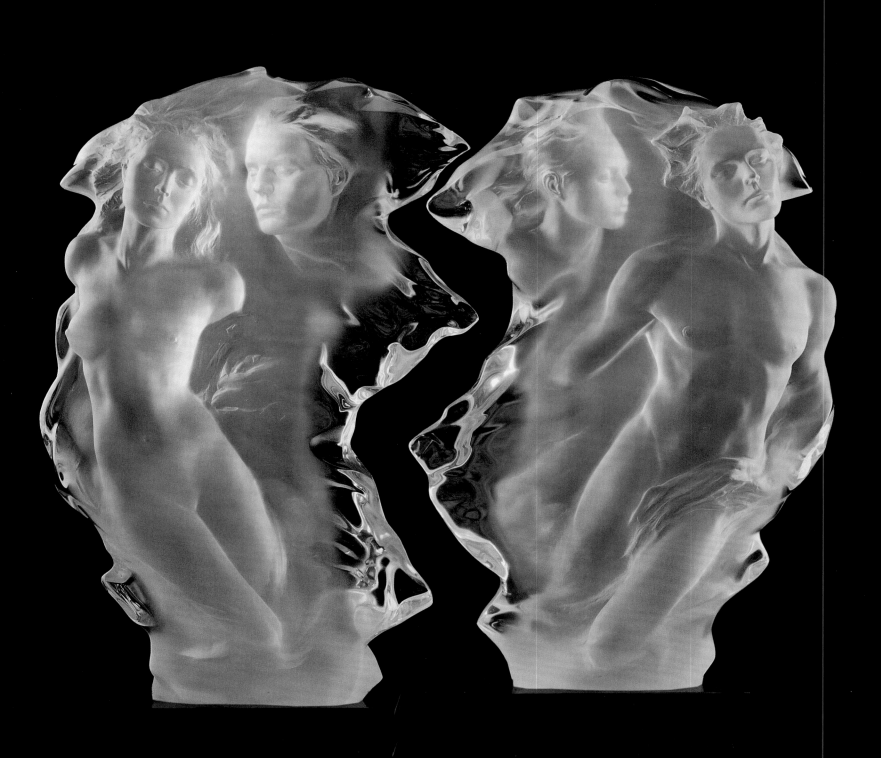

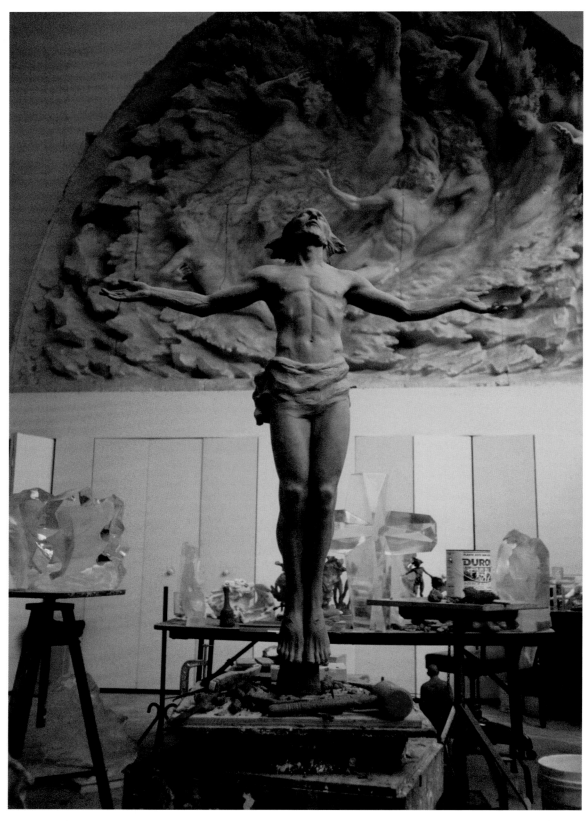

FIG. 87: *Christ Rising,* clay

PLATE 16: *Christ Rising,* 61¼", bronze, 1998

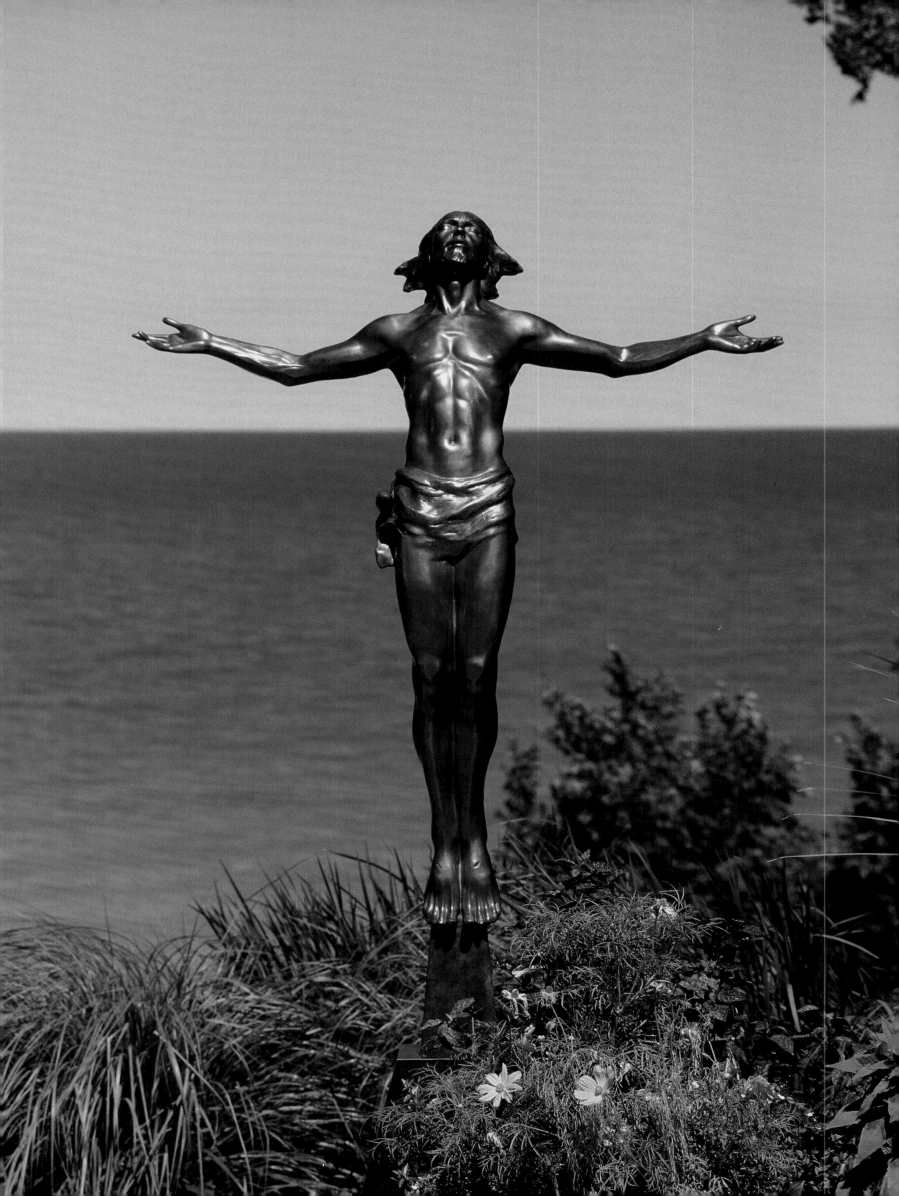

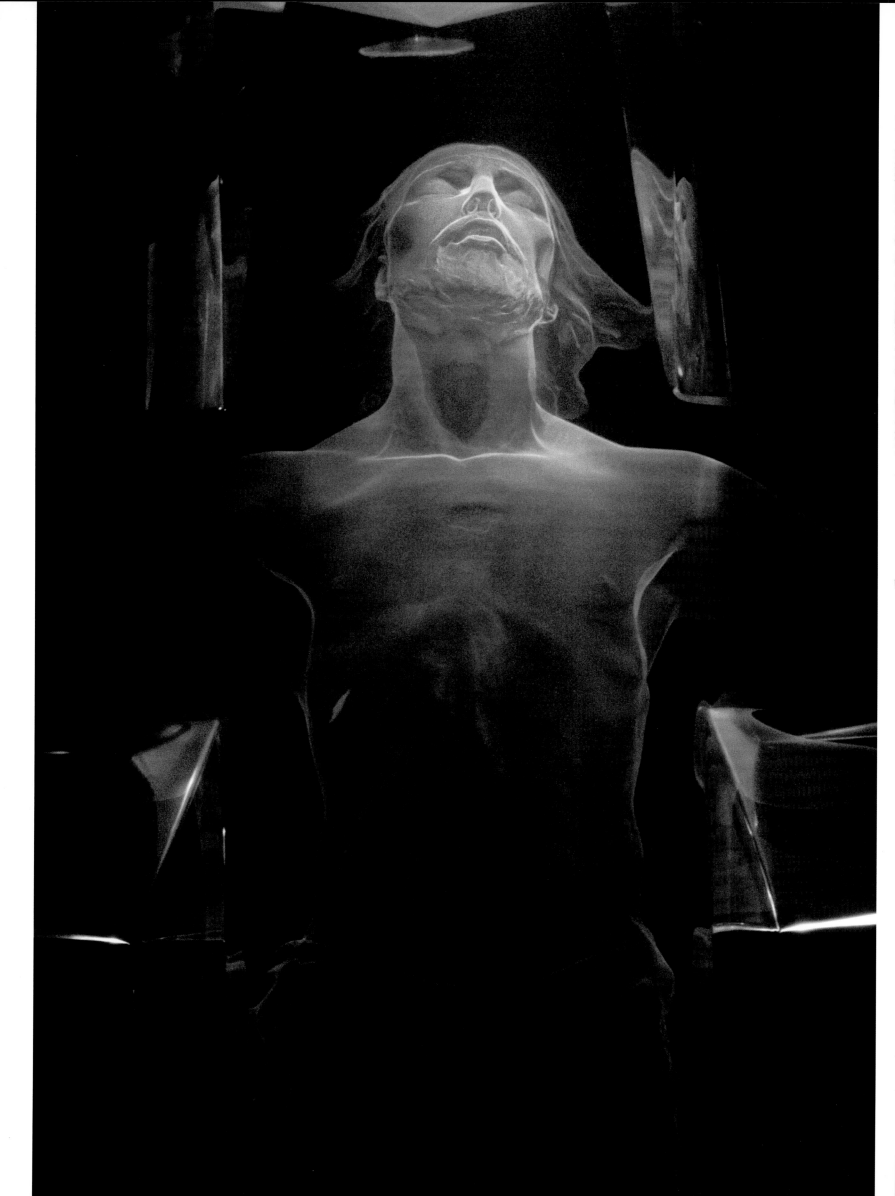

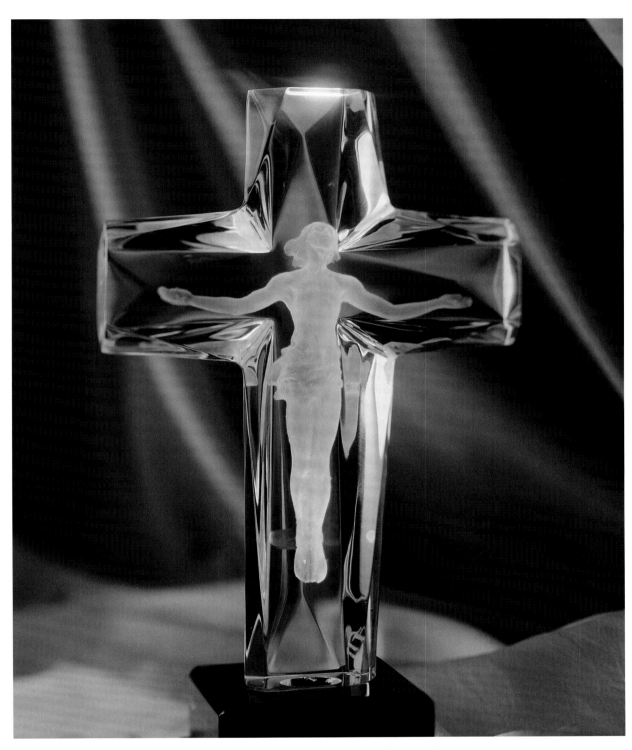

PLATE 18: *The Cross of the Millennium, Maquette: State II,* 11⅜", clear acrylic resin, 1995

PLATE 17: Detail, *The Cross of the Millennium,* (life-size), 69½", clear acrylic resin, 1996
Commissioned by Saint Vincent de Paul Catholic Church, Andover, Kansas

PLATE 19: *Daughters of Odessa* (one-third life-size), 25½", bronze, 1998

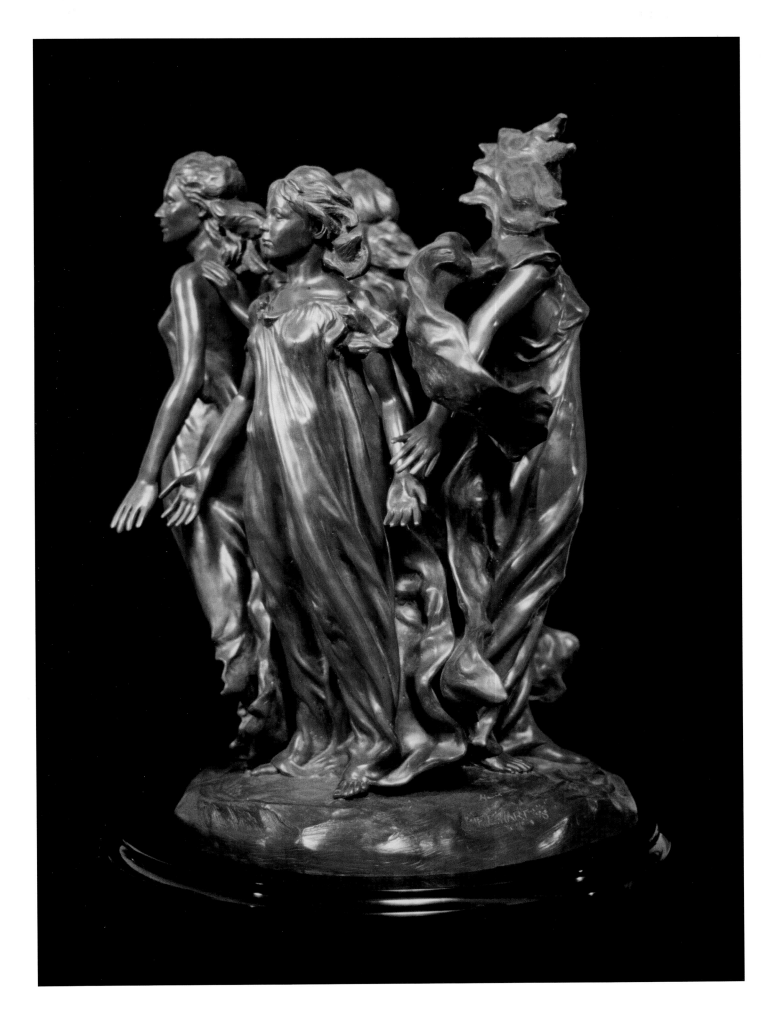

117

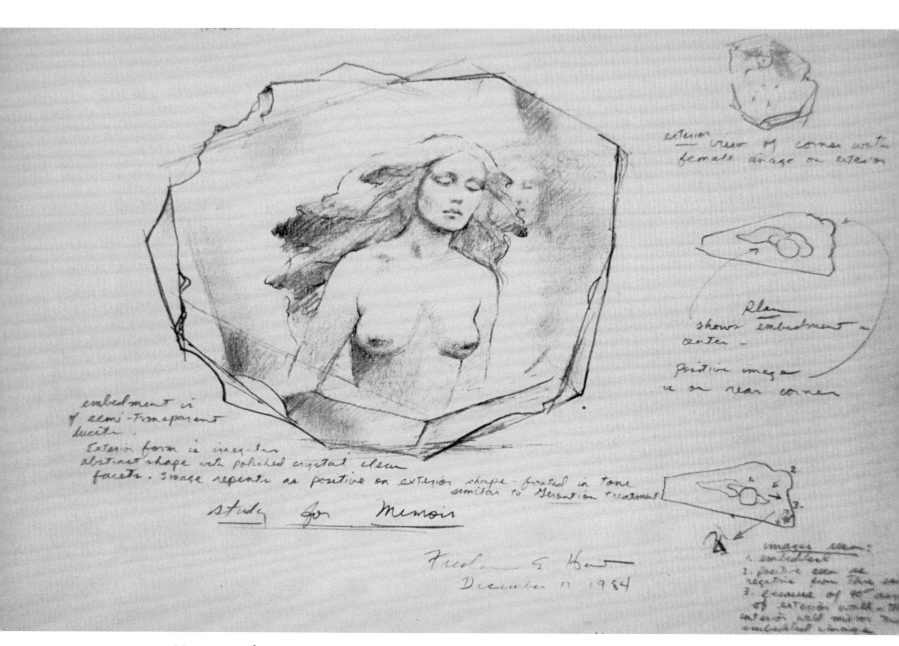

The drawing includes handwritten notes:

exterior view of corner with female image on exterior

Plan shows embedment in center —

positive image is on rear corner

embedment is of semi-transparent lucite. Exterior form is irregular abstract shape with polished crystal clear facets. Image repeats as positive on exterior shape - printed in tone similar to Generation treatment

study for Memoir

Frederick E. Hart
December 17, 1984

PLATE 20: *Memoir,* pencil on paper

PLATE 21: *Memoir,* clear acrylic resin, 12", 1985

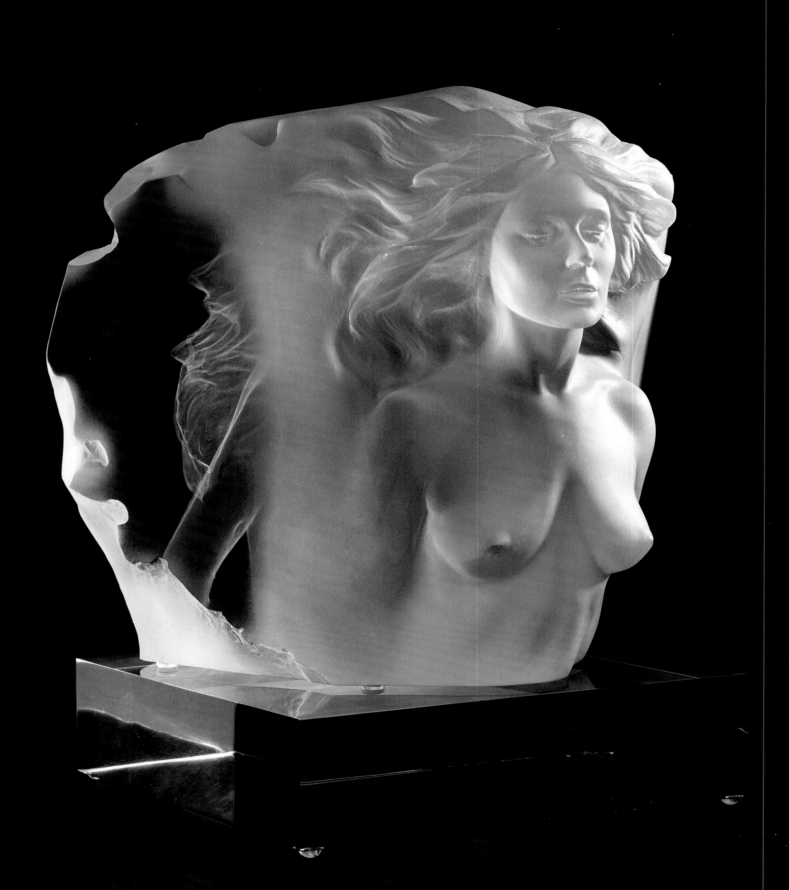

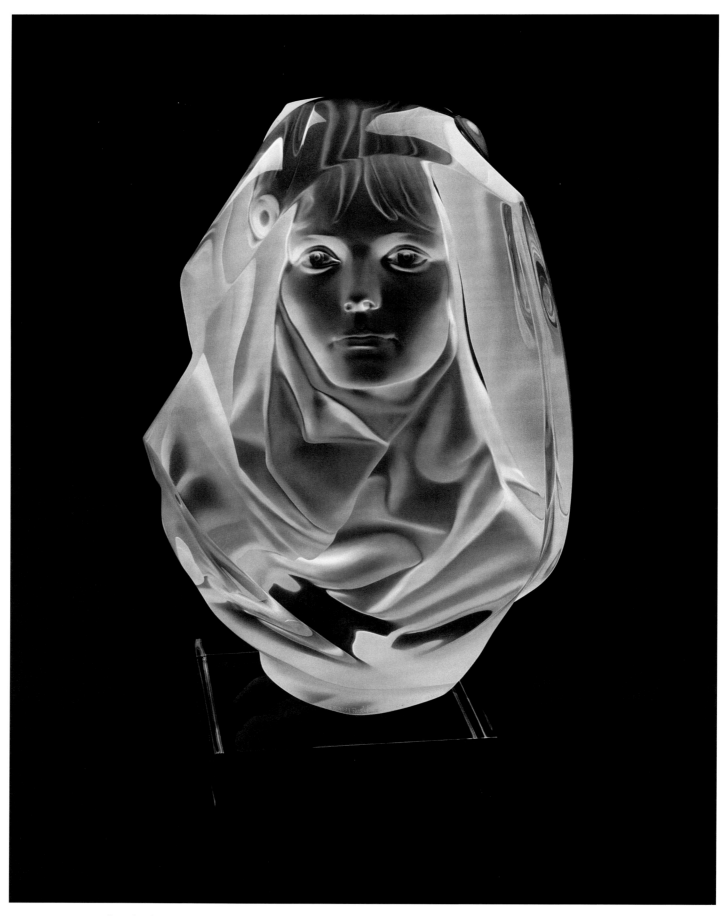

PLATE 22: *Penumbra* (back), 19", clear acrylic resin, 1989

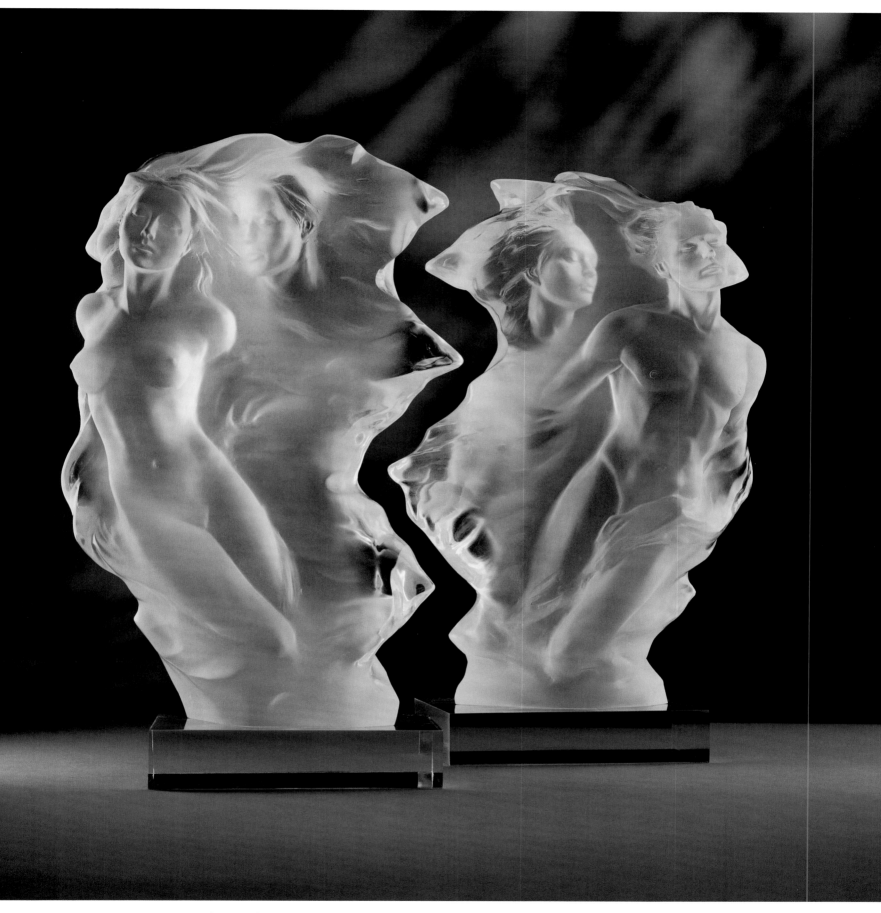

PLATE 23: *Duet: A Spiritual Song of Love* (one-fourth life-size), 16½", clear acrylic resin, 1996

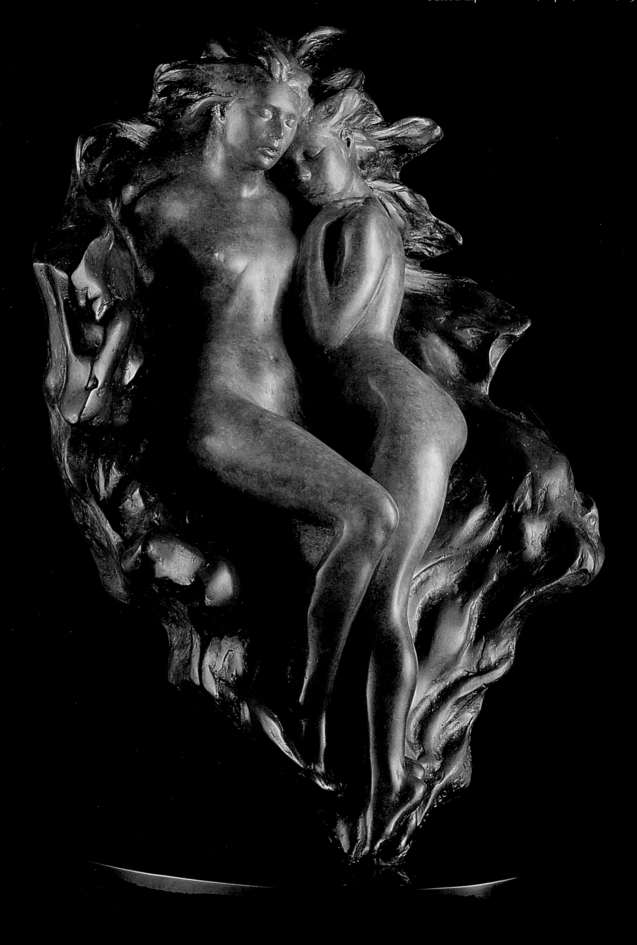

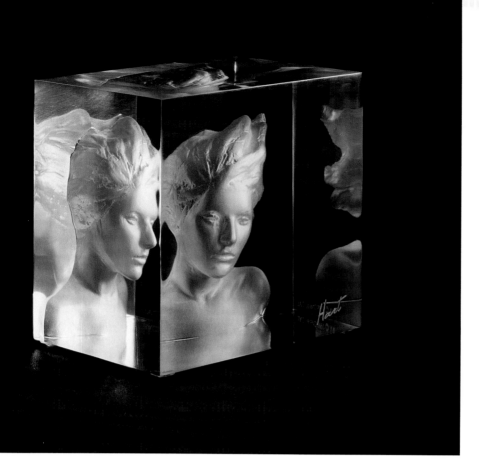

PLATE 25: *Memoria*, 3½", clear acrylic resin, 1999

PLATE 26: *Veil of Light*, 13¾", bronze, 1988

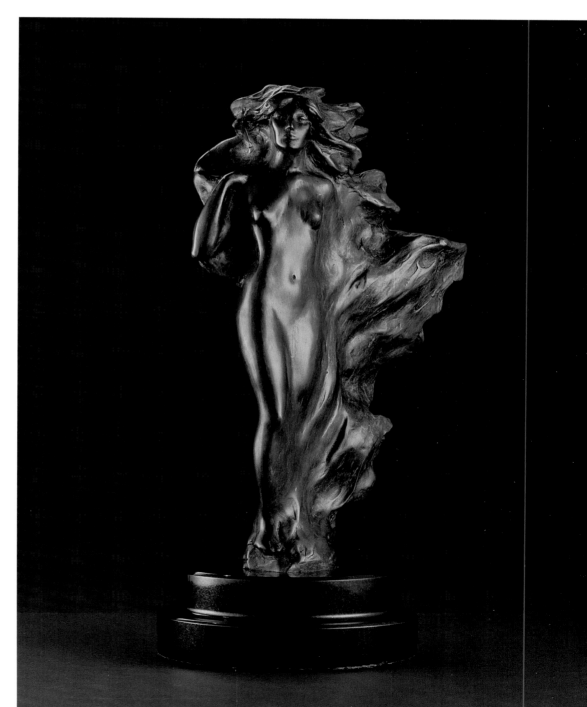

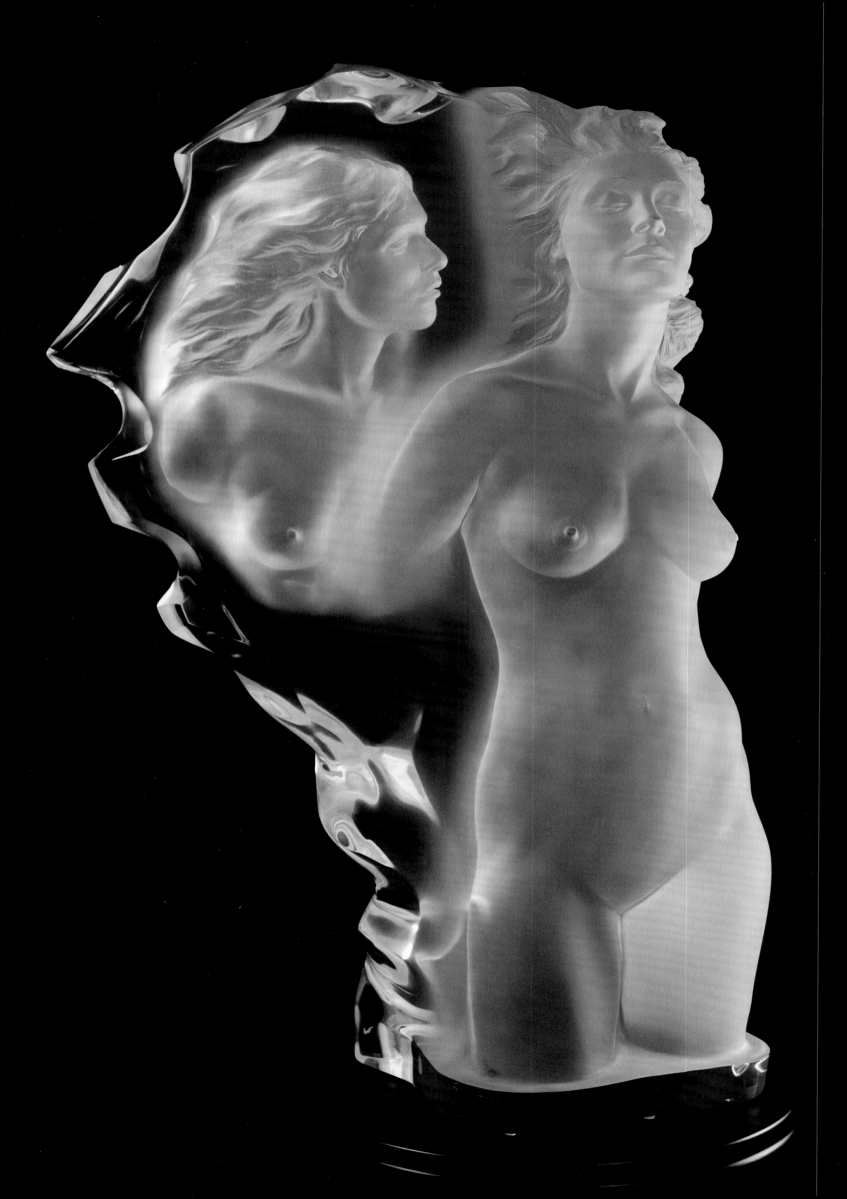

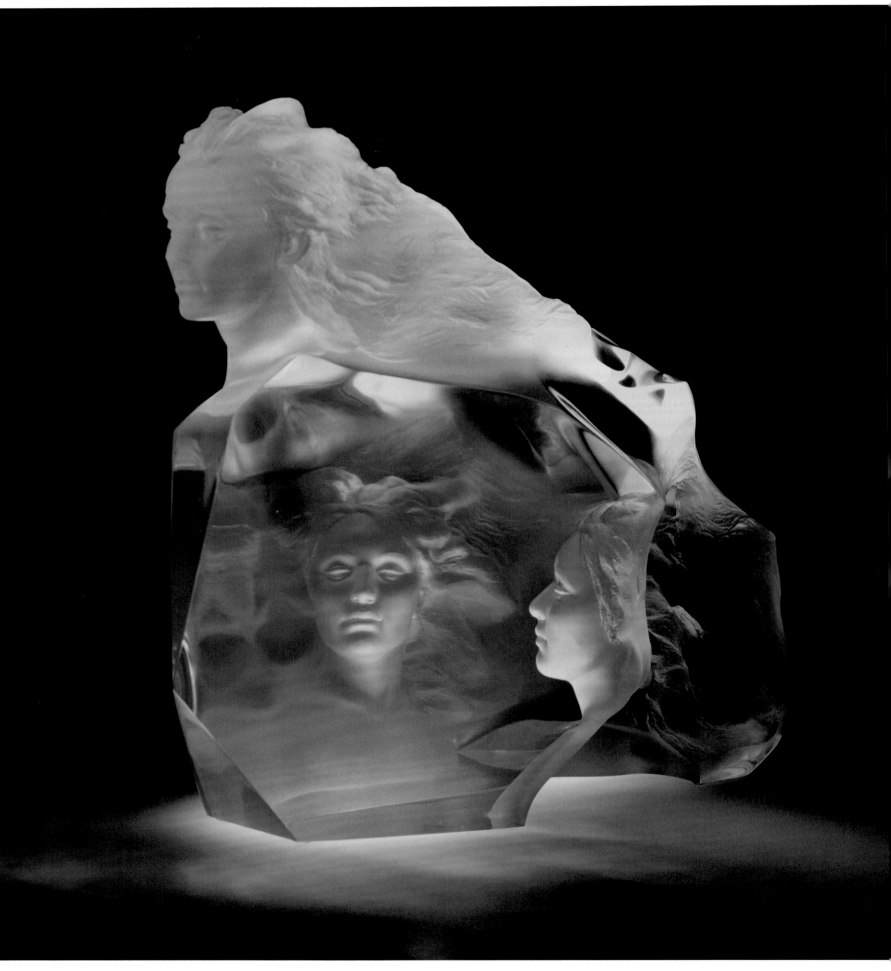

PLATE 28: *Destiny*, 12", clear acrylic resin, 1999

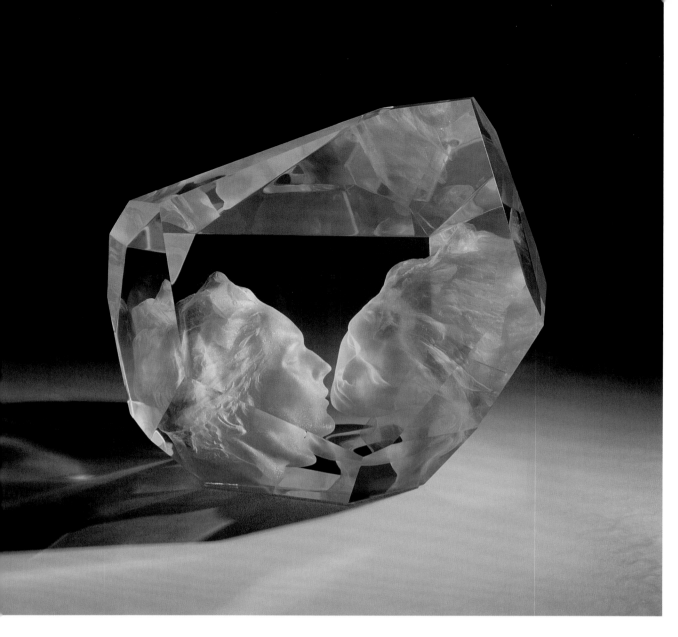

PLATE 29: *The Kiss* (front), 11",
clear acrylic resin, 2001

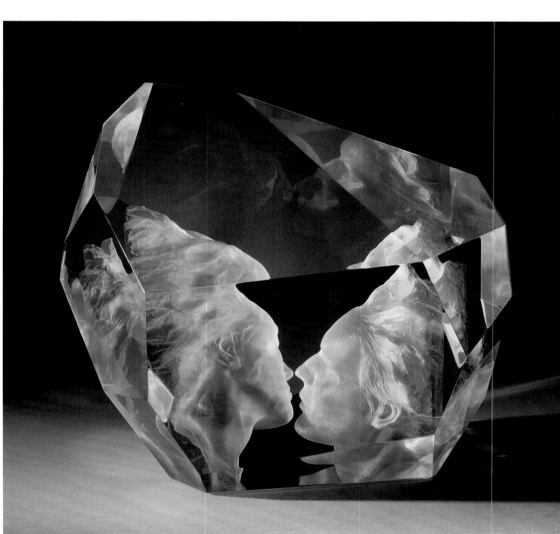

PLATE 30: *The Kiss* (back)

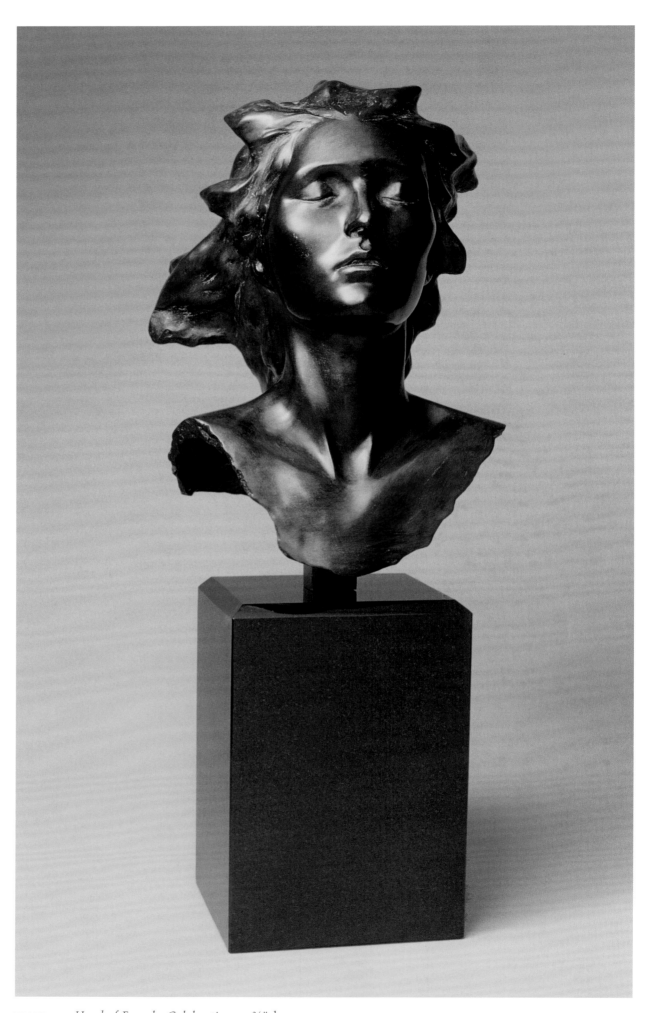

PLATE 31: *Head of Female: Celebration*, 21¾", bronze, 2002

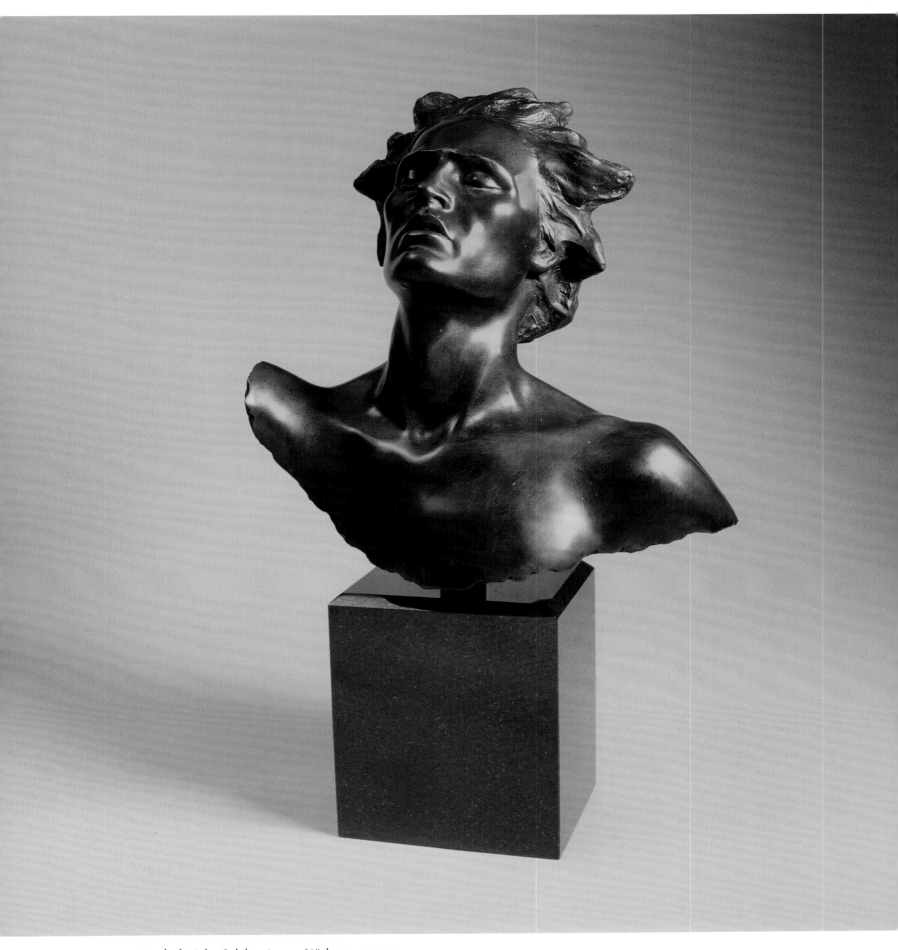

PLATE 32: *Head of Male: Celebration*, 23¾", bronze, 2002

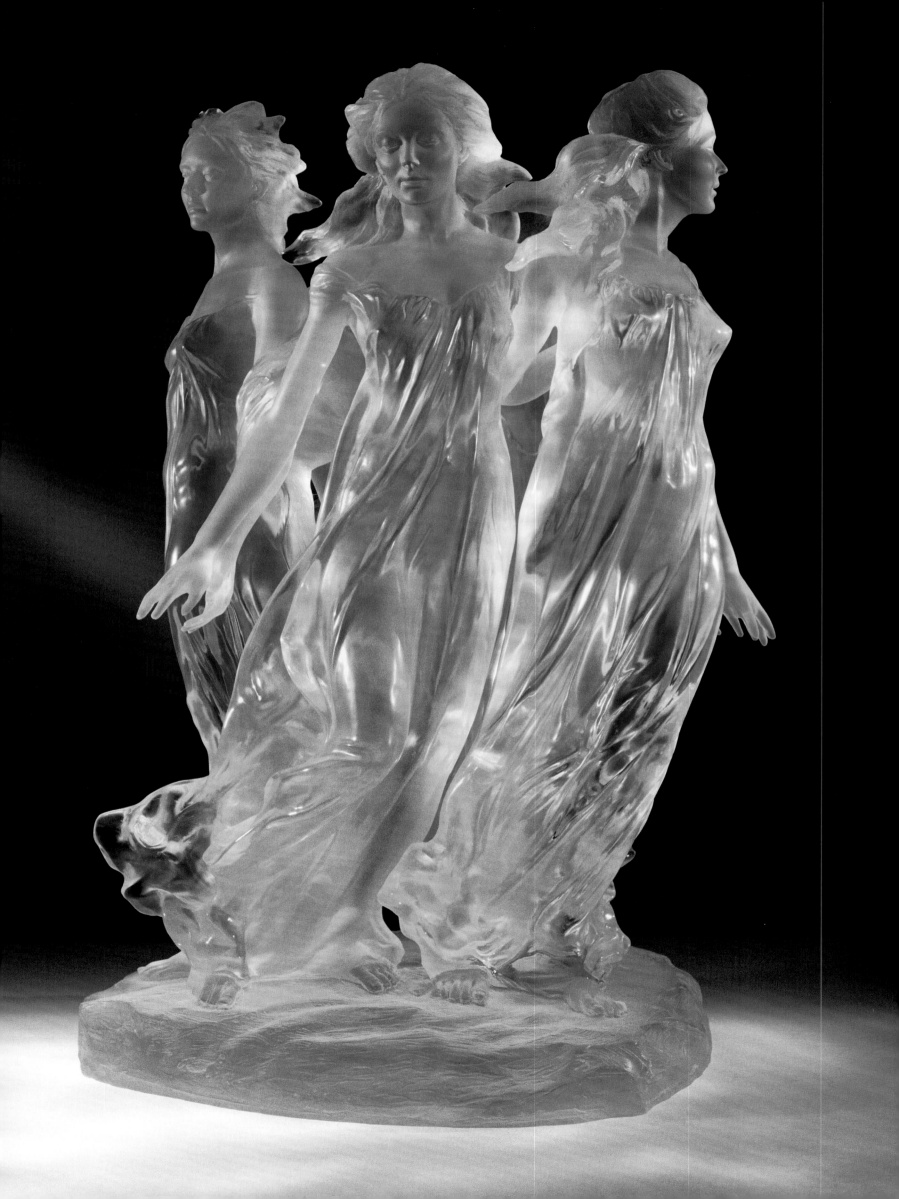

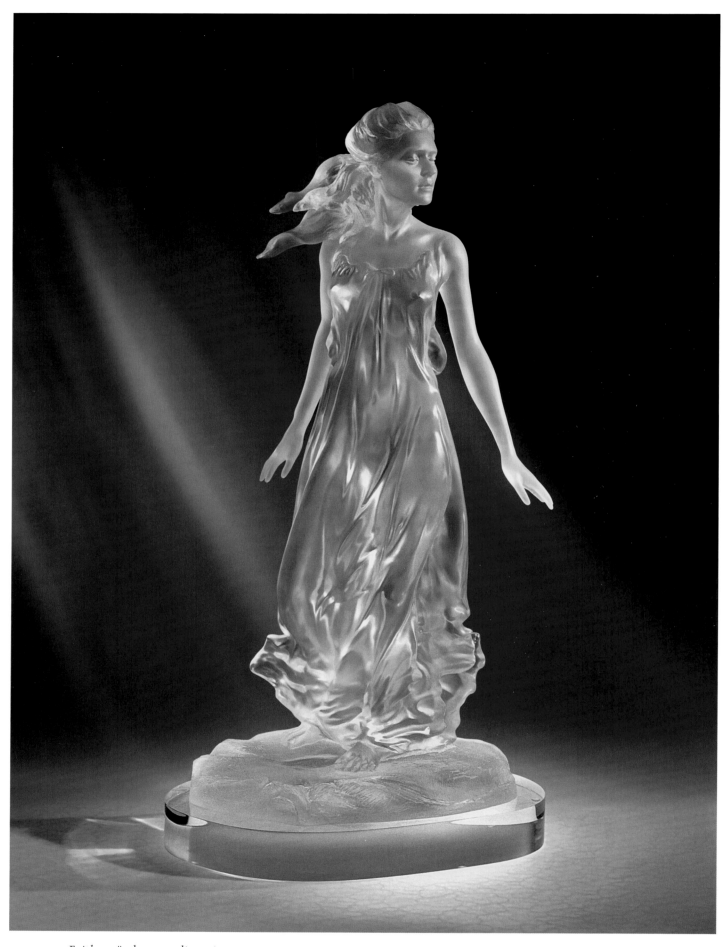

PLATE 34: *Faith*, 25", clear acrylic resin, 2000

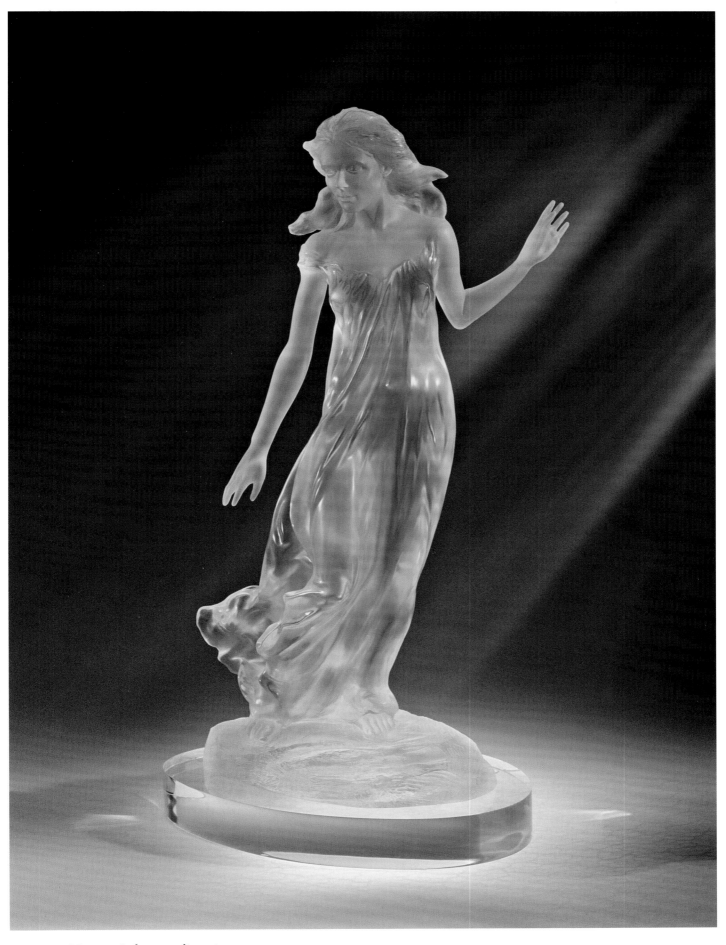

PLATE 35: *Hope,* 25", clear acrylic resin, 2001

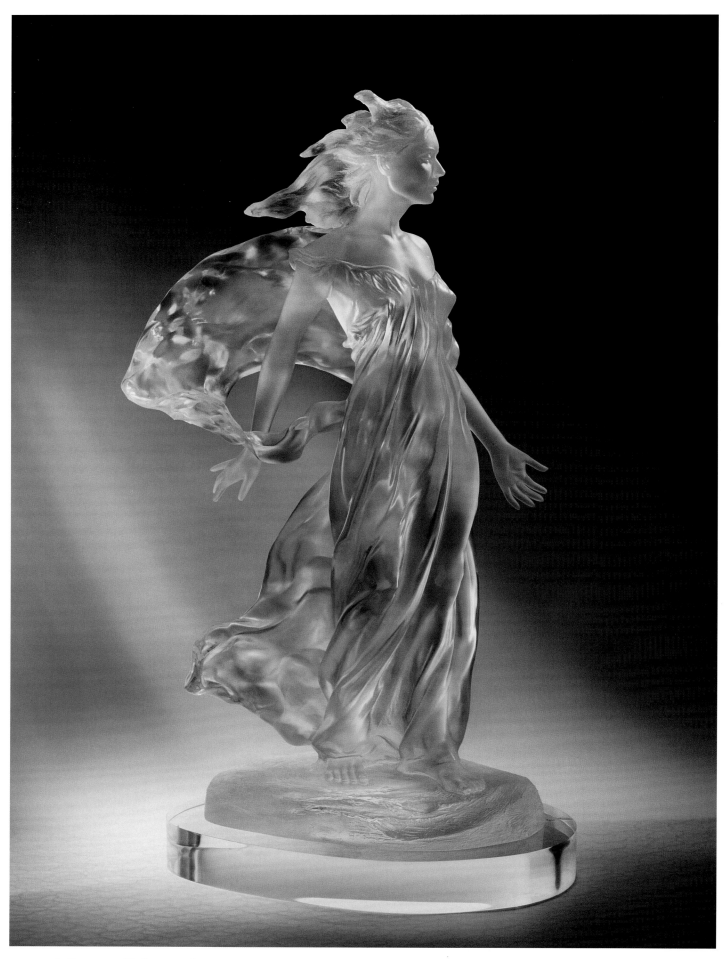

PLATE 36: *Beauty,* 26", clear acrylic resin, 2001

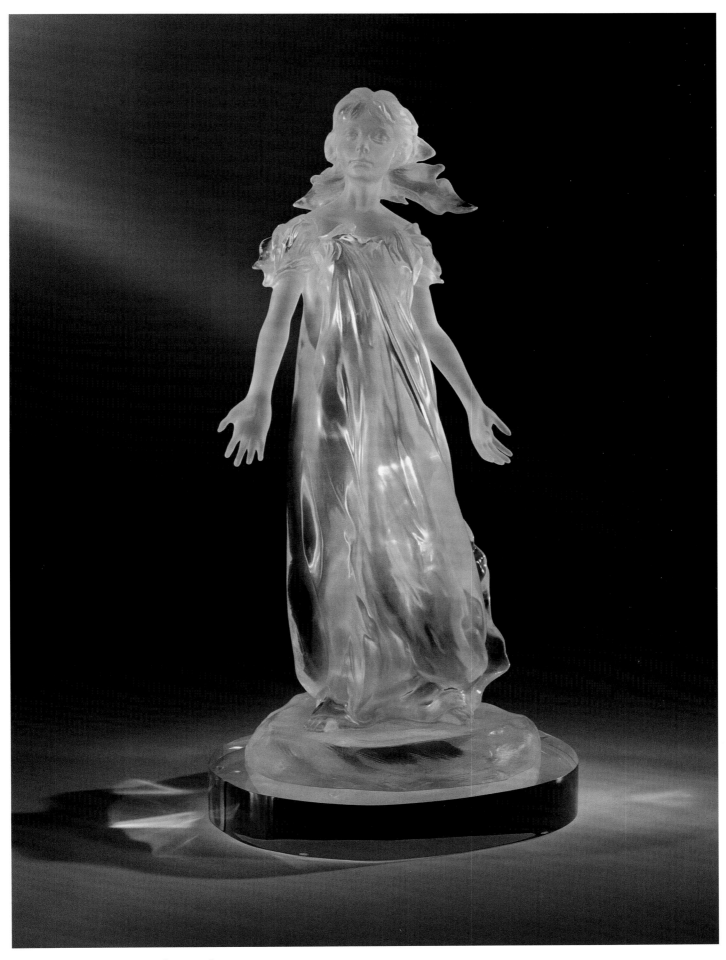

PLATE 37: *Innocence*, 24", clear acrylic resin, 1999

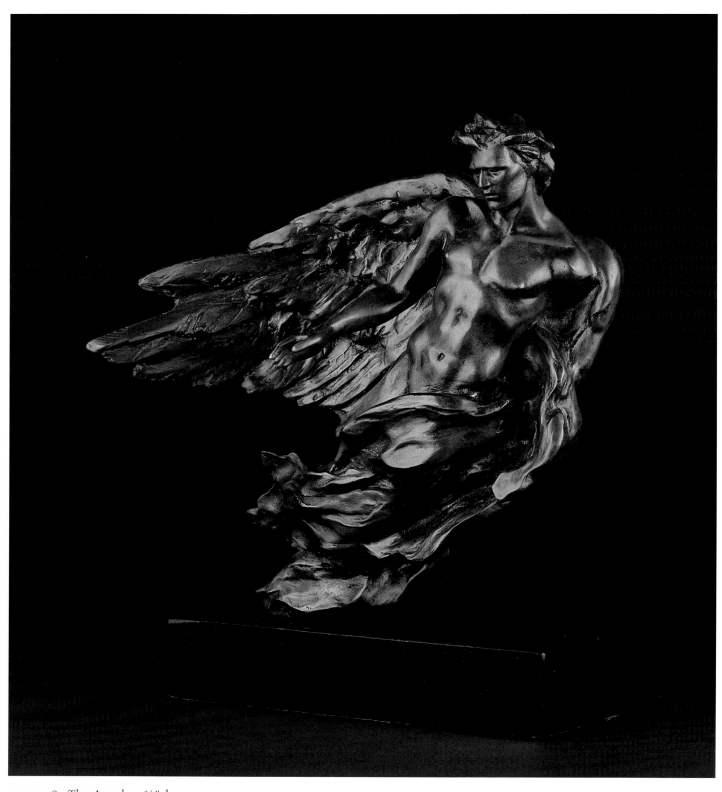

PLATE 38: *The Angel,* 13½", bronze, 1992

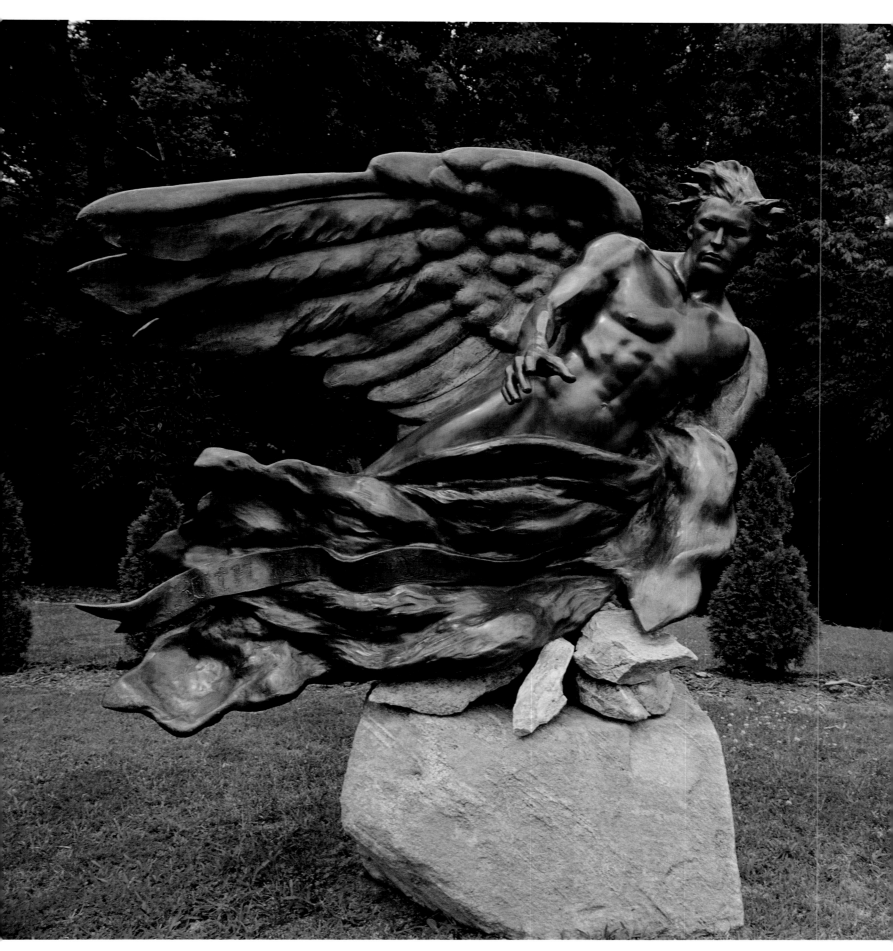

PLATE 39: *The Herald*, 50", bronze, 1992

PLATE 40: *The Divine Milieu: Homage to Teilhard de Chardin*, 20", clear acrylic resin, 2001

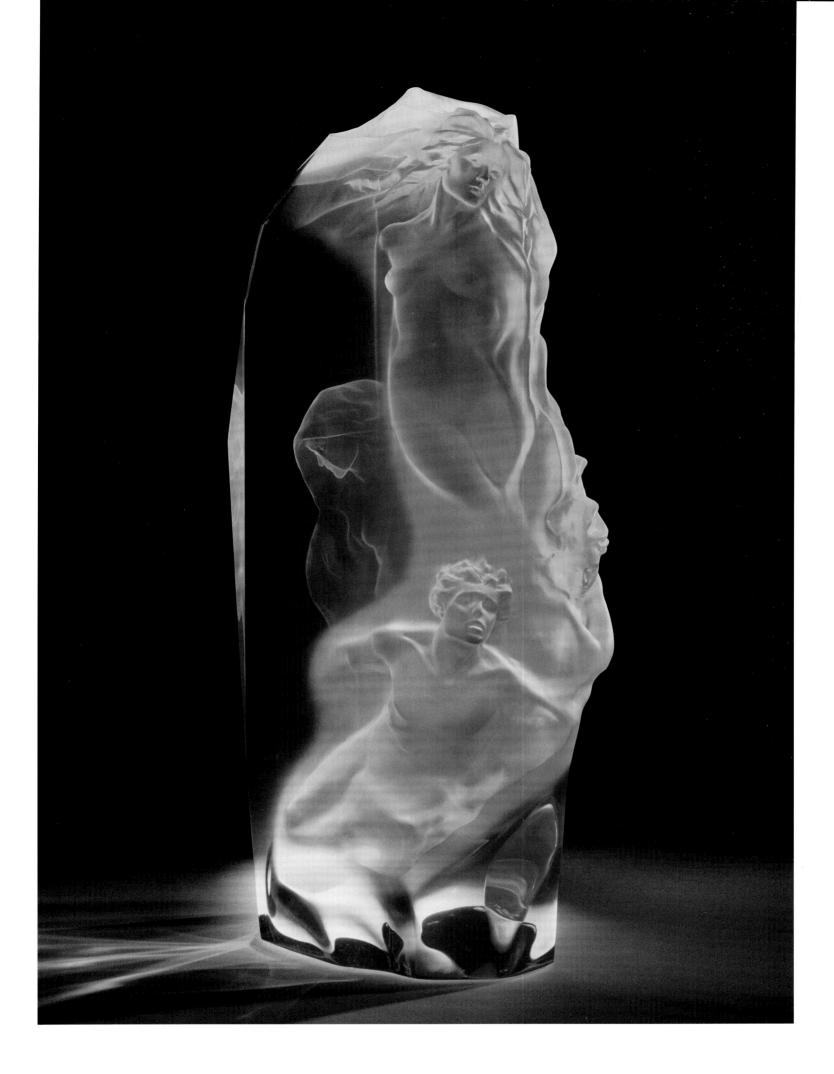

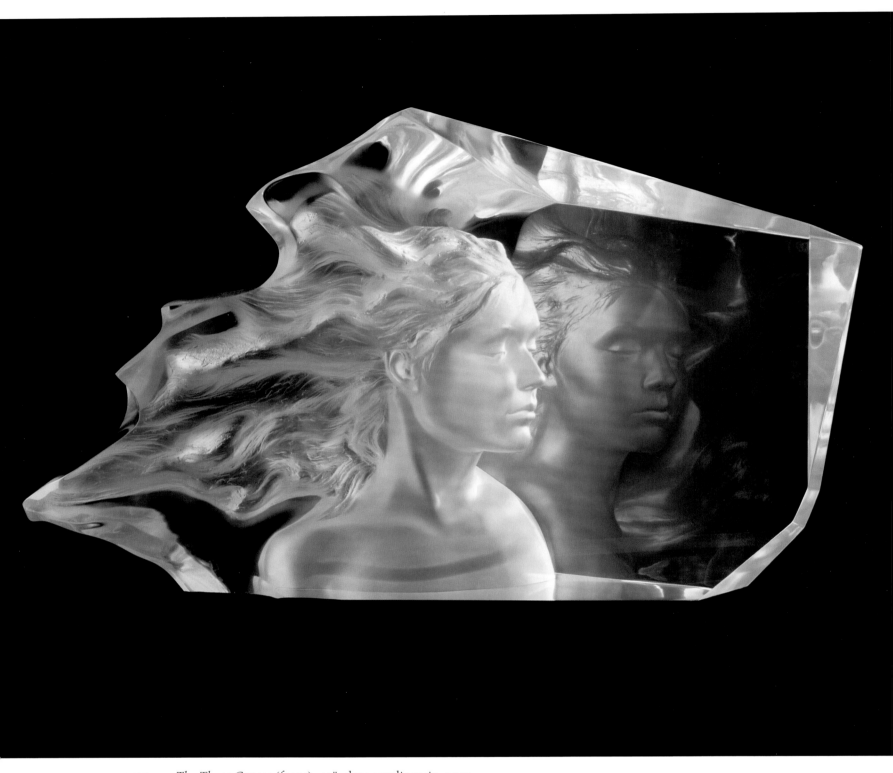

PLATE 41: *The Three Graces* (front), 14", clear acrylic resin, 2003

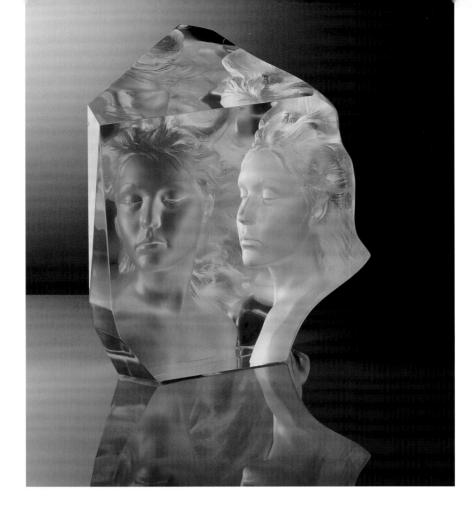

PLATE 42: *The Three Graces*
(back)

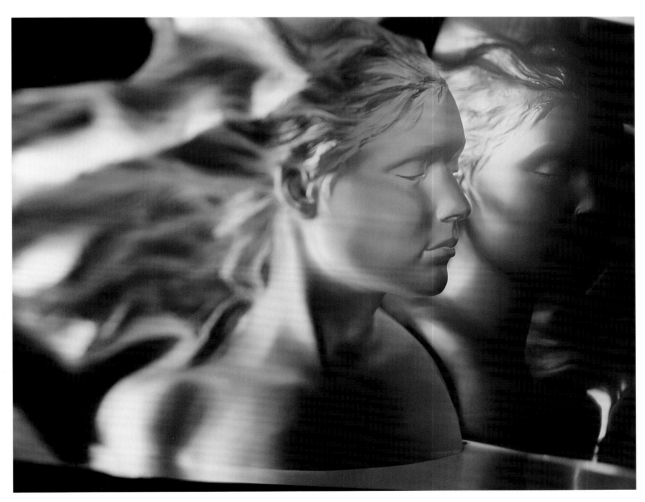

PLATE 43: Detail, *The Three Graces*

141

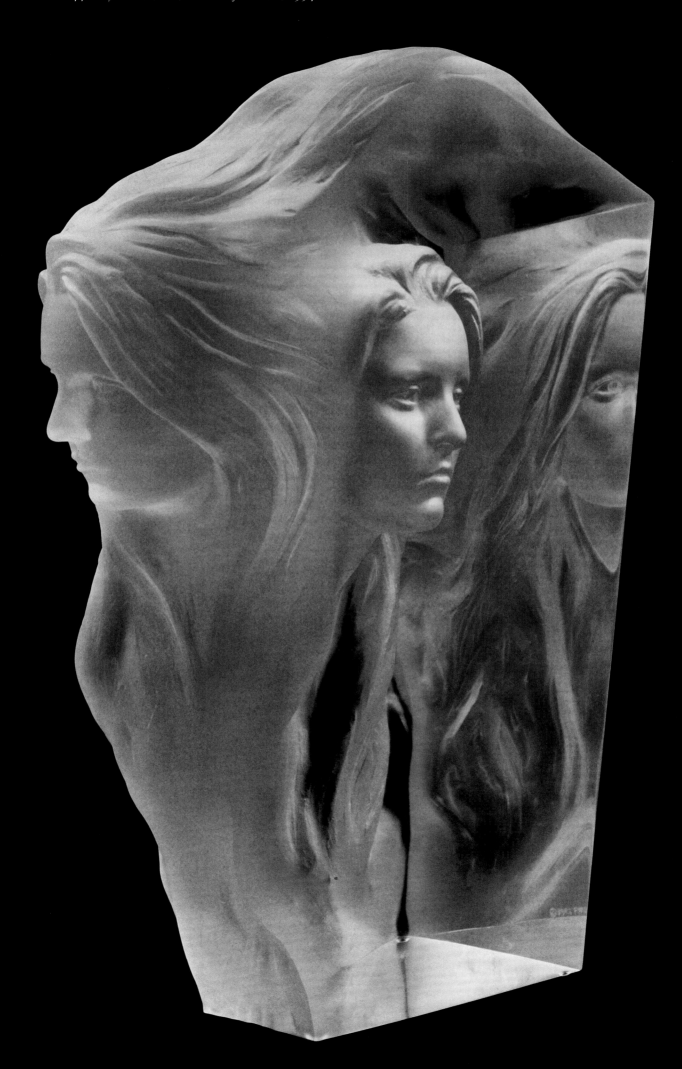

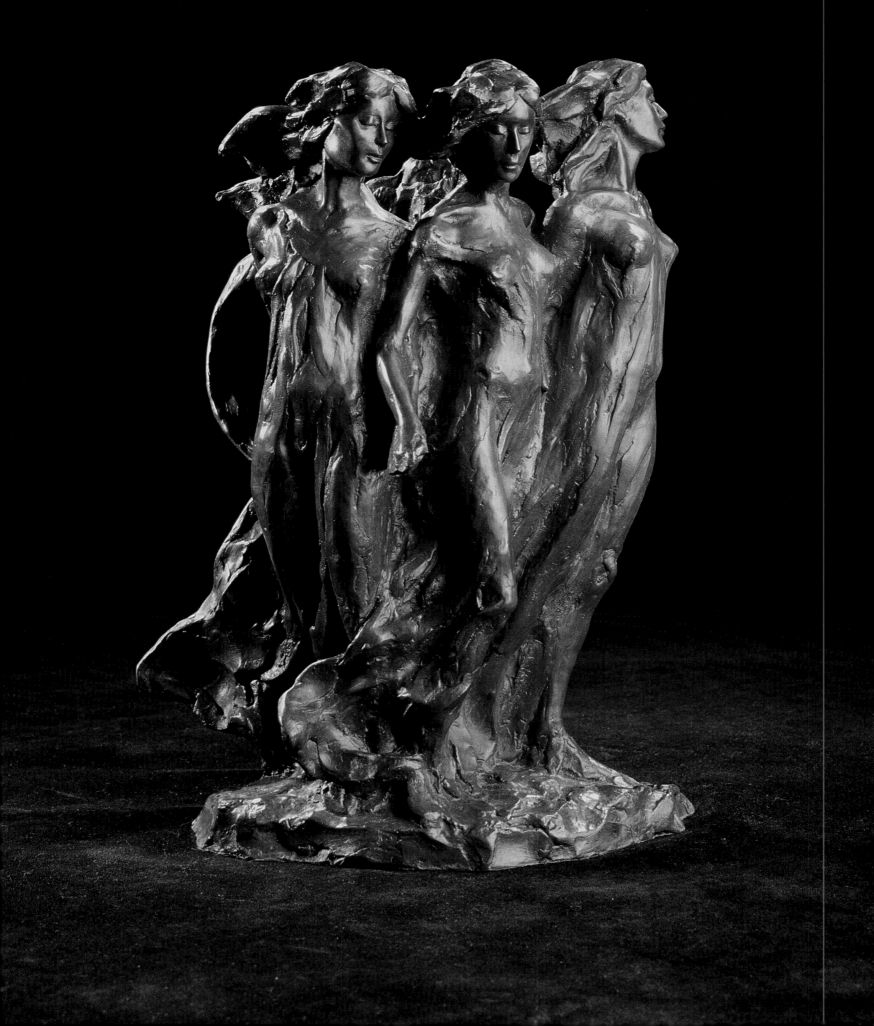

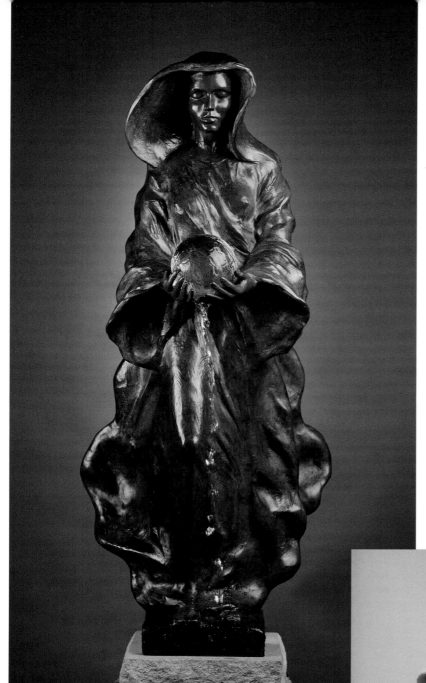

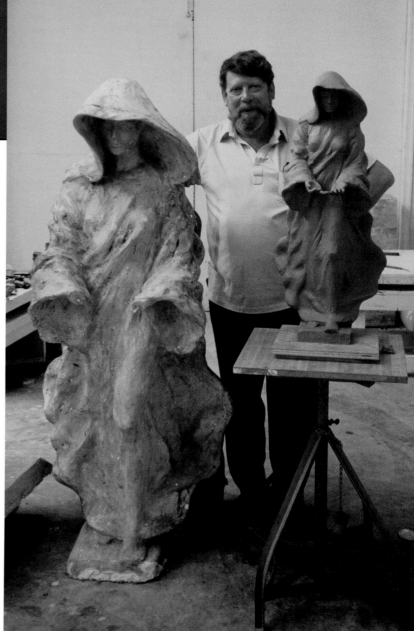

PLATE 46: *The Source* (one-half life-size), 34", bronze, 1995

FIG. 88: Hart with *The Source* (life-size), plaster, and clay model for *The Source* (one-half life-size)

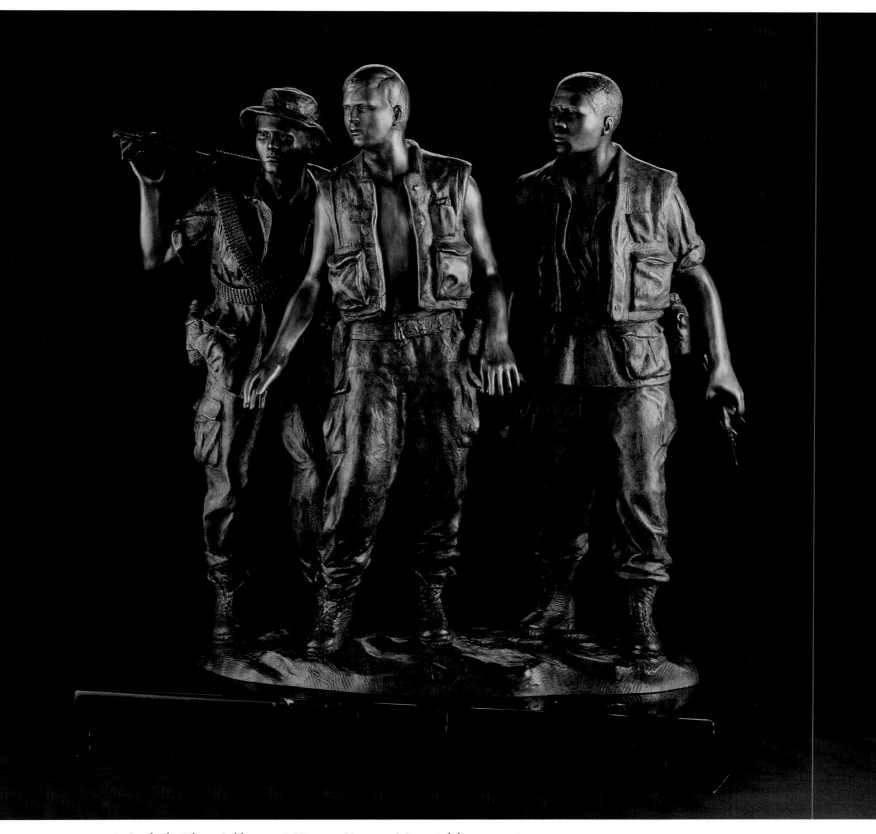

PLATE 48: Study for *Three Soldiers*, 20", Vietnam Veterans Memorial, bronze, 1984

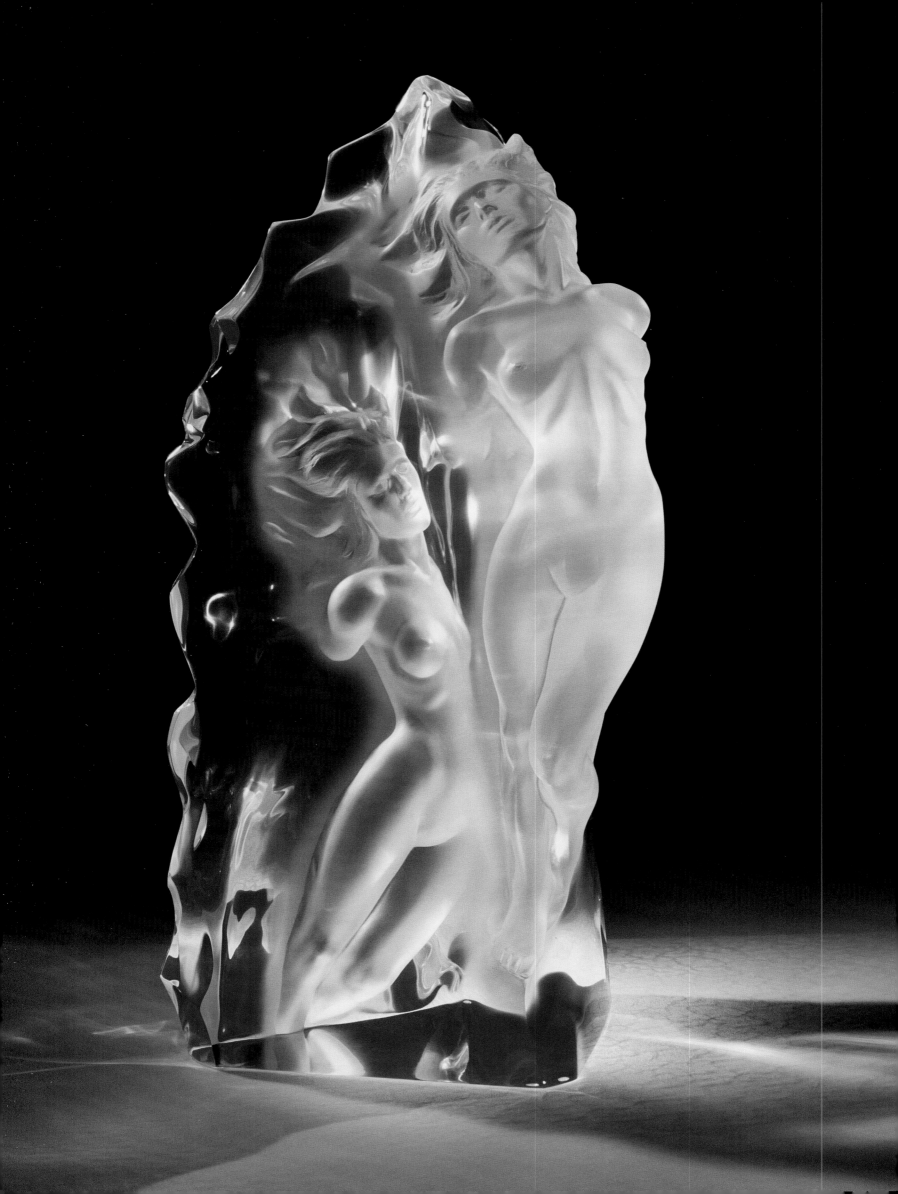

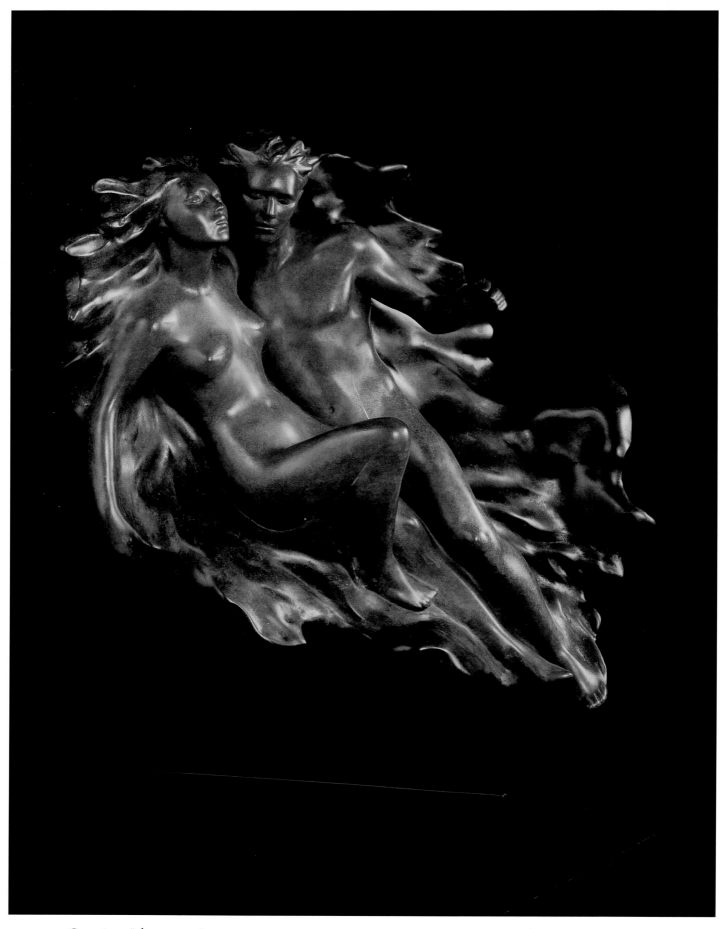

PLATE 50: *Genesis*, 12", bronze, 1989

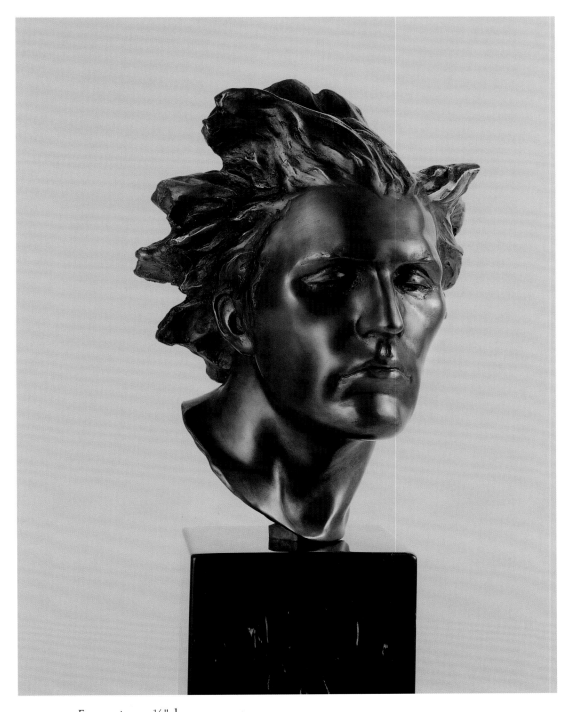

PLATE 51: *Encounter,* 24½", bronze, 1994

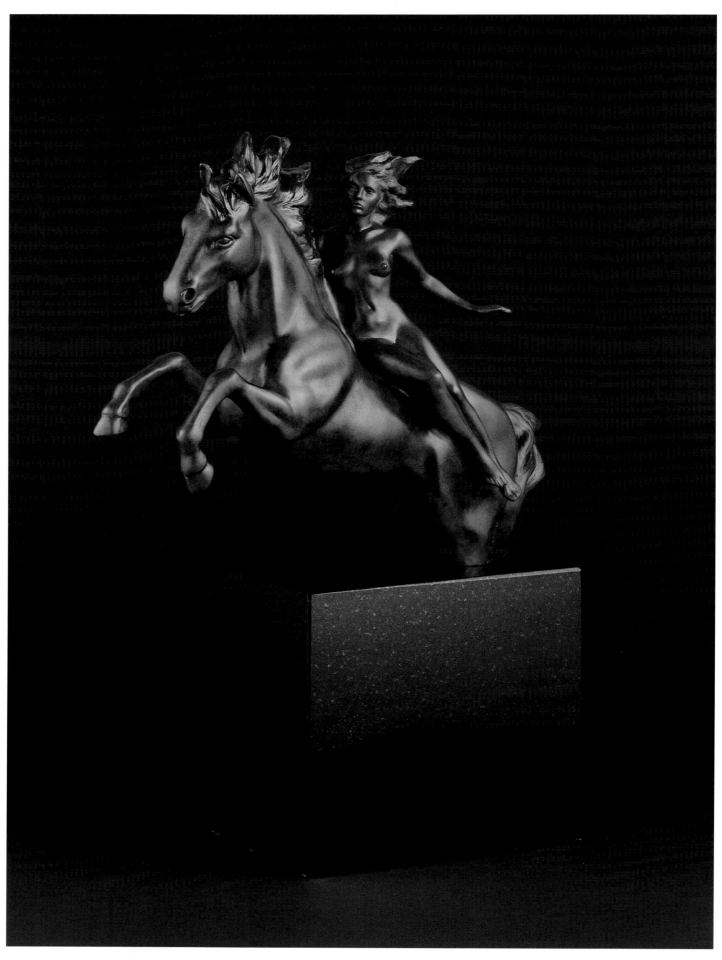

PLATE 52: *Equus,* 21", bronze, 1998

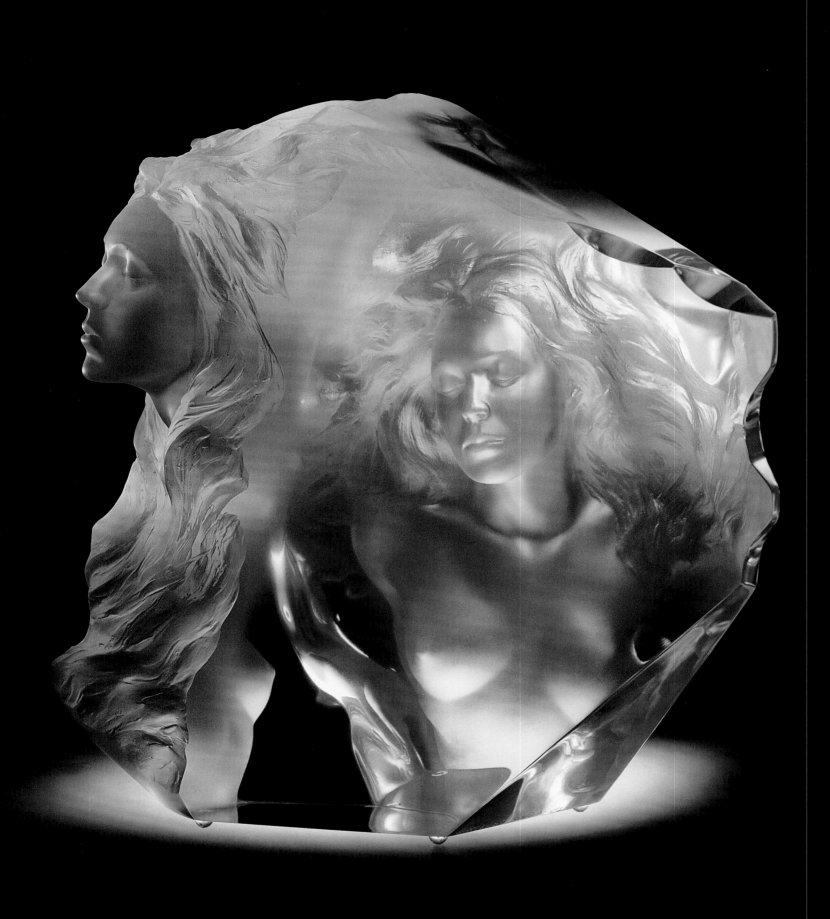

PLATE 53 : *Counterpoint*, 15", clear acrylic resin, 1997

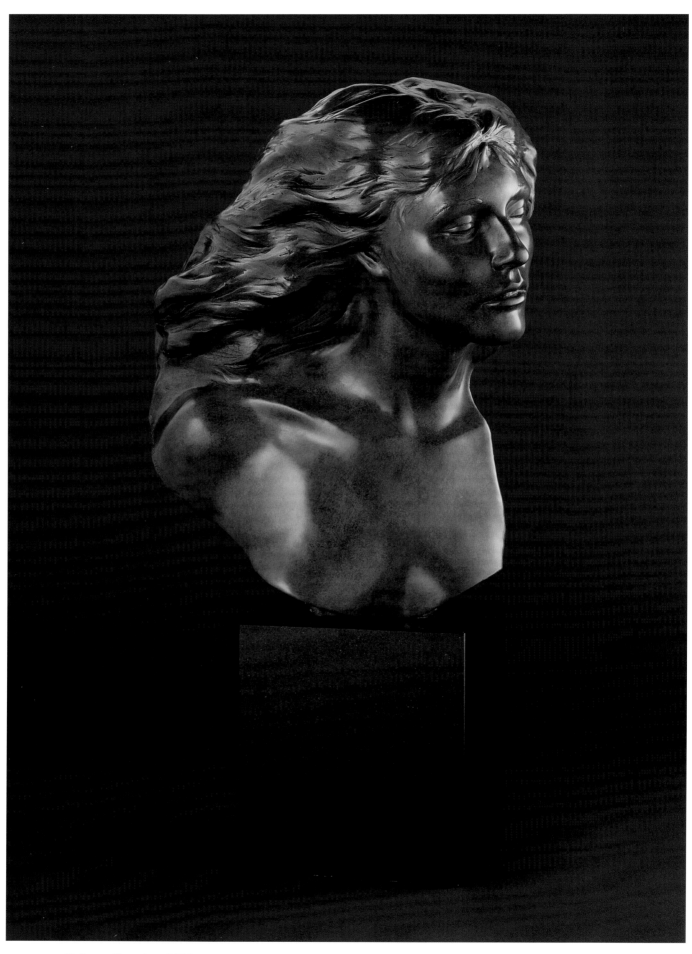

PLATE 54: *Enigma* (front), 25½", bronze, 1997

154

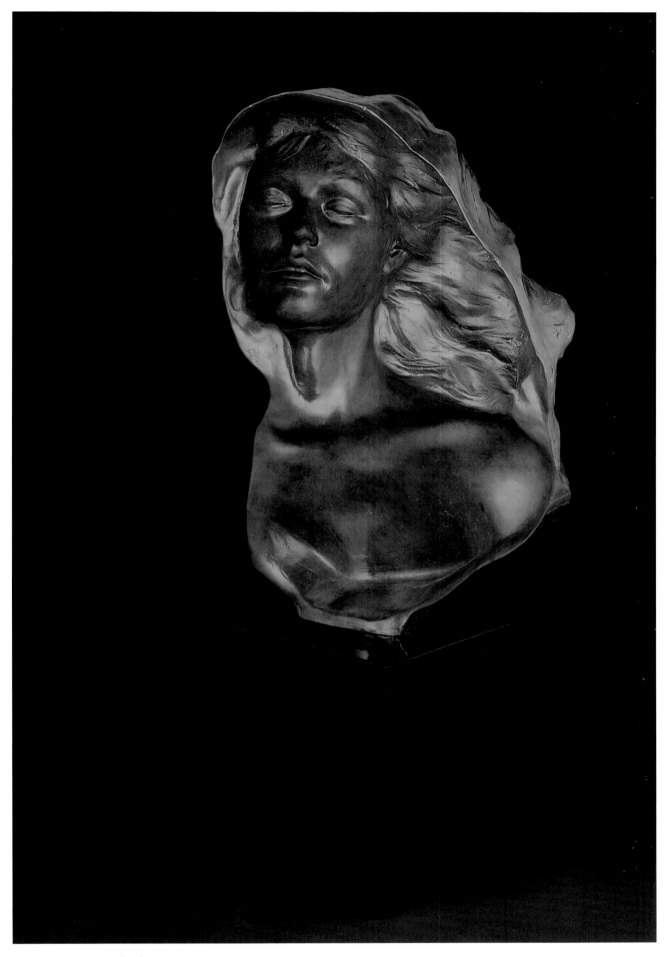

PLATE 55: *Enigma* (back)

155

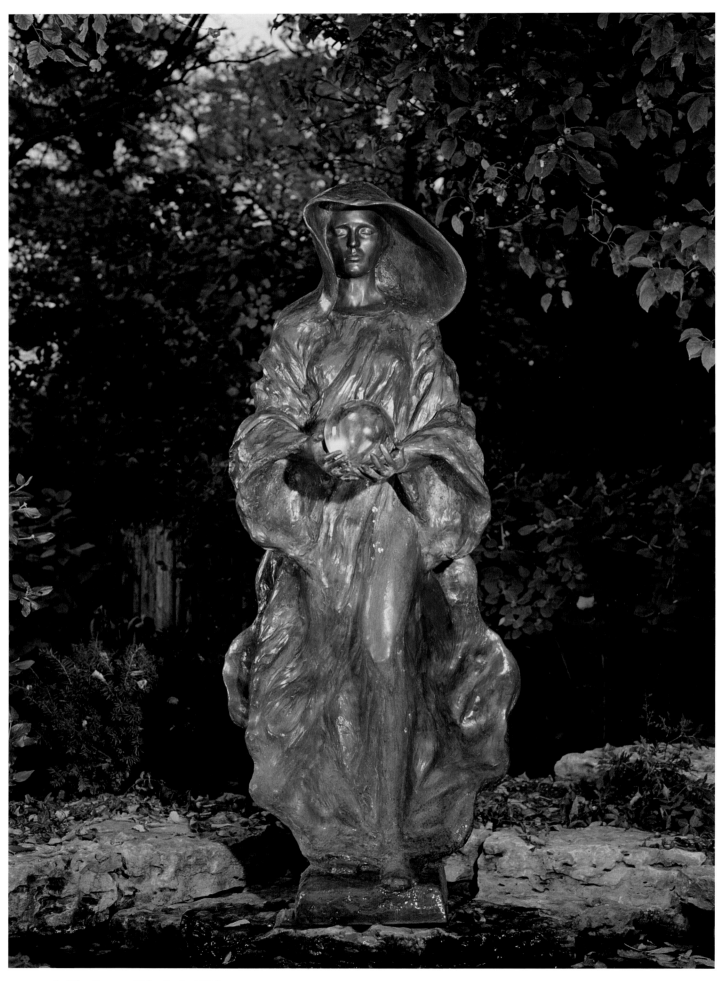

PLATE 56: *The Source* (life-size), 66", bronze, 1991

PLATE 57: *Celebration*, 83", bronze, 1991

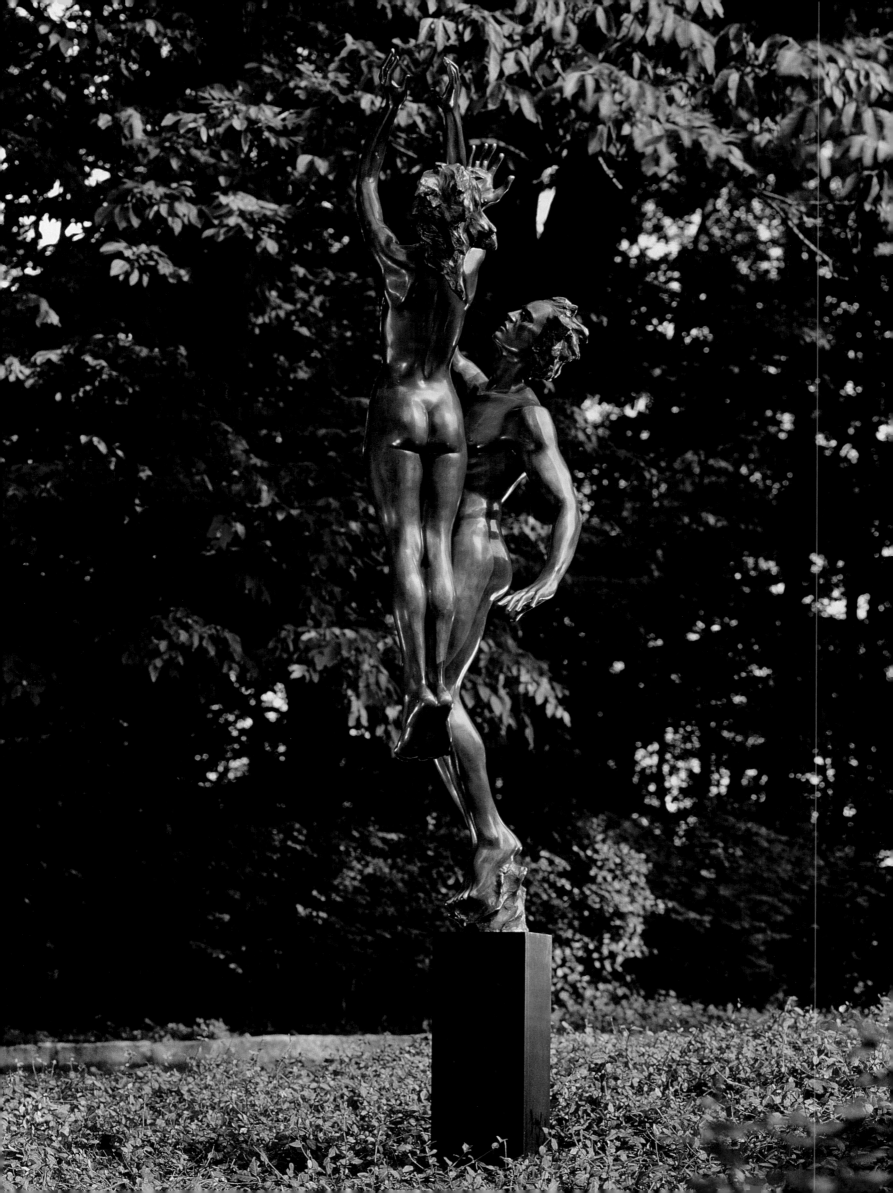

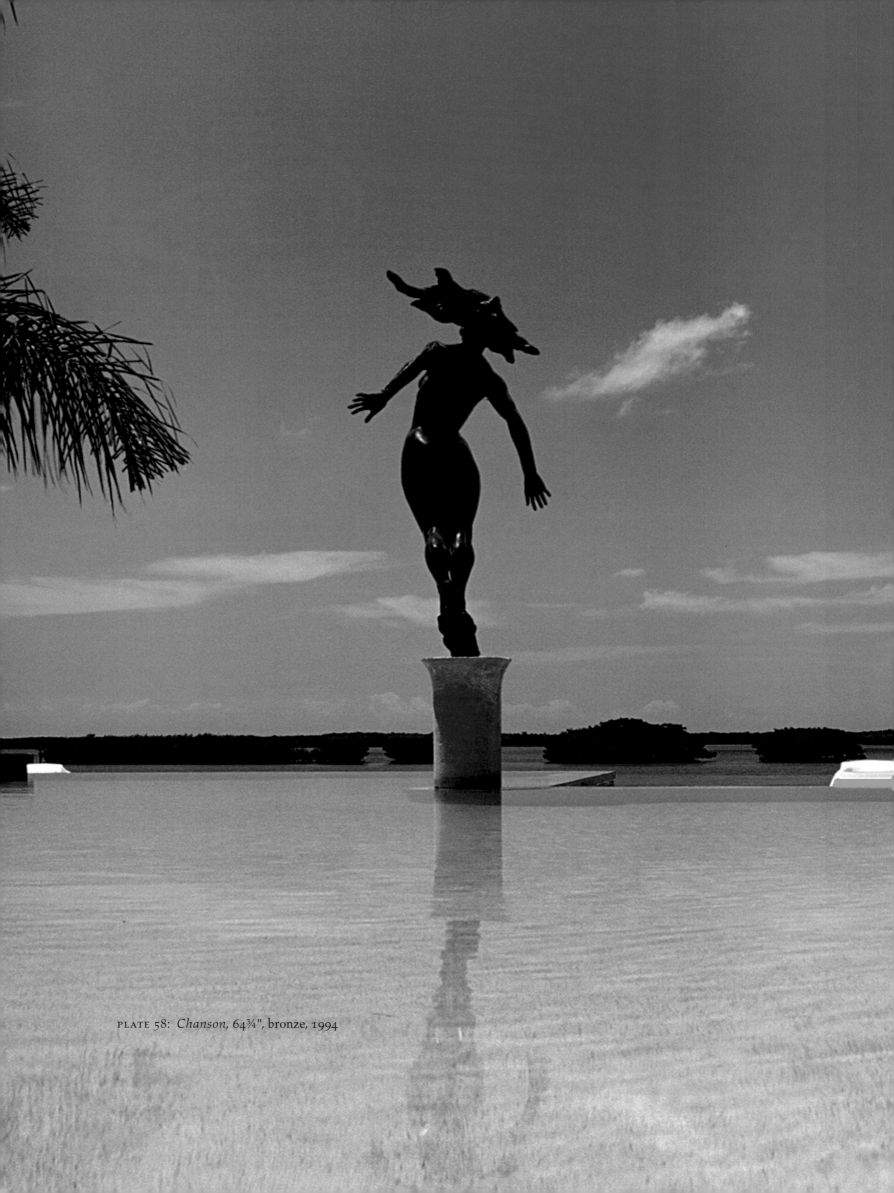

PLATE 58: *Chanson*, 64¾", bronze, 1994

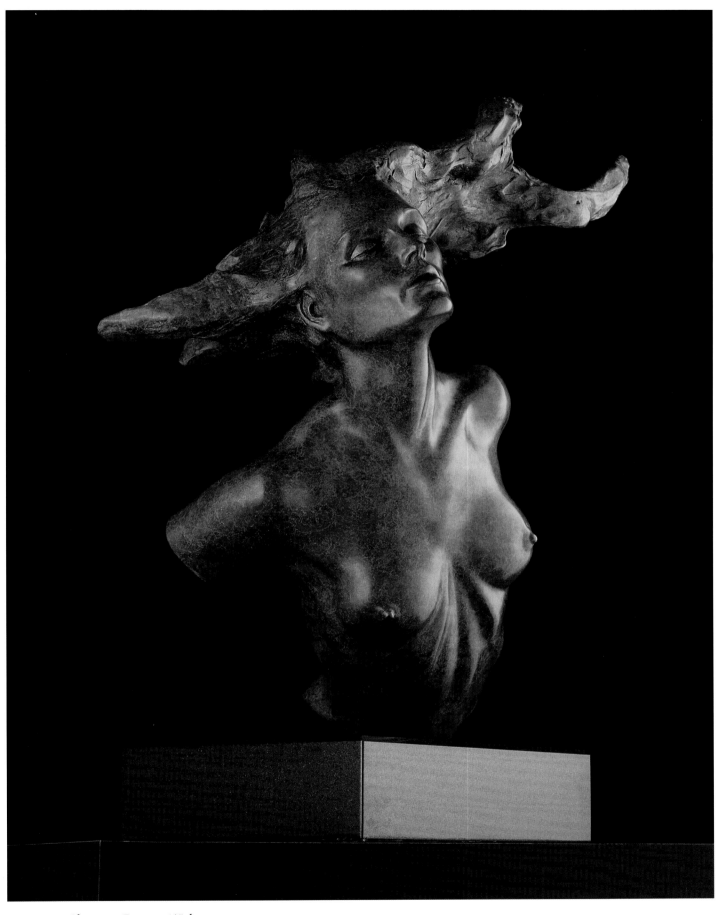

PLATE 59: *Chanson: Bust*, 31½", bronze, 2004

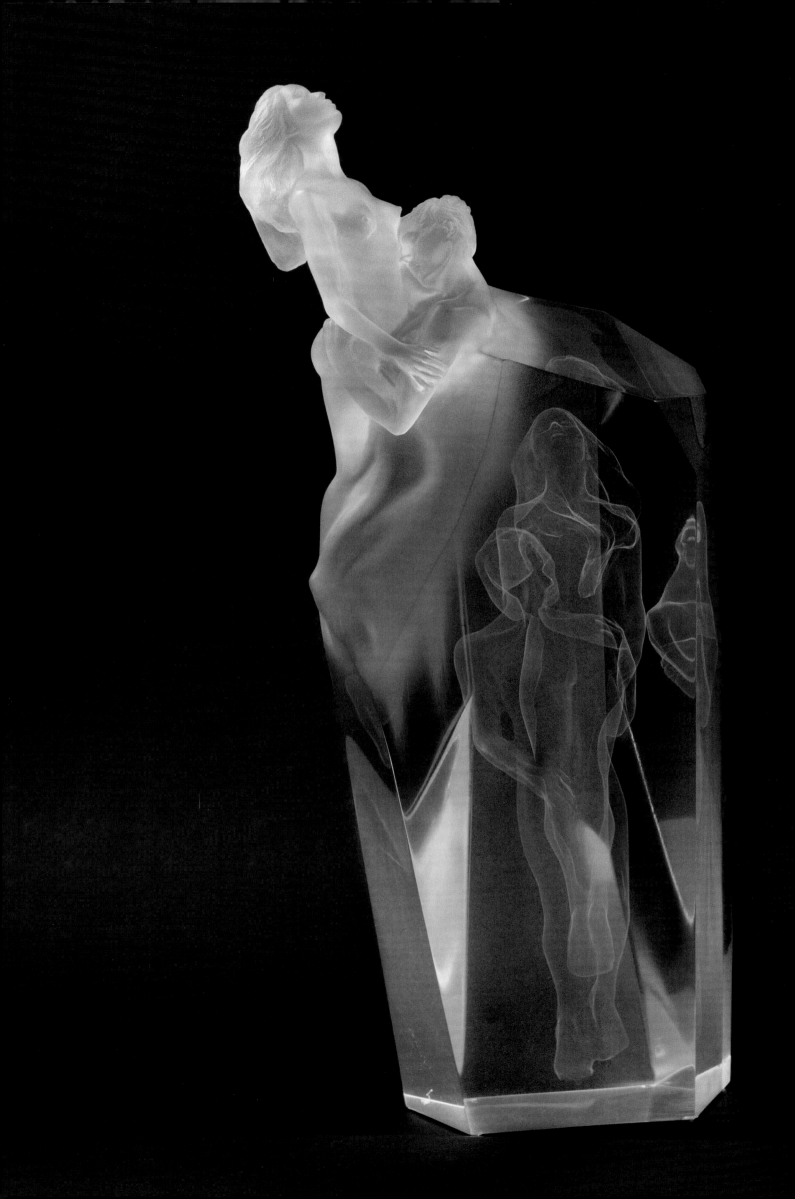

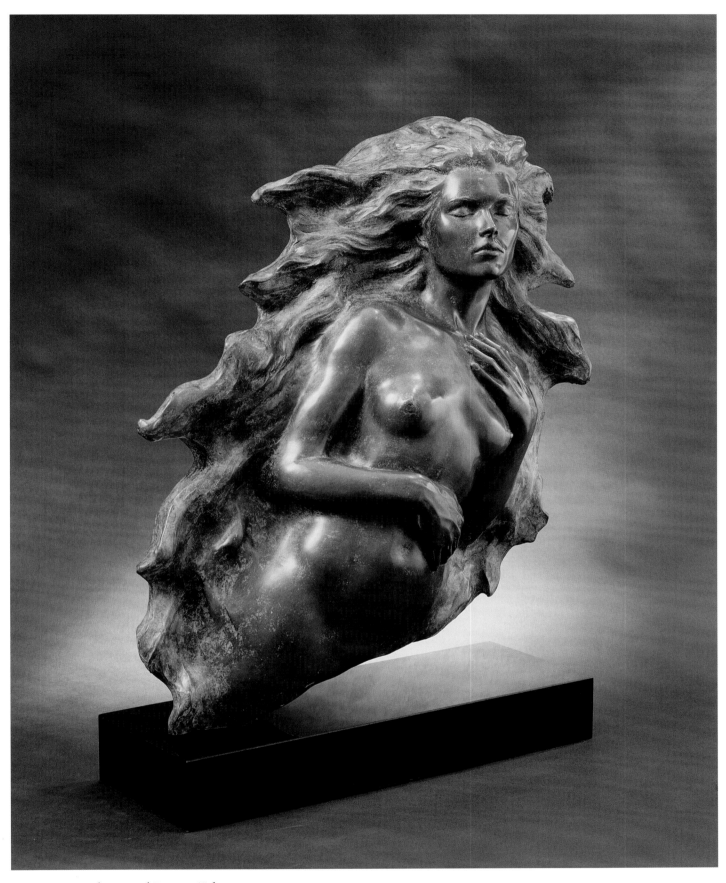

PLATE 61: *Awakening of Eve,* 19⅝", bronze, 1994

PLATE 60: *Dance of Life,* 23", clear acrylic resin, 1997

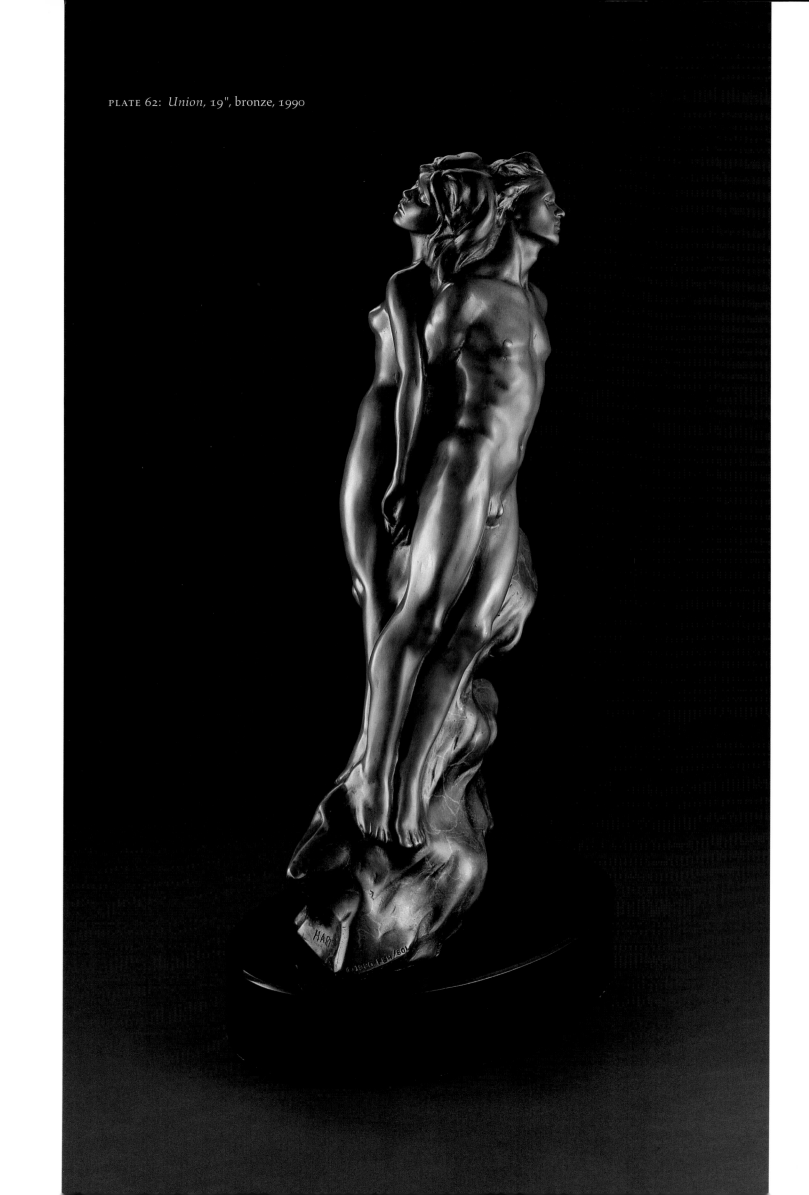

PLATE 62: *Union,* 19", bronze, 1990

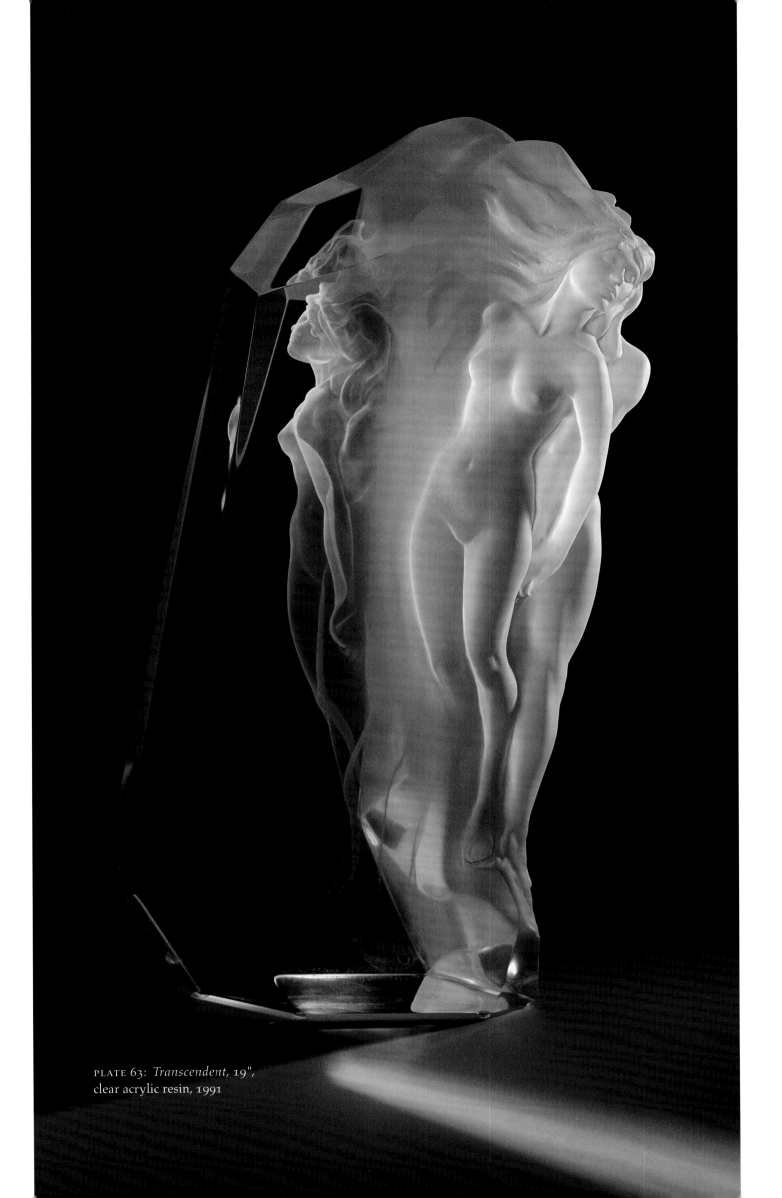

PLATE 63: *Transcendent*, 19",
clear acrylic resin, 1991

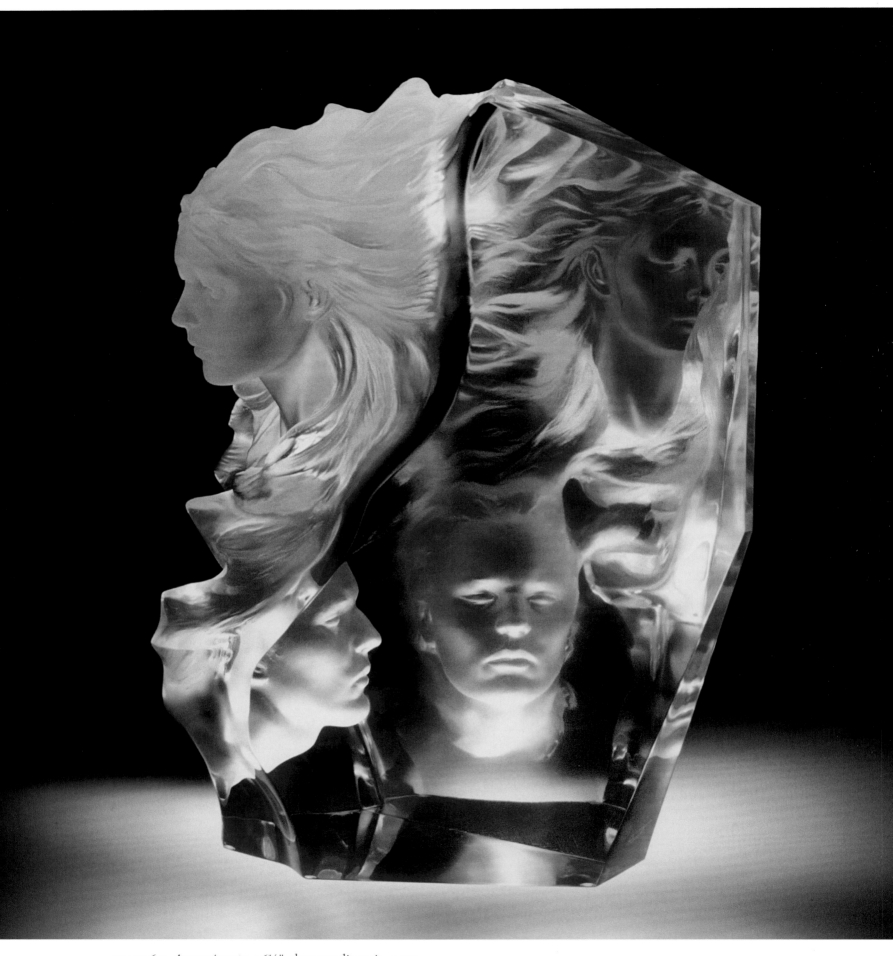

PLATE 64: *Appassionata*, 16½", clear acrylic resin, 2000

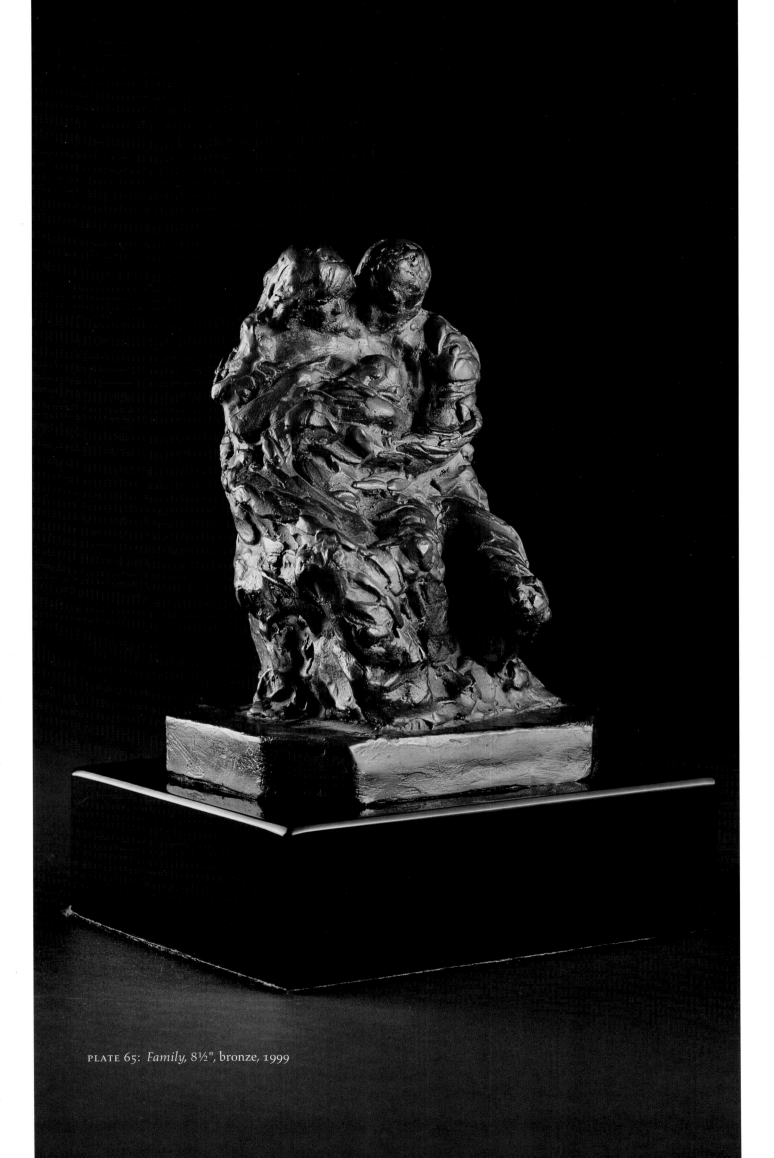

PLATE 65: *Family*, 8½", bronze, 1999

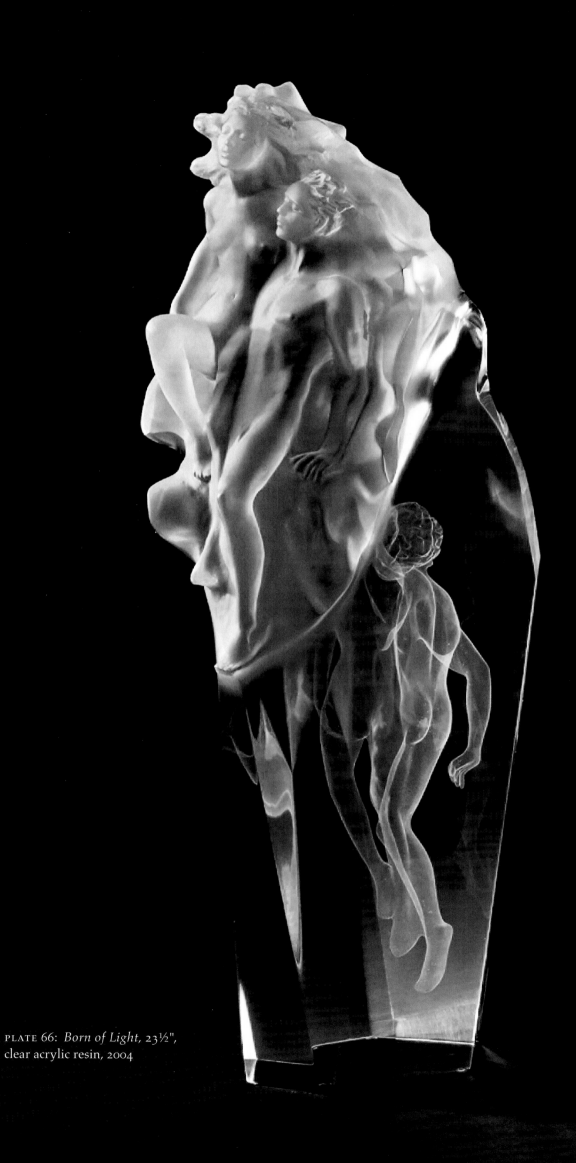

PLATE 66: *Born of Light,* 23½",
clear acrylic resin, 2004

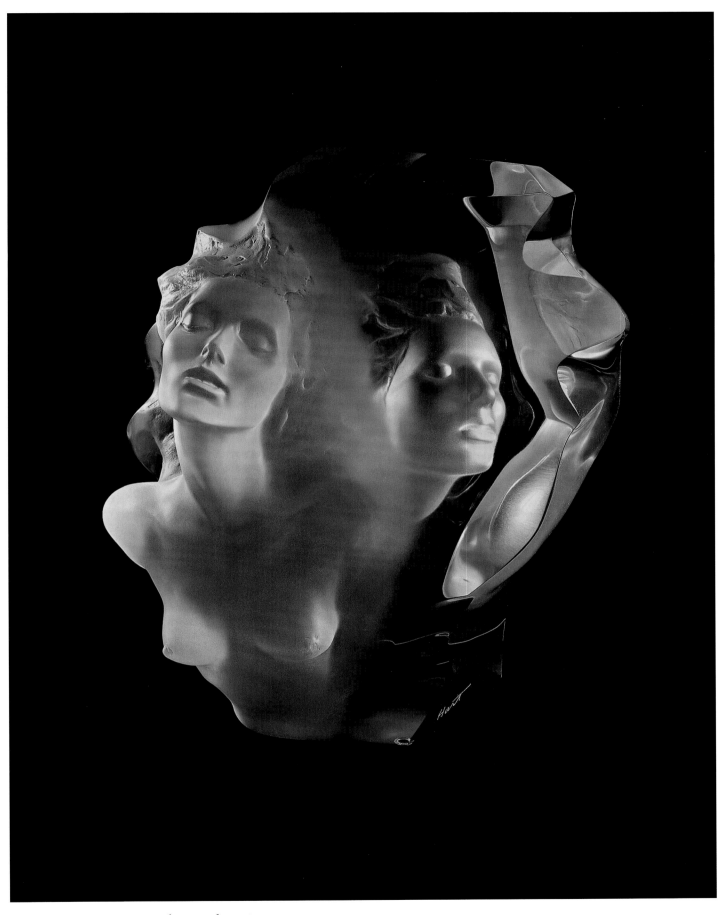

PLATE 67: *Spirit Song*, 10", clear acrylic resin, 2003

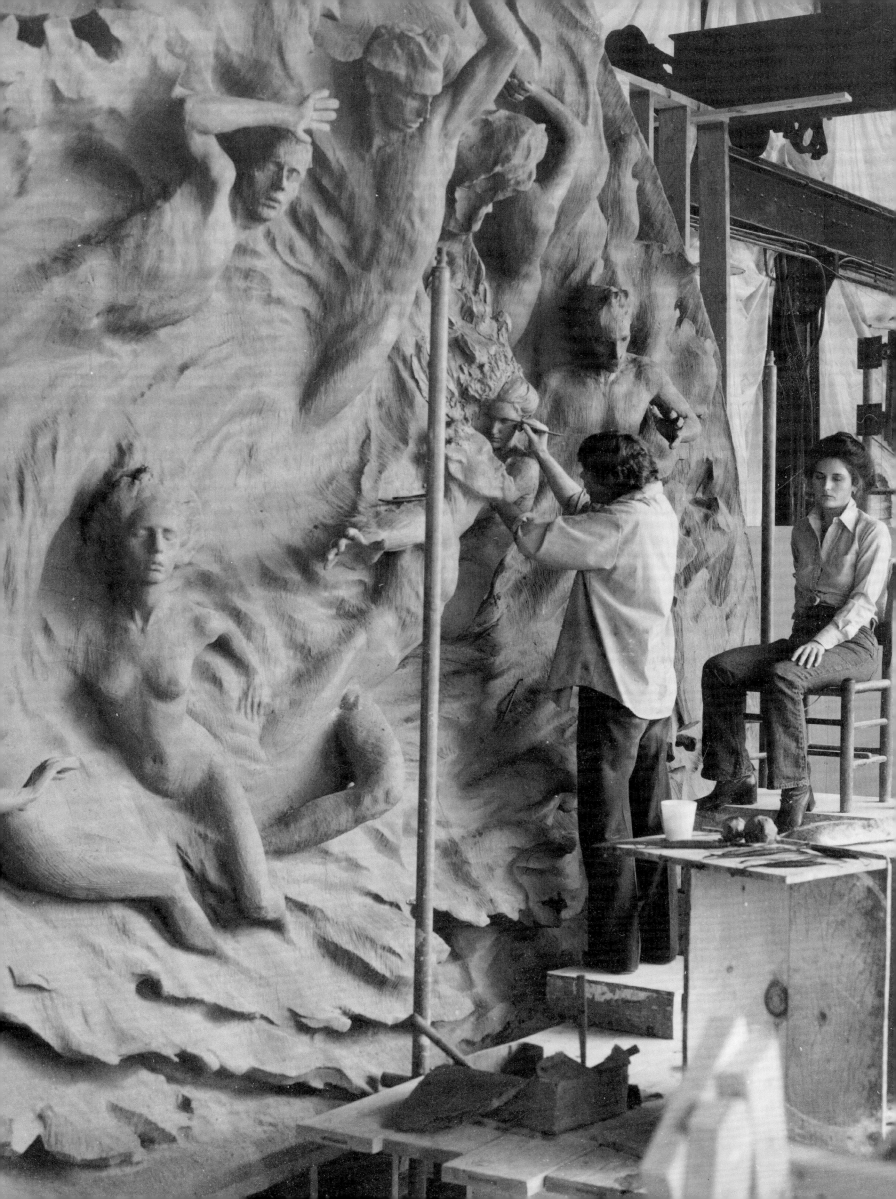

DREAM NO LITTLE DREAMS

Lindy Lain Hart

There was always music; but mercifully, no singing. Unlike Augustus Saint-Gaudens, who sang—some would say bellowed—while sculpting in his studio, Rick did not sing. He played the stereo. Any visitor opening the door to Rick's studio was greeted by a blast of music from a pair of gigantic, antiquated speakers mounted on either side of the life-size plaster cast of *Ex Nihilo*. The visitor might even catch Rick madly conducting an invisible chorus from Verdi's *Nabucco* or lip-synching the words to *La donna e mobile* while Jussi Björling did the singing. The stereo was either tuned to a classical radio station, or playing one of Rick's plaster-encrusted tapes or CDs. Rick and Saint-Gaudens shared some classical favorites, including the serenade from *Don Giovanni* and the Andante from Beethoven's Seventh Symphony; but Rick also enjoyed Cajun music, Irish folk songs, the wail of bagpipes, blues, Stefan Grappelli's jazz violin, show tunes—many types of music. One of his favorite tapes was Paul Simon's *Graceland*. Opera, however, was Rick's musical passion. It inspired him, not only as he worked in his studio but also when he was at home in the evenings, reading or pondering new projects. He loved everything about opera. He loved the music, the drama, the performers, and the production—but for Rick, opera was much more than an enjoyable and enriching interest. He had a profound understanding of the nature of opera and a deep trust in the truth of it. In his work as a sculptor, he mined the richness of that nature and drew repeatedly from the wellspring of that truth.

When I met Rick in 1977, he had been working on the Washington National Cathedral commission for three years, but he was not far removed from the days when his two German shepherds were the only source

Lindy Lain, soon to be Mrs. Frederick Hart, posing for *Ex Nihilo*, 1978

of heat in his garage studio/apartment. He had recently been evicted from his apartment above Schwartz's Drugstore at Connecticut and "R" Streets. All the tenants, who were artists, writers, and neighborhood characters, had been evicted because the building had been sold. Rick and the other tenants challenged the new owners but lost the battle. As a result Rick had just moved into a two-room basement apartment on Corcoran Street, N.W. He drove a belching old car that someone had given him, and his wardrobe consisted of little more than a pair of ancient plaid slacks (fig. 89) and an abused wool sweater dotted with coffee stains and cigarette burns. Most of the friends I had made since moving to the Dupont Circle neighborhood, including Rick, lived shakily and blissfully from paycheck to paycheck, but Rick was different in one respect. Those of us on limited budgets might go to the Kennedy Center either as volunteer ushers or with "standing room only" tickets. Rick, on the other hand, had box seats to the Washington Opera.

How did he manage such an extravagance? The previous year he had been the beneficiary of a small inheritance. He used the surprise windfall to buy a few pieces of antique furniture, a pair of crystal candelabra, and a chandelier for his apartment. He used the balance to buy box seats to the opera, as well as to the National Symphony Orchestra. He sometimes gave away the symphony tickets, but he never missed the opera. In the late 1970s, many members of the opera audience favored evening attire, especially box seat subscribers who were invited to opening night receptions and to a private lounge for refreshments during intermissions. Rick, fortunately, left the plaid slacks at home on such occasions and wore the only suit he owned at the time, a tuxedo.

What set the stage for Rick's intense affinity for opera? Perhaps it was a series of early and indelible

FIG. 89: Frederick Hart in his studio, 1975

experiences in his life. While I do not want to over-state this notion, Rick's life did seem to have an oper-atic sweep. His older brother, Frederick William, died in infancy. In 1947 when Rick was four years old, his mother took him to Conway, South Carolina, for a visit with her family. Joanna Elliott Hart was the beau-tiful and spirited "baby" of the Elliott family. During that tragic visit she fell ill with scarlet fever and died. Rick remained in Conway in his mother's childhood home where his grandmother still lived along with a house full of Elliott aunts, uncles, and rambunctious older cousins. There were dogs and cats and a constant stream of visiting friends and relatives from down the block or up state. It was a lively, loving mess of a south-ern clan ably presided over by Rick's grandmother and his beloved aunt Essie (fig. 90).

After receiving his wartime discharge from the Navy, Rick's father arrived in Conway to take Rick back to Atlanta. There Rick would meet his new stepmother. Rick's place, suddenly, was no longer at the center of a warm and indulgent family, but at the periphery of a new marriage that seemed to have little room for the uprooted little boy. When Rick was five, he contracted polio and lay gravely ill in an iron lung. Shaken by his illness, his parents drew closer to their son, but, in 1949, after his complete recovery from polio, the boy's life took another sharp turn. His sister Chesley (fig. 91) was born. Her arrival again cast Rick to the periphery of the family. His parents doted on their new daughter but were seemingly careless with the tender feelings of their six-year-old. Likely confused and hurt, Rick nevertheless adored his little sister, and he and Ches-ley developed a close sibling relationship.

Rick's family moved to the Washington, D.C., area in 1955, and Rick entered a troubled adolescence. Rick was an avid reader but an indifferent student. He was obsessed with drawing and had declared at an early age his intention of being an artist. He failed the ninth grade—twice, once in Virginia and again in South Carolina. A dedicated teacher in Conway recognized Rick's intellectual potential and urged him to take the ACT college entrance exam. By virtue of his soaring score, he was admitted at age sixteen to the Univer-sity of South Carolina. His one semester there in 1961

FIG. 90: Rick with his aunt Essie, 1953

FIG. 91: Rick with his sister Chesley, 1953

ended when he took part in a civil rights march and was jailed and subsequently chased out of Columbia, South Carolina, by the Ku Klux Klan. Rick did not return to his parents' home. He landed in Washington and drifted toward the arts community, where over the next several years he continued his faltering quest for direction and purpose. In 1965, Chesley was diagnosed with leukemia. Her illness exacted a bitter and debilitating toll on Rick's parents. As a consequence, Rick's aunt Grace, his stepmother's sister, stepped in to take care of Chesley. Yearning somehow to restore his disintegrating family, Rick helped his aunt as much as he could. He later transformed this struggle into a compelling sculpture called *Family* (fig. 92). When Rick was twenty-three and Chesley seventeen, she died.

Chesley's death struck Rick hard. It pierced his carefully welded armor of youthful nonchalance. Underneath was a highly gifted and brilliant young man, whose churning mind was anchored by a generous spirit, but whose life lacked direction. Grieving for Chesley's unfulfilled life, Rick began to examine his own. Around this time, he had "stumbled into a sculpture class at the Corcoran School of Art and was blown away." As he began to pour his abundant energy into this new passion, his grief forced him to ask life's basic questions. His maturing intellect and burgeoning talent thrust him into new realms of thought where an-

swers began to emerge from his art. Compelled by loss and guided by a need for hope, he persistently probed the outer limits of experience and imagination, catching glimpses of an illusory seam where being and nonbeing alternately unravel and knit together, where the spirit takes shape and creation begins.

Throughout his career Rick returned again and again to explore the confounding tension he had discovered in the divide between the known and the unknown, between the physical and the spiritual. The *Arm of Adam* (page 40) is a detail from the trumeau figure of *Adam* at the center of the west entrance to Washington National Cathedral (fig. 94). The modeling of the arm, a conscious tribute to the modeling of the arm of Michelangelo's *David* (fig. 93), conveys a constrained human physicality poised for the imminent and wondrous release of its spiritual power. Rick

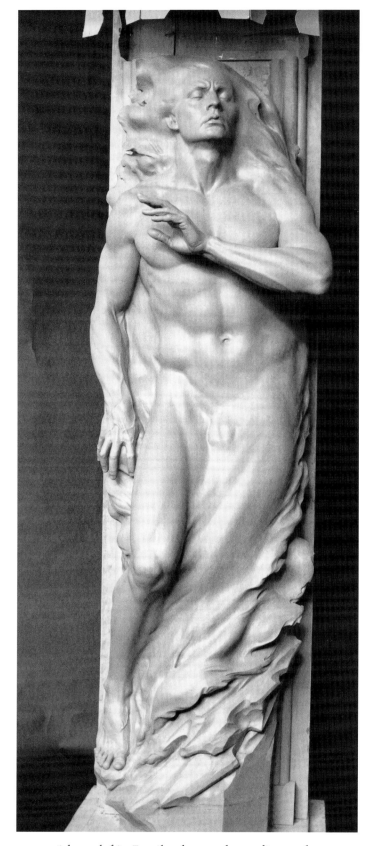

FIG. 92 (above, left): *Family*, clay, on the studio stand as Hart works on the clay of *Erasmus* for Washington National Cathedral, 1969

FIG. 93: *David*, Michelangelo Buonarroti, marble, Galleria dell'Accademia, Florence, 1501–03

FIG. 94: *Adam*, clay, for Washington National Cathedral

172

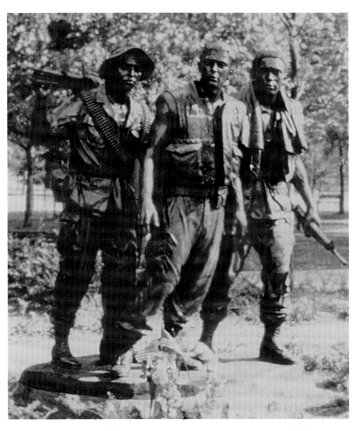

FIG. 95: *Three Soldiers*, Vietnam Veterans Memorial, bronze

FIG. 96: A party at Chesley in recognition of Washington National Cathedral Master Carver Roger Morigi (right) and Clerk of the Works Canon Richard Feller (left), 1993

created a similarly charged gesture for the arm of the leading figure in the group of three soldiers (fig. 95) he sculpted for the Vietnam Veterans Memorial (1982–84; see page 195). This taut, muscular arm is a recurring motif, expressing Rick's insistent faith that the force of the human spirit is freed from the depths of mere existence by man's discovery and knowing embrace of the divinity within himself. *Adam* must be pulled into consciousness as he struggles to emerge from the inert dream of the void. The soldier cautiously holds back his men before leading them into the next moment. Both the *Adam* and the memorial's unnamed soldier capture the fundamental tension between an individual's wary resistance to the demands of God and his will to embrace and fulfill those demands.

To Rick, who had always preferred drawing to painting, sculpting was simply drawing in three dimensions, and the more he studied sculpture, the more it captivated him. Ridiculed for wanting to pursue figurative sculpture and dissatisfied with the academic instruction he had received, Rick was drawn to Washington National Cathedral, the last great cathedral built in the Gothic style anywhere in the world. Construction had

begun in 1907 and was then in its sixth decade, under the charge of the Very Reverend Francis B. Sayre, Jr., the Cathedral's dean since 1950. At the time of his appointment, Dean Sayre had staunchly resisted efforts to persuade him to abandon the Gothic style and to recast the architecture of the Cathedral in a modernist style. His enthusiastic dedication to the Gothic aesthetic led him to assemble a skilled and talented workforce of craftsmen and artists to build the structure and to embellish it with beautiful art.

Stone carvers were among the highly skilled artisans employed at the Cathedral. They carved magnificent statues and bas-reliefs of saints, angels, statesmen, and ordinary men and women, as well as gargoyles and grotesques and other decorative flourishes that help define the Gothic style. The predominately Italian carvers formed a coterie steeped in tradition. In 1968, seeking to enhance his modeling skills by learning to carve, Rick was determined to break into the carvers' closed ranks. He took the only job open to him at the Cathedral, that of mailroom clerk. He eventually caught the attention of Richard Feller, Clerk of the Works, and Roger Morigi, Master Carver (fig. 96), both of whom agreed to hire Rick as a stone carver. Rick began a defining period in his life. Richard Feller became Rick's champion within the Cathedral community, and Roger became both a demanding, fire-breathing mentor and steadfast father figure. Rick's experience at the Cathe-

FIG. 97: Robert Chase on the scaffolding in Rick's studio viewing The Creation Sculptures

FIG. 98: Rick sculpts six-week-old Lain , 1980

FIG. 99: Hosting the Old Dominion Hounds Hunt Ball at Chesley, 1996

dral molded his life as an artist and began to shape his thinking about art. For Rick the Cathedral represented the rich and vital contributions art had made to the development of civilization, and it provided the tangible link the novice sculptor needed to bring together his fledgling ideas about the nature and purpose of art. In the stone carvers' shed and on the dizzying heights of the Cathedral scaffolding, Rick was under the watchful mentoring eyes of Roger Morigi and the other stone carvers. He flourished under the sometimes withering but consistently encouraging criticism and learned invaluable lessons of excellence, discipline, cooperation, and integrity. Rick treasured his youthful years on the Cathedral Close, where there was a strong bond of service among those striving to raise an edifice worthy of God's glory.

During his four years as a stone carver at the Cathedral Rick made many lasting friendships, but

in 1972, eager to concentrate on modeling in clay, he left the Cathedral in order to open his first sculpture studio. That same year the Cathedral opened an invitational competition for the sculptural treatment of the west facade portals. The traditional iconography for the west facade is the Last Judgment, but the Cathedral chose the theme of Creation. Richard Feller persuaded members of the building committee to include a young, unknown sculptor among the world-renowned sculptors invited to compete for the commission. After three years of work, the building committee judged the entries on a blind jury basis. The

young, unknown sculptor, Frederick Hart, won. Rick would devote the next ten years of his life to the completion of The Creation Sculptures. Still at work on the Cathedral sculptures, Rick was awarded the commission to create the processional cross for Pope John Paul II's historic Mass on the Mall in Washington, D.C. (1979). The *Three Soldiers*, a monumental figural group for the Vietnam Veterans Memorial on the Mall (1982–84) was the next project. Other works followed in quick succession: the bronze bust of James Webb, head of NASA, for the National Air and Space Museum, Smithsonian Institution (1982); the public sculptures of President Jimmy Carter (1994) and Senator Richard B. Russell, Jr. (1996); and a series of twelve editioned works entitled the *Age of Light* (begun in 1984). With the help of Robert Chase (fig. 97), who had become his publisher in 1979, Rick developed and patented a method of casting sculpture in clear acrylic resin. These acrylics became gallery successes, as did his bronzes. Two subsequent events in his life heightened what seemed to be a continuing drama. In 1997, he presented his *The Cross of the Millennium* to Pope John Paul II, and in 1998 he presented *Daughters of Odessa* to the Prince of Wales.

Rick and I married in 1978 and lived in Washington until 1987, when we settled with our two sons, Lain (fig. 98) and Alexander, on a farm in the Virginia countryside . We named the farm Chesley and built a house on the property in the grand Beaux-Arts style (figs. 99–101). Rick's long-time friend David Hytla (fig. 102) executed the plasterwork that distinguishes both the interior and exterior. Together David and Rick had started an ornamental plasterwork business, Hytla and Hart, in 1975, and although Rick no longer was a partner, he enjoyed helping with the design work for our house. Rick used to say that he had built the house he thought he grew up in. He was referring to a combined memory of the Elliott house in Conway, which was modest compared to Chesley, and the grander, historic house in Villa Rica, Georgia, where his aunt Grace had lived with her four children. Remembered through the eyes of a four-year-old and later through the eyes of a rejected adolescent, both houses were grand, but not simply because of the architecture. The true grandeur Rick recalled from childhood and sought to instill in

the house he created for our family, in all he created, was in life itself, with its jumbled, exuberant, and unpredictable force (figs. 103–105). He sought to create order in life by shaping beauty and being shaped by it.

Rick chose a secluded, wooded area of the property to build his studio, a shingled barnlike structure with a porch that was quickly engulfed by wisteria (fig. 106). Every spring the thick leaves and fragrant purple blossoms formed a soothing canopy of shade, which came alive with bumblebees sounding like a chorus of tiny buzz saws. Like the buzzing wisteria, the studio's tranquil setting belied the constant activity within (fig. 107). Rick savored the energizing serenity of life in the country until the fall of 1993, when he underwent open-heart surgery. Rick met the challenge to his health with a characteristic mixture of determination and good-humored impatience, but above all with an unyielding resolution never to take tomorrow for granted. One consequence of this resolute carpe diem attitude was Rick's decision to overcome his reluctance to travel. He especially wanted to offer our sons the enrichment of traveling as a family. One trip took us to Milan, which provided an operatic grace note to our travels together. Our suite in the Grand Hotel was the one where Giuseppe Verdi had lived for a time.

Whether or not the dramatic events of Rick's life contributed to his embrace of opera, it is clear that he found inspiration in opera, especially through his need and ability to translate life's essence into art. Opera is an extravagant concoction of art and artifice that is set roiling by conflict and conflict resolution. Opera unfurls the complete tapestry of human experience—love, hate, fear, revenge, remorse, hope, redemption, despair, joy. Like a flying carpet, it transports us to a realm of ineffable insight. Rick believed that art should explore that realm where the raw, messy business of life takes divine shape and meaning. In *Tristan und Isolde*, Richard Wagner wrote, "Life and death, the whole significance of existence of the external world, turn on nothing but the inner movements of the soul." Rick believed that to reveal the inner workings of the human soul, art had to be rooted in the everyday concerns of life—otherwise, no one would be looking.

Rick's expressive use of the human figure, his insistence that skill must not be divorced from imagination,

FIG. 100: Rick's sketches for the garden at Chesley

and his uncompromising view that art must nourish society ran counter to the thinking of most late twentieth-century contemporary artists. The resistance he

encountered only deepened his convictions. In a 1971 letter to Richard Feller (page 20) describing his vision for The Creation Sculptures, Rick had posed three

FIG. 101: Our home, Chesley. Rick liked to say that he built the house that he thought he grew up in.

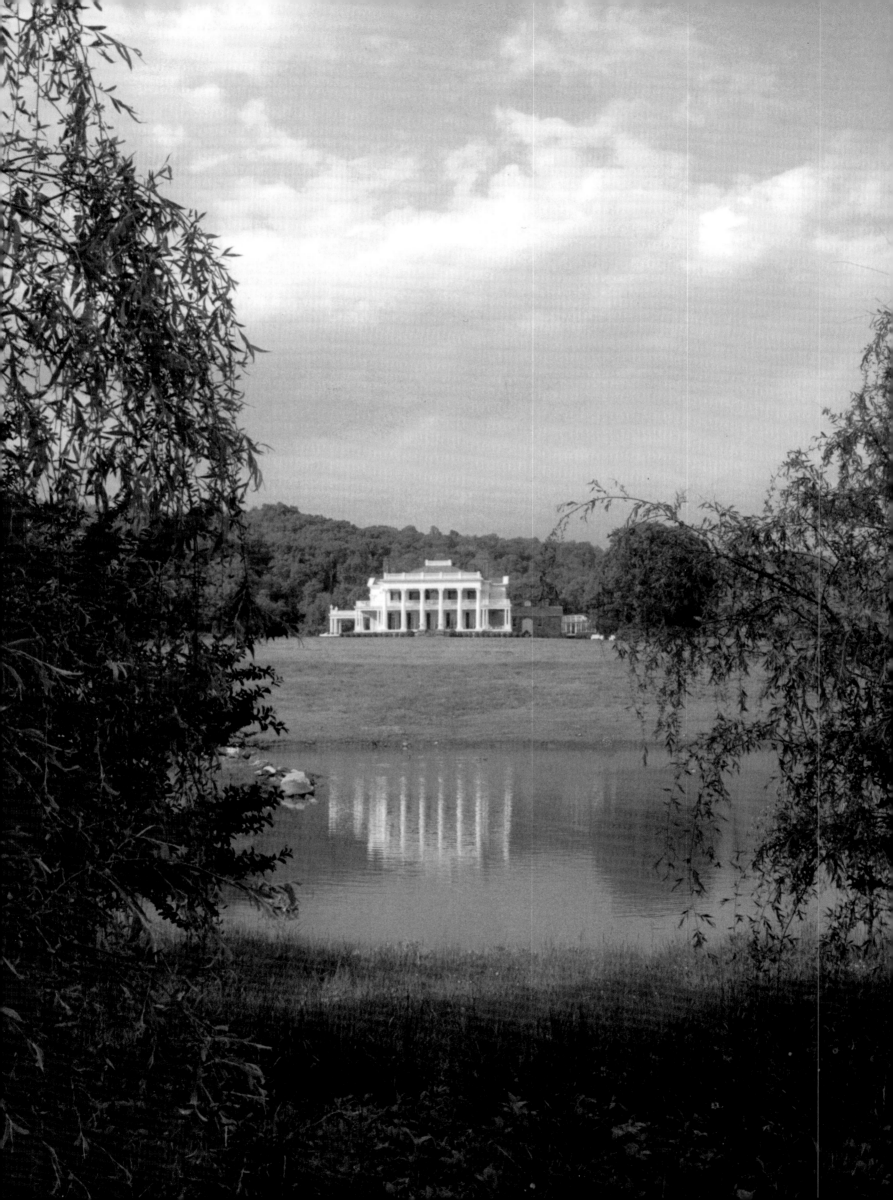

FIG. 102: Our sons, Lain (far left) and Xander (far right), "hilltopping" with their father and family friend David Hytla, 1994

FIG. 104: *The Source,* in a reflecting pond, leads into the teahouse, the final flourish to the rose garden that Rick designed.

FIG. 103: *Torso (female)* and, in the background, a fountain that Rick designed for *Chanson*

FIG. 105: The conservatory, the result of one of Rick's "kitchen table" designs, offers the best views from Chesley of the Blue Ridge Mountains.

essential questions, which he continued to ask throughout his life:

What is the meaning of art?

What is its real purpose?

What does it really contribute to life?

While seeking to answer these questions in the course of his own work, he also sought answers from the arts community, which largely ignored him until 1982 when a controversy erupted over the abstract design that won first place for the Vietnam Veterans Memorial. Rick's design placed third in the competition and was the only figurative design among the top three winners. When a number of veterans wanted a representational statue and American flag included in

FIG. 106: Rick chose a quiet, wooded spot to build his shingled, barnlike studio.

the memorial design, the Vietnam Veterans Memorial Fund turned to Rick who was asked to design a statue to be placed at an unspecified location at the memorial site. The Fine Arts Commission, headed by J. Carter Brown, approved Rick's proposal to create a balanced artistic tension between the two elements of the memorial by placing the *Three Soldiers* near the entrance to the memorial, away from the wall of names and facing it. Because many critics felt the inclusion of the sculpture and a flag was antithetical to the abstract concept, a strong public debate ensued about the memorial and about the legacy of the war itself. It was a blistering experience, but Rick was glad finally to find a forum for his ideas and to discover others on the same platform. Over the years he met like-minded artists, writers, poets, musicians, and philosophers, whom he invited to Chesley. Together they formed a group called the Centerists to challenge the established art world.

In the summer of 1999, shortly before his death, Rick was among a number of leaders in various fields who were asked by the *American Enterprise Journal* to write a "millennium" essay. In each essay, the authors were asked to envision the future contours of each one's particular field and to speculate on the direction in which new currents might flow. For his contribution, Rick proposed to take Augustus Saint-Gaudens on an imaginary tour of the National Gallery of Art Sculpture Garden. Saint-Gaudens, the nation's preeminent sculptor of the American Renaissance (1876–1917), played a leading role among the energetic visionaries who were then infusing America, battered by the recent Civil War, with confidence and muscle. He was a man of immense talent and generosity, with a robust

179

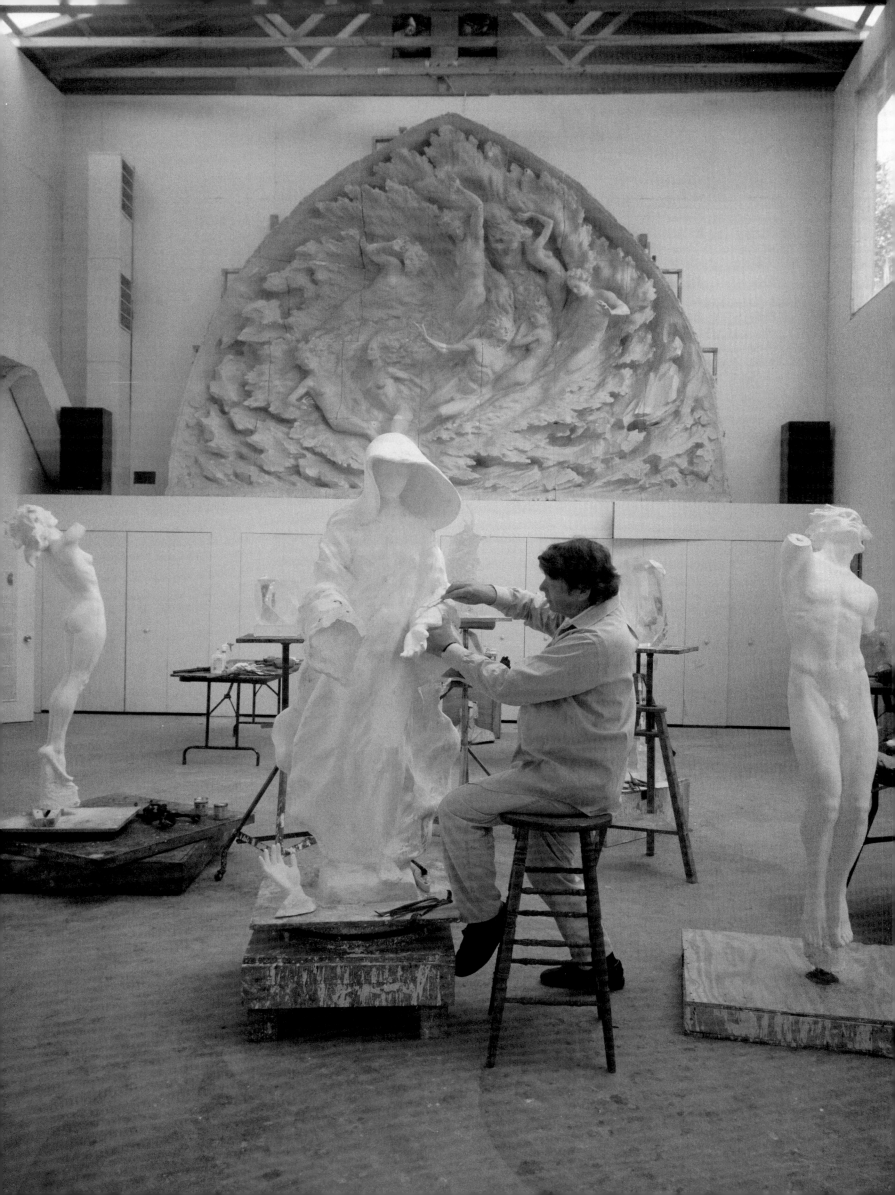

sense of humor, and an eye with the "equivalent of perfect pitch" (Wilkinson, 1985, p. 91). Saint-Gaudens devoted his life as an artist to serving society by molding, out of the morass of life's failings, comprehensible beauty that possessed the transcendent power to illuminate truth and goodness. Rick was intrigued with the idea of postulating how such an artist would have regarded a contemporary sculpture garden. He hoped to nudge the truth with good-natured conjecture and glimpse the future of art through Saint-Gaudens's perfect eye.

In preparation for the essay, Rick began rereading *Uncommon Clay*, a biography of Saint-Gaudens by Burke Wilkinson. He never finished it. I recently picked up the book. I turned to a description of a sculpture by Saint-Gaudens, which Rick referenced in his own sculpture, *The Source* (1991, page 156). The Saint-Gaudens sculpture, situated in Rock Creek Cemetery in Washington, D.C., has become known as the *Adams Memorial* (fig. 108). In Wilkinson's words: ". . . the figure transcends grief and has an element of the supernatural. She seems to sit at some far meridian of the known and unknown, some outer boundary where the finite touches the infinite."

As I began reading the Wilkinson passage, a delightful image floated into my mind. Rick and Saint-Gaudens were perched high on that far meridian, deep in discussion about the sculptures they had just seen on their walk together. As the conversation turned to a broader discussion of art, Rick asked Saint-Gaudens:

What is the meaning of art?

What is the value of art?

What does it really contribute to life?

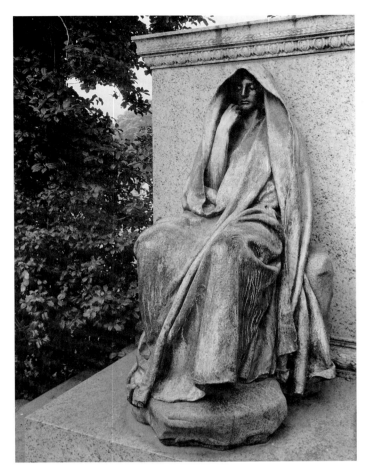

FIG. 108: Augustus Saint-Gaudens, *The Adams Memorial*, bronze, Rock Creek Cemetery, Washington, D.C., 1886–91

FIG. 107: Rick sculpting in his studio, 1990

Frederick Hart, c. 1970

THE ARTIST'S NOTEBOOKS: WRITINGS AND SKETCHES

The philosophical foundations of modern art are crumbling. If the history of art has shown us anything, it has shown that nothing—no school, no style, no philosophy—is permanent. As modes of thought wither and become hollow and empty, they are inevitably challenged and vanquished. That time has come again.

<div align="right">1983</div>

If art is to flourish in the twenty-first century, it must renew its moral authority by philosophically and fundamentally rededicating itself to life rather than art. Art must again touch our lives, our fears and cares. It must evoke our dreams and give hope to the darkness.

<div align="right">1989</div>

To renew this relationship of art and society is to renew art itself. I would like to see the ideal of Beauty in art reborn, based on a renewed understanding of the nature of Beauty, guided by the likes of Frederick Turner, wherein Beauty as an artistic ideal is understood in its metaphorical role: as a reflection of the highest and most noble values of mankind and society.

<div align="right">1995</div>

Letter to the editor,
The Washington Post
November 7, 1979

To judge by public reaction, art is rapidly becoming obsolete. William Greider's article, "The Mall's Artful Castle of Intimidation," and Jo Ann Lewis' "Don't Laugh—It's Your Money" (October 28) reflect the withered and shriveling state of contemporary art and the public disaffection for it.

Modernism in art, as in architecture, has failed. Principally, it has failed to acquiesce to the human dimensions, both spiritual and spatial. Aesthetics of pure form in art and architecture have brought about a deadening abstractionism as impersonal as statistics. The once ebullient modernist revolution is now philosophically senile, smug, and self-serving—out of touch with the basic existential needs of grace, meaning, and order.

Art has died and must now be reborn. It will be reborn by a renewed and enlightened perception of the nature of art itself. We do not suffer from a lack of talent, resources, or inclination, but from the lack of an impassioned vision of the purposes of art within the pursuit of civilization. A shared faith between the artist and public has been the hallmark of the great ages of art and civilization. The so often sterile landscape of contemporary life can be transformed by a reborn understanding of the function of art—an understanding that brings grace of thought and spirit, rather than intimidation, which offers enrichment to the public life, rather than isolating art from it.

It is within the philosophy and practice of art that this rebirth must occur. To survive and flourish, the concerns of art must be rehumanized, must explore the domains of existence and capture the deep resonances of our commonality. In every sense, art must again participate in life.

There exists today a deep and unsatisfied yearning for the substance, beauty, and proportion which art once exerted upon life and society. For art, to fulfill this need is the greatest challenge in the latter twentieth century.

Letter to the editor,
Art in America
November 1983

As has been said, everyone who knows the difference between a Tastee-Freez and a Roman frieze has an opinion about the Vietnam Veterans Memorial! This certainly includes Elizabeth Hess, author of "A Tale of Two Memorials" (A.I.A., April 1983). The snide and derisive treatment accorded my sculpture is rivaled only by her omissions and distortions, which are calculated to support her bias. Phrases such as "trite" or "traditional as a Hallmark card" are typical of the weary clichés contemptuously hurled at the serious figurative artist for far too long. Hess' attempt to turn the memorial controversy into a feminist issue is an idiocy which can only be explained as an act of opportunism—an exercise in ideological squatters' rights. The specific artistic issue actually raised by this controversy, but overlooked by Hess, concerns art and the public and the relationship of art to life.

The simple, bold, flat, unequivocal truth is that modernism has failed in its utopian dream of creating a new and universal language. It has not happened, it is not happening, and it may never happen. The figure is a necessary element if public art is in any sense to be truly public. The simple fact that the philosophical arrogance rooted in the concept of Art for Art's Sake has led to continuously diminishing levels of substance and meaning in art. Art is now nothing more than a cult, held to the bosom of smug elitists who dictate what is, and is not, fit for public consumption. What a stunning day in the history of Art for Art's Sake when a student, a mere student, can be indignant and outraged that a design intended solemnly to

honor the bitter sacrifice and suffering of 2.7 million people is felt to be, in some ways, inadequate. Art is no longer a part of life, no longer in the domain of the common man, no longer an enriching, ennobling, and vital partner in the public pursuit of civilization, no longer the majestic presence in everyday life that it was in the past. The arrogance of art today is equaled only by its insignificance. Do most people today care if art lives or dies? Of course they don't, but why? Because today's art has given them nothing, nothing that bears the slightest resemblance to their own lives, that touches their fears or cares, that evokes their dreams or gives hope to the darkness. It has, in short, become an irrelevant pursuit. It is not the public that has failed art; it is art that has failed the public. If anything can be art, then nothing is art.

If art is to survive into the twenty-first century as anything more than the hot-dog commodities game it has become, then it must be reborn. To be reborn requires a renewed and impassioned vision of the purpose of art within the larger purposes of civilization. The concerns of art must be rehumanized, must explore the domains of existence and capture the deep resonances of our commonality. In every sense, art must again participate in life.

The philosophical foundations of modern art are crumbling. If the history of art has shown us anything, it has shown that nothing—no school, no style, no philosophy—is permanent. As modes of thought wither and become hollow and empty, they are inevitably challenged and vanquished. That time has come again.

The Washington Post
August 22, 1989

The air is becoming suffocatingly pungent with the incense of pious indignation from the art world concerning Congress' reaction to the way the National Endowment for the Arts is spending taxpayers' money.

What is taking place is yet another perverse manipulation of the public by the contemporary art establishment. The public, through its instrument, Congress, has reacted to the baiting and taunting of its sense of decency by the art world through its instrument, the NEA. Underneath its outrage, the art world can barely contain its secret delight at this publicity bonanza featuring a heroic scenario of free spirits versus troglodytes.

What eludes the public is the current philosophy and practice of art, which not only delights in but thrives on a belief system of deliberate contempt for the public. In order to understand this, you have to understand the values of art today and how contemporary art is intellectually packaged for the marketplace. To grasp this is also to grasp the sorry moral condition of art today and how this is shriveling art, making it less and less a meaningful endeavor.

Since the beginnings of Bohemianism in art in the late nineteenth century, rejection by the public has become the traditional hallmark of what comes to be regarded as great art. An offended public is a critical necessity for the attainment of credentials by any artist. The idea that art and artist must be initially misunderstood and rejected has become doctrine in the mythology of great art, and it consequently has become one of the primary criteria in evaluating the historical importance of a given artist. The art world embraced this fable in the late nineteenth century and has been running hard with it ever since.

There is, however, a critical difference between then and now. Life in the late nineteenth century was heavily regimented by strict societal mores: the public expression of emotion and sexuality was severely repressed. When art and literature broke through those layers of repression, people were offended, outraged, and ill at ease about the truths they discovered about themselves. But we live in a different world. Today "repression" is a bad word. Nothing is ever, ever repressed. Everything is discussed, analyzed and ventilated by people ranging from Phil Donahue in the morning to Larry King at night, day in and day out. It's gotten dammed hard if not almost impossible to offend anyone anymore.

But art persists. Every artist worth his salt yearns to create works of art that are (mistakenly perceived, of course) so offensive, so insulting to the public as to earn him a clear judgment of genius for his success at being misunderstood.

185

It has become the intense pastime of contemporary art to pursue controversy, the bigger the better, as a form of art. But the artist has had to reach further and deeper to find some new twist with which to offend. A simple-minded little sophomoric gimmick of making people walk on the flag to make a cute point arouses vast passion and national controversy—for which artist and art world pat each other on the back.

What is really going on is the cynical aggrandizement of art and artist at the expense of sacred public sentiments—profound sentiments embodied by symbols such as the flag or the Crucifix, which the public has a right and a duty to treasure and protect.

When one looks back at the majestic sweep of art history and its awesome and magnificent accomplishments, how nasty and midgetlike are so many of the products and so much of the philosophy of contemporary art by comparison. Once art served society rather than biting at its heels while demanding unequivocal financial support. Once, under the banner of beauty and order, art was a rich and meaningful embellishment of life, embracing—not desecrating—its ideals, its aspirations, and its values.

Not so today.

Look about you. The artlessness of contemporary life has come about because of a breakdown in the fundamental philosophy of art and who it is created for. The flaw is not with a public that refuses to nourish the arts. Rather it is with a practice of art that refuses to nourish the public. The public has been so bullied intellectually by the proponents of contemporary art that it has wearily resigned itself to just about any idiocy that is put before it and calls itself art. But the common man has his limits, and they are reached when some of these things emerge from the sanctuary of the padded cells of galleries and museums and are put in public places, where the public is forced to live with them and pay for them. If one visited a town or a city in Renaissance Italy, the motive of art and its resulting products would come off entirely different. Art was not then thought of as an end in itself but as another form of service. When the Italian peasant looked about, he saw an array of dedicated embellishments from his church to his public buildings, fountains and plazas. The artwork, which was exquisitely

created, embraced his values, his religious beliefs, his history, his aspirations, and his ideals. It was meant to give enrichment through its artistry but, more important, to give purpose through its meaning. It was, as Dante called sculpture, "visible speech." It was not created for art's sake but for his sake.

The measure of achievement in art was determined by the degree to which that art was considered ennobling. Art and society had achieved a wonderful responsibility for each other. Art summarized, with masterful visual eloquence born of a sense of beauty, the striving of civilization to find order and purpose in the universe. This service to truth was more important than the endeavor of art itself. And it was this dedication to service that gave art its moral authority.

This moral authority is the critical element by which a society regards art either as an essential and meaningful part of life, as in Renaissance Italy or, as today, a superfluous bit of fluff, mainly indulged in by a small snobbish minority. Art is regarded by contemporary society much the same way architects now regard art—not as an essence, but as a high-rent amenity.

The most touching and noble impulse toward "visible speech" in recent times was the short-lived creation of the *Statue of Democracy* in Tiananmen Square. Naively executed, it was nonetheless a wonderful display of the unique ability of art to embody and enhance concisely and movingly a deeply felt public yearning for an ideal of a just society. The profound meaning the statue had for tens of millions of people gives the art a value and moral authority of profound significance.

In ancient Greece, which generated 2,500 years of Western art, there existed no distinction between aesthetics and ethics in the judgment of a work of art. Works of art achieved greatness by embodying great ideas, as well as by sheer mastery of the medium. The inspiration and the motivation for that mastery were in the nobility of the ideas pursued.

It is the contemporary renunciation of the moral responsibility of art that is the source of the recent hostilities between art and public. The cutback of funds by Congress is a graphic display of the public's declining conviction of the importance of art, caused by a self-absorbed art that has lost all sense of obligation to the

public good and the betterment of man. It is possible to live without art, and if the nourishment provided by art continues to be so nauseating, life without art will become, for some, desirable.

If art is to flourish in the twenty-first century, it must renew its moral authority by philosophically and fundamentally rededicating itself to life rather than art. Art must again touch our lives, our fears, and cares. It must evoke our dreams and give hope to the darkness.

"On Public Art "
c. late 1980s

A constant refrain heard from American tourists returning from Europe is their delight at how much a part of life art is for Europeans. It is not only that there is such an accumulated clutter of it, but that art is somehow a pervasive force in everyday life. It is baffling that this nation of ours, a country which in so many regards represents the zenith of the evolution of civilization, is so devoid, by comparison to Europe, of the rich interplay of art in everyday affairs.

But it is not for lack of trying. The culture boom in America of the last twenty years has vastly enlarged the audience for the arts. And yet, all in all, it has more the look of advanced status-seeking than substance. Pity the poor stockbroker, barely able to stay awake, as he sits through an interminable concert of dissonant, incomprehensible avant-garde music. He is paying his dues to high art. Compare him to the effusive taxi driver in Milan who will sing you, whether you like it or not, the duke's aria from *Rigoletto*. He loves it because it is simply—beautiful.

How is it that we have such a disparity? Looking back in history we find some answers. During the Renaissance, the measure of greatness of a work of art was how ennobling it was. The creation of art was not viewed so much as an end in itself, but as a means to embody and glorify the common values and ideals of society. The products of art were both literally and philosophically functional.

The plaza fountain where the peasant or burgher came for his water was replete with sculptural images familiar and dear to him, be they religious, historic idols, or myths and fables. His church, so much the physical embodiment of his moral laws, was filled with the art and artistry that spoke directly to him, reaffirming his values and interpreting them in breathtaking beauty. The human dimension, both spiritual and spatial, formed the heart of aesthetic doctrine. The delicate artistry of the decorative embellishments was meant to please his eye. The work was created not for art's sake, but for his sake. And he knew it. It was popular art of the most extreme sort, and it was created by such men as Leonardo, Raphael, Botticelli, and Michelangelo.

Art, at its most eloquent and greatest, is a tremendous thrust of spirit and meaning—intentionally wrought through high craft to embody a meaning considered far more important than the meaning of art itself. Or as George Bernard Shaw put it: ". . . the best established truth in the world is that no man produces a work of art of the very first order except under the pressure of strong conviction and definite meaning as to the constitution of the world. Dante, Goethe, and Bunyan could not possibly have produced their masterpieces if they had been mere art voluptuaries. It may be that the artistic by-product is more valuable than the doctrine; but there is no other way of getting the by-product than by the effort and penetrating force that the doctrine braces a man to."

This is, I believe, the key to understanding much of the indifference and occasional hostility shown by the public for much contemporary art. The lack of enthusiasm for contemporary forms of art by the public is not the result of an unwillingness to nourish art, but is the result of a concept of art which is unable, and unwilling, to nourish the public.

When the notion of Art for Art's Sake was born, the pursuit of art became an end in itself. The whole perception of creativity began to be egocentric and self-gratifying. The image of the artist as a hero daubing away in his individualistic and private vision of art, not understood by the boorish masses, was born. "I paint for myself!" became the rallying cry for modernism. Early modernists were utopians who believed that with their highly personalized vision of art they were creating a new and universal language of art, which, once

the people caught on, would be embraced by them. But it did not happen. And it never will happen.

One of the prized tenets of contemporary art is to create an artistic event where, as it is said, thought is not restricted or confined by an image or an idea and the imagination is left to run free—like seeing things in clouds; you bring to it what you will. This is a sort of brown bag approach to aesthetics. You had better bring something to munch on because nothing is being served. There is nothing there. In the case of public art, people will feel cheated and angered by this, especially if they had high expectations of seeing something that they could understand and would have meaning for them. How fulfilling would it be to climb the long, high stairs of the Lincoln Memorial to find an empty room? It would be, well, minimal.

In spite of the pedantic badgering and intellectual intimidation practiced by those seeking to promote and justify elusive and weak concepts of art, the simple fact is that their precepts of art neither reach nor serve the great majority of people today.

The fault clearly lies with a philosophy of art that arrogantly believes it knows what is best for people whether they like it or not, whether they understand it or not. The public is neither contemptuous of nor indifferent to art. The majority of the people I have encountered, all across the social and educational spectrum, have a humble wonder and deep appreciation for art. The contempt and indifference, I find, comes from the arts community toward the public. The public has not lost faith in the arts, but the arts have broken faith with the public.

The sad part of all this is that the great majority of people have been unnecessarily segregated from the world of art, which has become the jealously guarded domain of smug elitists. The majestic presence and rich sustenance that the practitioners of art once gave to the pursuit of civilization have been denigrated to a cult, isolated from society, producing work in which the substance and value are utterly obscure and irrelevant to the common man.

A shared faith between the artist and the public has been the hallmark of the great ages of art and civilization. That faith has been broken, but it can be restored by a reborn understanding of the function of art—an understanding that brings grace of thought and spirit, rather than intimidation, which offers enrichment to the public estate, rather than isolating art from it.

We do not suffer from a lack of talent, resources, or inclination. We suffer from the lack of an impassioned vision of the purpose of art within the pursuit of civilization. The so often sterile landscape of contemporary life can be transformed by a reborn understanding of the function of art. It is within the philosophy and practice of art that this rebirth must occur. To survive and flourish, the concerns of art must be rehumanized, must explore the domains of existence and capture the deep resonances of our commonality. In every sense, art must again participate in life.

But what am I suggesting? Abandon the contemporary idioms of art? Return to the image and figure in art? Explore the past once again to rejuvenate the humanist ideals? Revive the riches of the decorative crafts to enrich the visual splendor of our surroundings? Yes, I am. But isn't this pure heresy—reactionary and anachronistic? Perhaps. But it has happened before. And it was called the Renaissance.

"Back to the Future" delivered at "American Art: Today and Tomorrow and an Examination of Today's Issues and Tomorrow's Possibilities," a symposium sponsored by the Newington-Cropsey Foundation, New York, February 4, 1992

I am speaking, not as a critic or a scholar, but as an artist who has been asking himself, and is still asking himself: What is the meaning of art? What is its real value? What does it really contribute to life? Plato said, "Art is politics." What does that mean? Should art make political statements? Is art inherently political?

Not exactly. What I think Plato meant was that both politics and art spring from the same source. They're reflections of society's overall sense of things. Its values and ideals. Or as Tolstoy put it, ". . . the religious perception which governs all societies, even a society such as ours, which does not consider itself religious." In the same vein, Plato also said, "Give me the songs of a nation and I care not who writes the laws."

We are witnessing a colossal political event in the

collapse of a faith that has been seemingly unstoppable, expanding across the globe for almost a century — that is the disintegration of Marxism-Leninism.

We are witnessing the collapse and renewal of the human spirit. With the collapse comes necessity for renewal.

The decay in the foundation was becoming more and more evident, but the sudden breathtaking collapse stunned us all. They also have been stunned and disillusioned at the Café Flore in Paris. The hang-out for generations of France's leading intellectual elite. Its most famous character being John Paul Sartre who said in 1963, "An anti-communist is a dog. I won't move from that position and I never will." And he never did.

Revolutionary fervor has spawned innumerable intellectual and artistic currents and systems of thought, especially in Europe. But now a cloud of disillusionment drifts like volcanic ash across the Atlantic. One wonders how soon it will reach Europe's cultural cousins in America.

Decay, Collapse, Renewal. Renewal! To make new again.

Renew! To re-examine the past. To renew foundations. To renew the standards and to renew the spirit. For those of us who believe that decay has long been eating the foundations of art, we believe that the renewal of art in the coming age will be achieved by a return to past ages of art, not to imitate, but to renew the spirit of art.

What can we find in the great ages of art to rebuild these foundations? By what standards did the great ages flourish?

Noguchi once commented that he was happy to be living in a time when anything can be art. This is a charming and seductive thought, and it's one that is pretty much held by everyone in the art world now.

But if everything is art, then nothing is art. Nothing is set apart as being uniquely art. There are no standards, nothing to aspire to, nothing to rise to, let alone to judge. Judge? Judge a work of art? If you believe anything is art, you can't judge art.

When you look back at the majestic sweep of art in history and its awesome and magnificent accomplishments, it is puzzling why this age, so stupefying, so rich in human achievement, that in this age, art by comparison to the past, is so little a part of life. It imparts so little nourishment to society.

We're not short on talent. We're not short on resources. We're not short on opportunities or desire. What's missing?

You start thinking, is the public negligent? Or is there negligence built into the foundations of art as it perceives itself today?

There once was a golden thread that tied art and society together. For example, if one visited a town in Renaissance Italy, the motive of art would be perceived entirely differently from now. It was not viewed as an end to itself but as another form of service. Or as Tolstoy said, "Art is not one of the higher purposes. It is simply a unique instrument embracing them collectively."

When the Italian looked about his town, he saw a vast array of dedicated embellishments, both of the highest artistic caliber and entirely accessible to him. His church, his fountains, his plazas, his public buildings. The icons in his home embraced his values, his traditions, his history, his beliefs. They gave enrichment, but more importantly they gave meaning to his life. It was, as Dante called sculpture, "visible speech."

The voice that speaks is the voice of society's highest yearning and sentiments. The voice, as Tolstoy said, of society's "religious perception," that overall constellation of values and ideals. This is the true mirror of art.

Art's service to the community of man was more important than art itself. This dedication to service gave art its moral authority.

This is notably true of Renaissance Italy but it is equally true of, say, an American Indian village where art was unselfconsciously woven into daily life, reflecting that society's values and traditions. It is in fact, true of almost all cultures in history.

It is simply a fundamental characteristic of art that its greatest flowering occurs when it is in service to something it holds in greater esteem than itself. Or as G. K. Chesterton said, "Nothing sublimely artistic has ever risen out of mere art, any more than anything essentially reasonable has ever risen out of pure reason." There must always be a rich moral soil for any great aesthetic.

To renew this great relationship between art and society is to renew art itself.

To do so requires us to re-examine contemporary prejudices and presumptions. To restudy discarded axioms in order that we may rediscover and renew the standards. To find the past successes of art, the keys to our success in the future.

Let us go up into our attic, our communal attic, and dust off some forgotten standards. Probably the most antiquated notion, so to speak, is one which nonetheless did serve as a standard, a banner by which the measure of art was to be judged—that is the ancient trinity of truth, beauty, and goodness. Sounds good but what does it really mean? How does it work as a standard of art?

Speaking from a somewhat Tolstoyian view, the truth of a work of art means the sincerity of its expression. The authenticity of the spirit of the work, the degree to which the work is "infectious," as Tolstoy calls it. The splendid power of art to move us, to reach out and strike your heart. Whether it be the Saint Chrispen's Day speech from *Henry V* or the last, almost unbearable, high note from Samuel Barber's *Adagio for Strings*, or the tragic, noble dignity of Michelangelo's *Pietà*. It is infectious, irrefutably infectious. And the stronger the infectiousness, the greater the work! Let us resurrect that as a standard.

Beauty is not so much defined as that which is generally agreed to be beautiful, as much as it is a part of the greater aspect of art, defined as form. It is form and the crafts of forms which are essentially the carriers of infectiousness.

Mere beauty, or the worship of beauty by itself, is but a shallow variation of the greater aspect of form. Beauty is an effect of the mastery of form. Without right form, no true art can exist.

What is goodness in art? To Tolstoy, it would mean that the work embraces the "religious perception" of society, that constellation of values, aspirations, and expressions that make up society's highest strivings. That the arts must serve the progress of civilization by embracing this perception, that art's major function is to embody and impart the highest values of society.

Thus, for example, Leni Riefenstahl's Nazi propaganda film *Triumph of the Will* clears the first two hurdles easily. It is artistically infectious, its form superior, but in merit of substance, it is an evil and destructive work.

If we are to renew standards and be able to make judgments, then surely this one, merit of substance, is one whose time has come again.

So often today we are confronted with the dilemma of a work of art that is artistically superior, but is also destructive and perverse. And we are told because of its artistic viability and validity that it must be accepted. It's a genuine expression; it's relayed with mastery of form.

But this is gourmet poison—and if we accept the idea that anything can be art, and there is no justification for standards, then we have put ourselves in a position whereby we will have to eat the poison—whether we like it or not.

The avant-garde, the cutting edge, draws its intellectual legitimacy from the rhetoric of revolution and the dialectic. The deconstructionist and anti-middle class values of the avant-garde mindset are the intellectual offspring of European radicalism where a nearly 100-year-old skin is being shed because it has lost its viability, its believability, and, most importantly, its ability to nourish.

So, too, I believe it inevitable that suddenly, and just as surprisingly, shall follow a cultural renewal. A renewal, like its political sibling, based on a re-examination and a reassertion of humane foundations and standards.

So that art and society may yet again mutually nourish each other in abundance.

Let us reweave that golden thread back into the fabric of society.

I believe we are on the edge of a great age of man. And I believe we are on the edge of a great rebirth of art.

"Private and Public Art: Rebirth of the Heroic Spirit," delivered at "On the Rehumanization of Public Art and Civic Space," a conference sponsored by the Newington-Cropsey Foundation, New York, March 11, 1995

There are those who would dismiss what is going on here as an exercise in "wishful thinking." "Wishful thinking" might be defined as indulging in untenable fantasies in the face of an intolerable reality: a futile effort.

The ideal of "rehumanizing" public art still remains radically out of vogue, and any fantasies about changing the art world do indeed seem remote, seem to be "wishful thinking." I will spare you the usual harangues against modernism, examples and anecdotes of the depths reached by that which is currently allowed as art.

The obvious fact remains. We are still on the outside looking in. And the modernist establishment forces are still thoroughly entrenched in the world of the contemporary museum, in the critical press, and in academia.

I can cite some poignant examples of "wishful thinking." Writing about the imminent and inevitable collapse of the school of abstract painting, Columbia University philosophy professor Edwin Newman wrote in his book *Art and Aesthetics*, "while all painting is essentially abstract, a purely abstract style of painting cannot endure for long, as the recognizable image is the critical ingredient by which the viewer is initially involved in the painting." I believe he was right about the inevitability of its collapse, but was a victim of "wishful thinking" about the imminence of its collapse, as he wrote this in 1912.

On the other hand, "wishful thinking" is a precursor to any great social or cultural change. When Martin Luther King said, "I have a dream," it was "wishful thinking." In fact, anyone with a vision for the future is a practitioner of "wishful thinking," however much they may be optimistically seeking "triumph of hope over experience."

I myself have spent thirty years in a state of "wishful thinking." I made a conscious decision to reject the dominant and triumphant aesthetic philosophy of the twentieth century: modernism.

Whenever we do something new and we don't seem to get it right, we scan the past to see where it was done right, and how, and then capitalize on those successes. I have not attempted to try to relive or recreate the past; but I have sought guidance from those timeless elements in the past that remain valid and vital to the future.

In those past thirty years my "wishful thinking" has expanded, not contracted. Let me give you my laundry list.

My most ardent wish is to see a fundamental change in the philosophy of the "practice" of art. That is to say, a renewed vision of whom art is for, and what its role of service can be within the civilizing forces of society. I would like to see the idea of Art for Art's Sake debunked for the self-centered, dead-end philosophy that it is. As Tolstoy said, "Art is not one of the higher purposes; it is simply a unique instrument for embracing them collectively." It is a fundamental characteristic of art that its greatest flowering occurs when it serves something higher than itself. G. K. Chesterton masterfully put it, "Nothing sublimely artistic has ever arisen out of mere art, any more than anything essentially reasonable has ever arisen out of pure reason. There must always be a rich moral soil for any great aesthetic." To renew this relationship of art and society is to renew art itself. I would like to see the ideal of Beauty in art reborn, based on a renewed understanding of the nature of Beauty, guided by the likes of Frederick Turner, wherein Beauty as an artistic ideal is understood in its metaphorical role: as a reflection of the highest and most noble values of mankind and society.

Santayana said, "Beauty is a pledge to the possible conformity between the soul and nature, and consequently beauty is the ground of faith in the supremacy of Good."

I would like to see the public consciousness raised to understand the Good and the True inherent in the nature of Beauty. I would like to see the standard of Beauty regain its preeminent place in all aspects of public arts, whether it be industrial design — city planning — architecture, or the embellishment of public art

such as monuments — public installations — landscape architecture, or any of the infinite variety of decorative arts.

I want to see a public that prides itself on the ongoing debate and evaluation of artistic merit, a public involved in the creation of public works, taking civic pride in the creation of the beautiful and the noble. Conversely, I want to see a public where shame and disgrace are bestowed upon those who create ugliness, mediocrity, and nihilism, whether in the design of a freeway, a sculpture, or a development project.

I want to see again the truly timeless core metaphor of all great public art restored to its preeminence: the human figure. And by the use of this ageless device of art, I want to see the deep resonances of art brought back into the realm of the concerns, values, and aspirations of the common man, in a language accessible to him.

I would like to see the return of an unabashed elitism, a truly deserved adulation for those who have achieved the highest levels of excellence in the mastery of their craft — those who have achieved the highest levels of excellence in their ability to create art that deeply moves their fellow men to revere and reflect upon the greatness, the splendor, and the beauty of nature, of God, and of man. I would like all of this to meld in an explosion of inventiveness and variation through the multitude of new materials and formats available because of today's ever-expanding technology.

Such is my "wishful thinking." Far fetched? Perhaps not. In their book *Megatrends 2000: Ten New Directions for the 1990s*, John Naisbitt and Patricia Aburdene forecast a renaissance in the arts. "In the final years before the millennium, there will be a fundamental and revolutionary shift in leisure time and spending priorities. During the 1990s the arts will gradually replace sports as society's primary leisure activity. This extraordinary megatrend is already visible in an explosion of visual and performing arts well under way. Since 1960 Japan has built more than two hundred new museums. West Germany, in just ten years, has built some three hundred. In Great Britain museums have been opening at the rate of one every eighteen days." They go on to predict, "The 1990s will bring forth a modern renaissance in the visual arts, poetry, dance, theater, and music throughout the de-

veloped world. It will be in stark contrast to the recent industrial era, where the military was the model and sports was the metaphor. Now we are shifting from sports to the arts." This renaissance is not confined to 'kingdoms' like New York, Paris, and Tokyo; it is flourishing in small and medium-size cities, suburbs, and rural areas.

Attendance at the Alabama Shakespeare Festival in Montgomery, Alabama, for example, has grown from three thousand in 1972 to more than thirty thousand in 1989. "There are more people collecting art today as a percentage of the population than ever before, even during the Renaissance," says economist and art historian Leslie Singer. In Great Britain, the arts are a seventeen-billion-dollar industry, the same size as the British automotive industry. Of the total earnings from tourism, twenty-seven percent is directly attributable to the arts." They conclude by saying, "Sometime in the millennial 1990s the arts will replace sports as society's dominant leisure activity. By one measure, it already has: A landmark 1988 report by the National Endowment for the Arts calculated Americans now spend 3.7 billion dollars attending arts events, compared with 2.8 billion dollars for sports events. Between 1983 and 1987 arts spending increased twenty-one percent, while sports expenditures decreased two percent. Just twenty years ago people spent twice as much on sports as on the arts." So in a sense the stage is set. Renaissance Italy — Baroque Germany — Georgian England — none of them had the truly extravagant resources of the twentieth century. They had small constellations of wealthy families who had an educated vision coupled with a religious perception of the moral value of Beauty and its role in society.

Given the enormity of wealth in this country, the breadth of the educational system; given the credo of merit and the earnest public commitment that each and every human being (with no exclusions of race, sex, or creed) shall be free and encouraged to seek the zenith of his potential; given the essentially stable and just nature of our constitutional democracy; given the rising inclinations and expectations of a culture more involved in the public arts, as cited in *Megatrends*; given the incredible technological revolution offering stupendous creative opportunities; and finally, given

the end of the Cold War and I hope the beginning of a great era of peace, how splendidly indeed the stage is set for a great age.

The technologies, the educational level of the population, the regional stability, the functions of government were, by comparison, extraordinarily primitive in fifteenth-century Italy, but they nonetheless rose to sublime heights of achievement in the public arts by virtue of a vision. I believe the coming age of art can rise to equal glory. With the flame of a vision of art, great sweeping fires of sublime creations can be ignited. However, you cannot have a resurrection without a death. The better part of what we are seeing in the art world today represents a death, an end of a great cycle of history spanning over a century. An artistic ideology—modernism—has simply collapsed like the Marxist-Leninist ideology.

So it is abandoned. And we go back in history, not to hide in the past, but to find a way to start over again. Not to relive the past, but to find in the past what is timeless, that we may carry it into the future.

We will find again what we have very nearly lost, the real nature of Beauty, and a great treasure that has been temporarily misplaced.

<div style="text-align:center">

Letter to the editor,
The Washington Post
December 15, 1995

</div>

Congratulations to Meg Greenfield for her article on the culture wars ("Cultural Commissars," 12/11), which hits the nail on the head—if not quite squarely.

It is certainly true that both sides in the culture wars have failed to offer a convincing, much less inspiring vision of the value of the arts to society. This is especially true of both the proponents and the critics of the NEA. The show put on by the art world has, for the most part, done nothing but alienate and offend the public with shock art, arrogant gibberish, and elitist pontifications. On the other hand, critics from the right evidence no particular grasp of the values of the arts, nor have they been able to offer any substantive revelation for a better way.

But there is a critical distinction between the two

camps, which has gone unnoticed: Proponents and defenders of the art world and the NEA are defending the *performers,* while congressional critics and others are defending the *audience.* The catcalls and boos directed at the arts have to be understood as audience reaction. It simply doesn't square to continuously blame the audience for the failure of the play.

The antidote to the meaninglessness, the ugliness, and the nihilism that characterizes so much of today's art is not necessarily a Soviet-style dogma of art, or a rigid academy attempting to relive the past. The antidote to meaninglessness is meaning and value. The antidote to ugliness is beauty, and the antidote to nihilism is spiritual renewal. Meaning and values, beauty, and spiritual renewal are complex challenges subject to many interpretations. But the commitment to them is a very simple, albeit radical, change of direction—which in its search for interpretation will inevitably yield abundant fruit.

There are, in fact, many who in different quarters and disciplines have long been moving in this direction, and they are the changing flow in the coming cultural tides.

<div style="text-align:center">

Last public address, at the Vietnam Veterans
Memorial, Washington, D.C., May 31, 1999

</div>

I thought I would share with you some of the things I set out to achieve with the *Three Soldiers* statue. Over time, when visitors come to this place, many of the ties that connect these names regrettably will have loosened and will begin to fade. However, it is within the power of sculpture to portray and capture for generations to come many of the features that characterize the experience and the personality of the Vietnam combatant. As I worked on the sculpture I felt that it was urgent that future generations who visit this place were able to feel and I hope to understand better what characterizes the Vietnam veteran's experience.

First, I wanted to emphasize, in my portrayal, the youth of the Vietnam combatant whose average age was nineteen. A fact that has caused some to refer to the conflict as a children's war. That so many young lives were cut short on the threshold of adulthood is

a tragic feature, which future generations need to remember. I wanted to emphasize that these were three ordinary young men of similar youth drawn from different parts of American society.

Second, by the expressions on the faces of the three soldiers as they gaze at the wall, I wished to convey the intensity of the strain and anguish that was a part of the Vietnam veteran's experience both on the battlefield and at homecoming. By their endurance and youthful dedication to duty they reveal themselves as true heroes.

Last and most important, I wanted to emphasize the one aspect of the Vietnam experience that I found all of the veterans I interviewed treasured regardless of their feelings about the rightness or the merits of the war. That is, their deep bonds of loyalty, comradeship, and interdependence, or as one veteran put it: at first we thought we were fighting for our country, but soon came to realize we were fighting for each other. Through the gesture of the figures and the sense of how they relate to each other, I wanted coming generations to understand the profound importance of the bonds of men in combat.

It is these features of the humanity and the nobility of service of the Vietnam veteran that I felt were imperative to embody in the sculpture so that the coming generations would understand better and more fully sense the weight of the burdens of sacrifice that the Vietnam veteran bore.

Public art can have no higher or more majestic purpose than to reveal the nobility of the service to this country. Public art can serve no higher purpose than to reveal and embody the nobility of the human spirit such as that exemplified by the Vietnam veteran's dedicated service to his country.

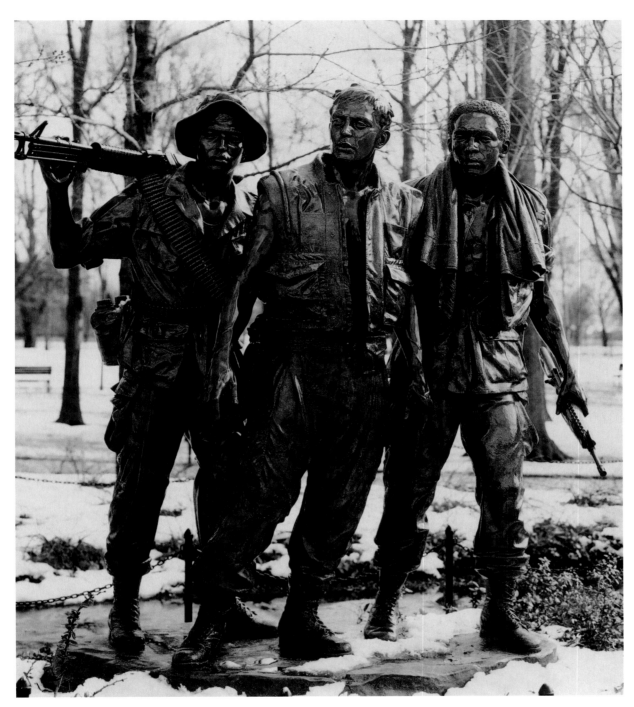

FIG. 109: *Three Soldiers*, bronze, Vietnam Veterans Memorial, Washington, D.C.

The portrayal of the figures is consistent with history. They wear the uniform and carry the equipment of war; they are young. The contrast between the innocence of their youth and the weapons of war underscores the poignancy of their sacrifice. There is about them the physical contact and sense of unity that bespeaks the bonds of love and sacrifice that is the nature of men at war. And yet they are each alone. Their true heroism lies in these bonds of loyalty in the face of their aloneness and their vulnerability.

 I see the wall as a kind of ocean, a sea of sacrifice that is overwhelming and nearly incomprehensible in its sweep of names. I place these figures upon the shore of that sea, gazing upon it, standing vigil before it, reflecting the human face of it, the human heart.

<div align="right">1984</div>

FIG. 110

I don't draw at all anymore. But sculpture is drawing. That is how I became an artist, really, because ever since I was a small child I was obsessed with drawing. When I was in art school I felt rather awkward at painting but I loved to draw. I think that is what so stunned and staggered me when I first got interested in sculpture (which was rather late, around twenty-three). I discovered that it was drawing in mass and drawing in substance. It was drawing of a kind I never realized before. At first it was very frustrating, because my brain wasn't adjusted to its three-dimensionality. But as soon as I could model in clay as well or better than I could draw, I quit drawing all together. I had gone into a different sphere. But I still feel that sculpting is, in a fundamental way, drawing.

FIG. 111

ORDER
RADIAL
INNER
INVISIBle
NIGHT

FIG. 112

FIG. 113

FIG. 114

Tangible phenomenon intangible

FIG. 115

FIG. 116

FIG. 117

FIG. 118

FIG. 119

FIG. 120

FIG. 121

FIG. 122

FIG. 123

FIG. 124

FIG. 125

FIG. 126

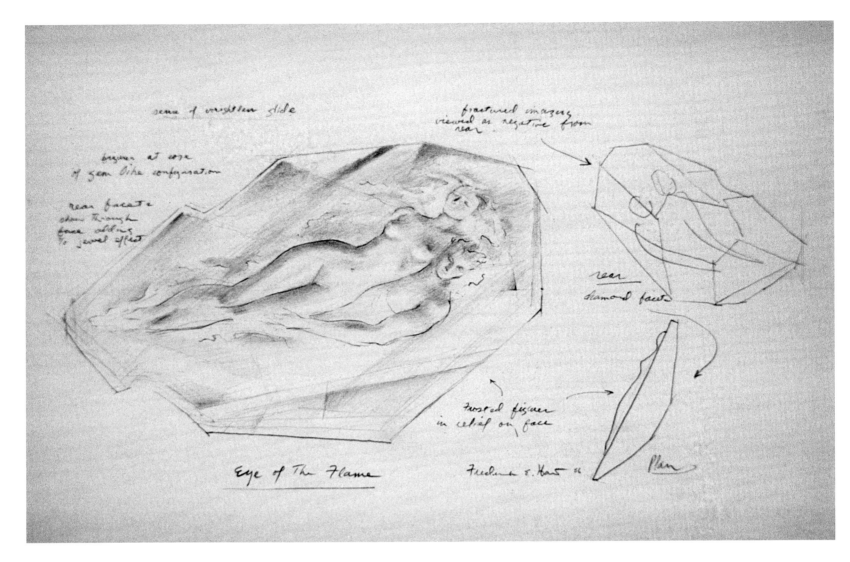

Eye of The Flame

FIG. 127

206

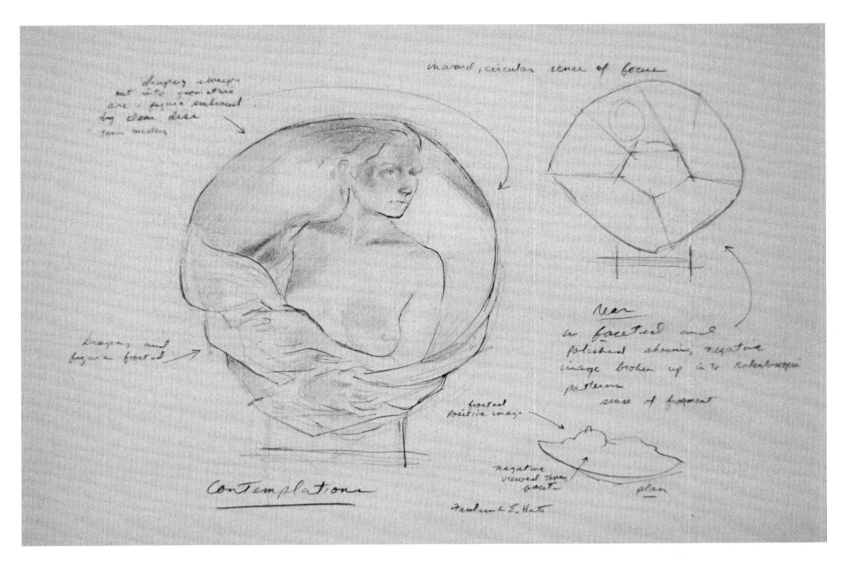

Contemplation

FIG. 128

NOTES

1. Fig. 110, March 16, 1997, pen and ink on paper.
2. Figs. 111–126, Cathedral years, c. 1970, pencil on paper, spiral-bound cardboard-covered sketchbook of the artist.
3. Fig. 127, 1986, *Eye of the Flame,* pencil on paper.
4. Fig. 128, c. 1986, *Contemplation,* pencil on paper.

Frederick Hart, 1993

A MEMORIAL TRIBUTE

Make no little plans; they have no magic to stir men's blood, and probably themselves will not be realized. Make big plans; aim high in hope and work, remembering that a noble, logical diagram once recorded will never die, but long after we are gone will be a living thing, asserting itself with ever growing insistency. Remember that our sons and grandsons are going to do things that would stagger us. Let your watchword be order and your beacon beauty.

—Daniel H. Burnham
Director of Works
World's Columbian Exposition, 1893

FIG. 129: Tom Wolfe

Frederick Hart died at the age of fifty-five on August 13, 1999, two days after a team of doctors at Johns Hopkins discovered he had lung cancer, abruptly concluding one of the most bizarre stories in the history of twentieth-century art. While still in his twenties, Hart consciously, pointedly aimed for the ultimate in the Western tradition of sculpture, achieved it in a single stroke, then became invisible, and remained as invisible as Ralph Ellison's invisible man, who was invisible "simply because people refused to see me."

Not even Giotto, the twelve-year-old shepherd boy who was out in the meadow with the flock one day circa 1280 using a piece of flint to draw a picture of sheep on the face of a boulder, when the vacationing Florentine artist Cimabue happened to stroll by and discover the baby genius—not even Giotto could match Frederick Hart's storybook rise from obscurity.

Hart was born in Atlanta to a failed actress and a couldn't-be-bothered newspaper reporter. He was only three when his mother died, whereupon he was packed off to an aunt in a part of rural South Carolina where people ate peanuts boiled in salty water. He developed into an incorrigible Conway, South Carolina, juvenile delinquent, failed the ninth grade on his first try and got thrown out of school on his second. Yet at the age of sixteen, by then a high-school dropout, he managed, to universal or at least Conway-wide amazement, to gain admission to the University of South Carolina by scoring a composite thirty-five out of a maximum thirty-six on an ACT college entrance test, the equivalent of a 1560 on the College Boards.

He lasted six months. He became the lone white student to join 250 black students in a civil rights protest, was arrested, then expelled from the university. Informed that the Ku Klux Klan was looking for him, he fled to Washington.

In Washington he managed to get a job as a clerk at the Washington National Cathedral, a stupendous stone structure built in the Middle English Gothic style. The Cathedral employed a crew of Italian masons full-time, and Hart became intrigued with their skill at stone carving. Several times he asked the master carver, an Italian named Roger Morigi, to take him on as an apprentice, but got nowhere. There was no one on the job but experienced Italians. By and by, Hart got to know the crew and took to borrowing tools and having a go at discarded pieces of stone. Morigi was so happily surprised by his aptitude, he made him an apprentice after all, and soon began urging him to become a sculptor. Hart turned out to have Giotto's seemingly God-given genius—Giotto was a sculptor as well as a painter—for pulling perfectly formed human figures out of stone and clay at will and rapidly.

In 1971, Hart learned that the Cathedral was holding an international competition to find a sculptor to adorn the building's west facade with a vast and elaborate spread of deep bas-reliefs and statuary on the theme of the Creation. Morigi urged Hart to enter. He entered and won. A working-class boy nobody had ever heard of, an apprentice stone carver, had won what would turn out to be the biggest and most prestigious commission for religious sculpture in America in the twentieth century.

The project brought him unimaginable dividends. The erstwhile juvenile delinquent from Conway, South Carolina, was a creature of hot passions, a handsome, slender boy with long, wavy light brown hair, an artist by night with a rebellious hairdo and a rebellious attitude who was a big hit with the girls. In the late afternoons he had taken to hanging about Dupont Circle in Washington, which had become something of a bohemian quarter. Afternoon after afternoon he saw the same ravishing young woman walking home from work down Connecticut Avenue. His hot Hart flame lit, he introduced himself and asked her if she would pose for his rendition of the Creation, an array of idealized young men and women rising nude from out of the chaotic swirl of Creation's dawn. She posed. They married. Great artists and the models they fell in love with already accounted for the most romantic part of art history. But probably no model in all that lengthy, not to say lubricious, lore was ever so stunningly beautiful as Lindy Lain Hart. Her face and figure were to recur in his work throughout his career.

The hot-blooded boy's passion, as Hart developed his vision of the Creation, could not be consummated by Woman alone. He fell in love with God. For Hart,

the process began with his at first purely pragmatic research into the biblical story of the Creation in the Book of Genesis. He had been baptized in the Presbyterian Church, and he was working for the Episcopal Church at the Washington National Cathedral. But by the 1970s, neither of these proper, old-line, in-town Protestant faiths offered the strong wine a boy who was in love with God was looking for. He became a Roman Catholic and began to regard his talent as a charisma, a gift from God. He dedicated his work to the idealization of possibilities God offered man.

From his conception of *Ex Nihilo*, as he called the centerpiece of his huge Creation design (literally, "out of nothing"; figuratively, out of the chaos that preceded Creation), to the first small-scale clay model, through to the final carving of the stone—all this took eleven years.

In 1982, *Ex Nihilo* was unveiled in a dedication ceremony. The next day, Hart scanned the newspapers for reviews . . . *The Washington Post* . . . *The New York Times* . . . nothing . . . nothing the next day, either . . . nor the next week . . . nor the week after that. The one mention of any sort was an obiter dictum in the *Post's* Style (read: Women's) section indicating that the west facade of the Cathedral now had some new but earnestly traditional (read: old-fashioned) decoration. So Hart started monitoring the art magazines. Months went by . . . nothing. It reached the point that he began yearning for a single paragraph by an art critic who would say how much he loathed *Ex Nihilo* . . . anything, anything at all . . . to prove there was someone out there in the art world who in some way, however slightly or rudely, cared.

The truth was, no one did, not in the least. *Ex Nihilo* never got *ex nihilo* simply because art worldlings refused to see it.

Hart had become so absorbed in his "triumph" that he had next to no comprehension of the American art world as it existed in the 1980s. In fact, the art world was strictly the New York art world, and it was scarcely a world, if world was meant to connote a great many people. In the one sociological study of the subject, *The Painted Word*, the author estimated that the entire art "world" consisted of some three thousand curators, dealers, collectors, scholars, critics and art-

ists in New York. Art critics, even in the most remote outbacks of the heartland, were perfectly content to be obedient couriers of the word as received from New York. And the word was that School of Renaissance sculpture like Hart's was nonart. Art worldlings just couldn't see it.

The art magazines opened Hart's eyes until they were bleary with bafflement. Classical statues were "pictures in the air." They used a devious means—skill—to fool the eye into believing that bronze or stone had turned into human flesh. Therefore, they were artificial, false, meretricious. By 1982, no ambitious artist was going to display skill, even if he had it. The great sculptors of the time did things like have unionized elves put arrangements of rocks or bricks flat on the ground, objects they, the artists, hadn't laid a finger on (Carl Andre); or prop up slabs of Cor-Ten steel straight from the foundry, edgewise (Richard Serra); or they took G. E. fluorescent light tubes straight out of the box from the hardware store and arranged them this way and that (Dan Flavin); or they welded I-beams and scraps of metal together (Anthony Caro). This expressed the material's true nature, its "gravity" (no stone pictures floating in the air), its "objectness."

This was greatness in sculpture. As Tom Stoppard put it in his play *Artist Descending a Staircase*, "Imagination without skill gives us contemporary art."

Hart lurched from bafflement to shock, then to outrage. He would force the art world to see what great sculpture looked like.

By 1982, he was already involved in another competition for a huge piece of public sculpture in Washington. A group of Vietnam veterans had just obtained congressional approval for a memorial that would pay long-delayed tribute to those who had fought in Vietnam with honor and courage in a lost and highly unpopular cause. They had chosen a jury of architects and art worldlings to make a blind selection in an open competition; that is, anyone could enter, and no one could put his name on his entry. Every proposal had to include something—a wall, a plinth, a column—on which a hired engraver could inscribe the names of all 57,000-plus members of the American military who had died in Vietnam. Nine of the top ten choices were

abstract designs that could be executed without resorting to that devious and accursed bit of trickery: skill. Only the number-three choice was representational. Up on one end of a semicircular wall bearing the 57,000 names was an infantryman on his knees beside a fallen comrade, looking about for help. At the other end, a third infantryman had begun to run along the top of the wall toward them. The sculptor was Frederick Hart.

The winning entry was by a young Yale undergraduate architectural student named Maya Lin. Her proposal was a V-shaped wall, period, a wall of polished black granite inscribed only with the names; no mention of honor, courage or gratitude; not even a flag. Absolutely skillproof, it was.

Many veterans were furious. They regarded her wall as a gigantic pitiless tombstone that said, "Your so-called service was an absolutely pointless disaster." They made so much noise that a compromise was struck. An American flag and statue would be added to the site. Hart was chosen to do the statue. He came up with a group of three soldiers, realistic down to the aglets of their boot strings, who appear to have just emerged from the jungle into a clearing where they are startled to see Lin's V-shaped black wall bearing the names of their dead comrades.

Naturally enough, Lin was miffed at the intrusion, and so a make-peace get-together was arranged in Plainview, New York, where the foundry had just completed casting the soldiers. Doing her best to play the part, Lin asked Hart—as Hart recounted it—if the young men used as models for the three soldiers had complained of any pain when the plaster casts were removed from their faces and arms. Hart couldn't imagine what she was talking about. Then it dawned on him. She assumed that he had followed the lead of the ingenious art worlding George Segal, who had contrived a way of sculpturing the human figure without any skill whatsoever: by covering the model's body in wet plaster and removing it when it began to harden. No artist of her generation (she was twenty-one) could even conceive of a sculptor starting out solely with a picture in his head, a stylus, a brick of moist clay and some armature wire. No artist of her generation dared even speculate about . . . skill.

President Ronald Reagan presided at a dedication ceremony unveiling Hart's *Three Soldiers* on Veterans Day 1984. The next day Hart looked for the art reviews . . . in *The Washington Post* . . . *The New York Times* . . . and, as time went by, in the magazines. And once more, nothing . . . not even the inside-out tribute known as savaging. *Three Soldiers* received only so-called civic reviews, the sort of news or feature item or picture captions that say, in effect, "This thing is big; it's outdoors, and you may see it on the way to work, and so we should probably tell you what it is." Civic reviews of outdoor representational sculpture often don't even mention the name of the sculptor. Why mention the artist since it's nonart by definition?

Hart was by no means alone. In 1980, a sculptor named Eric Parks completed a statue of Elvis Presley for downtown Memphis. It was unveiled before a crowd of thousands of sobbing women: it became, and remains, a tremendous tourist attraction; civic reviews only. And who remembers the name of Eric Parks? In 1985, a sculptor named Raymond J. Kaskey completed the second-biggest copper sculpture in America—the *Statue of Liberty* is the biggest—an immense Classical figure of a goddess in a toga with her right hand outstretched toward the multitudes. *Portlandia* she was called. Tens of thousands of citizens of Portland, Oregon, turned out on a Sunday to see her arrive by barge on the Willamette River and get towed downtown. Parents lifted their children so they could touch her fingertips as she was hoisted up to her place atop the porte cochere of the new Portland Public Services Building; civic reviews only. In 1992, Audrey Flack completed *Civitas*, four Classical goddesses, one for each corner of a highway intersection just outside a moribund mill town, Rock Hill, South Carolina. It has been a major tourist attraction ever since; cars come from all directions to see the goddesses lit up at night; a nearby fallow cotton field claiming to be an "industrial park" suddenly a sellout; Rock Hill comes alive; civic reviews only.

Over the last fifteen years of his life, Hart did something that, in art-world terms, was even more infra dig than *Ex Nihilo* and *Three Soldiers*: he became America's most popular living sculptor. He developed a technique for casting sculpture in acrylic resin. The

result resembled Lalique glass. Many of his smaller pieces were nudes, using Lindy as a model, so lyrical and sensual that Hart's Classicism began to take on the contours of Art Nouveau. The gross sales of his acrylic castings have gone well over $100 million. None was ever reviewed.

Art worldlings regarded popularity as skill's live-in slut. Popularity meant shallowness. Rejection by the public meant depth. And truly hostile rejection very likely meant greatness. Richard Serra's *Tilted Arc,* a leaning wall of rusting steel smack in the middle of Federal Plaza in New York, was so loathed by the building's employees that 1,300 of them, including many federal judges, signed a petition calling for its removal. They were angry and determined, and eventually the wall was cut apart and hauled away. Serra thereby achieved an eminence of immaculate purity: his work involved absolutely no skill and was despised by everyone outside the art world who saw it. Today many art worldlings regard him as America's greatest sculptor.

In 1987, Hart moved seventy-five miles northwest of Washington to a 135-acre estate in the Virginia horse country and built a Greek Revival mansion featuring double-decked porches with twelve columns each; bought horses for himself, Lindy, and their two sons, Lain and Alexander; stocked the place with tweeds, twills, tack and bench-made boots; grew a beard like the King of Diamonds'; and rode to the hounds — all the while turning out new work at a prolific rate.

In his last years he began to summon to his estate a cadre of like-minded souls, a handful of artists, poets and philosophers, a dedicated little derrière garde (to borrow a term from the composer Stefania de Kenessey) to gird for the battle to take art back from the Modernists. They called themselves the Centerists.

It wasn't going to be easy to get a new generation of artists to plunge into the fray yodeling, "Onward! To the center!" Nevertheless, Hart persevered. Since his death certain . . . signs . . . have begun, as a sixties

song once put it, blowing in the wind . . . the suddenly serious consideration, by the art world itself, of Norman Rockwell as a Classical artist dealing in American mythology . . . the "edgy buzz," to use two nineties words, over the sellout show at the Hirschl & Adler Gallery of six young representational painters known as "the Paint Group," five of them graduates of America's only Classical, derrière-garde art school, the New York Academy of Art . . . the tendency of a generation of serious young collectors, flush with new Wall Street money, to discard the tastes of their elders and to collect "pleasant" and often figurative art instead of the abstract, distorted or "wounded" art of the Modern tradition . . . the soaring interest of their elders in the work of the once-ridiculed French "academic" artists Bouguereau, Meissonier, and Gérôme and the French "fashion painter" Tissot. The art historian Gregory Hedberg, Hirschl & Adler's director for European art, says that with metronomic regularity the dawn of each new century has seen a collapse of one reigning taste and the establishment of another. In the early 1600s, the Mannerist giants (for example, El Greco) came down off fashionable walls, and the Baroque became all the rage; in the early 1700s, the Baroque giants (Rembrandt) came down, and the Rococo went up; in the early 1800s, the Rococo giants (Watteau) came down, and the Neoclassicists went up; and in the early twentieth century, the Modern movement turned the Neoclassical academic giants Bouguereau, Meissonier, and Gérôme into joke figures in less than twenty-five years.

And at the dawn of the twenty-first century in the summer of 1985, the author of *The Painted Word* gave a lecture at the Parrish Museum in Southampton, New York, entitled "Picasso: The Bouguereau of the Year 2020." Should such turn out to be the case, Frederick Hart will not have been the first major artist to have died ten minutes before history absolved him and proved him right.

FIG. 130: Reverend Doctor Stephen Happel

Rev. Dr. Stephen Happel, "The Cathedral Years," homily, *Transcendence and Renewal: A Memorial for Frederick Hart (1943–1999)*

"We have seen that without the involution of matter upon itself, that is to say, without the closed chemistry of molecules, cells and phyletic branches, there would never have been either biosphere or noosphere. In their advent and their development, life and thought are not only accidentally, but also structurally, bound up with the contours and destiny of the terrestrial mass" (Teilhard de Chardin, 1961, p. 273). "The term of creation is not to be sought in the temporal zones of our visible world, but . . . the effort required of our fidelity must be consummated *beyond a total metamorphosis* of ourselves and of everything surrounding us" (Teilhard de Chardin, 1960, p. 78). The evolution of everything cannot fulfill itself on earth except through reaching for something, someone outside itself. In doing so, literally everything is transformed.

These quotations from Teilhard de Chardin's *Phenomenon of Man* and *The Divine Milieu* were the human milieu that I found when I walked into Frederick

Hart's life in 1973–74. He had joined an Inquiry Class at Saint Matthew's Cathedral during a particularly difficult time in his life. Inquiry classes are traditional Catholic ways for people investigating new knowledge and spiritual meaning. Rick was living in his studio, a garage on P Street with a bedroom attached, his first plan for the facade of the Cathedral rejected (along with all the other sculptors). He was looking for a comprehensive vision in which his own work could struggle to be born. Or better, his artistic work struggled to evolve and create a world, an environment that could grow like a green space in a desert, expanding to nourish the beautiful on the planet. And he was looking for some words to mirror the sculptural world he was inventing.

Frederick Hart arrived at the National Cathedral in the 1960s as a mail clerk. He had decided, after trying his hand at painting, that sculpture was his vocation; but he needed a place to learn. The learning took place here on the spot, under the guidance of Roger Morigi, one of the last classic master stonemasons, whose techniques went back to Michelangelo and Leonardo. Rick graduated from mail clerk to apprentice, when Roger,

an often difficult, sometimes volcanic, professional father, found the fellow "promising." After Rick completed a bust of Philip Frohman, the architect of the Cathedral, a gift for the Cathedral (1969), the clerk of the works, Richard Feller, recognized that this young (now twenty-six) sculptor should be included in the competition for the facade sculpture. Rick continued to produce bosses, gargoyles, and the classic *Erasmus*, a Catholic reformer with an ironic tone (not unlike Rick's own) until April 1975, when his second set of motifs for the central tympanum and the trumeau sculpture was approved.

I met Rick at the Inquiry Class at Saint Matthew's Cathedral on Rhode Island Avenue. I gave a talk on the Sacraments in which I spoke about how symbols are neither subjective nor secondary in our religious lives. I paralleled the power and effectiveness of artwork and the Sacraments. Each of them transforms us if we let them; they invite us into the world they project in front of us. They announce a better world that has not quite arrived, but will if faith prevails. Artistic and sacramental symbols are not substitutes for what is not there, but an incipient presence of the whole, pushing its way into our sometimes dull and quotidian conscious life. Even though the routine of work and domestic life can screen out what is truly beautiful and holy, symbols can break through and insist on being seen, heard, and touched.

Rick, like the symbols themselves, had a way of fidgeting into a conversation. Although he was respectful of the fact that we had never met, he could not quite resist asking lots of questions early on at the meeting. It did not take long for the two of us to discover that we were cultural and religious siblings; we were both committed to the ways in which religious symbols could change public life. After the "official" conversation was over, Rick, Darrell Acree, Father James Meyers, and I went to the Dupont Village Pizza, regrettably no longer there, ordered pizza and (I have to say) more than one pitcher of beer while discussing art, the Sacraments, and his plans for the Cathedral's facade. Somehow I'm quite sure that the Lord would not have understood our discussing the Sacraments over the pizza and beer!

Rick was at the beginning of his new proposal. He basically wanted to know whether his view of the world was theologically crazy. It was not; it was genial. Through the help of his friends, he had not only made his way from Childe Harold and the Benbow, local pubs, but he had also read Teilhard de Chardin and classic philosophies of art. In between these books and his wanderings, he would take his meager paychecks from the National Cathedral to build a garden with a fountain in the backyard of the garage and draperies to remake his interior world. The next winter the drapes were useful; they kept him warm when he wasn't sleeping with the two dogs that sufficed as a heater in the unheated studio.

Rick physically lived on the margins during those years. Deliberately, energetically; he found the "in-between" a creative focus in which he could explore the ways in which the *body* could evoke *mind* and *heart*, in which the *material* embodied the *spiritual* and eternal, in which the *physical* could struggle, emerge, and become *other* than it is. This was a man from whom ideas were a passion; and passions could become ideas. I had no trouble finding a life-long friend—or better, a friend for all of his life.

Later that evening I saw the gouache designs he had already completed for the project of the Creation—Adam and Saints Peter and Paul. But as in all cases with my experience of Rick's work as it evolved, the idea was somewhere within, grasping for life and open air, to live in the public world. Rick had to produce a "statement," as you know, for the competition. That night he and I spoke about how Creation evolved, the role of human beings in this evolution, and the primary, initiating power of God's love. If you will, it was a course in Christian anthropology, a human nature aiming beyond itself, a human being unable to make sense of itself without reference to the Other—to God. I took the pieces he had produced, added some theological jargon and sent them back to him. He reworked them again and sent them in along with the drawings. He won. We are living in the results of his labor.

Medieval cathedrals emerged from a vastly different anticipated future. They were painted, very colorful places of worship, filled with multiple altars, incense, and song. An entry through the main doors at the cathedral at Autun shows an either/or world—either

heaven or hell. Christ the Judge seated on a throne presides in the midst of a heavenly court. On Christ's right, angels push souls into the mansions of heaven where Mary and the apostles reside; on the left, demons weigh souls and send them off to torment.

Rick's vision for the facade of the National Cathedral coincided with the courageous commitment of the building committee. The theme was Creation, a new image for a National Cathedral in a new country. The vision was *both/and*—the material and the spiritual. How to imagine both primordial past and a transformed future—at the same time? How to make the stone fly from earth into the infinite horizon of the Universe? How to unite the individual and the communal in a contemporary world where the radically autonomous, isolated subject is the ideal? Can what is new be rooted in history and tradition? For Rick, it was both/and in his sculpture, not either/or. Creation in the stone embodiment of Frederick Hart is an ongoing event—what theologians call a *creatio continua*—simultaneously "conservation" and "preservation" by God. This is not an image of a distant past event, astronomical or human, but the constantly emerging present life of the human community. *Ex Nihilo* symbolizes the choral dance, the human perichoresis in which we are all even now part of one another, linked body, soul, mind, and heart. The figures emerge from the ground, but are not yet completely defined. As Rick used to say, the ground from which they come is as primordial as the figures that emerge. Without the involution of matter, sinew, and bone folding and revitalizing themselves (as Teilhard said), the unique figures that are human beings would not appear.

Adam is the test case. The central trumeau figure is at once grasping for the air and being grasped. With closed eyes, he is the old Adam yearning with his right arm to push from the ground from which he comes; with the left, he is being pulled, however tentatively, from the swirling ooze, tugged by an invisible hand. The torso leans ever so slightly upward.

This Adam is both the old Adam—and on a longitudinal axis with the new Adam sitting in glory over the high altar on the reredos. He is also an Adam for an American context, both striving to enter the world and helped by One he cannot yet see. This is not a

solo, antagonistic, power-hungry figure in the style of Nietzsche; this sculpture has its humanity in and with an Other, a partner who cooperates to bring it into existence.

Perhaps it is this theme that is subversive in Hart's sculptural theology; the sculpture invites, seduces, even provokes the viewer into participation in the world it is announcing. *Saint Paul*, caught at the moment of transformation, the mystic transported to the seventh heaven, sinks below the emergence of the night sky from the whirling chaos. *Saint Peter*, the only facade sculpture with his eyes open, draws his net to build the church under *Creation of Day*. Thus Hart presents time and space in a single sensuous continuum in which the history of the early Church unfolds from the call of Adam and all humanity pulled out of the visible chaotic ground.

In this sense, Rick's work here (and elsewhere) offends people. Not simply because it does not "fit into" the current or recent art establishment—though the '70s were not a time for well-modeled, fine art. His work demands of the viewer a participation that insists on remaking the world. Again I quote Teilhard de Chardin: "To create, or organize material energy, or truth, or beauty, brings with it an inner torment which prevents those who face its hazards from sinking into the quiet and closed-in life wherein grow the vice of egoism and attachment. An honest workman not only surrenders his tranquility and peace once and for all, but must learn to abandon over and over again the form which his labor or art or thought first took, and go in search of new forms" (Teilhard de Chardin, 1960, p. 41). Frederick Hart knew this intimately, even painfully. The facade sculptures reach out from the center to the edges of day and night and extend themselves into the city and our world. They proselytize; they preach; they evangelize about how the world could be if values of beauty and truth were embraced. For Rick these were moral values.

Just as the Enlightenment values of autonomy, individual history, and emotional independence were moral imperatives, so Rick Hart's work pushes beholders into their inner lives, asking for cooperation to build a world. Rick's sculptures embody the very boundaries he lived between; they provoke viewers

into asking about the aura of the Other that envelops them in the material stuff of their day-to-day lives. But sensing the material as a symbol of the immaterial is not a current ideal. Cooperation is not a current norm. Newspapers are sold on conflict and disagreement; debates are structured on differences; business is won or lost on the basis of unique combative marketing; computer systems are structured on either-or options.

The theology of cooperation Rick espoused in his art, despite his love of playing the antagonist in conversation, was absolutely Trinitarian. The chorus of human activity was a symbol of the internal life of God. The God who creates us; the God whose Beloved Incarnate One we follow and worship; the Spirit that animates human history—all are One terrifying and vivifying, swirling fire. "We live in the midst of the divine milieu," as Teilhard says, "we cannot escape our God. "Is the Kingdom of God a big family? Yes, in a sense it is. But in another sense it is a prodigious biological operation—that of the Redeeming Incarnation." For Rick, God lives in the heart of matter, calling us, prodding us to share in the divine life of love, justice, and truth.

Rick's best work, his masterpieces on the facade of this building, invites the city to admire the house of prayer, but more to enter it. The sculptures set up the conditions under which a community, a city might transform itself. Enter the choric dance; establish a co-operative rhythm; be drawn like Adam to what you cannot see; drop the sword of contention and enter the mystical night—and maybe, just maybe, you will be able to build the day. You might find God.

Rick Hart was a friend. But I make no apologies for my praise of his work; I believe I have been privileged to know a great, passionate artist whose values emerged within his creative processes and embodied themselves there. As a result, I know that long after I am dead, the ideas and values he, I, and others shared in friendship will awaken others. The symbols will remain—continuing to make parts into wholes, building a community of living stones from the stones he shaped, drawing us beyond ourselves into God.

FIG. 131: Frederick Turner

In Memory of Frederick Hart

How shall his great hills still be fitly seen?
What eye but his could measure out their limbs,
His lakes with tall clouds imaged in their brims?
How shall his great hills still be fitly seen?

Who'll show our time its body and its face?
Master and maker, you gave us again
The brilliance of the angel, and the pain:
Who'll show our time its body and its face?

And what of those who've lost his powerful hand?
This was a friend that we were proud to own,
Noble and simple, and as deep as stone;
And what of those who've lost his powerful hand?

Let it so be that he has left his heart,
In art more cleansing to the eye than tears,
To the next hundred, and next thousand years.
Let it so be that he has left his heart.

Frederick Turner

Frederick Hart always stuck his favorite modeling tools, which he called "extensions of his fingers," into a work in progress or a little mound of clay on his worktable.

CHRONOLOGY

1943 Born November 3 in Atlanta, Georgia, to Joanna Elliot and Frederick William Hart.

1960– Attends the University of South Carolina,
1966 Columbia, and the Corcoran School of Art and American University, Washington, D.C.

1966– Serves a variety of apprenticeships, casting or-
1968 namental sculpture with Giorgio Gianetti and assisting sculptors Felix George Weihs De Weldon, Carl Mose, Don Turano, and Heinz Warnecke.

1968– Works as apprentice stone carver and sculptor
1971 at Washington National Cathedral.

1971 Begins to experiment with clear acrylic resin as a medium for sculptural expression.

1972 Opens sculpture studio in Washington and begins executing commissioned works.

1974 Wins international competition to design the sculptural program for the main entrance, west facade, of Washington National Cathedral. The program comprises three life-size statues, *Adam, Saint Peter,* and *Saint Paul,* and three relief panels, *Creation of Night, Creation of Day,* and *Ex Nihilo* (Out of Nothing).

1976 Appointment to the Sacred Arts Commission for the Catholic Archdiocese of Washington.

1979 Creates processional cross for Pope John Paul II's historic Mass on the National Mall in Washington, D.C.

1980 Submits proposal to national competition to design the Vietnam Veterans Memorial on the National Mall. Hart's proposal is awarded third place among 1,430 entries.

1982 Releases first editioned work in clear acrylic resin, *Gerontion.*

Receives commission for a figurative sculpture to be placed at the Vietnam Veterans Memorial.

Receives commission for bronze bust of James Webb of NASA from National Air and Space Museum, Smithsonian Institution, Washington, D.C.

1983 Creates Sacred Mysteries: Acts of Light (Male and Female), a suite in clear acrylic resin.

1984 *Three Soldiers* is installed at the site of the Vietnam Veterans Memorial and dedicated by President Ronald Reagan.

Commissioned to create the Age of Light, a series of twelve works in clear acrylic resin.

1985 Appointed by President Reagan to a five-year term on the Commission of Fine Arts, a seven-member committee that advises the United States Government on matters pertaining to the arts and guides the architectural development of the nation's capital.

1986 Appointed to the board of trustees, Brookgreen Gardens, Murrells Inlet, South Carolina (foremost outdoor collection of American sculpture).

1987 With Philip Frohman, architect of Washington National Cathedral from 1921 to 1971, receives Henry Hering Award for The Creation Sculptures from the National Sculpture Society, New York.

Participates in "100 Years of Figurative Sculpture," an invitational exhibition in Philadelphia in conjunction with the Bicentennial of the United States Constitution.

1988 Receives the Presidential Award for Design Excellence, given once every four years, for *Three Soldiers*.

1989 Receives commission for The Creation Sculptures: Themes and Variations, a series of eight sculptures (four clear acrylics and four bronzes).

1991 Creates and donates a comic bust of Mark Twain for the Design Industries Foundation for AIDS (DIFFA).

1992 Commissioned to create Dreams: Visions and Visitations, a series of four sculptures in clear acrylic resin.

Unveils *The Cross of the Millennium* at Easter Sunrise Service, Arlington National Cemetery.

Creates and donates a portrait study for the *Ruby Middleton Forsythe Memorial Plaque*, honoring an educator who devoted her life to teaching underprivileged youth in a one-room schoolhouse in Murrells Inlet, South Carolina.

Completes maquette for a proposed monumental statue and fountain honoring all American Olympic athletes to commemorate the 100th Anniversary of the Modern Olympic Games to be held in Atlanta, in 1996.

1993 Receives commission to create the *Richard B. Russell, Jr. Memorial Statue*, a larger-than-life-size marble sculpture of the late senator, for the rotunda of the Russell Senate Office Building in Washington.

The Cross of the Millennium is selected as the Best of Show and Visitors' Choice in "Sacred Arts XIV," the nation's largest annual juried exhibition of religious art, at the Billy Graham Center Museum, Wheaton, Illinois. *The Cross of the Millennium* is the first work of art to receive both awards simultaneously.

Billy Graham Center, Wheaton, Illinois, adds *The Cross of the Millennium* to the permanent collection.

In collaboration with Jay Hall Carpenter, completes and donates *A Tribute to Desert Storm*, a decorative sculptural railing, to the Fauquier County Veterans Memorial, Warrenton, Virginia.

Receives the *George Alexander Memorial Award* from the Blinded American Veterans Foundation for service on behalf of all veterans, particularly those with sensory disabilities.

Completes and donates to Operation Smile International the *John Connor Memorial Medal*, a bronze medal commemorating the Vietnam veteran John Connor, which will be awarded to individuals who have provided exceptional service to children who need reconstructive surgery.

Awarded honorary degree of Doctor of Fine Arts from the University of South Carolina, for his "ability to create art that uplifts the human spirit, commitment to the ideal that art must renew its moral authority by rededicating itself to life, skill in creating works that compel attention as they embrace the concerns of mankind, and contributions to the rich cultural heritage of our nation."

1994 Installs the *James Earl Carter Presidential Statue*, a larger-than–life-size bronze on the Georgia State House grounds, Atlanta.

Completes *The Herald*, a bronze angel commissioned for the entrance to the Newington-Cropsey Foundation and Cultural Studies Center, Hastings-on-Hudson, New York.

Publication of Donald Martin Reynolds's book *Masters of American Sculpture: The Figurative Tradition from the American Renaissance to*

the Millennium. It features the artistic and historic importance of The Creation Sculptures, *Three Soldiers*, and *The Cross of the Millennium*.

The Cross of the Millennium (life-size), clear acrylic resin, commissioned by Saint Vincent de Paul, Catholic Church, Andover, Kansas.

Hudson Hills Press publishes the first monograph, *Frederick Hart, Sculptor*.

1996 *Richard B. Russell, Jr. Memorial Statue* is installed and dedicated in the rotunda of the Russell Senate Office Building, Washington.

The Cross of the Millennium (life-size) installed in Saint Vincent de Paul, Catholic Church.

1997 *Lord Mountbatten*, bronze portrait, is installed in the Prince of Wales's private garden at Highgrove.

Receives commission for *Illuminata Trilogy*, editioned sculptures in clear acrylic resin.

Bronze bust of Senator Strom Thurmond is installed in the Thurmond Room of the United States Capitol Building, Washington, D.C.

The Cross of the Millennium (unique casting) is unveiled for Pope John Paul II at a private ceremony in the Vatican.

Admitted to the *Order of Saint John* as Serving Brother by Queen Elizabeth II.

The Cross of the Millennium is featured in Pageant of the Masters, Laguna Beach, California, production "Hidden Treasures."

1998 Receives the first annual Newington-Cropsey Foundation Award for Excellence in the Arts.

PBS documentary *Rodin & Hart, Master Sculptors* receives an Emmy Award, Washington.

Daughters of Odessa, a three-quarter life-size bronze sculpture, is presented to the Prince of Wales in recognition of his support of the traditional artistic values of beauty and order.

Three Soldiers is featured in Pageant of the Masters production "Metropolis: Art of the World's Great Capitals."

Receives commission to create the vice-presidential bust of James Danforth Quayle.

1999 Featured speaker for Memorial Day ceremony at the Vietnam Veterans Memorial.

Interviewed for *Think Tank* (a PBS television program hosted by Ben Wattenberg) feature "Frederick Hart: Shaping the Culture."

Dies August 13 at Johns Hopkins Hospital, Baltimore.

Gold Line Congressional Tribute is entered into *The Congressional Record* by Senator Strom Thurmond.

Posthumously awarded honorary degree of Doctor of Fine Arts from American University.

Celebration is featured in Pageant of the Masters production "The 20th Century: Ten Decades of Art."

2000 Life Achievement Award from Lyme Academy of Fine Arts, Old Lyme, Connecticut, is posthumously bestowed "for advancing the art of sculpture in reverence for the beauty and value of creation, for creating images that will tell future generations who we are and how we felt in the late twentieth century, and for challenging the next generation of artists to

visualize the mystery and power of truth and beauty."

Honored by the National Sculpture Society, which dedicated its Spring 2000 issue of *Sculpture Review* to Hart and his body of work.

Honored by Washington National Cathedral with a memorial tribute and sculpture exhibition: "Transcendence and Renewal."

2001 Cited for his contribution to the arts by *Think Tank*, PBS, "Art under the Radar."

2002 Washington National Cathedral and Chesley announce the release of limited editions of sculptures created for the Cathedral by Frederick Hart.

Exhibition, "Frederick Hart: A Celebration of Spirit," at the McKissick Museum, University of South Carolina.

A symposium, "Visual Arts in a Global Society," University of South Carolina, centers on the work of Frederick Hart.

Three Soldiers is featured in Pageant of the Masters production "Heroes and Heroines."

Cited in the Boy Scouts of America *Sculpture*

Merit Badge pamphlet along with Louise Nevelson and David Smith as "...among those who had their own unique way of sculpting and are admired for their creativity and dedication."

Ex Nihilo, Working Model in cast marble is donated to Belmont University, Nashville, for installation in the Maddox Grand Atrium of the Beaman Student Life Center and Curb Event Center.

Vice-presidential bust of James Danforth Quayle is accepted by the Senate Committee on Rules and Administration.

2004 Exhibition, "The Creative Spirit: The Sculpture of Frederick Hart," is held at the Leu Art Gallery and the Leu Center for the Visual Arts, Belmont University, Nashville.

A multi-disciplinariary symposium, "The Creative Spirit: Belmont Celebrates the Arts," Belmont University, centers around the work and philosophy of Frederick Hart.

Exhibition, "The Creative Spirit: The Sculpture of Frederick Hart," is held at the Las Vegas Art Museum.

Awarded the 2004 National Medal of Art by President George W. Bush.

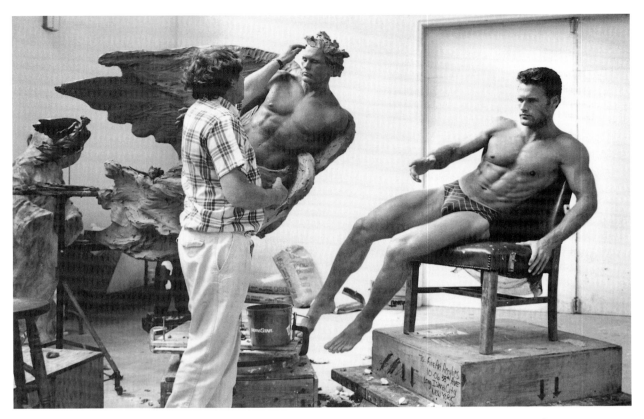

FIG. 132: Frederick Hart at work on *The Herald*, commissioned by the Newington-Cropsey Foundation, Hastings-on-Hudson, New York, 1991

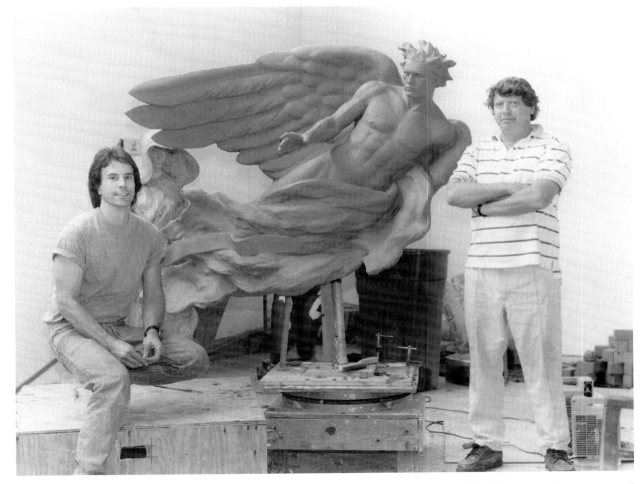

FIG. 133: Jeff Hall, Hart's studio assistant of many years, and Hart prepare to cast *The Herald*. Hall also prepared the molds from the plaster *Ex Nihilo* when they were cast in bronze for the Washington National Cathedral Collection.

FIG. 134: Frederick Hart simultaneously worked on many sculptures. Some would be half-finished for years. The studies and fragments in his studio often inspired other works.

FIG. 135: Clay model of Senator Strom Thurmond

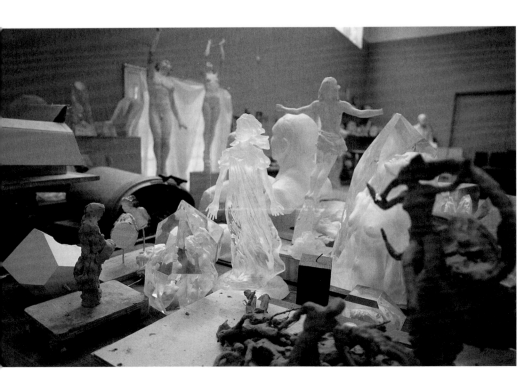

FIG. 136: The artist's studio

FIG. 138: Robert Chase and Frederick Hart discuss the beginning of a new sculpture, 1993.

FIG. 137: Robert Chase and Frederick Hart review calendar of future exhibitions, 1985.

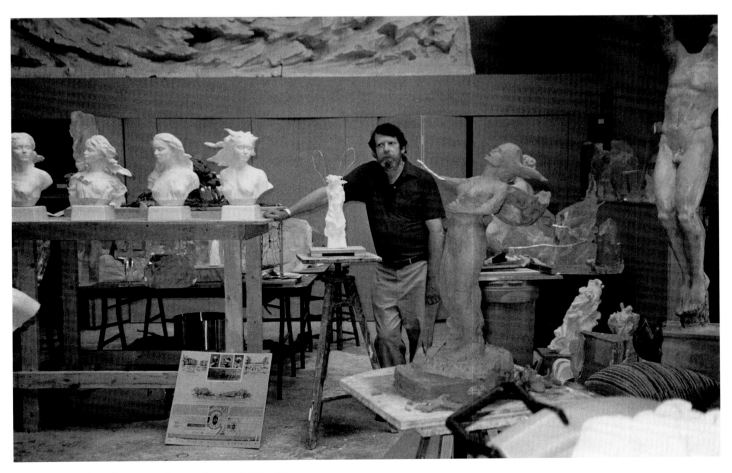

FIG. 139: Frederick Hart in his studio with The Muses, 1999

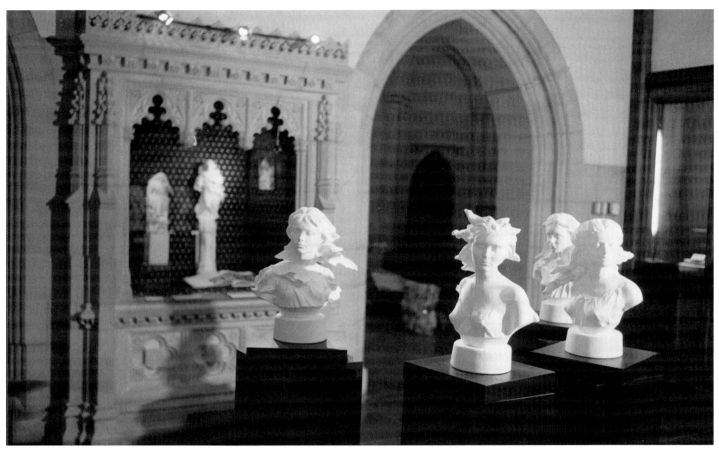

FIG. 140: The Muses, exhibited in "Transcendence and Renewal: A Memorial Tribute," Washington National Cathedral, 2000

FIG. 141: Moya Chase, Robert Chase, and Lindy Hart standing next to *Christ Rising* at a Chicago exhibition, 2003

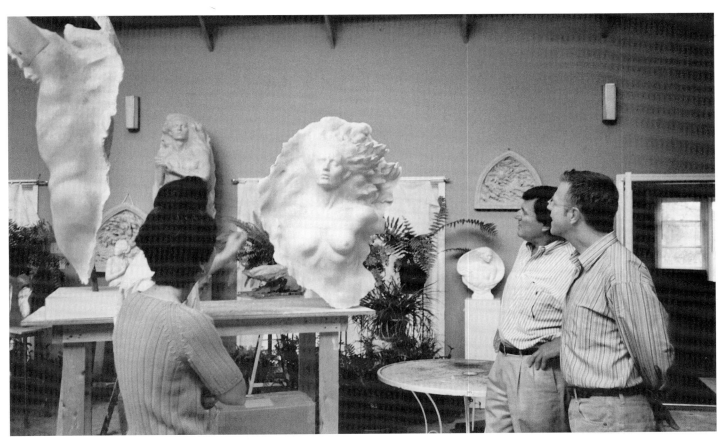

FIG. 142: Lindy Hart, Robert Chase, and Erik Vochinsky, Washington National Cathedral, view plasters from the Cathedral Collection at Hart's studio.

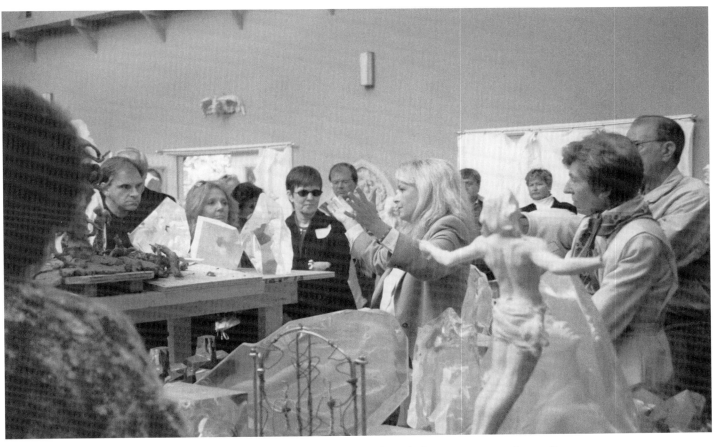

FIG. 143: Madeline Kisting tells the story of Frederick Hart's life and work during a visit to the studio.

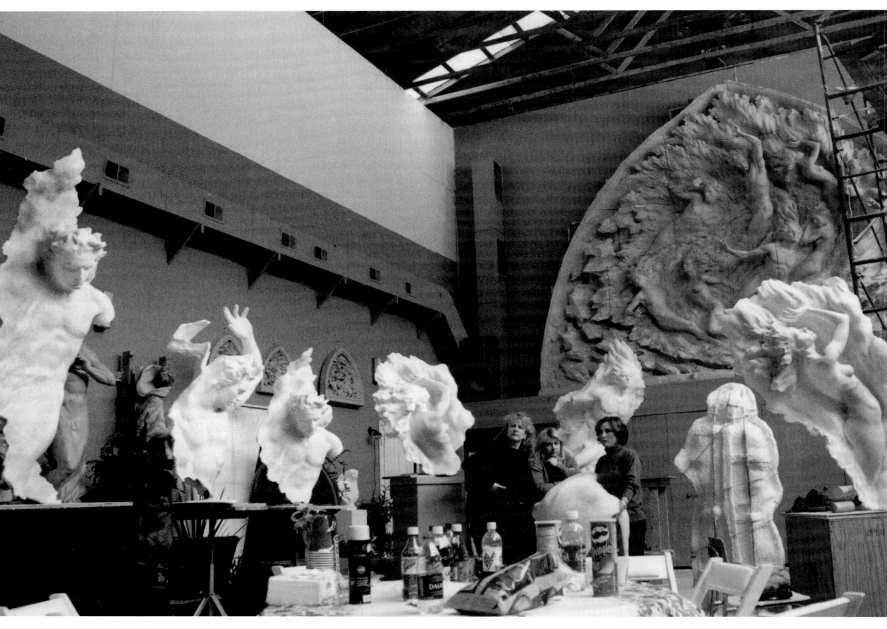

FIG. 144: Lori Schwartz, director of operations; Chesley LLC, the publishing company named for Hart's sister; Madeline Kisting, managing director, and Lindy Hart in the studio among the plaster casts for Washington National Cathedral Collection

BIBLIOGRAPHY

Frederick Hart, Sculptor. Robert Chase, James F. Cooper, Frederick Downs Jr., James M. Goode, Donald Martin Reynolds, Homan Potterton, and Frederick Turner, with an introduction by J. Carter Brown and commentary by Tom Wolfe. New York: Hudson Hills Press, 1994.

Camus, Albert. *The Rebel.* New York: Vintage Books, 1956.

Chesterton, G.K. "A Defense of Nonsense." New York: Dodd, Mead, & Company, 1911.

Conroy, Sarah Booth. "A Genesis in Stone," *Horizon* 22 (September 1979), 28-38.

Cooper, James F. "Frederick Hart: Inspired by God and Beauty." *American Arts Quarterly* (Spring-Summer 1990), 248-261.

John Paul II, *Letter to Artists.* Boston: Pauline Books & Media, 1999.

Jordan, Robert Paul. "Washington Cathedral, 'House of Prayer for All People.'" *National Geographic* (April 1980), 552–573.

Joyce, James. *A Portrait of the Artist as a Young Man.* New York: Penguin Books, 1976.

Machlis, Joseph. *The Enjoyment of Music.* New York: W. W. Norton and Company, Inc., 1963.

Marcel, Gabriel. *The Mystery of Being.* Chicago: Henry Regnery Company, 1960.

Maritain, Jacques. *Creative Intuition in Art and Poetry.* New York: Meridian Books, 1955.

Naisbett, John, and Patricia Aburdene. *Ten New Directions for the 1990s.* New York: Morrow, c. 1990.

O'Connor, Flannery. *The Habit of Being.* Ed. Sally Fitzgerald. New York: Farrar, Straus, and Giroux, 1988.

Santayana, George. *The Sense of Beauty.* Pt. IV, Expression. New York: Scribner's, 1902.

Teilhard de Chardin, Pierre. *The Phenomenon of Man.* New York: Harper, 1959.

———. *The Divine Milieu.* New York: Harper & Row, 1960.

Tharp, Louise Hall. *Saint-Gaudens and the Gilded Era.* Boston: Little Brown and Company, 1969.

Turner, Frederick. *Beauty: The Value of Values.* Charlottesville, University Press of Virginia, 1992.

———. *Natural Classicism: Essays on Literature and Science.* Charlottesville, University Press of Virginia, 1991.

———. *Rebirth of Value: Meditations on Beauty, Ecology, Religion, and Education.* Albany: State University of New York Press, 1991.

———. *The Culture of Hope: A New Birth of the Classical Spirit.* New York: The Free Press, 1995.

Wilkinson, Burke. *Uncommon Clay: The Life and Works of Augustus Saint-Gaudens.* New York: Harcourt Brace Jovanovich, 1985.

INDEX

PHOTOGRAPH CREDITS

The following photographers have contributed greatly to this book:

Darrell Acree: iv, xiv, xx, 10, 21 below, 22, 23, 26 left, 27, 28, 172 right, 182
Douglas Bening: 8, 36, 40–47, 49, 50, 51, 119, 122, 123, 136, 140, 141, 145, 147, 150, 152, 154, 155, 159, 162, 165–167
Gabriel Benzur: 73
Morton Broffman: 21 above, 29 above, 170
Photo by Sisse Brimberg. © 1980 National Geographic Society: 24
Raymond Brown: 168
Davis Buckley, Architects and Planners: 81 above right and below
Robert Chase: 2 below, 61 left, 65, 69, 112, 144 below, 227 below
Judy Cooper: 59 right
Foster Corbin: 70
Libby Cullen: 3
Diversified Photography: 78, 79
George Erml: 37
Photo by Scott Ferrell. Fauquier Times-Democrat: 208
Jeffery L. Hall: 30, 117, 230
William Gray Harris: 158
Alexander Hart: 178 below left, 179
Frederick Hart: 80, 81 above left
Jim Hedrich, HedrichBlessing: 106, 156, 157
Richard Hertzberg: 99, 163
Eric Herzog Photography: 111, 121
Carol Highsmith: 5, 20, 25 right, 26 right, 72, 137, 178 above right, 195, 220, 226
David Hofeling: viii, 104 above, 120, 142
Robert Lautman: 77
Michael Lies: 114
Robert Mauer Photography: 38, 39, 56, 59 left, 60, 92 above, 93, 98, 100, 101, 108 below, 126, 127–129, 131–135, 139, 143, 149, 164
Laszlo Martón: 125, 160
Neshan Naltchayan: 89, 210, 215, 219, 228 above
Cindy Paré: 6, 52, 55, 57, 58, 61 right, 62–64, 74, 178 below right
Diane Schroeder: 229 below
Lori Schwartz: 32, 48, 174, 229 above
Richard Shay: 33, 35, 66, 103, 107, 113, 228 below
Steve White: 97, 108 above, 109, 153
Carin Winghart: 115

Photographs have been provided through the generous courtesy of the individuals and entities named below:

Arte & Immagini srl/CORBIS: 172 below left
Walter S. Arnold: 29 below
Jeffery L. Hall: 225 below
Lindy Hart: 71, 173 right, 174 above right and below right, 178 above left
Library of Congress, Prints & Photographs Division, "HABS DC, WASH, 384–4": 181; "HABS DC, WASH, 643–4": 173 left
L'Osservatore Romano: 84
Col. & Mrs. E.L. Lucas: 172 above left
The Prince of Wales: 82 right, 85
Duke Short: 83
State Archives of Russian Federation: 54
U.S. Senate Catalogue of Fine Art: 75 below, 90, 91
The White House. Photo by Susan Sterner: 92 below